Grass Roots

African Origins of an American Art

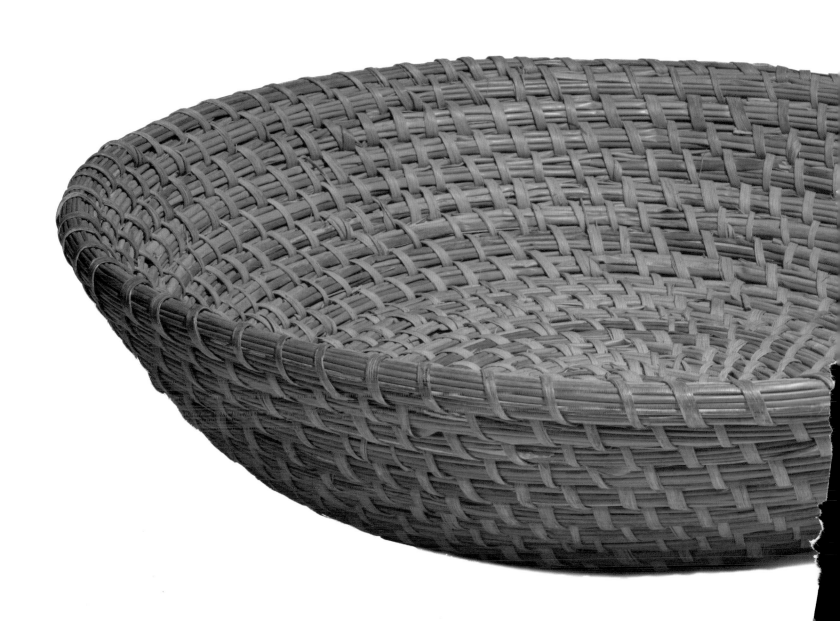

Grass Roots
African Origins of an American Art

Dale Rosengarten

Theodore Rosengarten

Enid Schildkrout

with contributions by

Judith A. Carney

Jessica B. Harris

Sandra Klopper

J. Lorand Matory

Fath Davis Ruffins

John Michael Vlach

Peter H. Wood

Museum for African Art, New York

Grass Roots: African Origins of an American Art is published in conjunction with an exhibition of the same title organized by the Museum for African Art, New York, in cooperation with Avery Research Center for African American History and Culture at the College of Charleston and McKissick Museum at the University of South Carolina.

The exhibition will travel to Gibbes Museum of Art, Charleston, South Carolina, Fowler Museum at UCLA, Los Angeles, California, McKissick Museum, Columbia, South Carolina, Museum for African Art, New York, New York, and other venues.

The exhibition and catalogue have been supported, in part, by grants from the National Endowment for the Humanities, the National Endowment for the Arts, the Gaylord and Dorothy Donnelley Foundation, and the MetLife Foundation's Museums and Community Connections Program. The National Endowment for the Humanities honored *Grass Roots* with a "We the People – America's Historic Places" designation. Any views, findings, conclusions, or recommendations expressed in this publication do not necessarily reflect those of the National Endowment for the Humanities.

Grass Roots: African Origins of an American Art is published with the assistance of

Exhibition co-curators: Enid Schildkrout and Dale Rosengarten
Editor: Theodore Rosengarten
Publication Coordinator: Donna Ghelerter
Design: Florio Design

Printed and bound in China by Global PSD

Library of Congress Control Number: 2008923614
Paper bound ISBN 978-0-945802-51-8
Cloth bound ISBN 978-0-945802-50-1

Distributed by: University of Washington Press
P.O. Box 50096
Seattle, WA 98145-5096
www.washington.edu/uwpress

Front cover: Cat. 32. Granary, Humbe, Angola, mid-20th century. H. 113.5 cm. American Museum of Natural History, 90.2/1346ab and Cat. 75. Egg basket, Elizabeth Mazyck, South Carolina, 2002. H. 38 cm. American Museum of Natural History, 26/1065.

Frontispiece: Cat. 122. Fanner basket, Welcome Beese, Waccamaw Neck, South Carolina, ca. 1938. D. 53 cm. Collection of Alberta Lachicotte Quattlebaum.

Page 6: Cat. 123. Wave basket, Linda Graddick Huger, South Carolina, 2004. D. 43 cm. Collection of Timothy and Pearl V. Ascue.

Back cover: Fig. 3.8. Winnowing rice, Mt. Pleasant, South Carolina, 1974. Photo: Greg Day.

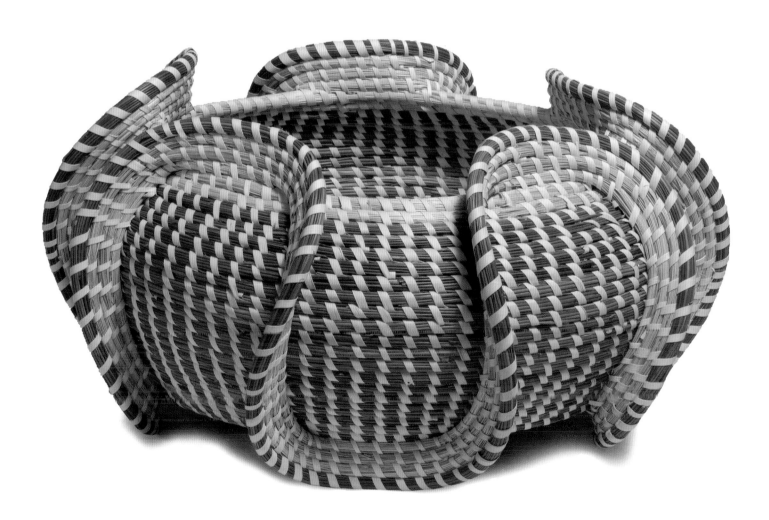

About three years ago, during the Museum for African Art's transition from nomadic quarters to a new permanent home in Manhattan, the idea of mounting a show of African "crafts" seemed like a modest way to organize an attractive small-scale exhibition. If nothing else, I thought, this would expand the public's appreciation of the diversity of African art.

What a revelation *Grass Roots* has proven to be! As the exhibition and this accompanying volume were taking shape, I began to recognize African contributions to American history and culture in entirely new ways. I knew that enslaved Africans were valued for their physical strength, and that it was their labor that made southern plantations the engines of the seventeenth- and eighteenth-century global economy. But I did not know that Africans had also provided the agricultural expertise and technologies that created prosperity for the slaveholding elite. I was surprised to learn that rice had been domesticated in Africa, as well as in Asia; that Africans who knew how to cultivate rice were worth a premium along the rice-growing coast of the American Southeast; and that so much of the artistic, religious, linguistic, and domestic heritage of Africa's rice growers had survived the transfer to America.

It is thrilling to be able to tell this story through the coiled basketry traditions that forever link the two continents. This book is about baskets in both places but, because of new scholarship brought to bear on the subject, it is really about much more. It explores many rich cultural patterns both lost and maintained; it shows how people have built and rebuilt their heritage over centuries of oppression and opportunity; it reveals how a simple but always beautifully crafted tool has come to be appreciated as an object of art.

In creating this book, the Museum has been honored to work with an amazing group of scholars and artists, including prominent art historians, anthropologists, basket makers, historians, a geographer, and even a master chef. My thanks go especially to writer and historian Theodore Rosengarten, whose editorial skills and deep knowledge of American history shaped the text; to co-curator and historian Dale Rosengarten, whose seminal research on Lowcountry baskets opened the door to the African side of the story; to Chief Curator and Director of Exhibitions and Publications Enid Schildkrout, whose long acquaintance with Africa, commitment to scholarship, and love for African art informed every aspect of the project; to Curatorial Associate Donna Ghelerter and Registrar Kate Caiazza at the Museum for African Art, who coordinated the many parts of *Grass Roots* with creativity and good cheer. Special thanks go to the staff of the Avery Research Center for African American History and Culture at the College of Charleston and to Lynn Robertson, Director of the McKissick Museum at the University of South Carolina, for working so closely and diligently with us over the past three years. Finally, I want to express my gratitude to the public and private funders who supported the project from its inception to its completion—to the National Endowment for the Humanities, which saw fit to honor *Grass Roots* with a "We the People—America's Historic Places" designation; the National Endowment for the Arts; the Gaylord and Dorothy Donnelley Foundation; the Getty Foundation (for the exhibition publication); and the MetLife Foundation's Museums and Community Connections Program.

Elsie McCabe
President, Museum for African Art

Among the many people involved in producing both the exhibition and the catalogue *Grass Roots: African Origins of an American Art*, especially deserving of thanks are the scholars who served as humanities consultants and contributed essays to the book: Judith A. Carney, Jessica B. Harris, Sandra Klopper, J. Lorand Matory, Fath Davis Ruffins, John Michael Vlach, and Peter H. Wood. We hope that their insights, from very different perspectives, are combined in this work in a way that enables readers to rethink the significance of the African contributions to American life.

As curators and editors, we owe a debt of gratitude to the many sweetgrass basket makers who shared their time and expertise with us at every step along the way. We would like to single out for thanks the leaders of the Sweetgrass Cultural Arts Festival Association (SCAFA), Henrietta Snype, Nakia Wigfall, Barbara Manigault, and Mt. Pleasant Town Councilor Thomasena Stokes-Marshall. For their help in organizing a dynamic planning workshop in the early phases of the project, we want to thank the following members of the Sweetgrass Steering Committee: Mary Jackson, Marguerite Middleton, Annie Scott, Richard Habersham, Betty Randolph, Joyce Coakley, Ricketta Coakley, and M. Jeannette Lee.

Colleagues who offered encouragement, advice, and material assistance in their fields of expertise include Mary Jo Arnoldi, Gary Chassman, Greg Day, Lindsay Hooper, Frederick Lamp, Daniel C. Littlefield, Richard D. Porcher, William Siegmann, and the late Lenore Kaufman. John Van Couvering provided valuable aid with the maps and Joseph Rubin with photo digitization. We are grateful to Tom Hennes and Ricardo Mulero of Thinc Design, for their timely help with exhibition planning; to Karin Willis for photography; to Yolande Daniels and Sunil Bald, of Sumo Design, for designing the exhibit; and to Linda Florio, Sol Salgar, and Soi Park for their artistry and craftsmanship in laying out this beautiful book and for their enduring enthusiasm for the subject.

Our thanks go to the institutions and their staffs whose cooperation and teamwork made *Grass Roots* a truly collaborative effort. At the American Museum of Natural History (AMNH), Samantha Alderson, Paul Beelitz, Lindsay Calkins, Naomi Goodman, John Hansen, Anne King, Barry Landua, Judy Levinson, and Kristen Mable facilitated the unusually large loan and, over many years, supported research into the AMNH African basket collection. Leila Potts-Campbell, Deborah A. Wright, Harlan Greene, Sue Jacoby, and Alada M. Shinault-Small at the Avery Research Center for African American History and Culture at the College of Charleston graciously organized and hosted planning meetings, assisted with research, and helped coordinate exhibition photography and preparation. In addition, Avery is creating an archive dedicated to Lowcountry basketry and, in partnership with the Museum for African Art and the SCAFA, producing a Lowcountry Heritage Tour Guide in both print and digital formats.

We owe a special debt to Lynn Robertson, Director of the McKissick Museum at the University of South Carolina, who has been part of this project from its inception and has unstintingly shared the research and collections assembled for McKissick's pioneering exhibition, "Row Upon Row: Sea Grass Baskets of the South Carolina Lowcountry." McKissick staff members Jill Koverman and Saddler Taylor provided essential support and service. At the Gibbes Museum of Art, Angela Mack, Joyce Baker, and Zinnia Willits have been effective and amiable associates. Rosalyn Browne at Penn Center welcomed us warmly on innumerable field trips and gave us access

to Penn's unique collections and to her family history. Richard Woodward and Mary Sullivan at the Virginia Museum of Fine Arts, Anne Bouttiaux, Hein Vanhee, and Agnès Lacaille at the Royal Museum for Central Africa, Carol Brown, Jenny Stretton, and Liana Turner at the Durban Art Gallery, and Chap Kusimba, Christopher Phillips, John Dodge, and Misty Tilson at The Field Museum of Natural History went beyond the call of duty to arrange loans from their institutions. And to all of the lenders who patiently worked with us through the various stages of planning the exhibition and catalogue, we thank you for your generosity.

We are indebted to the foundations and government agencies that provided major funding for *Grass Roots*, including the National Endowment for the Humanities, the National Endowment for the Arts, the Gaylord and Dorothy Donnelley Foundation, the Getty Foundation (for the exhibition publication), and the MetLife Foundation's Museums and Community Connections Program.

An outstanding video accompanying this exhibition was produced by the Center for the Documentary at the College of Charleston, in association with the Avery Research Center. Much of the research for that film is reflected in this book. We wish to thank director and videographer Dana Sardet, executive producer Virginia F. Friedman and her staff, and consultants Valinda W. Littlefield and John H. Rashford. To the Henry and Sylvia Yaschik Foundation, the South Carolina Humanities Council, and the South Carolina Arts Commission, which underwrote production and post-production costs, we are deeply grateful.

Finally, we wish to thank Elsie McCabe, President of the Museum for African Art, who embraced and supported *Grass Roots* from the start. Margo Donaldson and Kate Caiazza worked tirelessly on the project, while Carol Braide, Anna Conlan, Jerry Vogel, Lisa Binder, and interns Sara Dewey, Aditi Halbe, and Chris Richards responded skillfully to countless calls for assistance. We owe special thanks to Donna Ghelerter, whose critical intelligence and infinite care brought this book together.

Dale Rosengarten
Enid Schildkrout

JUDITH A. CARNEY, Professor of Geography at University of California, Los Angeles, and author of *Black Rice: The African Origins of Rice Cultivation in the Americas* (2001), is a specialist on African knowledge systems, water rights and irrigation, technology, and the environment. Carney received the 2002 Herskovits Prize, which recognizes outstanding original scholarly work in African studies. Raised in a "meat and potatoes" family in Detroit, she ate rice for the first time when she was twenty-two. Carney's forthcoming book, *Seeds of Memory: Africa's Botanical Legacy in the Black Atlantic*, traces the lineage of okra, sorghum, black-eyed peas, and other crops introduced to the Americas by enslaved Africans.

JESSICA B. HARRIS, culinary historian, is scholar-in-residence and Ray Charles Chair in Material Culture at Dillard University, in New Orleans. An acclaimed chef in her own right, Harris is author of nine books and numerous articles which have spread the word of African, Caribbean, and African-American cuisines around the world. Her works include *Iron Pots and Wooden Spoons: Africa's Gifts to New World Cooking* (1989), *The Welcome Table: African-American Heritage Cooking* (1995), and *Beyond Gumbo: Creole Fusion Food from the Atlantic Rim* (2003). She is the recipient of the Heritage Award from the Black Culinarians, and the Food Hero award from *Eating Well* magazine.

SANDRA KLOPPER is Vice Dean, Arts (Drama, Fine Arts, and Music) at the University of Stellenbosch, South Africa. Her research focuses primarily on how notions of tradition continue to inform the art and culture of contemporary South Africans. Klopper has written on many topics, including dress and hairstyles, hip hop, baskets, and, with her husband Michael Godby, the art of Willie Bester. Her co-authored books include *The Art of Southern Africa* (2007), *The Art of South-East Africa* (2002), and, with photographer Peter Magubane, *African Renaissance* (2000), *The Bantwane:*

Africa's Unknown People (2001), and *Amandebele* (2005). In addition to her academic career, Klopper was lead curator for the museum exhibition "Democracy X: Marking the Present, Re-Presenting the Past," which coincided with the celebration of ten years of democratic rule in South Africa.

J. LORAND MATORY is Professor of Anthropology and of African and African American Studies at Harvard University. He researches the transatlantic comings and goings of Yoruba religion, as well as ethnic diversity in black North America. In 1994, *Choice* magazine named Matory's *Sex and the Empire That Is No More: Gender and the Politics of Metaphor in Oyo Yoruba Religion* an Outstanding Book of the Year, and his *Black Atlantic Religion: Tradition, Transnationalism and Matriarchy in the Afro-Brazilian Candomblé* (2005) received the Herskovits Prize for the best book of the year from the African Studies Association. Matory's forthcoming work, which explores the changing nature of racial identity and the unspoken social curriculum of universities, will be delivered at the University of Rochester in the fall of 2008 as the Lewis Henry Morgan Lectures.

DALE ROSENGARTEN, historian, curated the exhibition "Row Upon Row: Sea Grass Baskets of the South Carolina Lowcountry," which opened in 1986 at the McKissick Museum, University of South Carolina, and has had a twenty-year run as a traveling show. Her doctoral dissertation, completed in 1997, traces the social origins of the Lowcountry basket and places the tradition in a global setting. Since 1995 Rosengarten has served as a curator in Special Collections at the College of Charleston library. In that capacity she built a major archive on southern Jewish history and culture, developed a national traveling exhibition, "A Portion of the People: Three Hundred Years of Southern Jewish Life," and co-edited a book of the same name.

THEODORE ROSENGARTEN, author of *All God's Dangers: The Life of Nate Shaw* (1974) and *Tombee: Portrait of a Cotton Planter* (1986), is an independent scholar with special interests in southern history, race relations, and the Holocaust. Recipient of both a Lyndhurst Prize and a MacArthur Fellowship, he currently teaches at the College of Charleston and the University of South Carolina. Rosengarten has served on the strategic planning team for Charleston's proposed International African American Museum, and has worked on several design projects of regional importance, including a master plan for the Rural Life Museum, in Baton Rouge, and the revitalization of Marion Square Park, in Charleston.

FATH DAVIS RUFFINS, Curator of African American History and Culture in the Division of Home and Community Life at the National Museum of American History, Smithsonian Institution, is a specialist in ethnic imagery in popular culture, the history of advertising, and African-American cultural history. She has written extensively on the theory and practice of mounting museum exhibitions, on the history of African-American preservation efforts, and on the origins of ethnic museums on the National Mall. Ruffins has curated or consulted on several major exhibitions dealing with the African-American experience, and played a key role in designing the National Underground Railroad Freedom Center in Cincinnati.

ENID SCHILDKROUT, Chief Curator and Director of Exhibitions and Publications at the Museum for African Art, was for three decades Curator of Anthropology at the American Museum of Natural History. A scholar of material culture and art, ethnicity, and gender issues, Schildkrout has published on ethnicity and migration in Ghana; women, Islam, and child labor in Nigeria; and the arts of Central Africa. Among her books are *African Reflections: Art from Northeastern Zaire* (1990), which won the Arts Council of the African Studies Association

Arnold Rubin Triennial Prize, and *The Scramble for Art in Central Africa* (1998), both with Curtis A. Keim, and *People of the Zongo: The Transformation of Ethnic Identities in Ghana* (1978). Schildkrout has curated many exhibitions including "Body Art: Marks of Identity" (1999), and, in collaboration with the British Museum, "Spirits in Steel. The Art of the Kalabari Masquerade" (1998).

JOHN MICHAEL VLACH is Professor of American Studies and Anthropology and Director of the Folklife Program at George Washington University. A prolific scholar on the subjects of African-American folk art, material culture, and plantation architecture, his *The Afro-American Tradition in Decorative Arts* (1978), which begins with a chapter on Lowcountry basketry, awakened national interest in these heretofore unheralded arts. In *Back of the Big House: The Architecture of Plantation Slavery* (1993), Vlach evokes the plantation landscape from the point of view of the enslaved. His most recent work, *The Planter's Prospect: Privilege and Slavery in Plantation Paintings* (2002), inspired the 2008 exhibition, "Landscape of Slavery: The Plantation in American Art," mounted by the Gibbes Museum of Art in Charleston.

PETER H. WOOD wrote the pioneering book on early South Carolina, *Black Majority: Negroes in Colonial South Carolina from 1670 through the Stono Rebellion* (1974), which inspired a generation of colonial historians to consider the role of people of African descent in the founding and building of American society. In *Strange New Land* (2003) and *Powhatan's Mantle* (2007), he has written suggestively about aspects of race relations in the South before 1800. Professor Emeritus at Duke University, Wood is a lead author for the U.S. survey textbook, *Created Equal* (third edition, 2008). He has collaborated on films concerning black history, co-authored *Winslow Homer's Images of Blacks* (1988), and recently published *Weathering the Storm: Inside Winslow Homer's* Gulf Stream (2004).

Theodore Rosengarten

Nobody likes to live without beautiful things.
　　—Guro weaver, Bandama River Valley, Ivory Coast

TRAVELERS TO THE REGIONS of Africa which sent millions of people to the Americas from the fifteenth through the nineteenth centuries found no craft more common or varied than basketry. Made to be used and wear out, discarded and replaced, the humble African basket settled into European consciousness as an anonymous functional object, unworthy of collecting.

A little more than a hundred years ago ideas about Africans and art began to change. Looking for inspiration beyond their Western heritage, artists and collectors, led by Pablo Picasso, Henri Matisse, and André Derain, made the momentous discovery that African masks and wood carvings were works of art. Almost overnight, African sculpture became admired as the product of a mature tradition that had attained a full understanding of its medium with scant influence from the West.

The parameters of art gradually encompassed a wide range of African ritual and domestic objects, but were slow to take in baskets. Made by hand and often with much skill, baskets have gained status as craft, and there are now devotees who describe them as art. The selection of objects for the seminal exhibition, "African Negro Art," mounted by the Museum of Modern Art in 1935, was driven by the insight that African aesthetic principles were at work in the most mundane utensils, from spoons to headrests to hair combs decorated with, or in the shape of, figurative carvings. Except for a single, marvelous exception, a piece loaned by the Musée du Congo Belge, at Turveren, baskets were not to be seen.

By its own reckoning, the MoMA exhibition marked the end of an era. Art museums across Europe and the United States had been mounting exhibitions of African objects for decades—some two dozen between 1912 and 1934. Natural history and ethnographic museums regularly displayed African collections, including basketry, textiles, and wood carvings, with labeling that commented on their artistry. Nevertheless, it was the view of James Johnson Sweeney, the young curator of "African Negro Art," that fine art was no longer being produced in Africa, "due to the decadence of the natives" who had been rendered art-less by harsh exploitation. Debunking the myth of African savagery, he replaced it with another: "The art of Africa," he announced, positioning the show as a retrospective, "is already an art of the past."

Forty-nine years later, the Museum for African Art opened its doors in New York City. By this time, no one contested Africa's seat at the table of the world's significant aesthetic traditions. The Metropolitan Museum of Art had dedicated the Michael C. Rockefeller wing, housing collections from Africa, Oceania, and the Americas, in 1982. The Smithsonian Institution had added the National Museum of African Art to the roster of museums on the National Mall in 1979. (The current building opened on the National Mall in 1987.) Far from seeing themselves as conservators of cultural remains, at least some curators at these institutions have added to their collections by seeking out living traditions and acquiring contemporary craft objects and works of art.

IN 1984, THE MCKISSICK MUSEUM at the University of South Carolina, the Southeast's only publicly supported museum of material culture and folk art, hired historian Dale Rosengarten to purchase sweetgrass baskets from basket makers in the South Carolina Lowcountry and to curate an exhibition about the history and current practice of coiled basketry. "Row Upon Row: Sea Grass Baskets of the South Carolina Lowcountry" was hugely successful in calling attention to the vitality of the tradition and raising the issue of the "Africanness" of the baskets. A profound connection to Africa seemed self-evident, sustained more by faith and intuition than by rigorous research. What was known for certain was that Africans brought as captives to the Lowcountry came from many different cultures with a diversity of basket-making traditions. Surrounded by grasses and sedge native to the coastal wetlands, they employed the technique of coiling to make a wide winnowing basket known as a "fanner," an essential tool for processing rice. Through a hundred and seventy years of slavery and now a hundred and fifty years of freedom, the descendants of the original African agriculturists have made coiled baskets without interruption.

Not only did "Row Upon Row" take the baskets from stands along the highway where they are normally displayed, and re-contextualize them as objects worthy to be shown in the high court of culture, but the basket sewers themselves shed their highway clothes and changed into evening gowns to attend the exhibition opening. It was as if a social transformation had taken place. The children of the old ruling class and the descendants of the original basket makers stood around admiring the baskets and talking to one another about the powerful shapes, fine stitching, and subtle surface decorations of the objects now displayed under Plexiglas.

Once fabricated to contain foods such as rice, cowpeas, and sweet potatoes, as well as tools and valuables, clothing and sewing supplies, the Lowcountry basket was being appreciated for containing and shaping space itself. The time had passed when women would return from the fields toting baskets of vegetables on their heads and their eager families would peer inside to see what there was to eat. In the museum all eyes shifted to the baskets. They were appraised by the tightness and regularity of the rows spiraling from the center and ascending to the rim. Craftsmanship and sensitivity to materials were the qualities that commanded attention. Utility had ceased to be the major arbiter of value. Ingenuity of design and seriousness of artistic purpose were becoming paramount.

BEFORE ROSENGARTEN HAD interviewed her first basket maker, or purchased the first basket for the McKissick Museum, Enid Schildkrout, then curator of African Ethnography at the American Museum of Natural History (AMNH), had begun to acquire a Lowcountry collection for her institution. Colin M. Turnbull, Schildkrout's predecessor at AMNH, signaled the Museum's growing interest in African and African-American basketry in 1968, when he installed a small exhibition comparing Lowcountry and Senegalese forms. Anthropologist Greg Day donated a collection of baskets he acquired in the early 1970s while doing research on the material lives and expressive culture of African Americans in Mt. Pleasant, South Carolina, the hub of coiled basket production. In 1984, the Gibbes Museum of Art mounted a one-woman exhibition showcasing the work of Mary Jackson, a rising star in the Lowcountry firmament.

Following up her work on "Row Upon Row," Rosengarten went to AMNH searching for examples of baskets that could provide clues to the African ancestry of the Lowcountry tradition—looking for look-alikes, for baskets that performed the same functions, for baskets that came from areas in Africa that were home to the people transported to South Carolina in the slave trade. Schildkrout cautioned that while coiled baskets from Africa may look similar to forms made in America, mere resemblance is a thin reed for proving kinship. Form follows function all over the world. Besides, nothing and no one in Africa stand still. Ethnic terms used to classify people as Yoruba, Gola, Mende, and Baga do not mean today what they meant to Europeans in previous centuries. Migration, and its impact on identity—subjects of Schildkrout's field work and scholarship in Upper Volta (now Burkina Faso) and

Ghana—are major themes of African history. Expect to find a crooked line when you try to trace craft and artistic influences among people who are moving around and constantly bumping into others.

In October 1998, Schildkrout and Rosengarten traveled together to Senegal where they observed coiled baskets for sale in market places and along the roads. The basket makers they met were surprised to hear that black women in America made baskets, too, and that the baskets looked a lot like theirs. The researchers stopped in the settlement of Sine Kane, sixty miles northeast of Dakar, where children, their fingers flying, turned out pieces for a French middle-man who had orders from Europe. In the rice-grow-ing village of Ross Béthio, in the lower Senegal River Valley, women were using coiled fanner baskets to separate the grain from the chaff, just as women of African origin in coastal Carolina used to do every day until recent times. The baskets were supplemented by enamel wash basins, a universal industrial age stand-in for the fanner.

In the fall of 2001, Schildkrout and Rosengarten collaborated on a small exhibit of African and South Carolina baskets at the San Francisco International Airport. Though conditions were hardly ideal—space for images and texts was limited and exhibition objects were delayed in transit in the aftermath of 9/11—the curators regarded the show as a rehearsal for a more substantial exhibition featuring the links between African and South Carolina coiled basketry and the transformations the coiled basket had gone through over three momentous centuries. The idea simmered on the back burner until 2005 when Schildkrout joined the Museum for African Art as its chief curator.

GRASS ROOTS: AFRICAN ORIGINS OF AN AMERICAN ART emphasizes the indisputable African contribution to Lowcountry basketry but opens the door to the pos-sibility of other influences as well. After all, Carolina's early sources of population stretched from Scotland to Mozambique. The Lowcountry basket is an American art because, to borrow a phrase from British historian Arnold Toynbee, its "history happened here." The passage through slavery and freedom was a distinctly American experience that contracted and expanded the basket makers' inventory.

Ultimately it is not the one-to-one correspon-dence of this African basket with that South Carolina form that holds our interest, but rather what the individual artist achieves with his or her material. Is it a beautiful basket? Does it have the look of something that has been done many times before or is it strikingly new? Has the maker been sewing from memory and habit or did the piece evolve spontaneously while her hands worked their magic over the familiar grasses?

The baskets selected for Grass Roots range from traditional utilitarian forms to works not even func-tional in concept. It is the way of the world that as coiled baskets have lost their usefulness and given way to metal, wood, and plastic containers, they have gained in stature and value as objects of admiration. But collectors and museum-goers are not the first or even the primary beneficiaries of baskets as art. Greg Day strongly argues that the making of "fancy" bas-kets goes way back into the plantation era and is not sequential to "work" baskets, though, of course, during the heyday of rice, work baskets predominated. The "in-and-out" basket produced by Lowcountry basket makers, a form that recalls African stepped baskets, may be a good example of a shape that continues to be made because its movement and symmetry please its maker, even as its freight of symbolic meanings was left on the African shore.

IN A CHAPTER ON LOWCOUNTRY coiled basketry that appeared in his trail-blazing study, The Afro-Ameri-can Tradition in Decorative Arts—the catalog of a 1978 exhibition by the same name—John Michael Vlach, a contributor to this volume, suggested that the search for the basket's African origins had scarcely begun and would not be easy. He was right. One les-son of Grass Roots is that likeness does not constitute proof of lineage. Another lesson is that looking too hard for similarities can blind us to the full range of forms within a tradition, and to the "Africanness" of the South Carolina basket, which consists less of an identity of shapes than of ideas of what makes a good and beautiful basket, as well as beliefs about where the

baskets came from. While made in America by people whose families have lived here for many generations, the Lowcountry basket retains ties to Africa because its makers see themselves as the heirs of people who came from Africa and brought the knowledge of how to make the basket with them. They see the basket as an African gift to American life.

The essays in this book demonstrate that baskets have had sundry meanings in different places and different eras. For example, in "African Origins: Ancestors and Analogues," the curators describe the multiple functions of basketry hats. A status symbol in the Congo and across West Africa, grass hats were sometimes used to identify runaway slaves in South Carolina. Another example is the changing fortune of the divination basket, made by men in various West and Central African societies, and used to learn "the opinions" of the unseen forces that dictate our fate. Commonly made at a time when people unreservedly accepted the efficacy of divination, this open bowl-shaped basket is not to be found today in South Carolina, unless the coiled grass collection plate passed around on Sunday in some coastal African-American churches is actually a divination basket stripped of the powers to foretell and appropriated for other spiritual purposes.

Peter H. Wood picks up the story in the late seventeenth and early eighteenth centuries when Africans were transported by the thousands to Carolina to clear forests, tend cattle, dike the swamps, and break new ground for crops. Group and individual identity came under fierce attack. Africans resisted by applying the very skills they used to enrich their masters to carve out dignity and elbow room for themselves. "But no skilled craft," writes Wood in "They Understand Their Business Well," "did more to undermine the identities the masters tried to impose on their chattel" than basket making, "this unbreakable link to Africa." Africans mastered the natural environment, knowing how to live off of, and with, the land. In effect, they filled an ecological niche vacated by the coastal Indians who, for all intents and purposes, were annihilated by 1715.

The transfer of knowledge is a vastly underappreciated aspect of the slave trade, in the view of

geographer Judith A. Carney. "Rice in the New World" characterizes the involuntary migration as "an unprecedented exodus of tropical farmers from the Old World to the New." These people brought knowledge systems, including technologies for moving fresh water on and off the rice fields and for turning raw rice into an edible food, which raised their chances of surviving and of producing a surplus crop. Like Wood, Carney notes that when European planters stocked their estates with slaves, they wanted only the brightest, healthiest, and most adaptable Africans, people who could quickly learn a language and take the initiative in making the kinds of decisions every pioneer has to make in a new environment.

In "By the Rivers of Babylon," *Grass Roots* co-curator Dale Rosengarten traces the coiled basket on its anonymous journey through centuries of slavery and the eras of Emancipation, Reconstruction, Redemption, and Jim Crow. War and neglect destroyed the rice banks; free black workers demanded land, wages, and some control of work conditions. In the general upheaval, rice production declined. Yet basketry withstood the drop in demand for agricultural forms and baskets continued to be made just as they were after the introduction of technologies that were supposed to replace them during rice's golden age. New uses for baskets such as transporting fruits and vegetables to market, the stirrings of tourism, intervention by outsiders, and the widespread conviction that making baskets linked people to their ancestors and in some imprecise way to their futures, kept the basket tradition alive.

Certainly people kept eating rice, and enough rice was grown on local farms to keep the stove pots boiling and the fanner baskets fanning. In Jessica B. Harris's essay, "Carolina's Gold," the Lowcountry rice kitchen is the setting for telling the culinary history of rice. Cultural historian Harris speculates that rations of broken rice actually were favored over whole rice by the enslaved because that is what Africans were used to eating. "In Senegambia," she points out, "broken rice still is reputed to better hold the sauce." Her focus on the influence of African Americans' deep-seated cultural preferences anticipates the views of Fath Davis Ruffins and J. Lorand Matory that the coastal way of life, typically represented as the product of isolation and

reaction, is in fact a creation of contact and conscious choice.

In "Missions and Markets," Dale Rosengarten describes what happened when outsiders with widely different motivations stepped in to offer basket makers a better road to their customers, and how the makers took initiatives of their own to reach potential buyers. Missionaries and teachers promoted basket making as the lynchpin of self-reliance; businessmen hoping to sell charming, useful, and locally produced craft items to an out-of-town clientele offered a steady, if paltry, commission. Though prosperity comes with grudging slowness, the modernizing world has brought welcome changes in the areas of education, jobs, political rights, and the protection of human dignity. Yet the same economic developments that help level the playing field seriously degrade the environment and threaten the future of basketry. Like oak trees that bear heavy crops of acorns as if sensing a hard winter ahead, and pine trees that drop multitudes of cones, what Rosengarten calls "a vibrant artistic culture" is preparing for the future by producing astonishing pieces of basket art, many of which appear more "African" than ever.

Sandra Klopper's "Necessity and Invention" surveys the region of southern Africa where it is possible to trace a historical trajectory parallel to the American story. In both cases, basket making has been stimulated by interaction with people from very different backgrounds and cultures who coveted baskets for entirely different reasons than the ones for which they were originally made. Klopper places basket making squarely in history by viewing the craft as practiced by diverse groups, some settled and others in migration, by treating developments in the making and marketing of baskets as watersheds in a changing society, and by attaching makers' names to baskets and recognizing the artistry of individuals such as Beauty Ngxongo and Reuben Ndwandwe.

In "Documentary Images and Devotional Acts," John Michael Vlach contends that the comforting portrait of the plantation past preserved for us in pictorial art is false. Vlach zeroes in on the watercolor paintings of the rice regime's most successful memorialist, Alice Ravenel Huger Smith. An accomplished draftsman and master of impressionist technique, Smith, working in the 1930s, used radiant pastels to poignantly render the Carolina rice plantation of the 1850s. But the picture is incomplete. "The cruelties of slavery," writes Vlach, are missing from her work. The coiled baskets that sit so perfectly and effortlessly on the heads of featureless black women, and the large fanners that double as portable cribs, become elements of planter-class propaganda. Nothing in Smith's representation of this world suggests it deserved to come to an end. The popularity of her paintings today and the acceptance of her perspective suggest to Vlach "that many Americans likewise remain unprepared for a rigorous and honest assessment of their nation's history."

Fath Davis Ruffins and J. Lorand Matory, in the two final chapters of this book, challenge the view that the coastal African-American culture, known today as "Gullah," was formed in isolation. From their first days in America, Africans in the Lowcountry participated in a global enterprise, producing rice by the millions of pounds for buyers across the sea. The long staple cotton grown on the Sea Islands commanded the highest prices on European markets, and enslaved workers in America felt the economic fallout of the famine in Ireland and the war in the Crimea. Even before the Civil War ended—in fact, just after it began—the region was flooded by soldiers, missionaries, and teachers, by correspondents from leading newspapers and magazines in the North, by photographers and engravers, song collectors and land speculators, all of whom mingled with the Gullah people.

The flood abated but did not stop, as writers, painters, and photographers kept visiting, drawn to a semitropical landscape and an exotic way of life. Composer George Gershwin visited Charleston and Folly Beach in 1934, where he turned DuBose Heyward's novel *Porgy* into a successful folk opera and classic of Americana. Edward Hopper stopped and painted in the Lowcountry, and many other artists did too. Ruffins evaluates the different styles of representation in the Sea Island portfolios of three women photographers: Bayard Wootten, Doris Ulmann, and Marion Post Wolcott. Their work conveys a message of noble acquiescence rather than class or racial struggle. In the campaign for civil rights thirty years later, music and

the visual arts were enlisted in the cause, as more and more of the agents of change came from inside the community. Ruffins concludes that the creative role of Africans as farmers and community builders, as transmitters of culture and practitioners of art, is the new symbolism of the coiled basket.

For white people in the Lowcountry, the basket has meaning as a badge of an authentic local identity that can be used to reinforce their own claims of origin, residence, and rights to power. In a relentlessly comparative approach, Matory finds a common pattern in how white elites across South America and the West Indies—including Charleston, the northernmost outpost of the Gulf-Caribbean plantation zone—"have avidly documented, celebrated, and at times even subsidized the 'folk' cultures of the dark people whom they regarded as their subordinates."

The Gullah people, Matory points out, are "among the most studied populations in the United States." The theory of isolation, in his view, is "in serious need of revision." He rejects its "unspoken prejudice" that given the choice between following an African-inspired culture and a European-inspired culture, people of African descent will chose the European. The Gullah language and Gullah names survived not because people had no alternatives, but because they preferred the African forms. Coastal African Americans have made choices about how they should live at every step along the way, and what they have learned about relating to others has given them the confidence to project their culture onto the world stage.

And who is going to remember...

1 African Origins: Ancestors and Analogues

Enid Schildkrout and Dale Rosengarten

And who is going to remember
To continue in the tradition
Of the elders?
In those days,
When things were shared out in common,
In this town,
What belonged to my village,
By right
Used to fill up a big basket.
> —prayer of titled men, Elders of Ihembosi in the grove of
> Ulaasi, Anambra State, Nigeria, August 1966[1]

STRIKING SIMILARITIES BETWEEN South Carolina Lowcountry and African baskets remind us of the ancestral connections between African people on two continents. Already skilled cultivators, the first generation of Africans in the British province of Carolina could be expected, within the limits of the new ecology, to introduce technologies like the ones they had used at home.[2] Winnowing baskets, grain storage and market baskets, and wooden mortars and pestles were fundamental tools in African grain agriculture, and these, too, were the most important implements on Lowcountry rice plantations.

Given the fragility of baskets and the ways in which their makers constantly invent new styles and designs, it is remarkable that today we still find African baskets which closely resonate with Lowcountry forms. Older baskets, including rare examples which survive from plantations and African baskets in museum collections, suggest close ties between enslaved Africans in America and populations in Senegal, The Gambia, Sierra Leone, Angola, and the Congo—all

Fig. 1.1
Mandinka women in a tidal rice field, Pacharr swamp, The Gambia, 1984. Photo: Judith A. Carney.

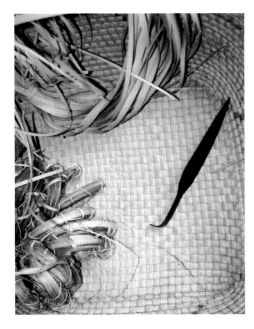
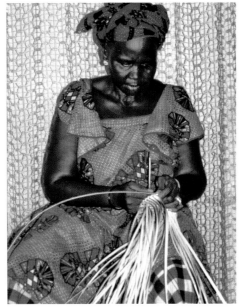

Fig. 1.2
Basketry materials and tool, Dakar, Senegal, 1998.
Photo: Dale Rosengarten.

Fig. 1.3
Thérèse Sonko making a basket, Dakar, Senegal, 1998.
Photo: Dale Rosengarten.

Born in Kagnobon, in the Casamance region of Senegal,
Thérèse Sonko moved to the capital city of Dakar in 1953
but continues to make the traditional rice winnowing
baskets, called *teng teng*, which she learned to weave
as a girl. She begins by weaving a base and changes to
twining as she builds up the sides.

places from which great numbers of people were shipped to the Americas long before the
boundaries of these modern countries were defined (figs. 1.10, 1.11b).

 While the variety of baskets found throughout Africa was and is enormous, only certain
types continued to be made in the Lowcountry. The prevalence of coiling points less to the
specific demographic origins of the people who made the baskets than to choices based on
the raw materials at hand. The coiled winnowing basket, and not the woven one still in use in
Sierra Leone, Liberia, and The Gambia, became the dominant form along the South Atlantic
coast most likely because Africans who landed in Carolina saw on every side a sea of marsh
grasses and sedge, including bulrush, ideal for making coiled baskets. In other parts of the
South, such as southwestern Louisiana, Africans winnowed rice with basket trays woven from
river cane (*Arundinaria gigantea*), just as indigenous peoples of the Gulf Coast did.[3]

 Virtually everywhere in Africa today people make both coiled and woven baskets.
In many cultures, the techniques are gender-specific: women coil grasses and men weave
splints. The coiled grass trays made in Senegal and Mali to winnow rice look a great deal like
Lowcountry fanners—wide, flat baskets used to separate the chaff from the grain (cats. 3, 6).
In the Inland Niger Delta and the savannahs of West Africa where rice originated and is still
grown, fanners and many other baskets are coiled (cat. 4). Yet, in Sierra Leone, Liberia, and
other rice growing regions where palm is abundant, fanners were, and still are, woven as often
as coiled (cat. 5).

 Within the same region, different basket making techniques and many kinds of baskets
may coexist. Apart from the relative abundance of certain materials, associations between
forms and functions determine the methods basket makers employ (cat. 7). A porous sieve, for
example, will most likely be woven, a container for holding liquids will most likely be coiled,
but a winnowing basket can be coiled, woven, or twined. Sometimes a single basket may com-
bine coiling, weaving, twining, and even decorative beading and wood carving. The Hausa and
Nupe in northern Nigeria make coiled baskets with colorful woven decorative surfaces, while
in the Casamance region of Senegal and The Gambia, makers use weaving and twining in the
same basket (fig. 1.3 and cat. 1).

 Looking at the relationship between African and Lowcountry baskets, two questions
arise. The first, easily answered, is why, out of the many types and techniques found in West
and Central Africa, only one method and a limited number of forms persisted in South

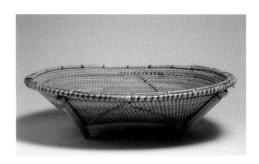

Cat. 1
RICE BASKET
Thérèse Sonko
Dakar, Senegal
1998
D. 44 cm.
Private collection

Carolina. The second, more difficult to resolve, concerns the geographic and cultural sources of the Lowcountry tradition. Even if precise origins are untraceable, the question remains intriguing because there are such suggestive resemblances between baskets from Africa and from the American South.

While baskets were associated with rice on both continents, in Africa rice was embedded in rich cultural systems that had evolved over centuries, in contrast to the rapidly organized slave plantation societies that emerged in semitropical America. African rituals of rice included masquerades and sculpture, harvest celebrations, and gifts to commemorate important life passages. In the Lowcountry, however, only baskets that served the needs of the plantation economy were mass produced; other forms may have persisted but were made rarely and in secret. Concern for the aesthetic possibilities of basketry was inevitably suppressed in the "gulag" of the American plantation system.[4] The pressure put on basket makers to produce great quantities of work baskets left little opportunity for embellishment and artistry.

EARLY ACCOUNTS OF AFRICAN BASKETRY: BEEHIVES AND HATS

Among African baskets described by European travelers in the era of the transatlantic slave trade, basketry beehives were of special interest because the hives housed a product that traders coveted—not the honey but the wax. Over the course of the sixteenth century, beeswax became an important export from Africa. Europeans used it for many purposes: to make candles, greaseproof cloth, and waxed thread; to seal bottles, jars, letters; to polish furniture; to make molds and metal castings; to lubricate machines; and to preserve eggs.[5] In 1594, in the Casanga territory on the coast of Sierra Leone, a Cape Verdian traveler, André Alvares de Almada, reported seeing as many as six hundred hives in a single tree.[6] By the eighteenth century, the aggregate export value of beeswax exceeded that of ivory.[7]

Across West Africa beehives are variations on the same theme: cylindrical containers with tight fitting lids and holes in the center of the bottom and cover which allow the bees to come and go (cat. 8). A stout stick fastened along the inside of the basket is attached to a rope from which the hive is suspended high in a tree. Among the many examples found in museum collections today are large, roughly sewn vessels; truncated, conical shapes; and elongated cylinders coated inside and outside with mud.[8]

The tree-hung, coiled beehive is a type of basket with no historical equivalent in South Carolina but, like the Lowcountry fanner, it is a traditional African form whose fabrication was stepped up to meet European demand. In Africa, wax was traditionally a by-product of honey, which was used almost exclusively to brew beer.[9] Demand from Europe changed the order of these priorities by placing greater value on beeswax. Traders increased their orders and they wanted the wax more highly refined. West African producers tended to comply. To the south, however, in Angola—a region that in the days of the slave trade encompassed the Congo—wax gatherers resisted the "more labor-intensive but less wasteful methods" and held to their traditional ways.[10] They continued to retrieve the comb and its contents by burning the bark hives, to clean the wax with fiber strainers, and to use large, shallow, coiled trays to dry the honey (cat. 31).

Just as beehives shelter bees from the elements, so do straw hats offer people protection from sun and rain. Made virtually everywhere in Africa, generally by men, hats were among the earliest kinds of basketry noted by Europeans. In the late 1600s, William Bosman observed fishermen on the Gold Coast wearing caps "made of Harts Skins or Rushes," though most tried to get "an old Hat of the Sailors, which serves them in hot as well as cold Weather."[11] Two centuries later, G. Cyril Claridge described among the Kongo an "early mania . . . for hats, which they sometimes wear in tiers of three or four."[12] European fashions were replicated by African basket makers. "In the art of imitating the African negro is expert," Claridge alleged. "He will copy the latest designs in straw hats with a grass of nature, and with a perfection which might

deceive an experienced shopwalker. He can turn out a panama variety of a texture and style almost identical with the genuine article."[13]

When his steamer stopped along the coast of Sierra Leone in 1906, University of Chicago Professor Frederick Starr collected coiled brimmed hats and covered baskets decorated with vegetable dyes. "We went to the market, where I noticed some things not before seen and made a number of purchases. We secured two types of native hats . . . [and] beautiful coiled baskets, shaped like incurved-rim bowls and with covers fitting the round openings. These were in a variety of coloring—natural, black, yellow and red."[14]

In South Carolina, too, basketry hats were frequently noted by slave masters and travelers as distinctive, and sometimes illicit, products made by the enslaved for themselves. There is an implication of shirking in St. Helena Island planter Thomas B. Chaplin's pique at his slave Jim "plaiting a palmetto hat, setting up in bed," when he was supposed to be lying down sick.[15] Among the array of headgear described for purposes of identification in advertisements for runaway slaves are occasional references to rush or straw hats.[16] Coiled grass hats continued to be made throughout the plantation era and, though less common today, they are still sewn by basket makers in Mt. Pleasant, a suburb of Charleston and the current center of basket production.

BASKET ART OF THE WEST AFRICAN SAVANNAH

The insulating properties of coiled straw that make it suitable for hats and beehives make it ideal for fabricating food covers—inverted conical baskets or flat mats set over a dish or bowl to protect the contents. Like beehives and hats, food covers are made in many parts of Africa. Unlike beehives and hats, however, they are usually fabricated by women, a logical extension of women's role in food preparation. In Senegal and The Gambia, for example, though woven baskets generally are made by men, Wolof women make coiled food covers used to serve steamed millet flour.[17]

Among the Fula (known as Fulani in Nigeria, Peul in Mali, and Toucoulor in Senegal) who inhabit the West African savannah from Senegal to Chad, women make coiled round mats to cover the tops of gourds in which they carry the milk that they sell or exchange for grain (cats. 10–13). Orange and black circular mats and "bowls" found in the street stalls of Freetown, Sierra Leone, made by Temne women, are adaptations of these mats. "While the technique is the same as the Temne use in *suku blai* [*suku* is the Temne word for coiled and *blai* for basket], the Fula value a woman who can make extremely fine coils and small stitches."[18]

In the past, and in some places to this day, the Fula were nomadic pastoralists, bartering milk products for grain and grazing land. Gourds and mats could easily be packed when the pastoral Fula moved with their herds. Today, many Fula who have settled in towns and villages across West Africa still make colorful round basketry trays used as covers, wall decorations, and marriage gifts. They display them on special platforms and hang them like pictures on the walls of their rooms, pass them on from generation to generation, or sell them (figs. 1.4, 1.6 and cats. 16–18).[19]

In this largely Islamic region, figurative designs on baskets were rare and the few examples that exist probably were made for sale to outsiders. Yet geometric designs engraved on gourds and sewn into the coiled basketry covers had names which referred to real objects, such as "palace," or "monkey's forehead," whether or not they looked like these things. Many designs replicated patterns that Fula women applied to their bodies through tattooing and scarification; in the past some motifs may have signified particular groups and stylistic regions (cat. 14).

Today in northern Senegal, a Toucoulor woman may bind the grass coils of her mats with colored synthetic strips obtained by disassembling imported flour sacks. These synthetic materials are pre-colored with industrial dyes. Traditional colors made with vegetable dyes

Fig. 1.4
Ramata Sy, Boundam Est, Senegal, 1998. Photo: Enid Schildkrout.

Coiled mats are made to cover calabashes of grain and to winnow rice. Here the mats are hung on the wall in a display with photos of family and friends. Ramata Sy obtains the colored synthetic wrapping material by unraveling commercial sacks of sugar (blue), rice (white), and onions (red).

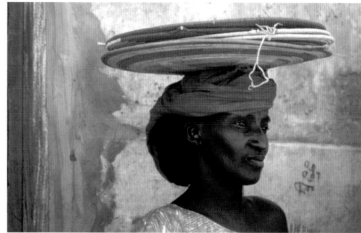

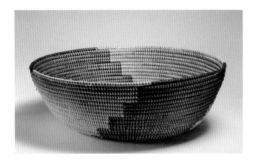

Fig. 1.5
Display of baskets for sale along the roadside, Thiès, Senegal, 1998. Photo: Dale Rosengarten.

Thiès, Senegal's second largest city, attracts artisans from areas to the south, such as Sine Saloum. Since the 1970s, basket makers have been binding their baskets with plastic strips obtained from a local floor mat factory. The colored binders are appreciated for their novelty and because they are easy to work with, but they deteriorate more rapidly than palm fiber bindings.

Fig. 1.6
Woman with basket mats on her head, Boundam Est, Senegal, 1998. Photo: Dale Rosengarten.

Cat. 2
BASKET WITH RECYCLED PLASTIC
Thiès, Senegal
Late 20th century
D. 44.5 cm.
Private collection

thus have given way to synthetic shades, prominently red, orange, white, and blue. Similarly in Thiès, a town near Senegal's capital, Dakar, coiled baskets in the form of bowls, mats, and hampers are decorated with plastic binding that the basket makers obtain from a nearby factory (fig. 1.5 and cat. 2). As in the production of telephone wire baskets in South Africa (see Chapter 7), or Gambian baskets sewn with strips from plastic bags (cat. 19), basket makers in Senegal have appropriated an industrial by-product for use in a traditional handcraft.

SOUTH CAROLINA AND SIERRA LEONE

"Gullah" is a creole language based on African grammatical principles and a lexicon composed mainly of English words but with important contributions from African languages and French. Over the past thirty years, the connection between the Gullah-speaking people of the South Carolina and Georgia Sea Islands and Sierra Leone has been the subject of intense research and media interest. The leading exponent of this link is anthropologist Joseph Opala. While he cautions that "Gullah culture seems to emphasize elements shared by Africans from different areas," Opala finds persuasive parallels in Sierra Leone and South Carolina across a wide range of folkways, including basket making, witchcraft, animal fables and trickster tales, and foods such as gumbo, red rice, and rice and greens.[20]

Rice is at the root of his argument. Carolina rice planters, he notes, would pay a premium for captives from rice-growing regions. When the London firm of Grant, Sargent, and Oswald took control of Bunce Island off the coast of Sierra Leone in the 1750s, the new owners rebuilt the fort, established a shipyard and a fleet of small vessels, and "concentrated heavily on supplying slaves to one particular market—Charlestown, South Carolina" (figs. 1.8, 1.9).[21] Although recent demographic analyses of the Atlantic slave trade show that only six percent of the Africans who disembarked in Charleston began their journey in Sierra Leone, Opala contends their numbers were large enough and they came "over a long enough period of time" to have had "a significant linguistic and cultural impact."[22]

For Opala, similarities between the basketry of Sierra Leone and the Lowcountry clinch the argument. Mt. Pleasant coiled baskets, he writes, "are constructed almost exactly like the Sierra Leone *shukublay*."[23] The claim has been repeated so often that some Mt. Pleasant basket sewers have come to accept Sierra Leone as the single source of their tradition. "The art itself," reads one basket maker's promotional brochure "came from the West Coast of Africa in a place called Sierra Leone. From there the slaves took the craft to the Sea Islands, from there to Mount Pleasant and Charleston."[24]

(continued on page 42)

GANG OF 25 SEA ISLAND
COTTON AND RICE NEGROES,

By LOUIS D. DE SAUSSURE.

On *THURSDAY* the 25th Sept., 1852, at 11 o'clock, A.M., will be sold at RYAN'S MART, in Chalmers Street, in the City of Charleston,

A prime gang of 25 Negroes, accustomed to the culture of Sea Island Cotton and Rice.

CONDITIONS.—One-half Cash, balance by Bond, bearing interest from day of sale, payable in one and two years, to be secured by a mortgage of the negroes and approved personal security. Purchasers to pay for papers.

No.		Age.	Capacity.		No.		Age.	Capacity.
1	Aleck,	33	Carpenter.		16	Hannah,	60	Cook.
2	Mary Ann,	31	Field hand, prime.		17	Cudjoe,	22	Prime field hand.
3—3	Lousa,	10			3—18	Nancy,	20	Prime field hand, sister of Cudjoe.
4	Abram,	25	Prime field hand.					
5	Judy,	24	Prime field hand,		19	Hannah,	34	Prime field hand.
6	Carolina,	5			20	James,	13	Slight defect in knee from a broken leg.
7	Simon,	1½			21	Richard,	9	
5—8	Daphne,	infant.			22	Thomas,	6	
					5—23	John,	3	
9	Daniel,	45	Field hand, not prime.					
10	Phillis,	32	Field hand.		1—24	Squash,	40	Prime field hand.
11	Will,	9						
12	Daniel,	6			1—25	Thomas,	28	Prime field hand.
13	Margaret,	4						
14	Delia,	2						
7—15	Hannah,	2 months.						

Fig. 1.7
Notice of a slave auction, Charleston, South Carolina, September 25, 1852. Rare Book, Manuscript, and Special Collections Library, Duke University.

WINDWARD COAST NEGROES, Who are well acquainted with the Culture of Rice.

Arrived from Bance Island,

To be SOLD on TUESDAY the 2d of AUGUST next,

At *Eveleigh's Wharf*, on Board the *Snow Mary*, *James Bowie, Master.*

CONDITIONS Cash, Produce, or a reasonable Credit, the Purchaser giving Bond with approved Security.

James Anderson, R. & W. Lindsay.

** *Considerable Allowance will be made for CASH.*

Fig. 1.8
Notice of a slave auction, *The Charleston Evening Gazette*, July 30, 1785. Early American Newspapers.

Fig. 1.9
Notice of a slave auction at Ashley Ferry, near Charleston, South Carolina, 1780s. Library of Congress.

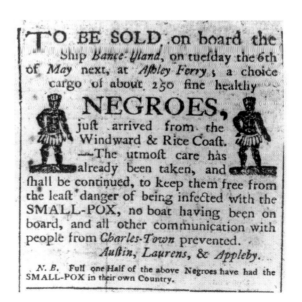

TO BE SOLD on board the Ship *Bance-Island*, on tuesday the 6th of *May* next, at *Ashley-Ferry*, a choice cargo of about 250 fine healthy NEGROES, just arrived from the Windward & Rice Coast. —The utmost care has already been taken, and shall be continued, to keep them free from the least danger of being infected with the SMALL-POX, no boat having been on board, and all other communication with people from *Charles-Town* prevented.

Austin, Laurens, & Appleby.

N. B. Full one Half of the above Negroes have had the SMALL-POX in their own Country.

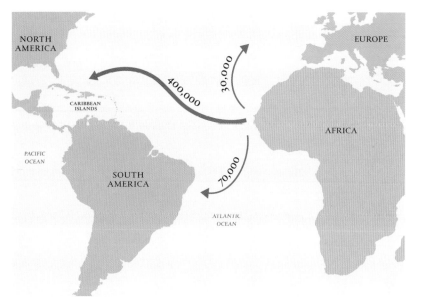

DEPORTATION FLOWS, 15TH – 16TH CENTURY: Portugal began importing slaves from sub-Saharan Africa in the 1440s to work on sugar plantations on islands off West Africa.

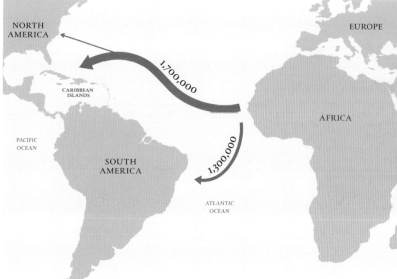

DEPORTATION FLOWS, 17TH CENTURY: By the 1640s, Britain dominated transatlantic slavery, carrying Africans to Caribbean sugar plantations.

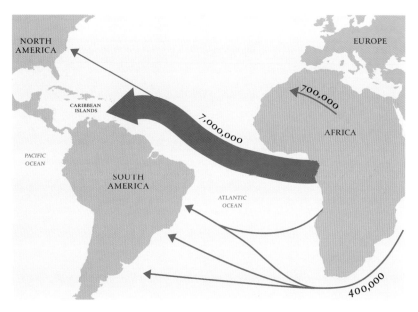

DEPORTATION FLOWS, 18TH CENTURY: This was the century when transatlantic slaving reached its grisly heights. The commerce in slaves and sugar brought vast wealth and power to the British Empire.

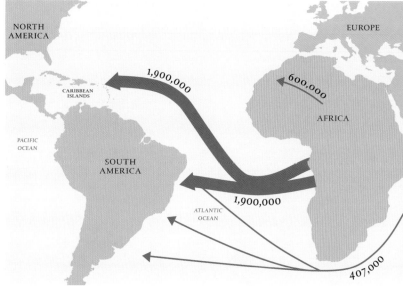

DEPORTATION FLOWS, 19TH CENTURY: Britain and the United States banned their transatlantic slaving in 1807 and 1808, respectively, but other nations continued the practice until later in the century.

Fig 1.10
The transatlantic slave trade over five centuries
© UNESCO 2006, Joseph. E. Harris (Howard University)

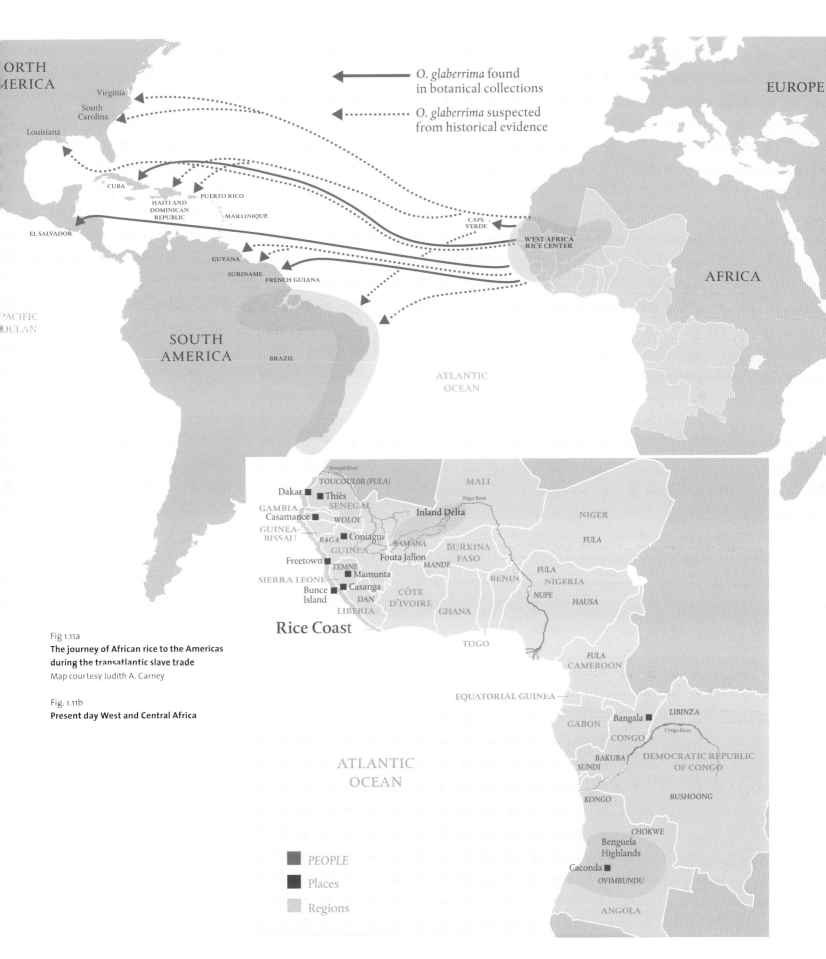

Legend (Fig 1.11a):

← *O. glaberrima* found in botanical collections

← *O. glaberrima* suspected from historical evidence

North America labels: Virginia, South Carolina, Louisiana

Caribbean/Central America labels: CUBA, HAITI AND DOMINICAN REPUBLIC, PUERTO RICO, MARTINIQUE, EL SALVADOR

South America labels: GUYANA, SURINAME, FRENCH GUIANA, SOUTH AMERICA, BRAZIL

Africa labels: CAPE VERDE, WEST AFRICA RICE CENTER, AFRICA, EUROPE

ATLANTIC OCEAN

PACIFIC OCEAN

Fig 1.11a
The journey of African rice to the Americas during the transatlantic slave trade
Map courtesy Judith A. Carney

Fig. 1.11b
Present day West and Central Africa

Fig 1.11b labels:

Senegal River, TOUCOULOR (FULA), MALI, Dakar, Thiès, Niger River, GAMBIA, SENEGAL, NIGER, Casamance, WOLOF, Inland Delta, GUINEA-BISSAU, FULA, BAGA, Coniagui, GUINEA, BAMANA, BURKINA FASO, Freetown, Fouta Jallon, MANDE, TEMNE, BENIN, FULA, NIGERIA, Mamunta, Casanga, CÔTE D'IVOIRE, NUPE, HAUSA, Bunce Island, DAN, GHANA, LIBERIA, **Rice Coast**, TOGO, FULA, CAMEROON, EQUATORIAL GUINEA, GABON, Bangala, LIBINZA, CONGO, Congo River, BAKUBA, DEMOCRATIC REPUBLIC OF CONGO, SUNDI, KONGO, BUSHOONG, CHOKWE, Benguela Highlands, Caconda, OVIMBUNDU, ANGOLA

ATLANTIC OCEAN

PEOPLE
Places
Regions

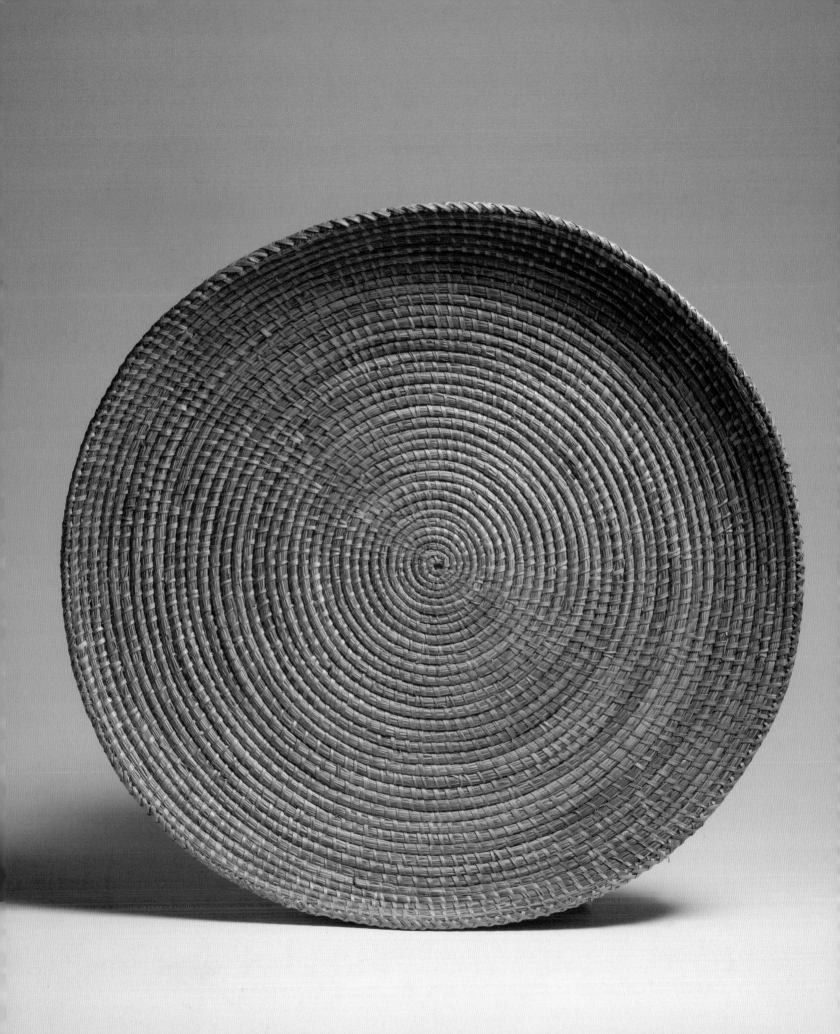

Cat. 3
RICE FANNER
Serer. Thiès, Senegal
1998
D. 47 cm.
Private collection

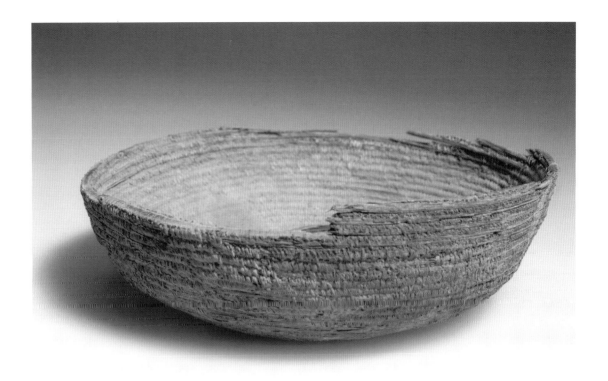

Cat. 4
BASKET
Bandiagara cliffs, Mali
15th–17th century
D. 17 cm.
American Museum of Natural History,
gift of Jerome Vogel, 95/3540

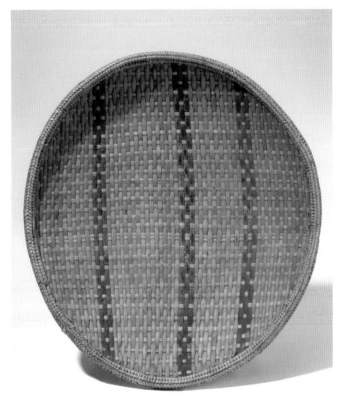

Cat. 5
**WOVEN BASKET FOR WINNOWING
RICE**
Kra. Liberia
Mid-20th century
D. 56 cm.
American Museum of Natural History,
gift of Tina and Jan Rolff, 90.2/9370

Cat. 6
SANTEE RIVER FANNER BASKET
Wedge Plantation, South Carolina
Ca. 1890
D. 48.9 cm.
Collection of Amy Lofton Moore

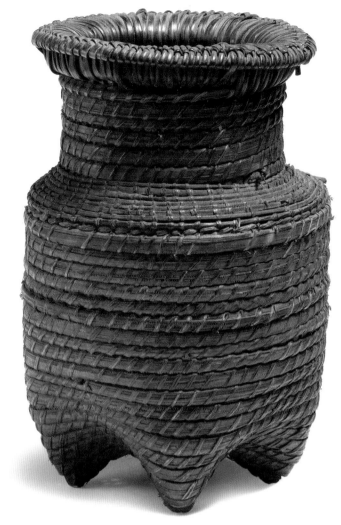

Cat. 7
SEED STORAGE BASKET
Keta. Democratic Republic of Congo
Early 20th century
H. 15 cm.
Collection of Bill and Gale Simmons

Cat. 8
BEEHIVE
Bassari. Senegal
20th century
H. 44 cm.
American Museum of Natural History,
gift of Monique Gessain, 90.2/9023ab

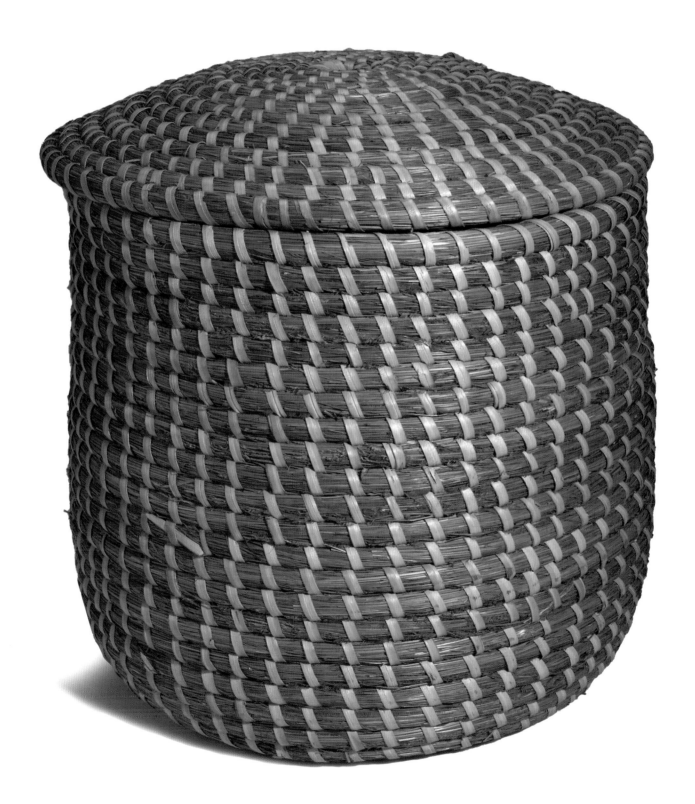

Cat. 9
COILED BASKETRY FUNNEL WITH
CALABASH BASE
Ovimbundu. Cunene Province, Angola
Mid-20th century
H. 37.5 cm.
Museu Nacional de Etnologia,
Lisbon, AF 985

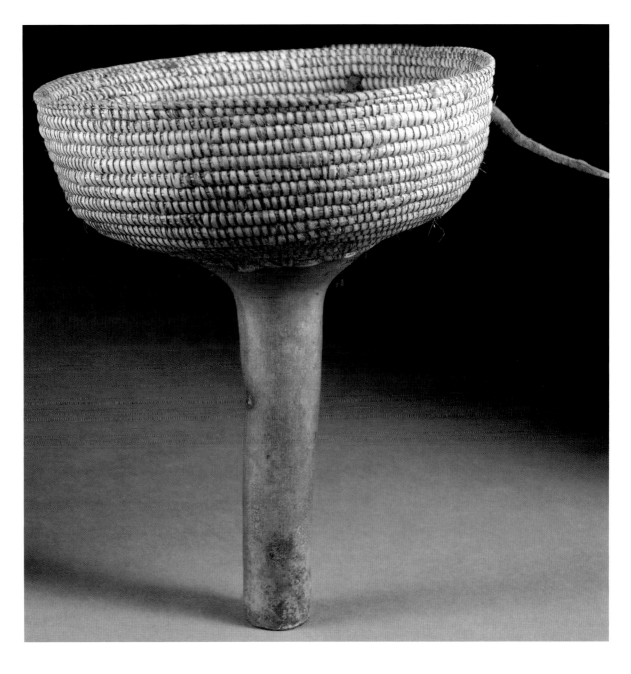

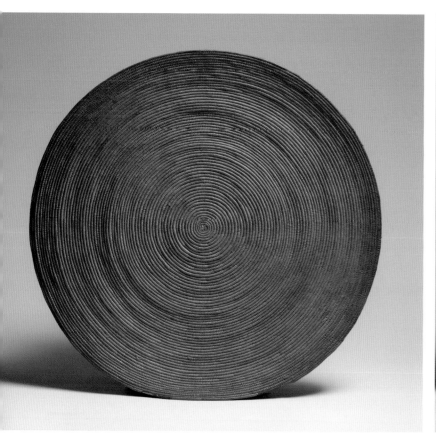

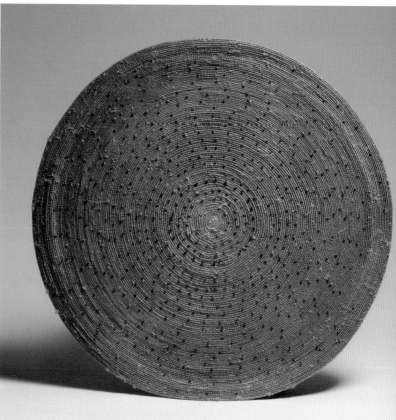

Cat. 10
CALABASH COVER
Fula. Chad
Late 20th century
D. 45 cm.
Museum for African Art, 2007.04.01

Cat. 11
**CALABASH COVER ORNAMENTED
WITH BEADS**
Fula. Chad
Late 20th century
D. 44 cm.
Collection of Bill and Gale Simmons

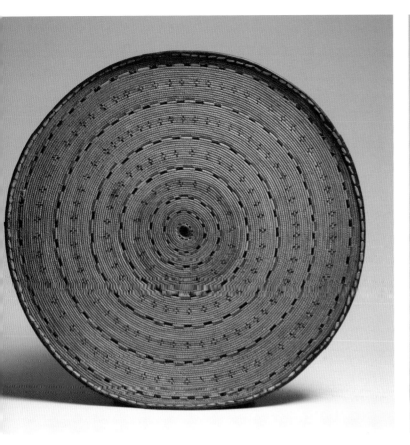

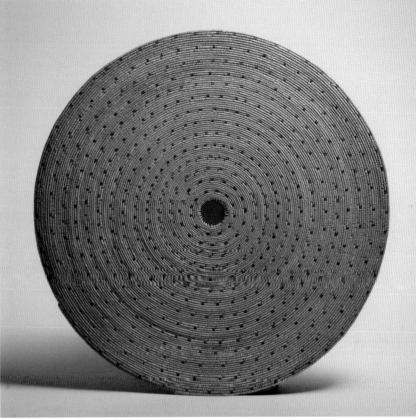

Cat. 12
**CALABASH COVER ORNAMENTED WITH
METAL AND SYNTHETIC FIBER BINDING**
Fula. Chad
Late 20th century
D. 47 cm.
Museum for African Art, 2007.04.02

Cat. 13
**CALABASH COVER WITH RECYCLED PLASTIC
AND SYNTHETIC FIBER BINDING**
Fula. Chad
Late 20th century
D. 45.5 cm.
Museum for African Art, 2007.04.03

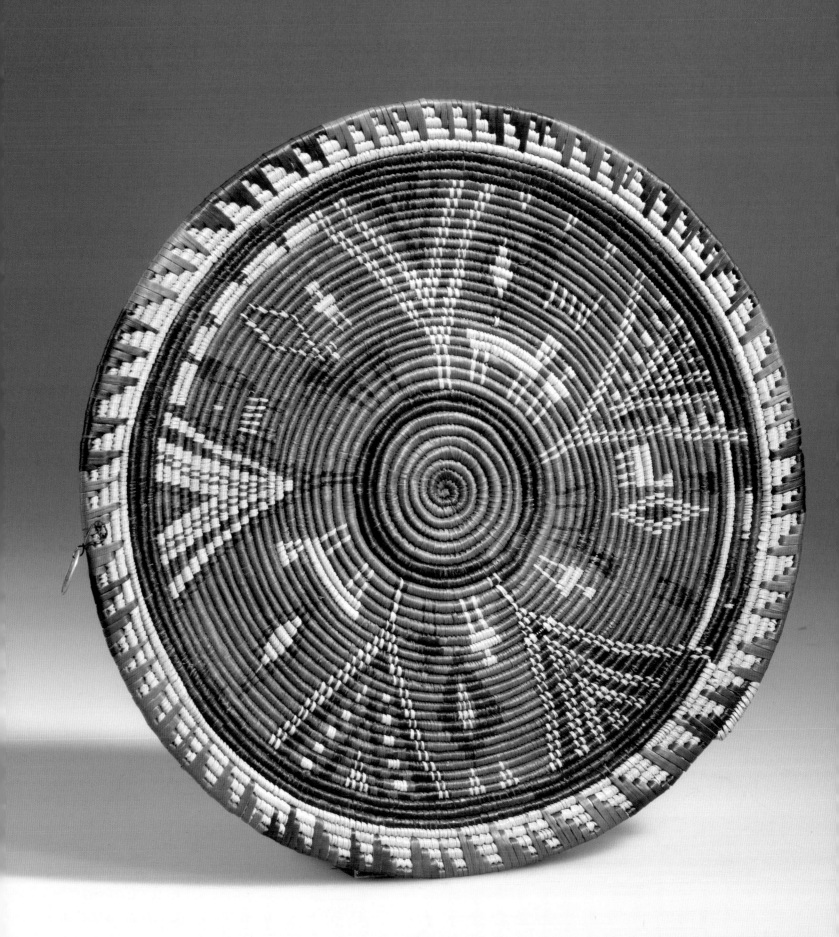

Cat. 14
CALABASH COVER
Hausa/Fula (Fulani). Kano, Nigeria
Early 20th century
D. 29 cm.
American Museum of Natural History,
gift of Martin Birnbaum, 90.1/6607

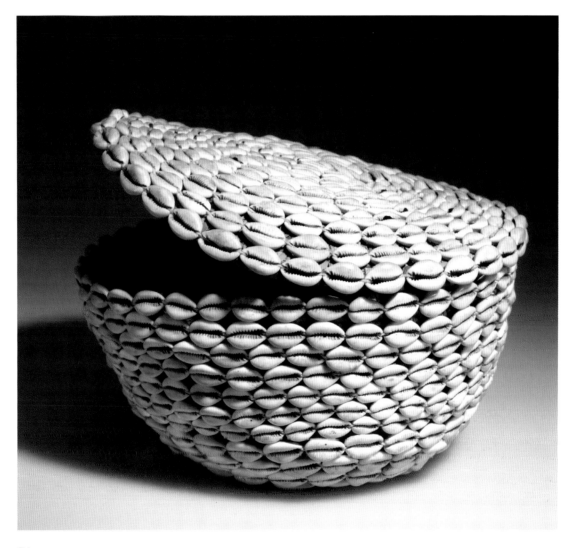

Cat. 15
BASKET WITH COWRIE SHELLS
Hausa. Nigeria
Mid-20th century
D. 25.5 cm.
American Museum of Natural History,
90.2/3410

The addition of cowrie shells, once
used as currency in West Africa,
suggests that this basket may have
been part of a bride's dowry.

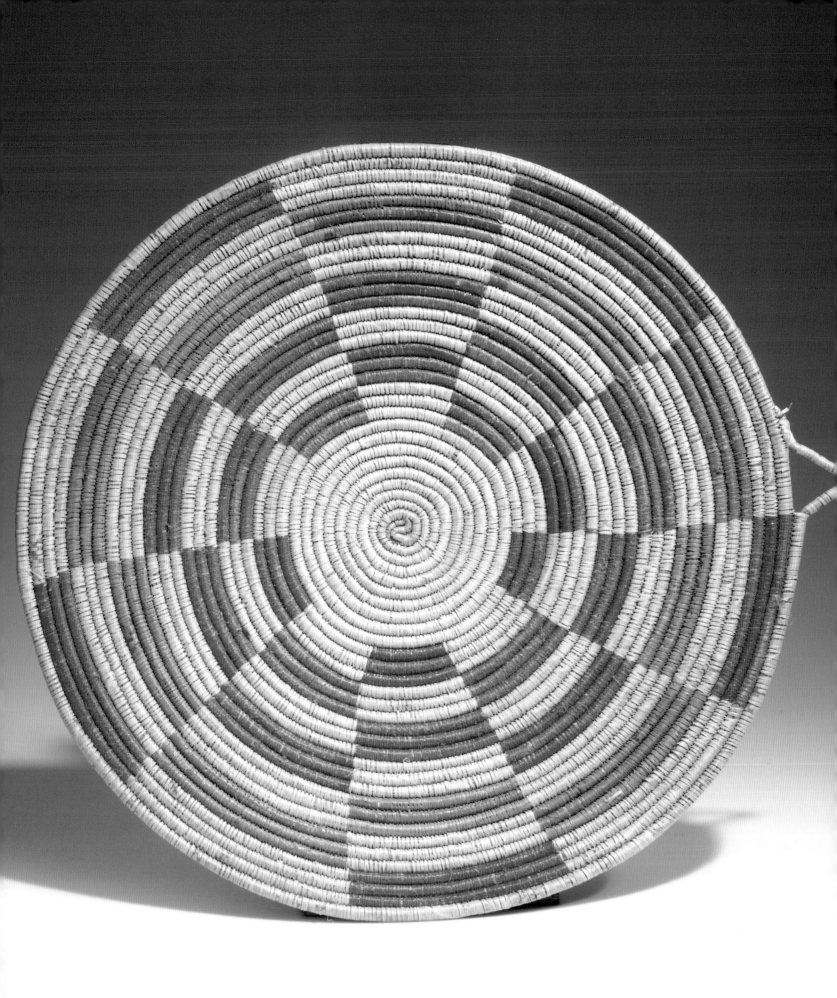

Cat. 16
CALABASH COVER MADE WITH GRASS AND SYNTHETIC FIBER
Ramata Sy
Fula (Toucoulor). Boundam Est,
Senegal
Late 20th century
D. 39 cm.
American Museum of Natural History,
90.2/9067

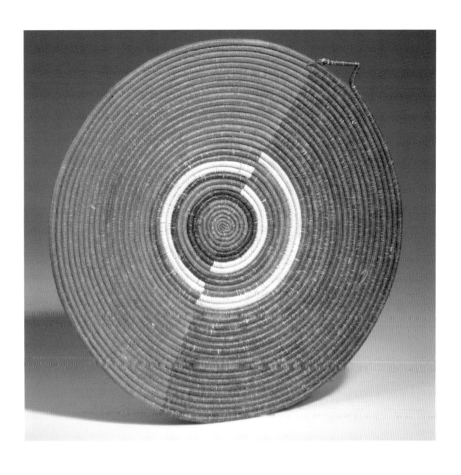

Cat. 17
CALABASH COVER MADE WITH GRASS AND SYNTHETIC FIBER
Ramata Sy
Fula (Toucoulor). Boundam Est,
Senegal
Late 20th century
D. 30.5 cm.
American Museum of Natural History,
90.2/9063

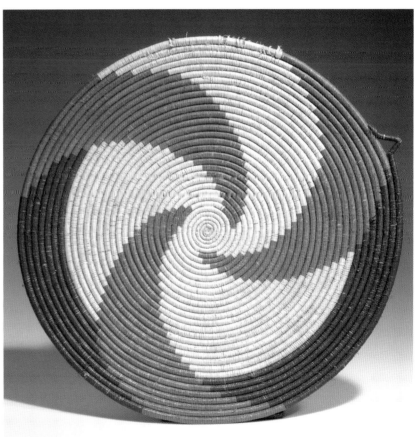

Cat. 18
CALABASH COVER MADE WITH GRASS AND SYNTHETIC FIBER
Ramata Sy
Fula (Toucoulor). Boundam Est,
Senegal
Late 20th century
D. 40.5 cm.
American Museum of Natural History,
90.2/9069

Cat. 19
FOOTED BASKET DECORATED WITH STRIPS
OF PLASTIC FROM DISCARDED BAGS
Mandinka. The Gambia
Late 20th century
D. 35.6 cm.
Museum for African Art, gift of Enid Schildkrout,
2006.07.02

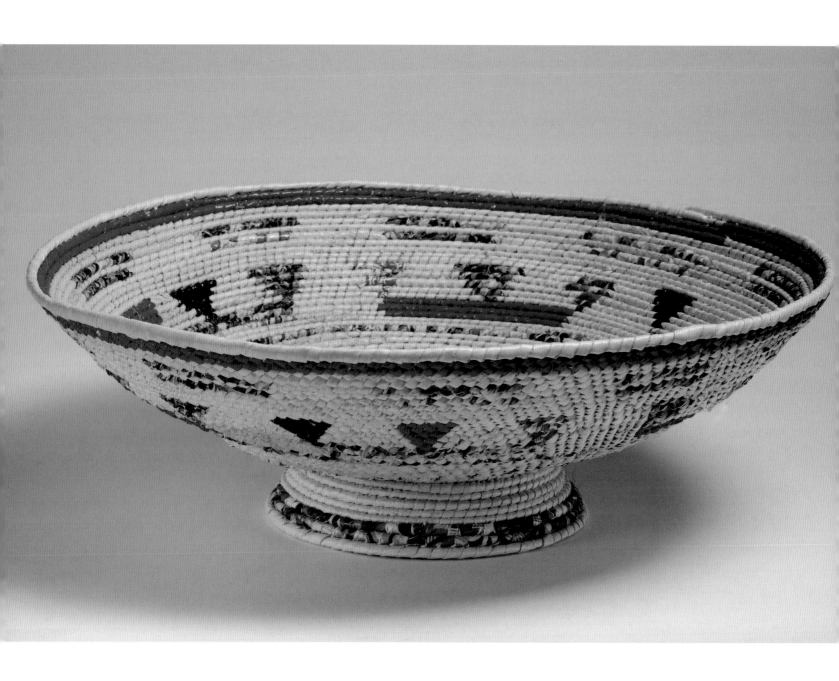

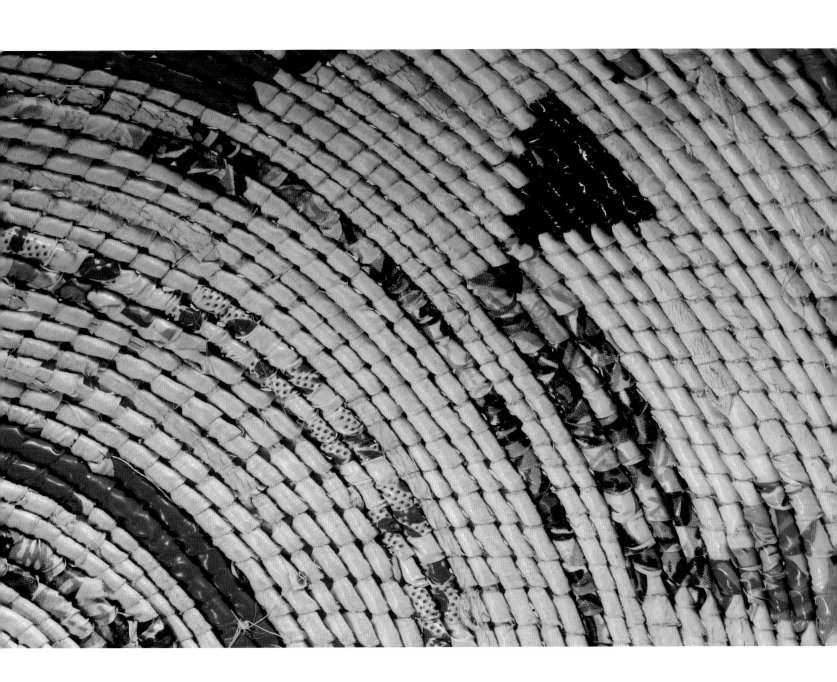

Yet the basket most closely connected to rice production, the fanner, or winnowing basket, does not sustain Opala's position. Today at least, basketry trays used to winnow rice in Sierra Leone, as previously noted, are woven rather than coiled, and contemporary Sierra Leone coiled baskets, *suku blai*, are technically quite different from baskets made of sweetgrass. The bundle of grass at the core of *suku blai* is completely wrapped by strips of raffia, whereas sweetgrass baskets have an exposed foundation. Using a large darning needle, the *suku blai* makers take a stitch through the coil every so often, while Lowcountry sewers pass the palmetto strip through the bundle with every stitch.[25] *Suku blai* are made with the outside or bottom of the basket facing up; when righted the basket appears to be coiled counterclockwise (fig. 1.12 and cat. 20). Lowcountry basket makers sew with the inside of the basket facing up, clockwise if they are right-handed, counterclockwise if they are left-handed.

Despite these technical differences, however, there are instructive parallels in the history and practice of basket making in Sierra Leone and the South Carolina Lowcountry. Journalist Margaret W. Sullivan profiled an African basket maker named Fatu Koroma, a Temne woman whom she described in 1977 as "one of the best makers of *suku blai* in Mamunta." Like most sewers in the Carolina Lowcountry, Fatu learned her basket-making skills from her mother and passed them on to her daughter. She starts her coil with the dried leaf of a *kek*—a fine material that can be twisted easily into tight circles. She then feeds in *ka lath*, "a longer and stronger grass better suited to making large baskets."[26] Likewise, basket makers in Mt. Pleasant often begin their baskets with pliable longleaf pine needles (*Pinus palustris*), adding sweetgrass (*Muhlenbergia*)[27] or bulrush (*Juncus roemarianus*) as the coil grows.

In both Mt. Pleasant and Sierra Leone basket-making materials are typically gathered by young men and boys. Even some of the same rules of etiquette and ecological sensitivity prevail: "By common understanding," Sullivan reports, "if a palm has been recently cut, the new growth is left so that the palms are not killed off."[28] The most telling parallels among modern

Fig. 1.12
Women making *suku blai*, Mamunta, Sierra Leone, 1975–76. Photo: Lisa M. Laramee.

basket makers, however, have to do with twentieth-century developments in the infrastructure of transport systems and markets. In Mamunta, about 120 miles east of Freetown, the capital of Sierra Leone, basket makers were able to capitalize on their skills because the village was at a railroad stop. "With the railway came ready access to markets, particularly Makeni and Freetown, and a growing reputation for the village's products." Even after rail traffic ceased in 1974, occasional trucks came periodically to buy the limited quantity of *suku blai* women produced, as well as raffia bags woven by Mamunta's men and *han blai*, "another kind of basket made by men in nearby villages."[29] In effect, the Government Railway built between 1895 and 1916 played the same role in central Sierra Leone that Highway 17, the main north–south coastal artery that passes through Mt. Pleasant, South Carolina, played in the 1930s.

BAGA RICE FARMERS

In searching for connections between the baskets of South Carolina and particular areas and ethnic groups in Africa, it is important to remember that in the centuries before, during, and after the slave trade, people were moving from place to place. Migration, in search of resources or for political reasons, is a constant theme in African history. Ethnic categories that may be identified today, seldom, if ever, reflect the reality of cultural variation or group identity that existed centuries ago. Baskets, lightweight and portable, have moved with people; they are easily traded across geographic borders and social boundaries. The basketry that today is closely associated with specific ethnic groups—such as the baskets of the Lozi in Zambia or the Zulu in South Africa—all were traditions that changed and converged in the late nineteenth century, often under the influence of Christian missionaries (cat. 21). In other words, matching contemporary forms of basketry with the cultural map at the time of the slave trade is highly problematic.

Many of the people shipped from the area then known as the Guinea Coast, or the Rice Coast, were of Baga ethnicity. As far back as their history can be traced, the Baga have grown rice. Their ancestors are said to have migrated from the north to escape the Fula rulers of Fouta Jallon, a fifteenth-century empire in northern Guinea. Rice, first domesticated inland along the Niger River, most certainly was cultivated in Fouta Jallon by that time.[30] Indeed, between 1100 and 1500 A.D. the region was settled by Mande farmers, traders, horsemen, and smiths who created a vast trading network that reached from the Senegal River basin all the way into the empire of Mali, the place where African rice was first cultivated. The Baga and their neighbors, who undoubtedly brought knowledge of rice cultivation with them to America, had moved south from Fouta Jallon and adapted their agriculture to the coastal estuaries.[31] The entire complex of rice, baskets, and attendant rituals has deep roots that extend over a vast geographic area and link the cultures of disparate groups, including the Fula, Baga, and Temne, to each other.

Writing in his journal of 1793–94, the British slave ship captain Samuel Gamble described the Baga method of controlling water in rice fields (fig. 3.3, p. 97) but neglected to mention other elements of Baga culture related to rice: the drums, masks, and figure carvings that celebrate the fertility of women and land. Made by the Baga people of the Guinea coast, the *D'mba* is a huge wooden dance headdress that signifies the female ideal. A *D'mba*-like mask was described by a Portuguese Jesuit, Manuel Alvares, around 1615.[32] A figure of great spiritual power integral to the culture of African rice growers, *D'mba* and other such ritual objects, like the *zigiren-wöndë* mask, dropped out of their repertoire when they crossed the Atlantic, except perhaps in memory and music (cats. 23, 25).

In Guinea, the Baga bust headdress and the large *D'mba* married-woman mask were specifically associated with rice. One Baga elder told art historian Frederick Lamp, "When the D'mba was danced, the old men of the village blessed the new rice in order that it would be well managed. . . ." Until recently, the *D'mba* was the principal entertainment at a Baga marriage,

honoring "the universal mother" and giving the bride "strength to bear children and to raise them to adulthood."[33] The bride received large ceramic vessels used for storing rice and a finely made basket that combined coiling with weaving; she would give the basket an idiosyncratic signature pattern by the way she tied the lid (cat. 26). Widespread conversion to Islam and political restrictions have suppressed the ritual, but Lamp reports that today the D'mba is at the center of a revival of traditional cultural forms.

Baskets were essential items in Baga marriage ceremonies. "In the traditional wedding ceremony practiced before mid-century," writes Lamp, "the bride (*wu-fura*) was expected to perform a dance, the *do-fura*, in which she carried on her head a basket called *ta-fala te kä-leka*, a spherical bowl atop a conical stem, rather like a wine glass. As she danced, which she did every day for a week, gifts of money from men and women onlookers were thrown into this basket, mingling with the rice grains tossed by the other women."[34]

There is a tantalizing connection between the arts of the Baga and another important sculptural form involved in rice rituals—the *ci-wara* or antelope headdress of the Bamana of Mali (cat. 28). *Ci-wara* headdresses come in several styles and are fastened to woven fiber hats worn by men to celebrate the harvest. The horizontal type, in which horns are affixed to a head that represents a "bird-man," resembles Baga headdresses called *A-Tshol*. These also have heads with beaks, evoke the figure of a hoe, and indeed are used in agricultural ceremonies (cat. 27). The *A-Tshol*, according to Lamp, is an "anthropomorphized spiritual cultivator." For anthropologist Dominique Zahan, the relationship between the Bamana *ci-wara* and the Baga *A-Tshol* is the logical consequence of migration and resettlement.

> In those cases in which the head of a "bird-man" appears, if such a head were presented without roan antelope horns, it would resemble the heads of Baga figures associated with rice culture. Such an association is not fortuitous, for we now know that the original homeland of the Baga is the Inland Delta of the Niger River in what is now Mali, where they cultivated a particular variety of rice that they took with them in their migrations to their current habitat in the Republic of Guinea.[35]

One art form related to agriculture that shows up in America, though perhaps without its original associations, is the carved staff or cane. In northern Ivory Coast, the Senufo champion cultivator staff, with a carving of a woman, is carried by a man honored for the productivity of his fields in a dance that pays tribute to both agricultural productivity and the role of women in cultivation and childbirth.[36] The Dan of western Ivory Coast and Liberia carve beautiful rice spoons, some with human and animal faces, others with legs. A large figurative spoon is carved for a woman, the *winkirle*, who is honored as the most hospitable in her village. Some spoons are said to be portraits of specific individuals. When a woman becomes old, she passes the spoon on to another who she believes is most qualified to succeed her. At special feasts the *winkirle* distributes rice to guests and dances with the spoon; women also dance with spoons at funerals to banish the ghosts of the dead. Still in use today, the spoons symbolize abundance and fecundity and represent women's connection to the spirit world (cats. 29, 30).[37]

ANGOLA'S OVIMBUNDU PLATEAU

The broad belt of woods and grasslands that stretches over central Angola, known as the Benguela Highlands or Ovimbundu plateau, is well suited to the production of coiled basketry. The area once served as a staging ground for the Angolan slave trade, and for a hundred years was one of two major sources of African labor for Lowcountry plantations. Between 1735 and 1740, a span for which there are unusually complete records, about seventy percent of the Africans brought to South Carolina came from Angola. The forced migration surged again in

the "slave rush" around the turn of the nineteenth century, as buyers and sellers sought to beat the deadline of December 31, 1807—the mandated ending of the North American trade.[38]

There is no question that baskets from this general region in many respects resemble baskets made in the South Carolina Lowcountry. Though the Benguela Highlands historically was not a rice-growing area, the baskets made there to process maize and manioc show strong similarities in form and technique to Afro-Carolinian work baskets. An exceptionally well-documented collection of baskets from the Ovimbundu plateau was acquired in 1929 and 1930 by Wilfrid D. Hambly, assistant curator of African ethnology at Chicago's Field Museum of Natural History. Hambly not only bought baskets (among a vast array of other ethnographic items), he also photographed baskets in many contexts—lying near pots, gourds, and mortars and pestles, and carried to fields and markets. He rightly declined to connect the basketry made on the plateau with any parent form, noting that "the coiling method is far too widespread and generic to afford evidence of contacts" and that "the nature of the material controls the shapes of the designs to a great extent in coiled basketry."[39]

Certain Ovimbundu baskets, such as divination trays and granaries (cat. 32), typically were made by men. But the association of women with baskets was so strong that baskets came to symbolize women in kinship terminology and burial rites. Among the Ovimbundu, the people affiliated with the father's patrilineage (*oluse*) and the mother's matrilineage (*oluina*) are divided into male and female "sides," the male being the side of the bow (*onele yohonji*) and the female, the side of the basket (*onele yohumba*).[40]

Baskets also served to mark the graves of women, a practice noted in 1875 by mining engineer and zoologist Joachim John Monteiro, and photographed by Hambly a half-century later.[41] An earthen mound marked by a staff and two large, coiled baskets is identified in Hambly's notes as an Mbundu burial site near Caconda, in the Benguela Highlands (fig. 1.13).[42] Similarly, baskets were placed on graves of women basket sewers in the South Carolina Lowcountry. Maggie Polite Manigault, an elder among Mt. Pleasant basket makers, described a square-cornered coiled basket left on the grave of her mother, Sarah Ann Polite, when she was interred in 1937.[43] Lying on the ground and exposed to the elements, baskets vanish quickly,

Fig. 1.13
Mbundu grave near Caconda, Angola, F. H. Rawson Expedition, 1929–30. The Field Museum of Natural History.

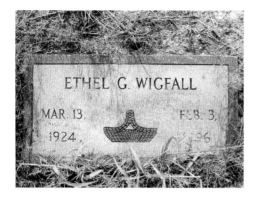

Fig. 1.14
Gravestone of Ethel G. Wigfall, Olive Branch
A.M.E. Church, Mt. Pleasant, South Carolina, 2007.
Photo: Karin Willis. Museum for African Art.

as opposed to more durable objects, such as pottery, sea shells, bottles, and clocks, commonly found on African-American grave sites. In recent years, a permanent monument signifying that the deceased was a basket maker has appeared: the gravestone of Ethel G. Wigfall (1924–1996), in the burial ground behind Mt. Pleasant's Olive Branch A.M.E. Church, is inscribed with a basket (fig. 1.14).

Almost any Ovimbundu woman, Hambly reported, could make baskets, but production was concentrated in the hands of those who showed the greatest aptitude. Makers used a grass called *osoka* to bind the rows of fine baskets; they wrapped coarser coils with strips from the leaf of the screw pine, *emañalalo*, then sewed the rows together with the bark called *olondovi*, rethreading the needle each time it passed through a coil. To maintain rows of uniform thickness, observed Hambly, "there is constant inspection and plucking out of a strand of grass here and there."[44]

Hambly collected unfinished as well as finished baskets. He noted changes in basket production, including the substitution of synthetic dyestuffs for natural colorants (cat. 33); some Ovimbundu basket makers even tried to extract dyes from typewriter ribbons and shoe polish. The baskets he collected undoubtedly were products of cultural changes that began with the introduction of American food crops into Angolan agriculture at the turn of the sixteenth century (cat. 34). Corn, sweet potatoes, and manioc, along with a hoe and pounder, filled the large *ohumba*, or field basket, that a woman would carry on her head. For sifting maize the Ovimbundu used wide, flat, coiled trays, called *ongalo*—versatile enough to be used for cleaning corn and millet and for drying fruit and honey (cat. 31). Similarly, the Lowcountry fanner basket served a variety of purposes. Fanning rice was its chief function, but it was also employed in winnowing benne (sesame) and sorghum seed, "raking grits," and carrying husked corn, peas, and other produce too small to be contained in a splintwork basket. Fanners even were used for cradling babies.[45]

SPIRITS OF THE ANCESTORS

Another important Ovimbundu basket is the *ongombo*, used in ceremonies that seek information and advice from the spirit world. Indeed the basket is so identified with divination that diviners are known as *ocimbanda congombo*, "of the basket," while makers of medicine are *ocimbanda coviti*, "of trees or sticks." *Ongombo* may be woven or coiled or made of a combination of materials (cat. 37).

Unlike other types of religious communication, divination is not intended "to alter the behavior or judgment of the supernatural powers, but merely to discover their opinions."[46] *Ongombo* are used to reveal the cause of sickness, death, or evil; to interpret omens and dreams; to give advice on personal problems; to dispense medicines and charms; to bring or withhold rain, or determine who is guilty of withholding it. The basket, with its contents of small carvings and medicinal objects, each with a symbolic connection to human destiny, is "the concrete medium through which the spirits reveal their will to their descendants on earth, and warn them of dangers, human or supernatural."[47]

The diviner prepares a basket containing various natural and man-made objects: animal parts, iron ore, copper, quartz, shells, potsherds, pieces of gourds, corn cobs and honey comb, roots, wooden carvings, an arrow head, a plumb bob, the key from a tin of sardines, a piece of coiled or woven basketry. Calling on the spirit of the basket, the diviner shakes the *ongombo* and questions the spirit "who speaks in and through" it. The audience chants in response. The objects in the basket shift. The diviner studies the disposition of objects on top of the pile, identifies the spirit who is causing the trouble, and tells his client what its demands are. "If the enemy is a living person," reports anthropologist Merran McCulloch, the diviner "indicates in a general manner from whence the trouble comes." He might tell a woman, for instance, "Your baskets are too well made; you are hated because of them." The diviner, if requested, "makes a counter-charm to offset that which has caused the ill."[48]

Special care is taken of the *ongombo* when not in use. The *olombumba* or "servants of the basket" are boys who carry the diviner's accoutrements, wait on him, and provide their master with information about the community. The basket may be kept in an *etambo* or spirit-hut expressly built for it. If a diviner's son "can master the secrets of the basket and pass the tests which are given during his initiation into the profession," he inherits his father's basket; if not, the basket goes to someone who meets the qualifications.[49]

In Ovimbundu divination, small bell-shaped, coiled baskets festooned with tufts of light-colored animal hair are worn as amulets on the head or wrist of a healer during dances. Ritual items such as divination baskets and amulets played a central role in ceremonies practiced in the Benguela Highlands, home to tens of thousands of people who were shipped to South Carolina. Might some individual have stowed one of these baskets with him as he boarded a vessel bound for Charleston? No divination baskets that might have made the transatlantic passage or were produced in the Lowcountry have survived to tell a tale. Less perishable objects linked to spiritual practices, however, have been recovered from slave sites across the American South, including earthenware bowls marked with Bakongo-style cruciforms retrieved from river bottoms bordering Lowcountry rice plantations.[50]

In their journals, account books, and letters, planters refer again and again to utilitarian elements of their laborers' material culture, including fanners, vegetable baskets, and head-tote baskets. Baskets used for divination, however, would have been the very sort of objects concealed from white people. In contrast to rites that were at least superficially Christian, such as funerals, Sunday worship, and prayer meetings, divination was an activity at which whites would not have been welcome. In a rare instance, a former slave owner reported in 1839 that on his Florida plantation "the guinea negroes had sometimes a small inclosure for their 'god house.'"[51] This extraordinary observation, archaeologist Leland Ferguson speculates, "probably represents hundreds, if not thousands, of never-mentioned 'god houses' and shrines built by Africans and their descendants on southern plantations."[52]

CONGO CONNECTIONS

In the Congo (now the Democratic Republic of Congo), G. Cyril Claridge reported in 1922 that "bush grass," second only to raffia palm as a material for basketwork, grows "out of proportion to anything else." Grass was woven into fine cloth and used for house thatch, sleeping mats, nets, and vessels of many shapes (cat. 38), including "unbreakable kitchen ware"—basketry dinner plates, pudding dishes, drinking cups—and "artistic little baskets with lids and handles to match."[53]

Europeans were impressed by the antiquity and refinement of the Congo's basket traditions. Emil Torday, who collected for the British Museum in 1905, claimed that among the Bushoong the apex of basketry art was reached in 1600 A.D. during the reign of Shamba Bolongongo.[54] Using weaving techniques, the people of this region were known for making traps, hats, shields, sheaths, sandals, skirts, and containers of all kinds. String baskets were woven tight enough to hold water; coated on the inside with resin and on the outside with red clay or kaolin, the baskets could withstand the heat of a slow fire. The most famous fiber art of the region was the soft raffia cloth known as "Kasai velvet," a form of cut pile embroidery made over a woven base. Paying the ultimate colonial compliment, British botanist, explorer, and administrator Sir Harry Hamilton Johnston (1858–1927) wrote: "The large, coarsely woven mats of Bakuba are so beautiful in design and so strong that they are almost worth exportation to Europe."[55]

(continued on page 58)

Cat. 20
COILED BASKET (*SUKU BLAI*)
Mende. Port Loko, Sierra Leone
Early 20th century
D. 29.7 cm.
American Museum of Natural History,
exchange from the Free Museum,
Liverpool, England, 90.0/1996

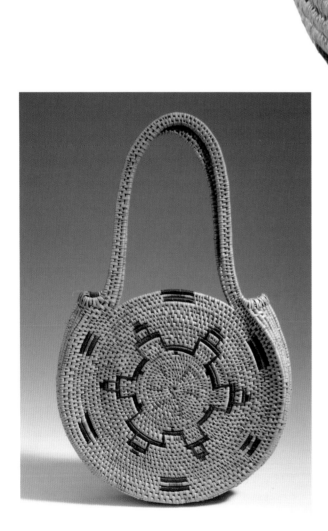

Cat. 21
MISSIONARY BAG
Zimbabwe
Early 20th century
H. 43.8 cm.
American Museum of Natural History,
gift of the government of Southern
Rhodesia, 90.1/6822

Cat. 22
FIGURES (*NOMOLI*) USED TO GUARD RICE FIELDS
Sapi. Mende region, Sierra Leone
Ca. 1500s
H. 12 cm.
Collection of William Siegmann

Small anthropomorphic figures made centuries ago are found in Sierra Leone and Liberia and currently used by the Mende people who place them in shrines and in rice fields to ensure a good harvest.

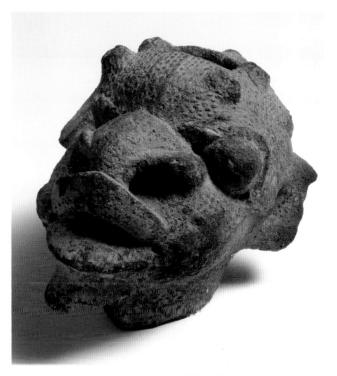

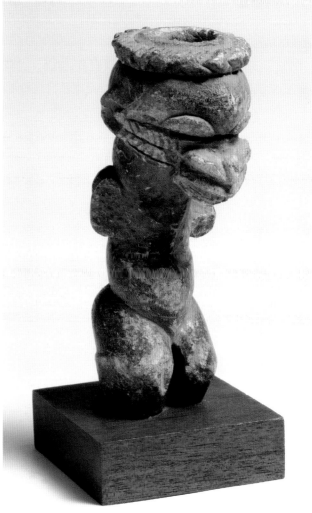

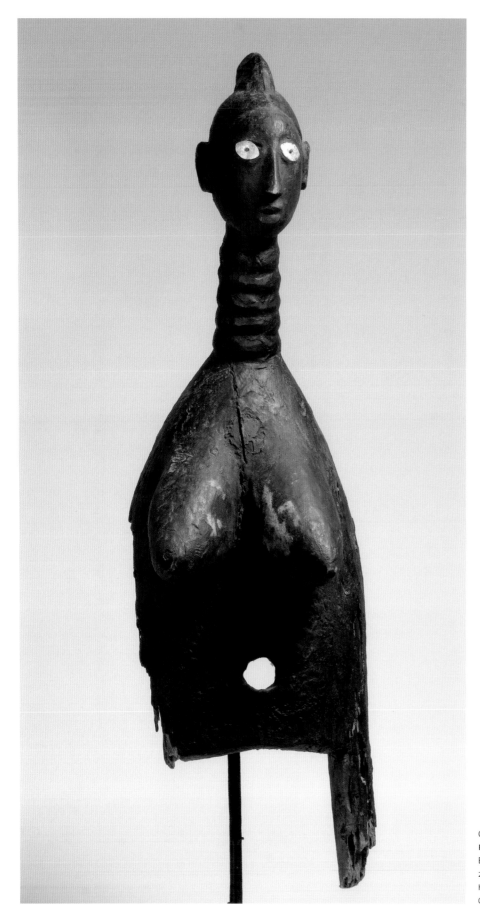

Cat. 23
FEMALE BUST MASK (*ZIGIREN-ẄONDË*)
Baga. Guinea
20th century
H. 71 cm.
Collection of Frederick John Lamp

Cat. 24
NESTED SET OF RICE MEASURING
BASKETS
Baga. Guinea
20th century
Largest bowl: D. 71 cm.
Collection of Frederick John Lamp

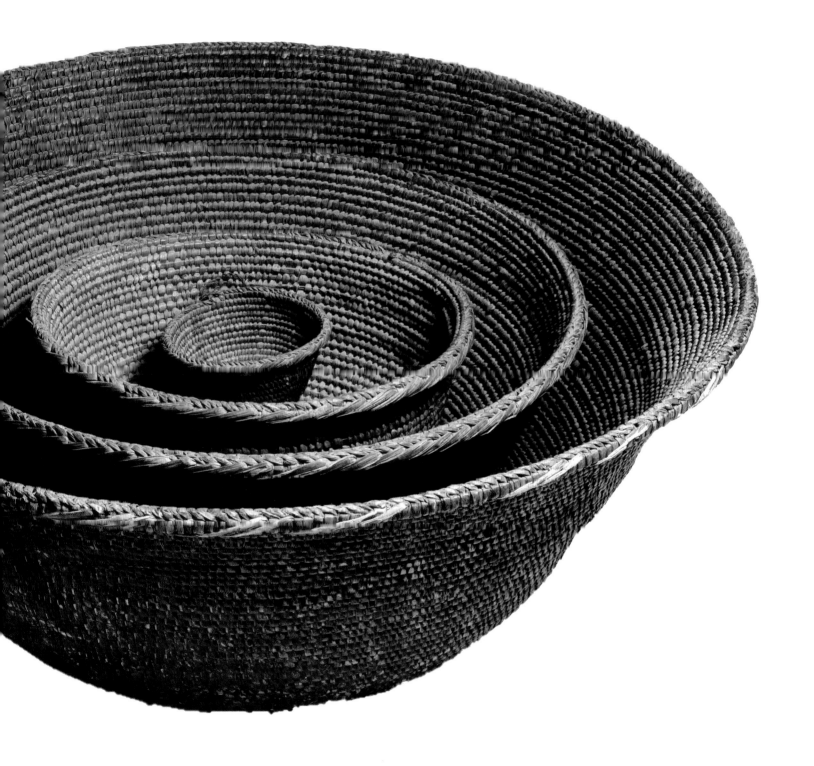

Cat. 25
DRUM
Baga. Guinea
20th century
H. 142.2 cm.
Private collection

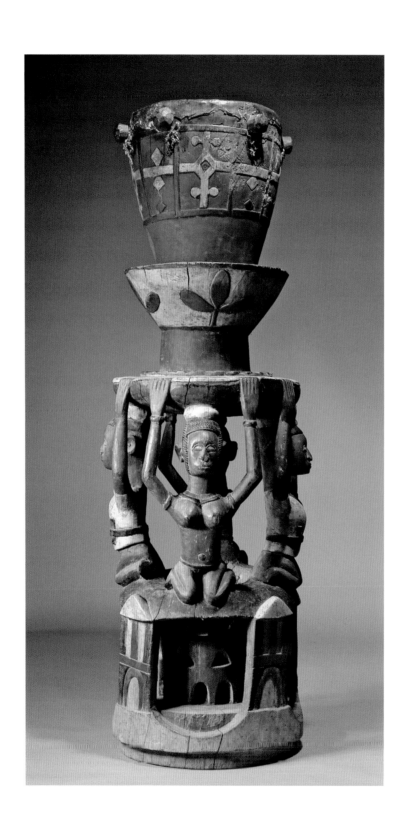

Cat. 26
MARRIAGE RICE BASKET
Baga. Guinea
Mid-20th century
H. 52.5 cm.
Collection of Frederick John Lamp

Baga marriages and harvest rituals
celebrate the fertility of women
and the productivity of rice fields.

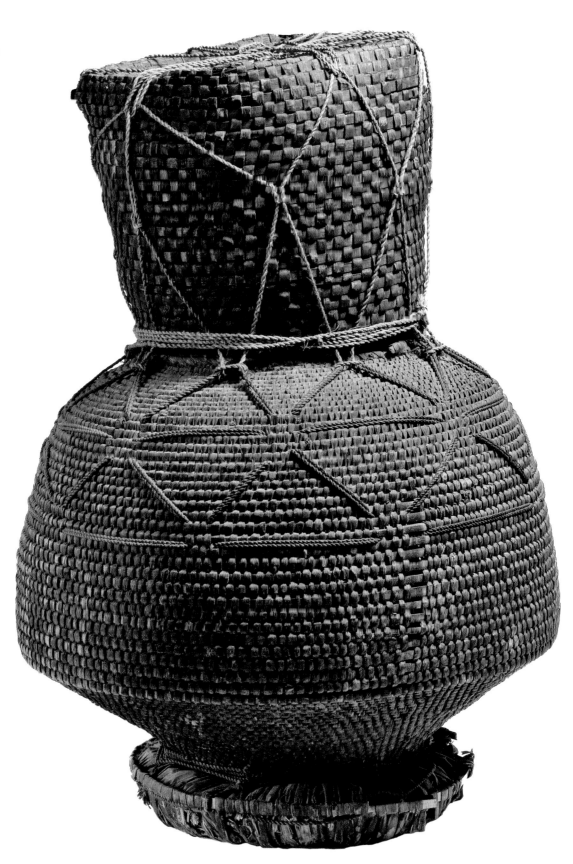

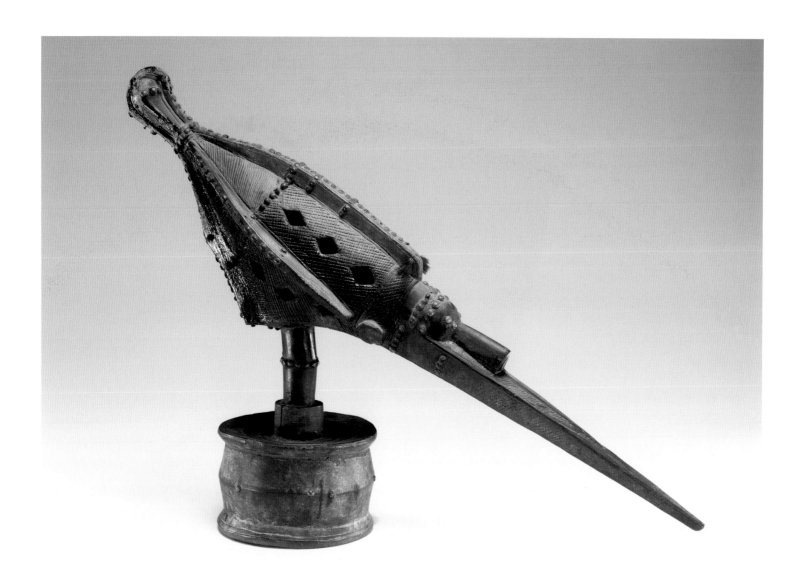

Cat. 27
A-TSHOL HEADDRESS
Baga. Sitemu region, probably
K'fen village, Guinea
Late 19th century
H. 59.7 cm.
Virginia Museum of Fine Arts,
from the Robert and Nancy Nooter
Collection, the Adolph D. and Wilkins
C. Williams Fund, 2003.13

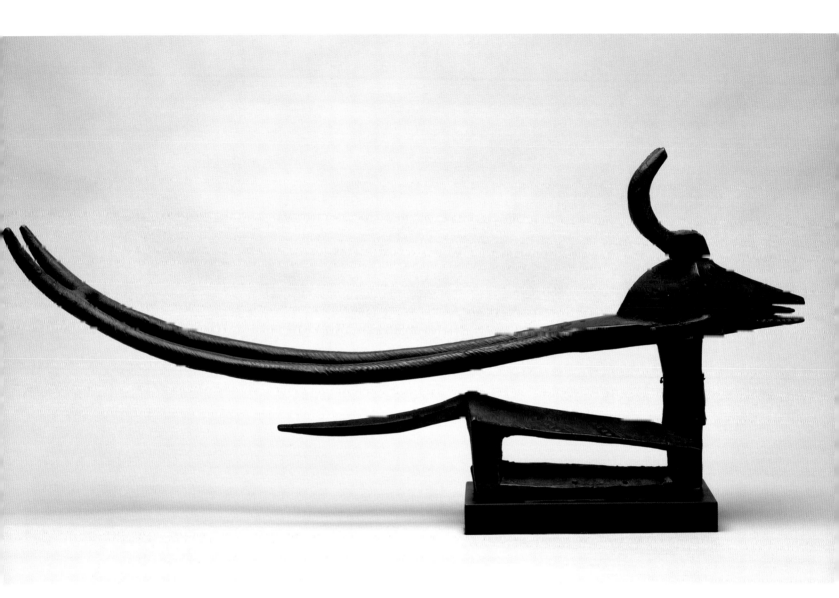

Cat. 28
CI-WARA HEADDRESS
Bamana. Mali
Late 19th or early 20th century
W. 80 cm.
Museum for African Art,
Richard J. Faletti Family Collection,
2001.1.1

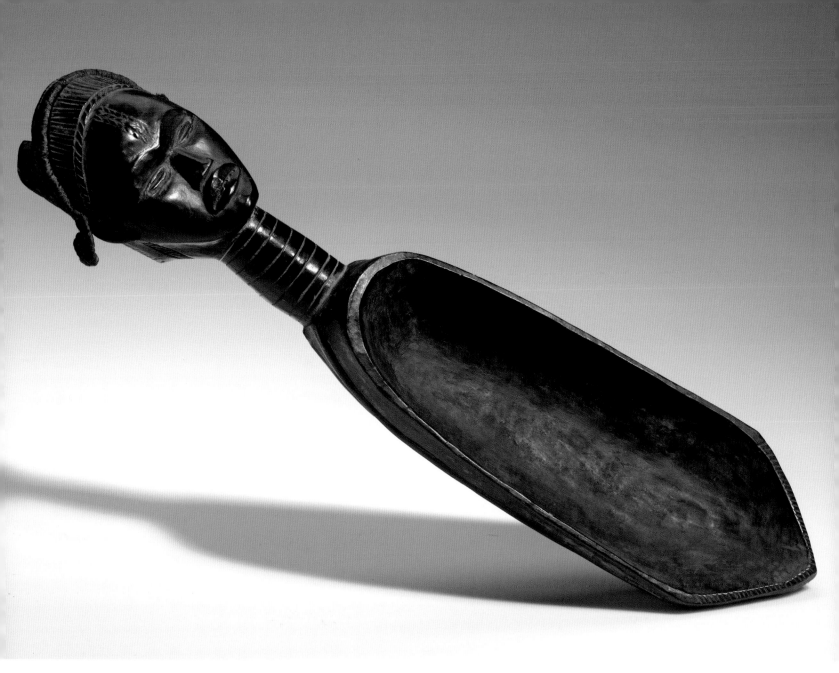

Cat. 29
FEAST LADLE (*WUNKIRMIAN*)
Dan. Liberia
Mid-20th century
H. 53 cm.
American Museum of Natural History,
gift of Mr. and Mrs. Guston T.
de Havenon, 90.2/5081

Cat. 30
FEAST LADLE (*WUNKIRMIAN*)
Dan. Liberia
Early 20th century
H. 56.8 cm.
Brooklyn Museum, gift of
Blake Robinson, 1998.80.4

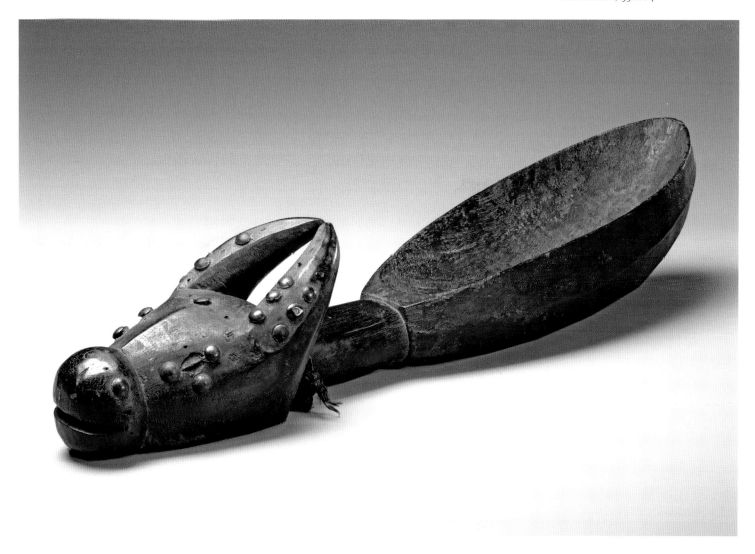

Baskets that served as containers for commercial products, rubber in particular, caught the attention of European traders. Under King Leopold II of Belgium, who ruled the Congo Free State as a personal preserve from 1885 to 1908, when it became a Belgian colony, the extraction and production of rubber had the impact of turning the region into a vast forced labor camp for the benefit of European and American investors who built cars and other goods dependant on this product of the African forest.[56] Rubber was collected in baskets and measured in baskets, although the baskets themselves were of no intrinsic interest to the rubber exporters.[57]

To show off what might be regarded by the European public as the more attractive side of colonization, Leopold II, and later the Belgian government, encouraged the collection of native arts and crafts. Along with wood carvings, masks, metalwork, and textiles of every description, large quantities of baskets and mats were shipped to Europe, not as trade goods but as ethnographic specimens and decorative items. Frederick Starr, who in 1911 sold almost four thousand Congo artifacts, including many baskets, to the American Museum of Natural History, speculated that the craze for California Native American baskets among collectors might one day be extended to African basketry.[58]

Many of the baskets in the Royal Museum for Central Africa in Tervuren, Belgium, founded by Leopold II, come with sufficient accession information to give a sense of regional distribution and continuity over time. One class of baskets, in shape and size reminiscent of the fruit and flower baskets displayed on every stand in Mt. Pleasant (cat. 40 and cat. 73, p. 149), was identified by the Belgian Colonial Office as a *panier-coupe*, or basketry cup.[59] These stemmed baskets were finely made and in some cases ornamented. The stitching pattern or color of the binding element could vary, or the rim could be wrapped closely and reinforced, producing an ornamental accent. In a basket collected in the Congo in 1940, the maker alternated darker and lighter binding material to create a banded effect. The technique was used extensively in both the Congo and Angola, and in some cases served practical as well as decorative ends. Single rows stitched with dark binders, for example, mark levels used as measures of capacity on a steep, conical, Ovimbundu basket; large bowls for grain were banded in colors that most likely served as measuring marks (fig. 1.15 and cat. 35).

Fig. 1.15
Women making baskets, Democratic Republic of Congo, 1928. Photo: J. Vandevelde. Royal Museum for Central Africa, Tervuren.

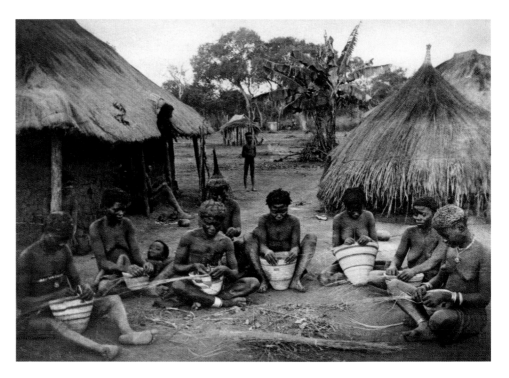

In South Carolina, too, African-American basket makers occasionally stained their binders, soaking white oak splints in a solution of ash and alternating them with natural oak splints to produce bands of grey on the sides of a basket. Few Lowcountry examples of this type survive and the technique itself is no longer practiced. Early in the twentieth century, however, Mt. Pleasant basket makers introduced a dramatic new decorative device. They lay dried needles of the longleaf pine tree on the outside of the bundle of sweetgrass, creating a band of russet color that produces a visual effect comparable to banded baskets from Angola and the Lower Congo. Over the years South Carolina sewers have embellished the practice, accenting the rows of needles with tightly tied "French knots," a term borrowed from embroidery (cat. 82, p. 160). Rarely is pine used as the sole foundation material. Its purpose, sewers say, is to make the basket more colorful and attractive.

John H. Weeks, an English missionary based near the capital of the ancient Kongo kingdom, described baskets as indispensable tools in every woman's life. Girls were taught by their mothers the skills to prepare their own materials and embellish their basketry with designs in red and black.[60] "At any time between six and eight o'clock in the morning," Weeks recounted in 1914, "you can hear the rattle of brass anklets as the women and girls pass your bungalow on the way to their farms. Poised on their heads are baskets, each containing, maybe, an empty calabash, or a hoe." The women return in the evening with the baskets filled with food, "bundles of firewood in their arms, and calabashes of water tied on their backs, or if carrying babies on backs, water is balanced among the food in their baskets." The whole village comes out to greet the group and "scan with hungry, inquisitive eyes the contents of the baskets that are now on the ground."[61]

Weeks observed that basket making in the Congo was primarily women's work, but men made certain forms. Among the Sundi, for example, work baskets, carrying baskets, and baskets used to dry beans, store pepper, and make salt were woven by women; square-bottomed, round-rimmed "tube-baskets" (nseba) and colorful, patterned baskets called mbangu were made exclusively by men.[62] In many places, men produced the baskets they themselves used; they made hats, caps, divination trays, and other "high status" baskets; they crafted traps, cages, mats, and enormous coiled grass baskets for storing grain. A photograph published in Claridge's account of his twelve-year sojourn in Africa shows five men and two boys in the Congo engaged in making "corn bins." One man holds a bundle of grass, two work on large, coiled disks, and two sit inside the baskets they are sewing, building from within.[63]

Coiled grass granaries similar to the Congo "corn bin" can be found in many parts of Africa. A portable granary of much the same size and shape was photographed—with a man sitting inside it—some fifty years later in Coniagui, on the Guinea coast (fig. 1.16). In Angola, granaries of coiled grass were made by women, as in the case of a Humbe woman photographed in 1933, sitting or kneeling inside a huge grain storage basket. In an image taken in 1965, a woman in modern dress uses the same technique to sew a similar basket.[64]

Men often made baskets associated with power and status, including some, as among the Chokwe, that formed the tops of masks—masks being the prerogative of men almost everywhere in Africa. In most places, men fabricated the objects related to hunting and warfare, including fiber traps and shields. Large stepped-lid baskets known as kinkungu also were made exclusively by men. Karl Laman, a Swedish missionary who lived in the Congo between 1891 and 1919, noted that kingungu (an alternate spelling) were among the "relatively few objects" found in the house of an unmarried Sundi man.[65] Kinkungu in the collection of the Royal Museum for Central Africa were made by coiling a single, flexible element and passing the binder over two rows at a time, a technique also used in Chokwe divining trays. Like Kongo and Mbundu caps, the baskets themselves may have been deemed especially powerful.[66]

The distinctive stepped lids of the kinkungu might allude to BaKongo kings' graves, often built in stepped tiers[67]—a parallel suggested by comparing the form of the kinkungu with a

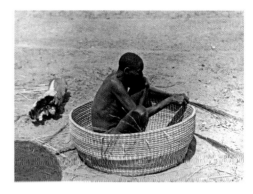

Fig. 1.16
Basket maker sitting in a coiled granary, Coniagui, Guinea, ca. 1970. Photo: M. Gessain. Musee du Quai Branly, Paris.

picture of a Libinza grave in Bangala, taken by Frederick Starr in 1905 (fig. 1.17 and cats. 42, 43).[68] Art historian Robert Farris Thompson interprets the stepped form as signifying the passage of the soul through birth, life, and death. Four steps represent the "four moments of the sun," an idea expressed in its simplest form as four points around a circumference, a cross, or a cross within a circle.[69] Three points on the circle—three of the steps—refer to the physical world of the living, and the fourth refers to the spiritual world of the dead.[70]

In an alternate mapping of the Kongo cosmos, anthropologist Wyatt MacGaffey describes a "three-zone model, as it were a stack of plates," which stands for "the visible world . . . of land and water; the sky, abode of God and the spirits; and the place of the dead."[71] Thus a three-tiered basket might represent the whole universe of the living and dead, which MacGaffey calls "the spiral universe."[72] If one accepts this interpretation, the coiled basket may be seen as representing the passage of time, a function consistent with the use of basketry to symbolize the cosmos or the order of society.

A remarkable basket acquired by the American Museum of Natural History in 1911 features three smaller cylinders sewn around the circumference of the cover, and a fourth placed at the center (cat. 39). Whether this basket represents a model of the cosmos is difficult to say, but stepped forms do have suggestive analogues in some of the oldest African-American baskets known. "Handicraftsmen" on Lowcountry plantations made tiered sewing baskets that were described in detail by David Doar, the last commercial rice planter on the Santee River in South Carolina. Using "a finer kind of grass, sewed with palmetto or oak strip," basket makers fabricated "three-storied" baskets, "that is, one on top of the other, each resting on the cover of the one below and getting smaller as they went up" (cats. 44–48).[73]

Two stacked baskets lashed to wooden legs made before the Civil War—one with a North Carolina provenance and the other from Lancaster County, South Carolina (cat. 41)—may represent an early link in the hypothetical sequence from the stepped lids of Kongo *kinkungu*, to double and triple sewing baskets made on Lowcountry plantations, to the contemporary Mt. Pleasant "in and out" basket, named for the technique of "hauling in" and "playing out" the basket's sides (cat. 50).

In the 1970s, anthropologist Greg Day called the practice of stacking an African-inspired "additive approach to design" that shows up in the African-American strip quilt and the Lowcountry "in and out" basket.[74] The latter form also makes a sexual reference, according to Day's colleague, Kate Young, whose doctoral dissertation explored kinship networks in the Mt. Pleasant basket-making community.[75] During the long hot summer afternoons Young spent sewing baskets in Manigault Corner—an extended family settlement that has been a center of basket production for a hundred years—"women often joked and bragged about their sexuality" and "mentioned the names of certain basket forms representing particular parts of the male and female body." A tall, corrugated basket, with "in and out" sides—the kind that sewers describe as a wastepaper or yarn basket to tourists who stop at the stands—was known among themselves as a "beaty basket." "Beaty," Young reports, "is the Gullah word for penis."[76]

Lowcountry basket makers explain the triple sewing basket in strictly functional terms: the bottom compartment holds fabric scraps, the middle thread, and the top needles, pins, and buttons. Yet a shape or a number system that embodies an idea may endure and be put to new uses after the original idea is forgotten. The cosmogram that inspired stepped lids on baskets in the Lower Congo is unknown to the Mt. Pleasant basket makers who make "double" and "triple" baskets, yet these shapes may replicate the three- and four-tiered *kinkungu*. Perhaps it is not coincidental that the numbers three and four, which recur in Kongo diagrams of the universe, also appear in Mt. Pleasant, in the grouping of rows of pine straw to make bands of color on the sides of a basket (cat. 49).

THE SEARCH FOR ORIGINS

Returning to the question of origins, the deceptively simple query—where does the Lowcountry basket come from—yields a multi-faceted answer. Transplanted to America, African men and women of many ethnic groups mingled in ways that did not occur in Africa.[77] The culture that emerged was not a simple mixture of ingredients but a new creation. The material culture of the enslaved, as historian Charles Joyner argues, "was neither 'retained' from Africa nor 'adopted' from [European Americans]. . . . Rather it was created . . . from a convergence of various African cultural patterns, white cultural influence, and the necessities of a new environment."[78]

Part of the new reality, of course, was the proximity of people of European descent, usually in positions of absolute power. Fortunately for the survival of coiled basketry, Europeans of many nationalities were familiar with the technique of coiling, and the situation was ripe for what anthropologists call "syncretism"—a process of cultural formation best understood as a kind of problem solving undertaken by people of different backgrounds thrust into sudden contact. Along the South Atlantic coast, where both Africans and Europeans recognized the utility of coiled winnowing trays, Africans were encouraged, and in some cases commanded, to produce a tool essential for preparing rice—the coastal region's first big money-making crop.

African Americans have been making coiled baskets without interruption for more than three hundred years, impelled for the first two centuries by the needs of global commerce, but always in response to their own desires and purposes too. The expertise Africans brought to America as cultivators of the soil, hunters and fishermen, artisans, and close observers of the natural world helped them preserve a sense of connection to the places and people from whom they had been severed and provided a lifeline to their descendents struggling to survive in a hostile environment. The African skills that produced enormous wealth for owners of rice plantations also afforded the enslaved a measure of control over their situation and a means for achieving a subsistence within terrible constraints.

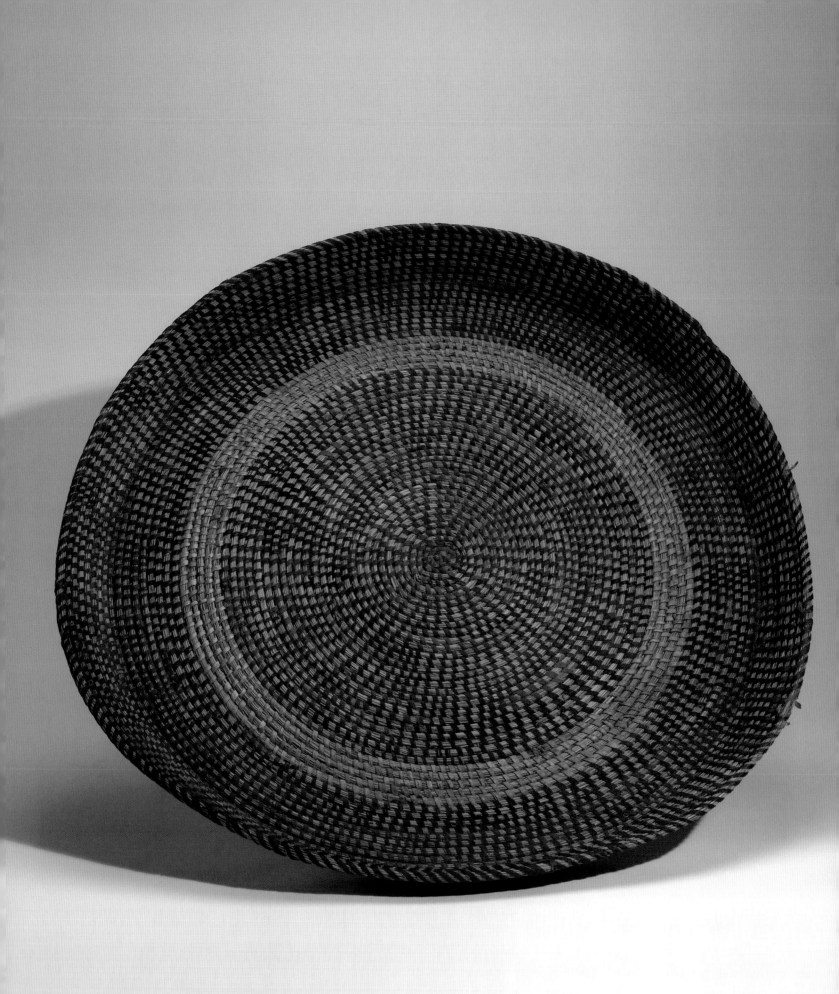

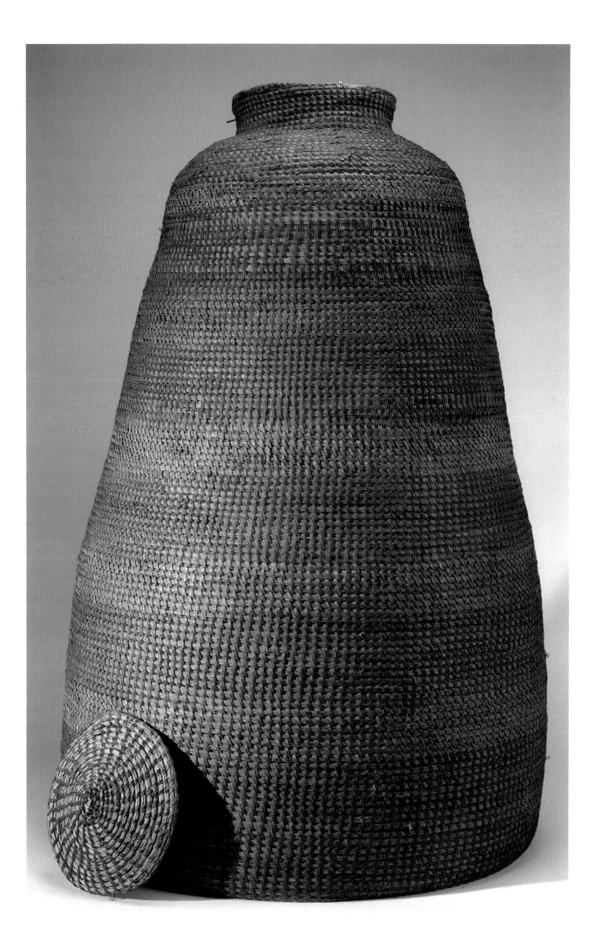

Cat. 31
**TRAY USED FOR DRYING HONEY
OR PROCESSING GRAIN**
Humbe. Angola
20th century
D. 78 cm.
American Museum of Natural History,
gift of Clarence Lyon, 90.2/1343

Cat. 32
GRANARY
Humbe. Angola
Mid-20th century
H. 113.5 cm.
American Museum of Natural History,
gift of Clarence Lyon, 90.2/1346ab

Cat. 33
OPENWORK BASKET
Ovimbundu. Angola
Early 20th century
D. 25.4 cm.
The Field Museum of Natural
History, 208931

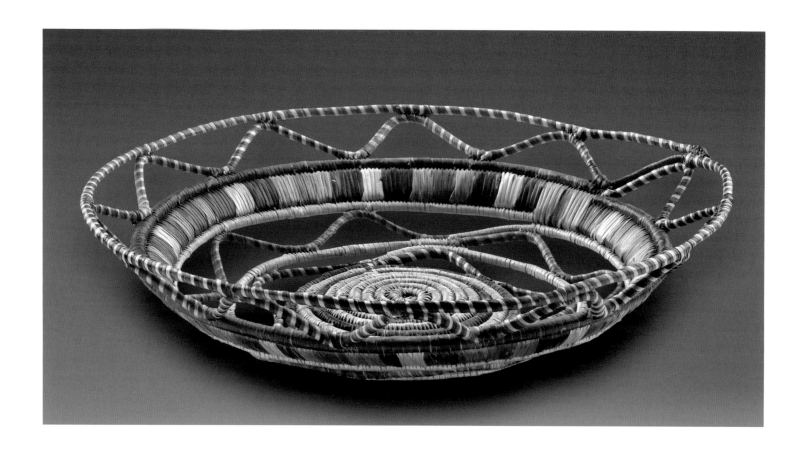

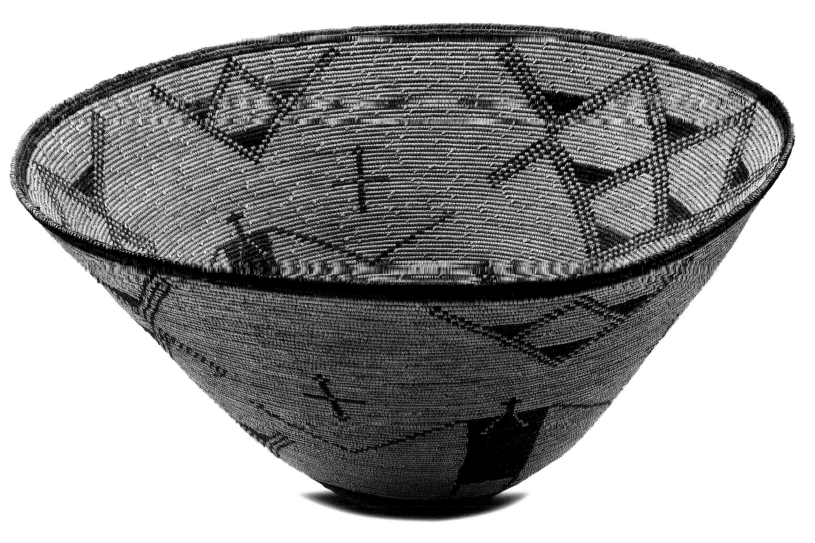

Cat. 34
BOWL
Ovimbundu. Angola
Early 20th century
D. 62.2 cm.
The Field Museum of Natural
History, 208952

Cat. 35
BOWL
Malenje Province, Angola
Mid-20th century
D. 57 cm.
Museu Nacional de Etnologia,
Lisbon, AH972

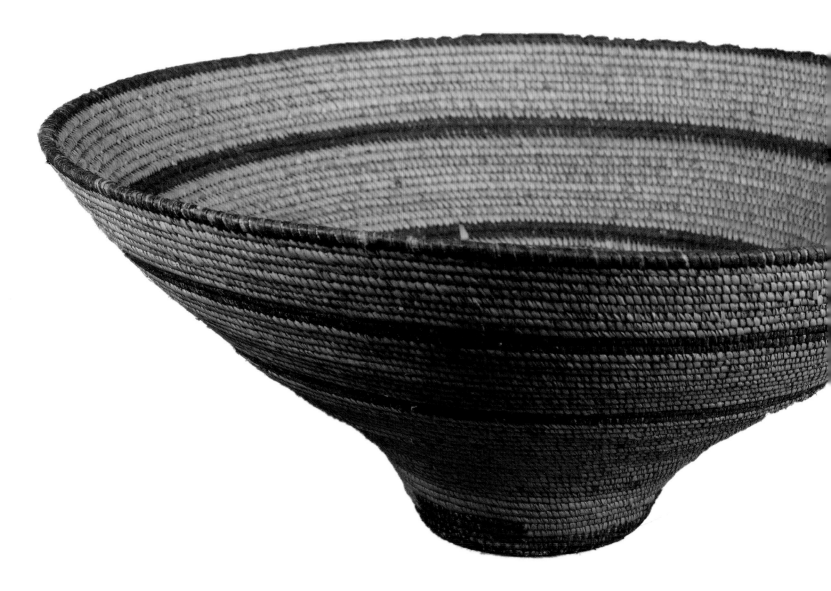

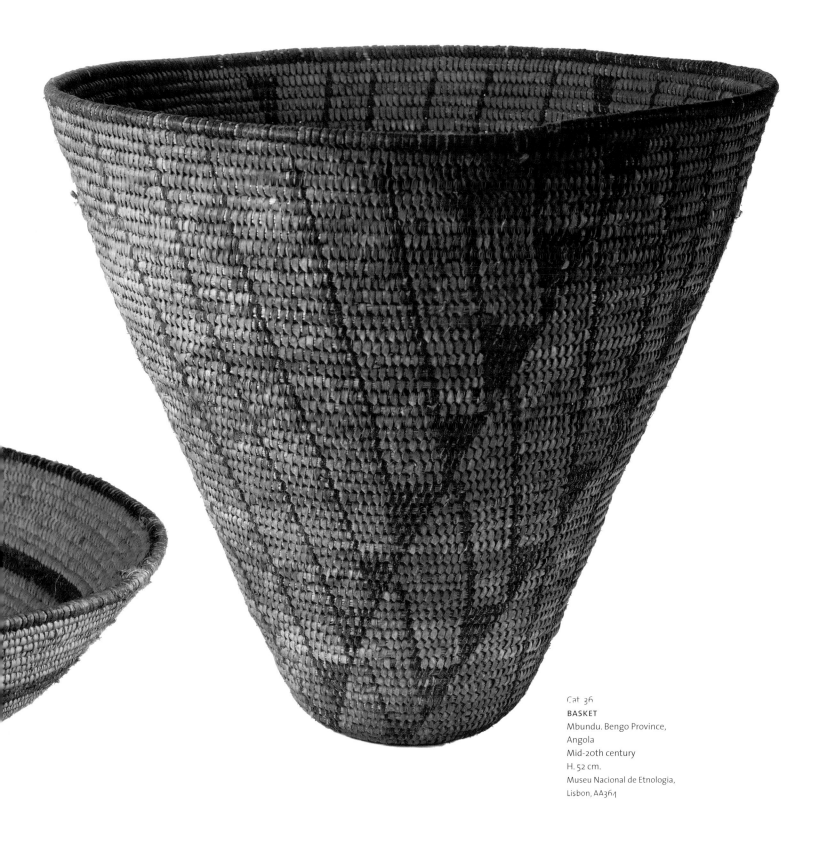

Cat 36
BASKET
Mbundu. Bengo Province,
Angola
Mid-20th century
H. 52 cm.
Museu Nacional de Etnologia,
Lisbon, AA364

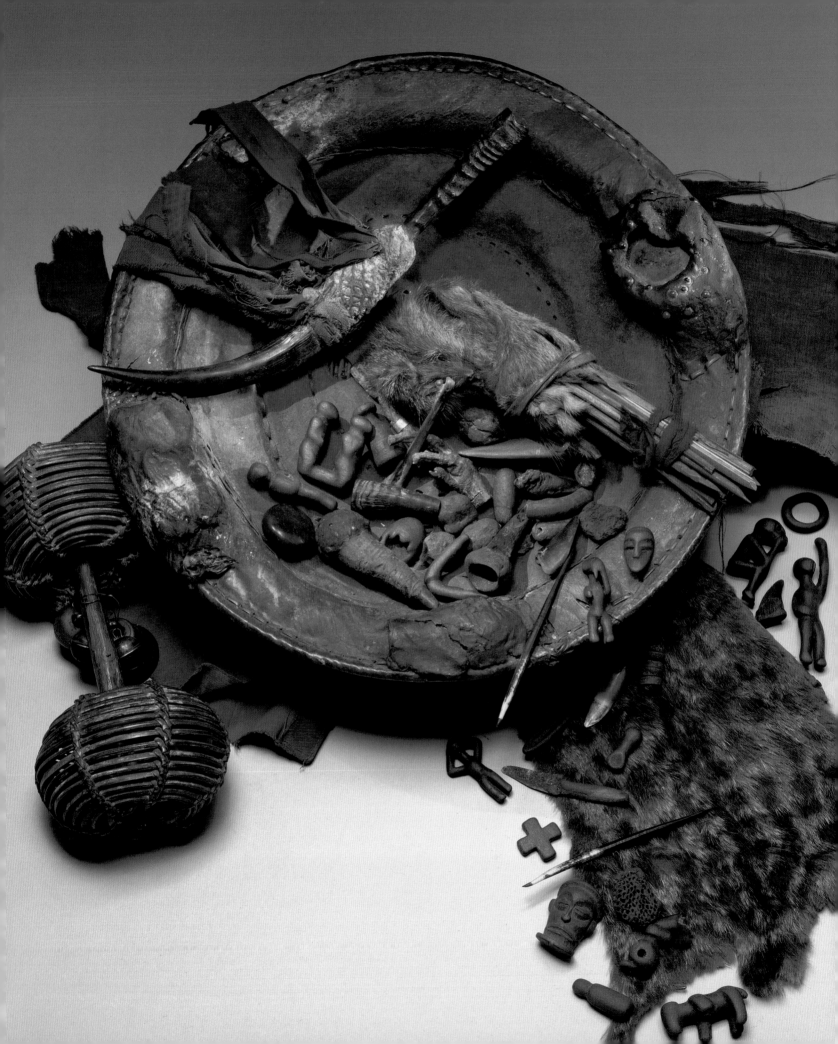

Cat. 37
DIVINATION BASKET (*NGOMBO*)
Chokwe. Angola
20th century
D. 35.6 cm.
Museum for African Art, gift of
Cecilia S. Smiley, 2002.4.1

This basket, lined with leather, contains
a variety of objects, including rattles,
fur seed pods, quills, and sticks, that
once made it an efficient instrument
of divination.

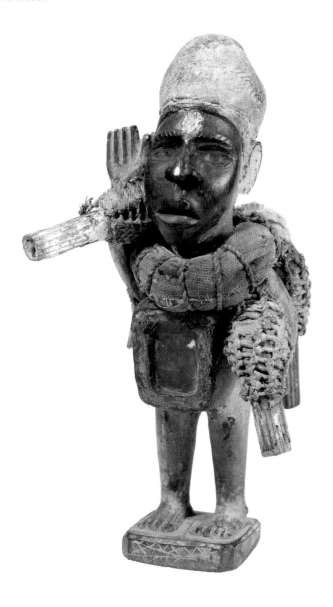
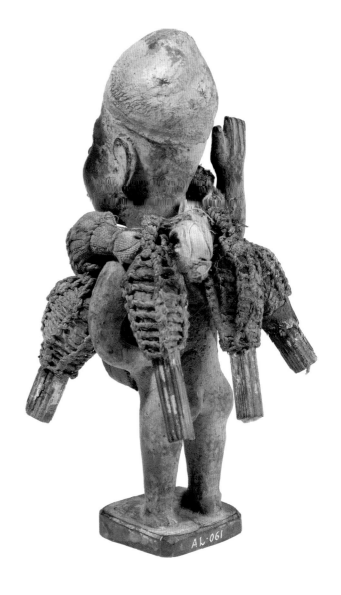

Cat. 38
FIGURE CARRYING FIBER NET
Kongo. Cabinda Province, Angola
Mid-20th century
H. 23.5 cm.
Museu Nacional de Etnologia,
Lisbon, AL061

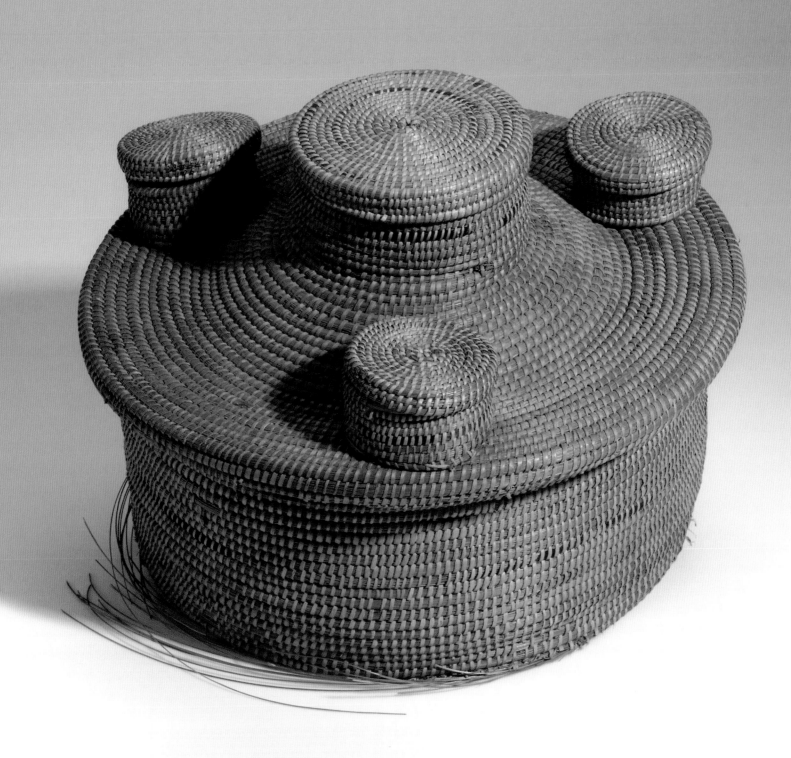

Cat. 39
**BASKET WITH FOUR BASKETS
ON THE LID**
Democratic Republic of Congo
Early 20th century
D. 36.7 cm.
American Museum of Natural History,
exchange with Frank Wood, 90.1/161ab

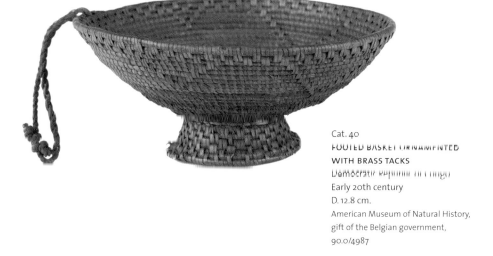

Cat. 40
**FOOTED BASKET ORNAMENTED
WITH BRASS TACKS**
Democratic Republic of Congo
Early 20th century
D. 12.8 cm.
American Museum of Natural History,
gift of the Belgian government,
90.0/4987

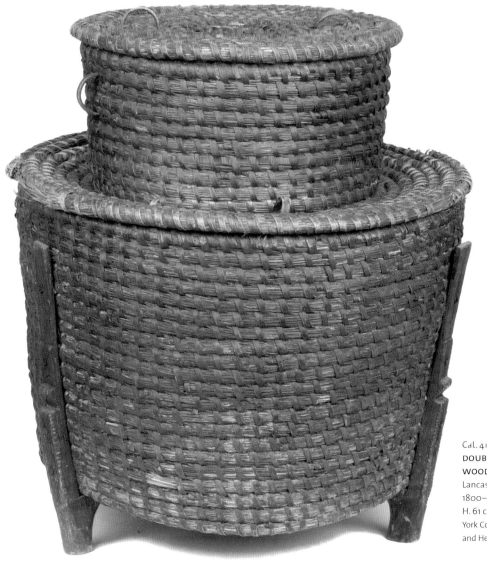

Cat. 41
**DOUBLE SEWING BASKET WITH
WOODEN LEGS**
Lancaster County, South Carolina
1800–60
H. 61 cm.
York County, South Carolina Culture
and Heritage Museums, 1998.047.001

Cat. 42
OVAL STEPPED-LID BASKET (*KINKUNGU*)
Democratic Republic of Congo
Late 19th or early 20th century
L. 73 cm.
Royal Museum for Central Africa,
Tervuren EO.1998.25.1

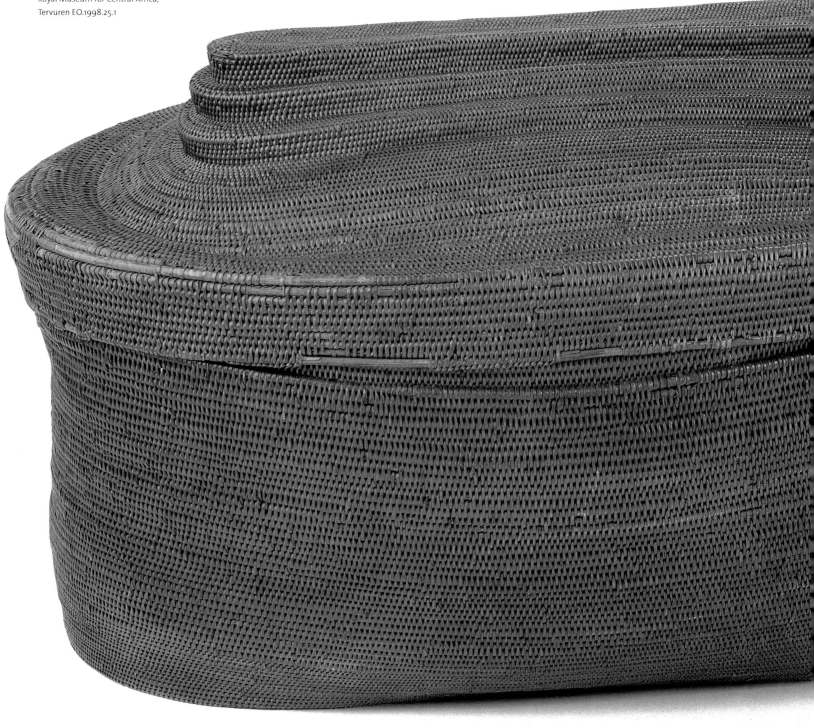

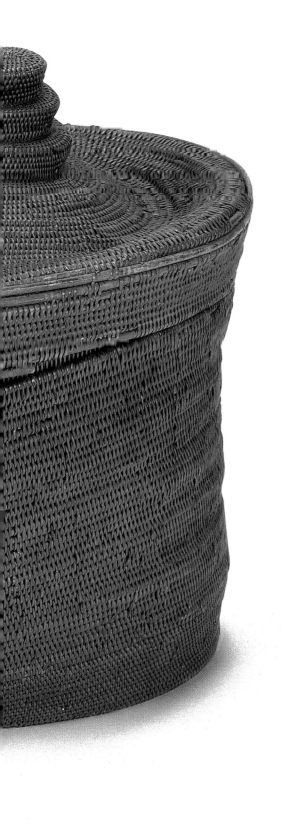

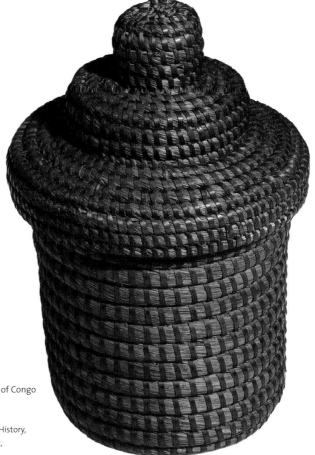

Cat. 43
BASKET WITH STEPPED LID
Yombe. Democratic Republic of Congo
Early 20th century
H. 14.1 cm.
American Museum of Natural History,
gift of the Belgian government,
90.0/2041ab

Cat. 44
DOUBLE BASKET
Mary Jane Manigault
South Carolina
1985
D. 34.3 cm.
McKissick Museum, University
of South Carolina, 14.37

Cat. 46
STEPPED LID BASKET
Ida Jefferson
South Carolina
Ca. 1998
H. 17.8 cm.
Museum for African Art,
gift of Enid Schildkrout,

Cat. 45
COVERED BASKET
Nathaniel Wright
South Carolina
2006
H. 22.8 cm.
McKissick Museum, University
of South Carolina, 14.87

Cat. 47
TRIPLE BASKET
Mary Jane Manigault
South Carolina
1974
H. 30.5 cm.
Collection of Greg Day

Cat. 48
TIERED BASKETRY HAT (*BOTOLO*)
Ekonda. Democratic Republic
of Congo
Late 19th or early 20th century
H. 33 cm.
Collection of Amyas Naegele
and Eve Glasberg

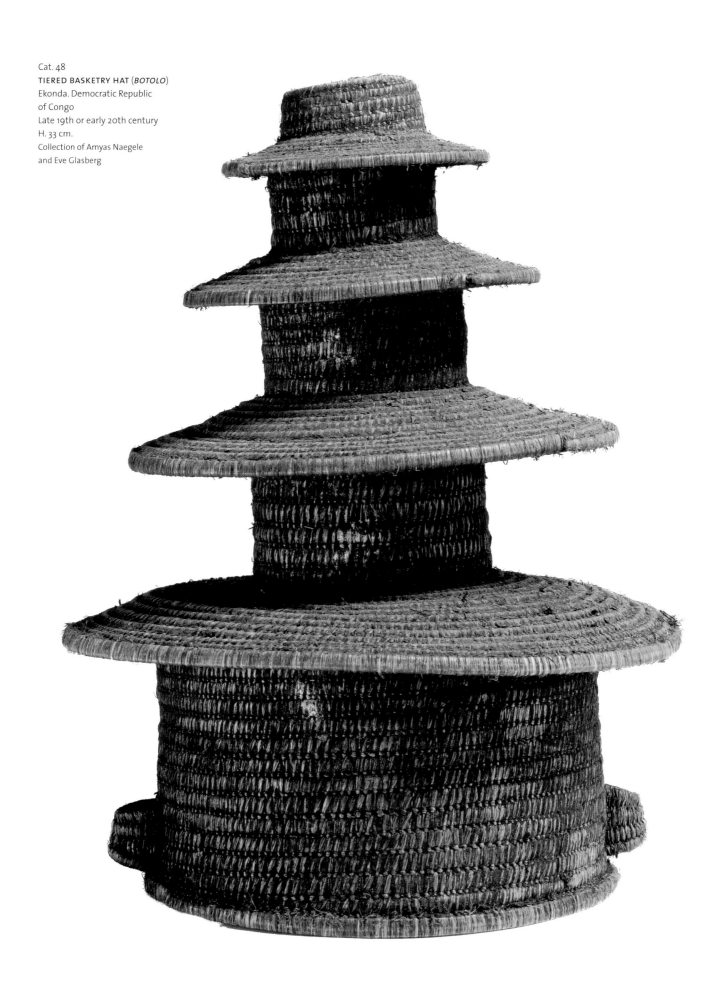

Cat. 49
BASKET WITH WING HANDLES
Alethia Foreman
South Carolina
2006
H. 21 cm.
McKissick Museum, University of
South Carolina, 2006.13.00.06

Cat. 50
IN AND OUT BASKET
Louise Graddick
South Carolina
1973
H. 38.1 cm.
Collection of Greg Day

2

They Understand Their Business Well:
West Africans in Early South Carolina

Peter H. Wood

FOR GENERATIONS, MOST AMERICANS believed that enslaved Africans carried almost no cultural knowledge with them across the Atlantic. These forced immigrants, so the story went, brought only crude muscle power and brute strength to America, little more.[1] Indeed, many whites inferred that these black newcomers had been imported into the early South *in spite* of being thoroughly "unskilled," or perhaps even *because* of that so-called fact. It followed from this false assumption that the central chore facing colonial masters must have been one of patient and one-sided education, so that "ignorant" slaves could be taught to manage simple tasks.[2] Later, earnest scholarship during the mid-twentieth century—though coming from an opposite direction—reached somewhat similar conclusions. By this account, the grim Middle Passage from Africa and the brutal conditions encountered in America had been so traumatic as to wipe away most of whatever rich cultural heritage these migrants had possessed before they were sold into slavery. "What they had been and known receded rapidly," historian Richard Hofstadter concluded in 1971, "and the course of their experience tended to reduce their African identity to the withered husks of dead memories."[3]

Since then, a generation of scholarship has thoroughly revised these notions. African newcomers—their staggering hardships notwithstanding—were not ignorant or helplessly traumatized, as these competing schools of thought had contended. It now appears that in reality something very different took place, especially in early South Carolina, where Africans are finally being given credit—long overdue—for the introduction and cultivation of rice (fig. 2.3).[4] This West African crop rapidly became the colony's most important export commodity.[5] Indeed, the second major agricultural export in eighteenth-century South Carolina—indigo—was also introduced from Africa and produced by enslaved people, some of whom had grown the plant and extracted the dyestuff in their native lands. But even as these major contributions gain acknowledgment, we still do not fully understand the underlying story of how a black majority of African newcomers adapted to the coastal environment of colonial South Carolina's Sea Island region.

In the earliest years of the Carolina colony, Africans who had passed through the creole culture of the West Indies demonstrated a reservoir of talents. Within several decades, the Europeans' drive to expand settlement and produce export crops led to an increase in the size and diversity of the black population, and a further variety of African skills emerged which were strikingly appropriate to the Lowcountry frontier. Africans, therefore, were far from being the passive objects of white instruction. A process of mutual education took place among the black workers themselves, despite initial language differences, and many, regardless of legal status, ended up teaching their white masters as well. Hence the problem faced by white Carolinians during the first and second generations of settlement was less one of imparting knowledge to unskilled workers than of controlling for their own ends African expertise that could be readily turned against them.

The comparative advantages that Africans possessed over Europeans in this New World setting can be seen in a variety of ways. South Carolina, first of all, was in a different geographic zone from England and from all the earlier English colonies in mainland North America. This fact was pleasing to white settlers on one level, but disconcerting on another, and they were slow to make the adjustments necessary for life in a somewhat alien semi-tropical region. John Lawson, an amateur naturalist who explored the Carolinas at the start of the eighteenth century, commented that if English colonists "would be so curious as to make nice Observations of the Soil, and other remarkable Accidents, they would soon be acquainted with the Nature of the Earth and Climate, and be better qualified to manage their Agriculture to more Certainty." But he went on to admit, as would Thomas Jefferson and others after him, that Europeans seemed to become less careful and observant rather than more so in the unfamiliar environment of the American South.[6]

West Africans, on the other hand, were not only more accustomed to the flora and fauna of a subtropical climate generally, but they possessed an orientation toward what anthropologist Claude Lévi-Strauss has called "extreme familiarity with their biological environment, . . . passionate attention . . . to it and . . . precise knowledge of it."[7] In Carolina their ability to cope with this particular natural world was demonstrated, and reinforced, by the reliance Europeans put upon them to fend for themselves and others. Instances of black self-sufficiency (like instances of Indian assistance) made a lasting impression upon less well acclimated whites, and as late as 1775 we find an influential English text repeating the doctrine that in Carolina, "The common idea . . . is, that one Indian, or dextrous negroe, will, with his gun and netts, get as much game and fish as five families can eat; and the slaves support themselves in provisions, besides raising . . . staples."[8]

By far the largest number of people entering South Carolina during the colonial period came from West Africa, and, in the course of a century of immigration, items indigenous to parts of that vast region were transported with them. For example, white colonists debated at length which European should receive credit for introducing the first bag of rice seed.[9] It now seems evident that successful rice cultivation followed the arrival of seeds aboard a ship from Africa.[10] Often the botanical imprecision of contemporary Englishmen makes it hard to say exactly which plants were introduced and when. Semantic confusion about guinea corn and Indian corn provides a case in point. Maurice Mathews reported during the initial summer of settlement that along with Indian corn, "Guiney Corne growes very well here, but this being ye first I euer planted ye perfection I will not Aver till ye Winter doth come in."[11] This grain or some subsequent variety clearly took hold, for in the next generation Lawson reported guinea corn to be thriving; he noted it was used mostly for hogs and poultry, while adding that many of the enslaved ate "nothing but" Indian corn, with salt.[12] A definition offered by Mark Catesby in 1743 reveals that Indian and guinea corn had become interchangeable in English texts, if not in actual fact: "*Milium Indicum*. Bunched Guinea Corn. But little of this grain is propagated, and that chiefly by negroes, who make bread of it, and boil it in like manner of firmety. Its chief use is for feeding fowls. . . . It was at first introduced from Africa by the negroes."[13]

Catesby also recorded "The Leg-worm, or Guinea-worm" among the "insects" he found in Carolina, and Lawson listed among varieties of muskmelon a "guinea melon" which may have come from Africa. Others mentioned the "guinea fowl" or "guinea hen," a domesticated West African bird introduced into North America during the eighteenth century. Prominent planters, including Henry Laurens near Charleston and George Washington at Mount Vernon, acquired seed for "guinea grass," a tall African grass used for fodder.[14]

The West African and Carolinian climates were similar enough so that even where

flora and fauna were not literally transplanted, a great deal of knowledge proved transferable. African cultures placed a high priority on their extensive pharmacopoeia, and remedies known through oral tradition were readily transported to the New World. For example, expertise included familiarity with a variety of herbal antidotes and abortives.[15] A South Carolina slave received his freedom and one hundred pounds per year for life from the colonial Assembly for revealing his antidote to certain poisons. "Caesar's Cure" was printed in the *South-Carolina Gazette* and appeared occasionally in local almanacs for more than thirty years.[16]

Although certain medicinal knowledge was confined to especially experienced individuals, some of whom were known openly as "doctors," almost all Africans showed a general familiarity with lowland plants. Black Carolinians regularly gathered berries and wild herbs for their own use and for sale. John Brickell noted of slaves in Carolina, for example, that "on Sundays, they gather Snake-Root, otherwise it would be excessive dear if the Christians were to gather it."[17] The economic benefits to be derived from workers with such horticultural skills were not lost upon speculative Europeans. In 1726, Richard Ludlam urged the collection and cultivation of special plants upon which the cochineal beetle (an insect used to produce red dye) might feed and grow. According to Ludlam, "Two or Three Slaves will gather as many Spontaneous Plants in one day, as will in another Day regularly Plant Ten Acres."[18]

Because Africans brought a greater awareness of the environment with them than their equally foreign masters, they were better able to profit from contact with Native Americans. Both West African and Southeastern American cultures understood a variety of similar plants and processes, and such knowledge must have been shared and reinforced upon contact. Gourds, for example, served as milk pails along Africa's Gambia River in much the same way that large gourds, or calabashes, had long provided water buckets for Southeastern Indians.[19] Coastal fishermen in Africa as well as North America employed dried gourds as floats to buoy up their fishing nets.[20] Numerous African groups employed gourd bowls as containers for grains, milk, and various foods (cats. 51, 52); the Ga'anda of northeast Nigeria used artfully decorated dipper gourds of all sizes as spoons and scoops.[21]

It is impossible to say whether it was Africans or Indians who fashioned the first long-handled drinking gourd, an object that would become the standard water dipper on southern plantations. African Americans soon applied the phrase "drinking gourd" to the constellations

Fig. 2.1
Snipe family basket stand on Highway 17, Mt. Pleasant, South Carolina, 2007. Photo: Karin Willis. Museum for African Art.

The blue house was inhabited until recently, when Highway 17 was widened, encroaching on the front yard and bringing traffic too close for comfort. The Snipe family moved out and turned the front porch into a wrap-around basket stand.

in the northern sky known as the Big Dipper and the Little Dipper. The latter formation containing the Pole Star took on great significance in later times for people attempting to escape from enslavement by heading north.[22]

Since Europeans had limited experience with gourds, Africans or Native Americans must have shown Carolina planters, around 1700, how to hoist hollow gourds near their fields to serve as birdhouses to attract martins. According to Lawson, "The Planters put Gourds on standing Poles, on purpose for these Fowl to build in, because they are a very Warlike Bird, and beat the Crows from the Plantations."[23] In Africa, gourds served as resonators for xylophones and formed the base for a variety of string and percussion instruments. Africans in America used hollow gourds closed with a skin to make small drums and banjoes. "The instrument proper to them is the Banjar," Thomas Jefferson observed, "which they brought hither from Africa."[24]

The palmetto, symbol of the novel landscape for arriving Europeans, was well known to Africans and Indians in Lowcountry Carolina for its useful leaf. They made fans and brooms from these leaves and may well have entered into competition with Bermudians who were already exporting women's hats, baskets, buckets, and "pretty Dressing-boxes" made of woven palmetto.[25] An authority on Carolina furniture writes, "The very early inventories frequently mention Palmetto chairs or Palmetto-bottom chairs."[26] The design of such objects combined elements from Africa and Europe, and much of the skill and labor required to make these traditional items in early Charleston was undoubtedly African. The 1729 mortgage of Thomas Holmes, a producer of chairs and couches, listed as collateral three of his slaves "by name Sesar, Will, and Jack," who were "by trade Chairmakers."[27]

Similarly, the creation of elaborate baskets, boxes, and mats from various reeds and grasses was familiar to Southeastern Indians, while European and African newcomers brought diverse basket-making practices, which they could adapt to Lowcountry materials. The region's strong coiled basketry tradition is still plainly visible on Highway 17 north of Charleston, in the vicinity of Mt. Pleasant, where sweetgrass baskets have been produced for sale for almost a century (fig. 2.1).[28] Tracing the roots of this distinctive basketry has been a difficult challenge. Baskets, like gourds, are biodegradable. Few specimens endure from previous centuries, and written descriptions are scarce. Lawson, living in eastern North Carolina, wrote: "The Baskets our Neighbouring *Indians* make, are all made of a very fine sort of Bulrushes, and sometimes of Silk-grass, which they work with Figures of Beasts, Birds, Fishes, &c. A great way up in the Country, both Baskets and Mats are made of split Reeds, which are only the outward shining Part of the Cane."[29]

Most Southeastern Indians were noted for making woven, rather than coiled, baskets, while the earliest examples of baskets made by Africans in Carolina are coiled. They have been shown in both method and form to bear a close resemblance to coiled African baskets with long lineages.[30] "Talented slave basketmakers were responsible for producing the fanner baskets used for winnowing rice," explains historian and folklorist Charles Joyner. "These and other baskets made by the slaves were examples of coiled basketry, which is indubitably of African origin."[31] Coiled baskets, unlike the woven baskets of American Indians, were made from "black rush, an abundant marsh grass, bound with thin splits of white oak or strips from the stem of the saw palmetto. As rice culture spread, so did the manufacture of these coiled work baskets. After the Civil War, men and some women continued to sew rush baskets for use on those plantations which weathered Reconstruction, and on small, family farms which were carved out of the old estates" (fig. 2.2).[32]

In basket making, as in the creation of distinctive unglazed, low-fired earthenware pots, recent research suggests that Africans in early South Carolina drew more from their remembered traditions than from the Native American artistry around them.[33] This may reflect

Cat. 51
CALABASH
Fula. Cameroon
20th century
D. 40 cm.
Private collection

Cat. 52
CALABASH COVER
Hausa/Fula (Fulani). Nigeria
20th century
D. 49 cm.
Private collection

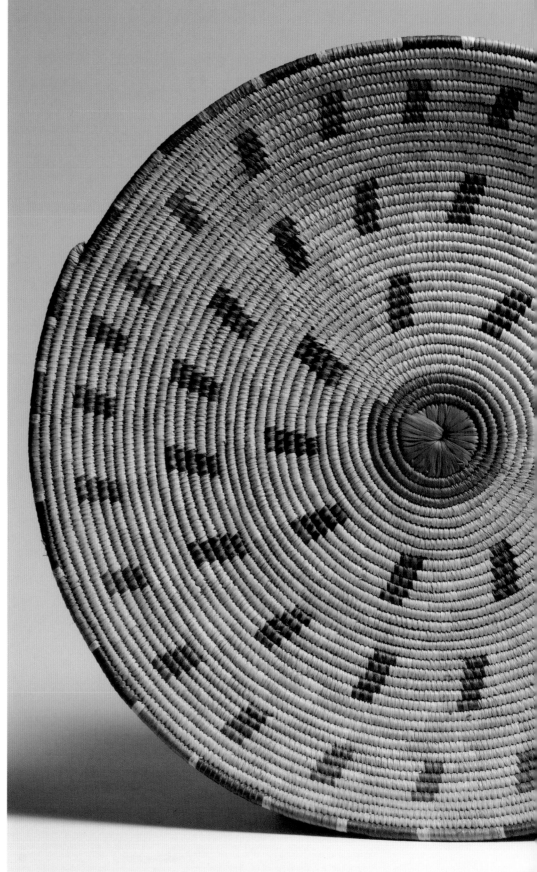

tragic demographics more than anything else. Through the first two generations of colonial intrusion, Native Americans frequently lived among the Africans in lowland Carolina, both as fellow slaves and as free neighbors.[34] But warfare and diseases, especially smallpox, brought calamitous changes for coastal Indians, and their numbers fell precipitously. In 1743, when the region's African population had reached forty thousand, an Anglican minister described the only remaining Indians in St. Paul's Parish near Charleston. They numbered "about 65 Men Women and Children in all; tho formerly they consisted of about 1000, as they say."[35] By mid-century, numerous coastal groups had disappeared entirely.[36]

Fig. 2.2
Work baskets, Sandy Island, South Carolina, ca. 1937.
Photo: Bayard Wootten. Brookgreen Gardens.

AFRICAN SKILLS

As the number of Indians steadily declined, and as their once-formidable know-how slipped away, it was the black Carolinians who had assimilated the largest share of their lore and who increasingly took over their responsibilities as "pathfinders" in the southern wilderness. Blacks became responsible for transporting goods to market by land and water and for ferrying passengers and livestock. From the first years of settlement, the primary means for direct communication between masters was through letters carried by slaves. Charleston set up a local post office at the beginning of the eighteenth century, and by 1740 there was a weekly mail going south toward the new colony of Georgia and a monthly post overland to the north via Georgetown, South Carolina, and Cape Fear, North Carolina. But with the exception of these minimal services, responsibility for delivering letters in the region throughout the colonial period fell entirely to Negro boatmen and runners.[37]

There is no better illustration of white reliance upon black knowledge of the environment than the fact that servants became quite literally the guides of their masters. Contemporary records give adequate testimony. Lawson, traveling from the Ashley River to the Santee River by canoe at the start of the eighteenth century, relates that at one point a local doctor "sent his Negro to guide us over the Head of the Swamp."[38] A public official such as the Provost Marshal would sometimes be loaned a boy "to Show him the way" between plantations.[39] When darkness made travel even more difficult, the servant often lit the way by carrying a pine torch—a stick of pinewood with a resinous knot at one end that provided a bright flame when ignited. In October 1745, a white traveler coming from Philadelphia recorded in his journal: "had a Negro to guide us the Road being Intricate."[40]

In the same month, a minister of the Society for the Propagation of the Gospel wrote that his parishioners had urged him to purchase a family of three Negroes. "I consented," he wrote, "not knowing full well the ways and management of country affair[s] . . . and was obliged also by extream necessity to buy 3 horses with bridles and saddles, one for me, another for my wife, and the other for a Boy servant, for it would be impossible for me to go through the Parish between the woods without a Guide."[41] In 1770, William De Brahm observed that servants, besides being stationed at their masters' gates to offer hospitality to travelers, were often sent with departing guests "to cut down small trees in the way of carriages, to forward and guide through unfrequented forrests, . . . [and] to set them over streams, rivers and creeks."[42]

In the next century, twenty-year-old Joseph Lyons recounted a trip from Savannah to Charleston during the spring of 1834, "going partly by land partly by water and the rest by mud." To reach "Carolina ground," he and several other passengers were ferried across the Savannah River, "a row of an ½ hour," no doubt by African-American boatmen. By the time the travelers reached "Purrysburgh, it was so dark that I could see nothing." Dense foliage increased the pitch darkness; Lyons complained that even "had there been 2 or 3 suns I should have seen not more than twice as much." To reach their destination for the night, he recalled, they depended upon a "negro who lit with a pine torch our way up to the house." Along the way, the parson accompanying Lyons "enquired of the negro" in whom they were both putting their faith "if he was a christian." Lyons, who was Jewish, was amused by the query of "my

dome headed parson" and also highly respectful of their torchbearer. Concluding his diary account with an ironic nod to scripture, Lyons compared the man leading them out of darkness to the Bible itself, for he offered a "lamp to our feet, a light for our path."[43]

Not surprisingly, African Americans commonly served as guides to white sportsmen on the Sea Islands and along the inland waterways of the coastal South.[44] From colonial times black Carolinians living near estuaries, rivers, and creeks knew their way on water as well as they knew their way on land. Europeans were unrivaled as the builders and navigators of oceangoing ships, but most early white immigrants had little preparation for negotiating the labyrinth of swamps and tidal marshes that interlaced the lowland. African Americans drew on a different heritage. Some enslaved newcomers had scarcely seen deep water before their forced passage to America, and none had sailed in ocean vessels. Yet many had grown up along rivers or beside the ocean and were more at home in and around water than most Europeans, for whom a simple bath was still exceptional.[45] Lawson, describing the awesome shark, related how "some Negro's, and others, that can swim and dive well, go naked into the Water, with a Knife in their Hand, and fight the Shark, and very commonly kill him."[46] The southeastern alligator horrified Europeans, since it was unfamiliar and difficult to kill with a firearm. Yet black Carolinians, who had protected their stock from crocodiles in Africa, readily handled this fresh-water reptile.[47]

Most importantly, dugout canoes were a major means of transport in colonial Carolina, where they were built and piloted almost entirely by Africans. It is significant, therefore, that similar boats had long filled "a major role in the political and economic life of West Africa," according to Robert Smith, the definitive scholar on this topic. "The canoe, carved and usually also burnt-out from a single tree trunk, played a part in the history of the coastal, lagoon, and river-side peoples of West Africa similar in importance to that of the horse in the savannah states. . . . The builders were specialists, usually living in the forests, where the most suitable trees were found." According to Smith, "The early Arabic writers testify to the importance of the canoe on the Upper Niger, and the extension of the Mali and . . . Songhay empires was made possible by water transport." Canoes were in use when the first Europeans reached the coast. As the Atlantic commerce in human cargo grew over several centuries, millions of bound captives were ferried to coastal trade forts and transported to waiting slave ships via African canoes.[48]

Jean Barbot, a French Huguenot who sailed to West Africa in 1678 and again in 1682 for the French Royal African Company, commented on the multitude and variety of boats that he saw during his travels. Each African language had its own word for these boats, but European newcomers used a New World term to describe them. "The name of *Canoe* is properly of the West Indies," Barbot explained, "and from those people the *Spaniards* learnt it." In what appears to be an early reference to the gun trade in Africa, he remarked on huge military canoes that held "fifty or sixty men, besides ammunition and provisions for fifteen days." He also reported coastal transport canoes that could "carry above ten tun of goods, with eighteen or twenty blacks to paddle them." Barbot noted that the Africans managed these crafts "with such dexterity in the most dangerous places that it is much to be admired." He was particularly struck by the sailors along the Gold Coast who maneuvered their boats "over the worst and most dreadful beating seas."[49]

In 1705, William Bosman, author of *A New and Accurate Description of the Coast of Guinea*, also reported seeing impressive canoes used for fishing and transport along the African coast. Some measured thirty feet in length and six feet in the beam; more than a dozen rowers propelled them, using paddles shaped like spades. Many of the boats carried extensive fishing gear, including large seines and wide casting nets.[50] More than a century later, a visiting captain observed that Africans were expert boatmen, skillful in the construction of large canoes for ocean fishing. With the slave trade still in full swing, he watched and listened as a fleet of huge

Fig. 2.3
Advertisement for sale of slaves, from *The Columbian Herald*, August 5, 1785. Early American Newspapers.

On TUESDAY, March 18, 1783,

Will be fold in George-Town, at public Vendue, by Directions from Mr. JONAH HORRY,

HIS Entire Gang of NEGROES, in Number about feventy, remarkably prime and orderly, having never deferted to the Britifh; among them are Carpenters, Coopers, Boatmen, Sawyers, Cooks, Spinners, Waiters, &c. Credit will be given on Bond with Security for one, two or three Years, on legal Intereft annually paid. Alfo, at private Sale, a Quantity of clean and rough RICE.
ANTHONY BONNEAU,
PETER HORRY,
HUGH HORRY.
George Town, February 20, 1783.

canoes, each capable of carrying more than a hundred people, was given a noisy send-off with drums, horns, and gongs. When the boats returned nearly a week later, they brought back more than fifteen hundred captives, who were sold to waiting European slave ships the following day.[51]

In the mid-nineteenth century, when Joshua Carnes reached the west coast of Africa, he saw similar canoes that had once been used to convey living cargoes. Some were well over fifty feet long and deep enough for hogsheads of tobacco to fit beneath the horizontal thwarts, or seats.[52] Carnes observed sleek canoes for fishing and long-distance travel, along with flat bottomed canoes, "more calculated for burden then speed," transporting oranges, bananas, plantains, coconuts, yams, and rice, as well as goats, pigs, poultry, and fish. He even witnessed an elaborate "Royal Yacht" that carried a head of state while the crew paddled in perfect unison while chanting a rhythmic work song.[53]

Similar slender boats were essential for travel in early South Carolina for several generations, while roads and bridges were still too poor and infrequent for easy land travel.[54] Small canoes were hollowed from single cypress logs by Africans or Native Americans, or by whites whom they instructed in the craft.[55] To make the larger canoe known as a pettiauger, two or three trees were used, giving the boat additional beam for cargo without significantly increasing its draft, so that barrels of tar or rice could be ferried along shallow creeks and across tidal shoals.

These boats were frequently equipped with one or even two portable masts for sailing and often ventured onto the open ocean.[56] "Even vessels as large as schooners were occasionally

Fig. 2.5
Boats on the Savannah River from von Reck's journal, 1736.
Library of Congress.

In 1736 Philip Georg Friedrich von Reck, a German-speaking immigrant to Georgia, made this composite sketch of boats on the Savannah River. The new Georgia colony, formed on the river's south side in 1734, outlawed slavery until 1751, so European newcomers pulled their own oars to move their bateaux upstream (upper right and bottom). But they shared the river with South Carolina Indian traders whose long boats were rowed by enslaved Africans (upper left).

manned entirely by slaves," Charles Joyner notes. "One of Robert F. W. Allston's overseers wrote of the *Waccamaw*, which picked up rice at the Allston rice mill, that 'there is no white men on her when she comes to the mill.'"[57] Boat design may have derived from a merging of European, Caribbean, and Indian styles on the one hand, and on the other hand diverse coastal traditions from West Africa, where the silk cotton tree (*Ceiba pentandra*) was used to fashion both round- and flat-bottomed craft.[58] Negro crews, directed by a black "patroon," managed these boats, and many of their earliest rowing songs were apparently recalled from Africa (fig. 2.5).[59]

The fact that dexterity in handling large dugout canoes was an art brought from Africa is underscored by an advertisement for a runaway in the Virginia colony. The notice concerned "a new Negro Fellow of small Stature" from Bonny on the coast of what is now Nigeria. It stated, "he calls himself Bonna, and says he came from a Place of that name in the Ibo Country, in Africa, where he served in the Capacity of a Canoe Man."[60] In South Carolina male slaves often were advertised in terms of their abilities on the water (fig. 2.4): "a very good Sailor, and used for 5 years to row in Boats, . . . a Lad chiefly used to row in Boats," "a fine strong Negro Man, that has been used to the Sea, which he is very fit for, or to go in a Pettiaugua," "all fine Fellows in Boats or Pettiau's." So many Africans brought these skills with them, or learned their seamanship in the colony from others, that black familiarity with boating was accepted as axiomatic among whites. In 1741, Henry Bedon advertised to sell two black men "capable to go in a Pettiauger." He added that they had been "going by the Water above 10 Years," and that the pair "understands their Business as well as most of their Colour."[61]

"Their business" often included fishing, and it is not surprising that in the West Indian and southern colonies Africans quickly proved able to supply both themselves and their European owners with fish.[62] In Charleston, an entire class of "fishing Negroes" had emerged early in the eighteenth century, replacing local Indians as masters of the plentiful waters.[63] "There is . . . good fishing all along this Coast, especially from October till Christmas," wrote James Sutherland, who commanded Johnson's Fort overlooking Charleston harbor during the 1730s, adding (perhaps with fisherman's license), "I've known two Negroes take between 14 & 1500 Trouts above 3 feet long, wch make an excellent dry fish."[64] A French visitor whose ship anchored not far from Johnson's Fort early in the next century found himself "in the midst of

twenty-five dug-outs, each containing four Negroes who were having excellent fishing. Ten minutes doesn't go by," he noted, "without there being hauled into the dugout fish weighing from Twelve to fifteen pounds. After they are taken on the line, they are pulled up to the level of the sea where one of the black fishermen sticks them with a harpoon."[65]

Skill with hooks and harpoons was complemented by other techniques more common in Africa and the Caribbean than in Europe. The poisoning of streams to catch fish was known in West Africa,[66] and fish drugging was also practiced in the West Indies, first by Island Caribs and later by enslaved Africans who would dam a stream or inlet and add an intoxicating mixture of quicklime and plant juices to the water. They could then gather inebriated but edible fish from the pool almost at will.[67] Black South Carolinians in the early eighteenth century exploited a similar tactic, for in 1726 the Assembly charged that "many persons in this Province do often use the pernicious practice of poisoning the creeks in order to catch great quantity of fish," and a public whipping was imposed upon any slave convicted of the act.[68]

West Africans also imported the art of throwing a cast net to catch shrimp and small fish in the creeks and tidal shallows of Carolina. The doctor aboard an American slaving vessel off Africa's Gold Coast in the mid-eighteenth century recorded in his journal: "It is impossible to imagine how very dextrous the negroes are in catching fish with a net, this morning I watch'd one man throw one of 3 yards deep, and hale it in himself with innumerable fish."[69] Weighted drawstring nets, like the dugout canoes from which they were cast, may have represented the syncretic blend of several ancient Atlantic fishing traditions.[70] The men who could handle nets could also make and mend them; in 1737, for example, a runaway named Moses was reported to be "well known in Charlestown, having been a Fisherman there for some time, & hath been often employed in knitting of Nets."[71] The prevalence of black commercial fishermen in the Southeast, as in the Caribbean, continued long after the end of slavery, and African Americans who guide shrimp boats and oyster bateaux in present-day Carolina earn their living at a calling familiar to many of their West and Central African forebears (figs. 2.6–2.8).[72]

No single industry was more important to the early colonization of South Carolina than the raising of livestock. The first generation of adventurers, coming mainly from Barbados, hoped to develop crops that suited the warm climate but did not undercut the exports of existing colonies.[73] One early English promoter believed that "Lime-trees, Orange, Lemon, and other Fruit-trees" could "thrive exceedingly," and that marshy coastal fields could be readily irrigated and used to grow rice. "The Meadows," he reported in 1666, "are very proper for Rice, Rape-seed, Lin-seed, etc., and may many of them be made to overflow at pleasure." But initial prospects lay in grazing, since vast marshes and meadows stretching over thousands of acres offered "excellent food for . . . Cattle both great and small, which live well all the Winter, and keep their fat without Fodder; Hogs find so much Mast and other Food in the Woods, that they want no other care than a Swine-herd to keep them from running wild."[74]

At first, therefore, the Europeans in Carolina depended for their livelihood primarily upon cattle and hogs, since these animals could be raised with a minimum of labor, while the newcomers searched for a crop that might make them wealthy. Beef and pork were in great demand in the West Indies, and these were items the English had long produced. But even here there was an unfamiliar element. According to traditional European patterns of animal husbandry, rural residents confined their cows in pastures, milked them regularly, and slaughtered them annually. Since winter fodder was limited in Europe, farmers there maintained only enough stock through the cold months to replenish their herds in the following spring. This practice made little sense in the Lowcountry region, where cattle could "feed themselves perfectly well at no cost whatever" throughout the year.[75] Stock grew lean but rarely starved in South Carolina's mild winters. Colonists therefore might build up large herds with little effort, a fact which could benefit the settlement but which dismayed their London sponsors, the

Fig. 2.6
Arthur Manigault, Jr., casting for shrimp, Mt. Pleasant,
South Carolina, 1974. Photo: Greg Day.

Identical cast nets are still made and used in West Africa.

Fig. 2.7
Net maker Jerry Washington sewing a cast net, Mt.
Pleasant, South Carolina, 1972. Photo: Greg Day.

Fig. 2.8
Dragging a seine in Hamlin Sound, Mt. Pleasant, South
Carolina, 1974. Photo: Greg Day.

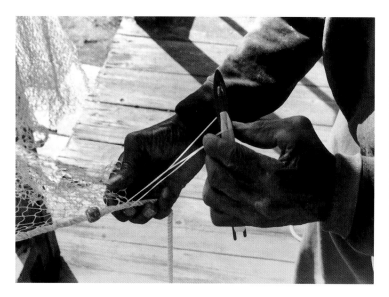

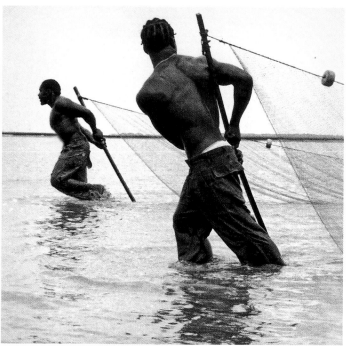

eight Lords Proprietors in London. It has been "our designe," they stated indignantly, "to have Planters there and not Graziers."[76]

Africans, however, had no such disdain for open grazing and, among those drawn from interior savannah areas where cattle were commonplace, many would have had experience tending large herds. In the forest and coastal regions between Senegal and Congo-Angola, domesticated cattle were absent, due to the chronic presence of the tsetse fly, but such animals were regularly traded to coastal communities from the savannah grasslands.[77] African coastal merchants even exchanged stock for Atlantic export on occasion. In 1651, for example, the English Guinea Company, precursor of the Royal African Company, instructed a captain to barter liquor at the Gambia River for a "Cargo of negers or Cattel" to be carried to Barbados.[78] People from the Gambia region, the area for which South Carolina slave dealers expressed a steady preference, were often expert horsemen and herders if they had grown up in the interior. Among the Fula people along the Gambia River, for instance, English visitors expressed high admiration for their standards of cleanliness with respect to dairy products. "The women had the right to the milk of the herd," writes historian Douglas Grant, "and sold it and the butter in well scoured gourds," taking care to keep out the smallest hairs or bits of dirt. Contemporary descriptions of Fula animal husbandry bear a striking resemblance to what would later appear in Carolina. Fula herds grazed on the inland fields bordering the river and on the low-lying *lougans* (paddies) after the rice was harvested. At night, stock was tethered within a cattle fold, around a raised platform with a thatched roof, where half a dozen armed men sat to guard the animals.[79]

As early as the 1670s, there is evidence of absentee investors relying upon enslaved Africans to develop herds of cattle in Carolina.[80] Even when the white landowner lived within the province, the care of his livestock often fell to a black man who would build a small "cow-pen" in some remote region, attend the calves, and guard the grazing stock at night. When Denys Omahone sold a fifty-acre tract to a new arrival in the 1680s, the property contained, besides the Indians who still inhabited it, four calves, three steers, five sows, one boar, and a "Negro man by name Cato."[81] In 1690, Seth Sothell gave his father-in-law one of several large landholdings, plus "thirty head of Cattle belonging to ye Said Plantation and one Negro Man."[82] Upon the death in 1692 of Bernard Schenckingh, a well-to-do Barbadian migrant with four estates, the appraisers of his James Island holdings reported that "In sight and by account apeareth 134 head of Cattle [and] one negro man."[83] Half a century later, the estate of Robert Beath at Pon Pon on the Edisto River included "a Stock of Cattle . . . said to be from Five Hundred to One Thousand Head. . . . Also a Man used to a Cow Pen and of a good Character."[84] It became so common for a black man or boy to oversee the abundant herds of cattle that scholars have speculated whether the western term, *cowboy*, had its roots in the colonial Southeast.[85]

BLACK RESISTANCE

The same African skills that were harnessed to break the land and create wealth for the masters could pose a threat to white rule. While it is now clear that black South Carolinians did much to shape the regional culture, it is equally clear that they received little in return. The oppression was immediate and undeniable, and their plight only worsened as white power increased and racism became institutionalized. Enslaved for life, shiploads of newcomers were cut off from all means of advancement or fulfillment, and their children inherited the same status. With no wages paid, there was virtually no money to spend or save. Traveling freely, speaking frankly, and resisting openly were forbidden. Choosing a clothing style, a dwelling place, or a personal name fell out of reach. Others controlled such basic details of life as when

you rose, how you dressed, where you worked, and what you ate. Your spiritual faith, your family identity—even your own body—were subject to arbitrary assault. Trapped in these circumstances, Africans quickly proved that the same abilities that benefited Europeans, such as gathering herbs and guiding canoes, could also be used to oppose and threaten them. Soon, therefore, clear connections emerged between black expertise and black resistance.

One object that symbolizes the link between work and subversion is the humble rice mortar. This large wooden vessel used to pound rice could also serve as a drum to convey messages and convene meetings (cat. 53). Mortars could be fashioned crudely from a hollow gum tree, or, when time, skill, and tools allowed, they could be tapered at the base and decorated on the sides, as was common in Africa. This gave them the shape of large upright wooden drums, such as those used by the Asante, of present-day Ghana.[86]

Since wood decomposes over time, few mortars survive today, but during the eighteenth century they were more common than wagon wheels in the Lowcountry.[87] Indeed, without thousands of mortars and pestles carved by black Carolinians, the colony's lucrative annual rice harvest could not have been "cleaned" of its husks and prepared for market. Did mortars used for pounding rice during harvest season double as drums at other times of year, with a skin stretched tightly across the open top? We shall never know for certain, but clearly artisans who made such mortars could also make drums, and vice versa. In Tidewater Virginia, where an Asante-style drum was found, nervous planters outlawed the practice of African drumming at an early date. More than five decades ago, one historian pointed out that in 1676, the year when black workers played an active part in Bacon's Rebellion, "the Colony of Virginia took the lead . . . in prohibiting the assemblage of Negroes by drum beat."[88] In neighboring Maryland, a court complaint was filed in Somerset County early in the eighteenth century because slaves were "Drunke on the Lords Day beating their Negro drums by which they call considerable Number of Negroes together in some Certaine places."[89]

In South Carolina, planters fearful of drumming could hardly outlaw mortars, which were needed to process the lucrative staple crop. With so many mortars on every plantation, the rice pounding and the drumming traditions inevitably overlapped. It is not surprising that during the early successful hours of the Stono Uprising in 1739, scores of rebels beat loudly on drums as they headed southward.[90] According to a contemporary account, "they halted in a field and set to dancing, singing, and beating Drums by way of triumph."[91] Colonial authorities repeatedly outlawed drumming as a subversive activity. Music historian Dena Epstein observes, "The prohibition of drums, ignored to a great extent on the islands and in South America, was more strictly enforced on the North American mainland, but," she adds pointedly, "one should not conclude that even there the edicts were completely effective."[92]

The raising of livestock provides another instance where the routines of daily servitude and actions subversive to the plantation regime clearly overlapped. Increased production of cattle and hogs provided many whites with the substance for enlarging their holdings in Africans, and European observers marveled at this growth.[93] The livestock workers, on the other hand, benefited little from this enterprise. Consequently, they often helped themselves to the stock that they tended, falsifying brand marks and slaughtering cattle and hogs. Ex-slaves reported that it was common to kill a pig with a mallet leaving no mark, claim that it had died of a sickness, and then consume the remains—feet, intestines, and all—when the master proved fearful to eat the "tainted" pork. For herders to "steal" the meat of animals they had raised proved subversive in several ways at once. The fencing, or illegal trading, of meat and other stolen goods cut into white profits. This activity reinforced black networks of mutual support, and also strengthened personal alliances across the widening color divide.

Regulations introduced by the government even before 1700 to control the branding of livestock did little to deter these practices. Slaves altered brands with such dexterity that in the

Negro Act of 1722 their owners denied them the right to keep and breed any horses, cows, or hogs whatsoever.[94] Nevertheless, livestock rustling continued, and in 1743 the Assembly was obliged to draft "An Act to prevent Stealing of Horses and Neat Cattle," which went so far as to declare, "it shall not be lawfull hereafter for any Slave whatsoever to brand or mark any horses or neat Cattle but in the Presence of some white Person under the penalty of being severely whip[p]ed."[95]

A law passed the following year required that Negro ferrymen, suspected of transporting fellow slaves, were to be accompanied by a freeman at all times.[96] By then it had been apparent for decades that the skills of black boatmen could be a liability as well as a source of profit to white colonists. As early as 1696 an act had been passed, patterned on laws already in force in the West Indies, which threatened any slave who "shall take away or let loose any boat or canoe" with thirty-nine lashes for the first offense and loss of an ear for repetition.[97] Related acts in the eighteenth century prohibited "unfree Negroes" from owning or using any boat or canoe without authorization.[98] Such repeated legislation underscores the fact that slaves who were involved in building and manning these boats had all the skills necessary to use them for travel or escape.

Among the black Carolinians whose seamanship was most valuable and also most problematical for whites were those who served aboard Charleston pilot boats or were otherwise knowledgeable in local navigation. The possibility that Africans would make such strategic skills available to an international rival was a recurrent source of concern for English settlers. There was alarm, for example, during hostilities with Spain in 1741, when the blacks from Thomas Poole's pilot boat were carried to St. Augustine, Florida, by a Spanish privateer.[99] Colonists were well aware that for several decades Bermuda had suffered serious depredations from Spanish vessels piloted by black Bermudans who had defected.[100] Four years later a man named Arrah was seized from Hugh Cartwright's schooner and "great encouragement was offered to be given him by the enemy if he would join with them against the English, and assist them as a pilot for . . . Carolina." When he stoutly refused and succeeded after several years in making his way back to Charleston, the grateful Assembly granted him his freedom by a special act.[101]

African knowledge of herbs and poisons was the most vivid reminder that black expertise could be a two-edged sword. In West Africa, men and women with the herbal know-how to combat poisoning could inflict it as well, and this gave the enslaved a weapon against their new white masters. In Jamaica, poisoning by so-called "obeah-men" was a commonplace means of black resistance in the eighteenth century, and incidents were also reported in the mainland colonies.[102] In South Carolina the administering of poison by a slave was made a felony in the punitive Negro Act of 1740 that followed in the wake of the Stono Rebellion.[103] Eleven years later an additional law observed that "the detestable crime of poisoning hath of late been frequently committed by many slaves in this Province, and notwithstanding the execution of several criminals for that offence, yet it has not been sufficient to deter others from being guilty of the same."[104]

The statute of 1751 suggests the seriousness with which South Carolina legislators viewed the poisoning threat, for they attempted belatedly to root out longstanding black knowledge and administration of medicinal drugs. It was enacted, "That in case any slave shall teach or instruct another slave in the knowledge of any poisonous root, plant, herb, or other poison whatever, he or she, so offending, shall, upon conviction thereof, suffer death as a felon; and the slave or slaves so taught or instructed" were to receive a lesser punishment. "And to prevent, as much as may be, all slaves from attaining the knowledge of any mineral or vegetable poison," the act went on, "it shall not be lawful for any physician, apothecary or druggist, at any time hereafter, to employ any slave or slaves in the shops or places where they

keep their medicines or drugs." Finally, the act provided that "no negroes or other slaves (commonly called doctors,) shall hereafter be suffered or permitted to administer any medicine, or pretended medicine, to any other slave; but at the instance or by the direction of some white person." Any Negro disobeying this law was subject to the most severe whipping that the colony's Assembly ever prescribed. Yet even this strict legislation was apparently not enough to suppress such resistance, for in 1761 the *South-Carolina Gazette* reported, "The negroes have again begun the hellish practice of poisoning."[105]

The matter of poisoning was discussed at length in a letter that Alexander Garden (the Charleston physician after whom Linnaeus named the gardenia) sent to Charles Alston, his former teacher in Edinburgh, in 1756.[106] Garden acknowledged that some masters had been "actually poisoned by their slaves," but he added his candid opinion that local doctors listed numerous other deaths as poisonings simply to "screen their own ignorance." Whatever the truth, actual instances of poisoning intrigued him, and he put forward a scheme "to examine the nature of vegetable poisons in general." Garden took most seriously the implications that black proficiency derived from Africa. He requested from Alston, "assistance in giving me what information you could about the African Poisons, as I greatly and do still suspect that the Negroes bring their knowledge of the poisonous plants, which they use here, with them from their own country." He even went so far as to state explicitly that it was part of his plan "to investigate the nature of particular poisons (chiefly those indigenous in this province and Africa)." But his scheme was of little avail at a time when European knowledge of African flora was still so limited.

In one area after another, slaves were forced to use their skills to make their masters wealthy and to develop the country. But at the same time, they used the same skills to preserve their identities and to subvert their enslavement. Cow herders poached animals they had raised and tended; root doctors held white people in a state of anxiety. The same African-American blacksmiths who kept wagons rolling and decorated Charleston houses in wrought iron also were suspected of making and storing pikes—turning plowshares into swords. Enslaved carpenters ran away with their tools, so they could hire themselves out to willing white people and stay on the lam. This same pattern of resistance applied to basketry as well. The clever hands that fashioned thousands of wide, shallow baskets for winnowing rice were producing a tool that was essential to process South Carolina's money crop. But no skilled craft did more to undermine the identities the masters tried to impose on their chattel than this unbreakable link to Africa. Artful coiled baskets, sewn row upon row, were used to haul and process white-owned produce grown by the enslaved. But these same baskets could also be used to hold the maker's own beloved newborn (cat. 118, p. 214), or to shelter an infant at the edge of a field while the mother hoed weeds in the baking sun. The giving of "basket names" is a tradition that outlasted slavery precisely because it offered a protection against identity theft. From birth, most black Carolinians have two given names. One is an official name used in dealings with outsiders; the other is a "basket name," known only among family and friends, given when a child is small enough to sleep in a basket.[107] And when the Great War finally came, the same hands that made scores of flexible fanner baskets for winnowing the master's rice might even sew a basket boat for escaping (see Chapter 4). Like prisoners in the Siberian "gulag" of the Soviet Union in the twentieth century, people in southern slave labor camps during the eighteenth and nineteenth centuries occasionally managed to defy great odds to obtain freedom.[108]

At first, Europeans arriving in colonial South Carolina did not anticipate black skills or the uses to which they might be put. Indeed, most were ignorant of the environment they entered and of the labor they purchased. But white settlers soon realized that African workers possessed expertise to be exploited and knowledge to be feared.[109] Within several

generations, the Europeans had imparted aspects of their culture to the Africans and had themselves acquired practical know-how in matters such as rice growing.[110] The exchange of crucial knowledge between Africans and Europeans happened quite quickly and was reinforced by physical proximity, mutual need, and mounting coercion. To whites, early black contributions could prove threatening at times. Ironically, skills drawn from Africa served to strengthen, rather than weaken, the European rationale for expanding the system of racial enslavement.

3 Rice in the New World

Judith A. Carney

THE INTRODUCTION OF RICE to colonial South Carolina has long been explained in terms of the ingenuity of white planters who first settled the region. The story begins with the arrival of Europeans to the Carolina colony in 1670. In the surrounding lowland swamps they envisioned a landscape where rice would grow. They then solicited seed from their mercantile contacts in the Orient. From two deliveries in the 1680s, Europeans built a plantation economy that subsequently made Carolina rice famous around the globe.[1]

Duncan Heyward popularized this version of Carolina rice history in *Seed from Madagascar*, written in 1937.[2] Heyward had witnessed the ruin of his family's rice plantations after the Civil War. His memoir commemorated the imagination and initiative that gave decisive impetus to Carolina rice culture. But Heyward's tribute to planter enterprise overlooked one significant detail in colonial rice history: the founding generations of European colonists knew nothing of rice culture. Yet, the first settlers did include "planters" quite experienced in rice cultivation—enslaved Africans. Among those held in bondage were some from ancient rice-growing societies who, in their own struggle for sustenance and survival, brought about the cereal's introduction. Many had come to the colony on slave ships provisioned in Africa with rice.

This essay brings to bear another perspective on Carolina rice history by shifting the geographical context for discussion of rice introductions from Asia and the Indian Ocean to slave societies and the Black Atlantic. The argument centers on the significance of the forced migration of some fifteen million people—among them expert rice growers—and the African foodstuffs carried on the slave ships to the Americas. Nearly every departing shipload of captives depended on food grown in Africa for provisions. The early appearance of rice cultivation in South Carolina can be seen as one episode of a broader account of the ways enslaved growers pioneered African subsistence staples in diverse cultivation environments of the Americas.

HOW RICE REACHED AMERICA

When Carolina historian A. S. Salley identified in 1919 two introductions of seed rice in the seventeenth century, he failed to see the implications of another recorded grain shipment his research had uncovered. In fact, Salley cites evidence of a third introduction, which came by way of Africa:

> About this time [in the 1690s] "a *Portuguese* vessel arrived, with slaves from the east, with a considerable quantity of rice, being the ship's provision: this rice the *Carolinians* gladly took in exchange for a supply of their own produce.—This unexpected cargo was distributed, which gave new spirit to the undertaking, but was not sufficient to supply the demand of all those that would have procured it to plant."[3]

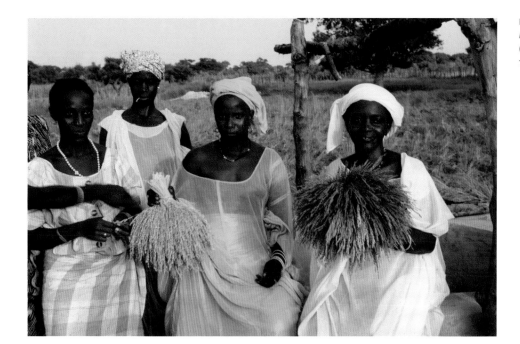

Fig. 3.1
Mandinka women displaying bundles of African rice
(right) alongside the Asian species, Casamance, Senegal,
1987. Photo: Judith A. Carney.

Salley offered his account as an early instance of planter initiative in establishing rice as
a plantation crop. However, it provides a clue to another mechanism for the introduction of
rice to the colony. First, the account records how rice from Africa was landed in seventeenth
century Carolina as leftover slave provisions. Second, the Carolinians took the vessel's rice
to *plant* it; therefore, the rice must have been *seed*—unmilled grains with the outer hulls still
intact. Once the hull is removed by milling, the grain cannot be planted and is useful only as
food. A closer reading of Salley's account thus reveals that the ship carried rough rather than
clean rice as provision; that is, grain not yet milled.

Rice figured among the chief food staples ship captains purchased to feed their captives.
It is estimated that during the period of transatlantic slavery, twenty to forty thousand
voyages transported enslaved Africans to the Americas.[4] While provisions at times fell short,
African-grown crops repeatedly arrived at New World ports of disembarkation. Salley's
account also suggests that among the captives on board, some may have been rice growers. It
is not unreasonable to suppose that where slavers found rice for their stores, they also found
rice-growing people—some already in servitude—for their holds.[5] Surplus foodstuffs from
transatlantic voyages, in the form of seeds or rootstock, thus provided multiple opportunities
for displaced Africans seeking to grow familiar crops. As we shall see, they used the food plots
allocated to them on plantations to reestablish their dietary preferences.

One of the rice shipments identified by Salley came through an official of the Dutch
East India Company; the second arrived in 1685 on a ship from Madagascar.[6] In Salley's day,
at the beginning of the twentieth century, scholars considered all rice to be of Asian origin.
It is therefore not surprising that he looked to the Orient for the beginnings of Carolina
rice culture. It was even believed during the Atlantic slave trade that European mariners
introduced rice to West Africa on their return voyages from Asia.

Salley's investigations of Carolina rice culture identified two types of seed rice that were
present in the colony: one was white, the other red. But French botanists working in West
Africa at that time were beginning to make the case that the red rice grown throughout the
region was uniquely African and a separate species.[7] They found the same rice present in
seed collections made in the first half of the nineteenth century along the Upper Guinea
Coast. This rice was covered with a red husk. Africa's red rice was no stranger to slave

traders. In an epistolary exchange that arranged a seed shipment to Thomas Jefferson, traders described it as "Red Rice, as this kind is sometimes call'd."[8] African red rice undoubtedly served as one of the earliest grain deliveries to the colony, shipped with the captives for whom it was a traditional food.

TROPICAL FARMERS IN TWO WORLDS

More than three thousand years ago West Africans independently domesticated a unique species of rice, *Oryza glaberrima*. This African rice is an entirely separate species from that domesticated in Asia, *Oryza sativa* (fig. 3.1). Red in color and lower yielding than Asian *sativa*, African rice is remarkably adapted to marginal growing conditions, especially drought and salinity. In the millennia before European overseas expansion, the cultivation of African rice spread along Sahelian river floodplains from the West African interior to the Atlantic coast extending from present-day Senegal to Liberia (fig. 1.11a, p. 27). Long before slave ships removed Africans to the Americas, rice was central to the cultural identity and foodways of millions.[9]

Archival references indicate that captains of slave ships bought rice in both milled and unmilled forms from coastal African societies. Rough rice sold for less; however, it required milling during the voyage to ready it for human consumption. When cereals such as rice and millet were purchased unmilled, enslaved women on board carried out the work. Not coincidentally, African women have always borne the task of milling and processing food.[10]

A remarkable eighteenth-century painting depicts women milling grain on the quarterdeck of the Danish slave ship *Fredensborg* (fig. 3.2). They are portrayed pounding the cereal in the customary African manner, jointly, with pestles alternately striking a mortar filled with grain—possibly rice but more likely millet. The image provides important visual confirmation that the *Fredensborg* purchased at least a portion of its grain unprocessed and relied on the captives to pound it. The painting also reminds us that unmilled grain from a slave voyage could potentially serve as seed after the ship arrived at port. All things considered, the red rice mentioned in the earliest seed introductions to Carolina likely was African *glaberrima*.

An examination of rice beginnings in other parts of the Americas indicates the cereal often came to the attention of planters as a crop slaves grew in their provision food plots. Africans cultivated rice for subsistence on sugar plantations in sixteenth-century Brazil and

Fig. 3.2
Skibet Fredensborg, anonymous, 1788. Watercolor on paper. Private collection.

This painting of the Danish slave ship, *Fredensborg*, depicts women on the quarterdeck pounding grain in a mortar (see detail on right).

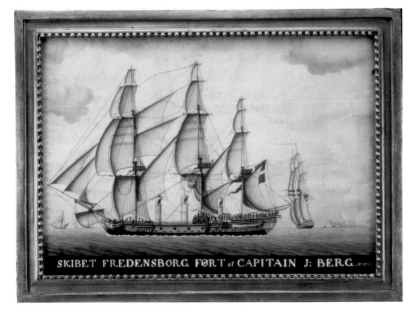

Fig. 3.3

Illustration and description of Baga rice cultivation from the log of the slave ship, *Sandown*, Captain Samuel Gamble, 1793–94. National Maritime Museum, London.

The Baga people of Guinea irrigated their crops through a system of hollowed-out logs that transported water from reservoirs to the fields. At a calculated time the water would be drained off on the "other side" of the fields through another log or logs. Similar devices were used on Carolina rice plantations situated in the inland swamps, before rice planters moved their operations in the mid-eighteenth century to lands adjacent to tidal rivers.

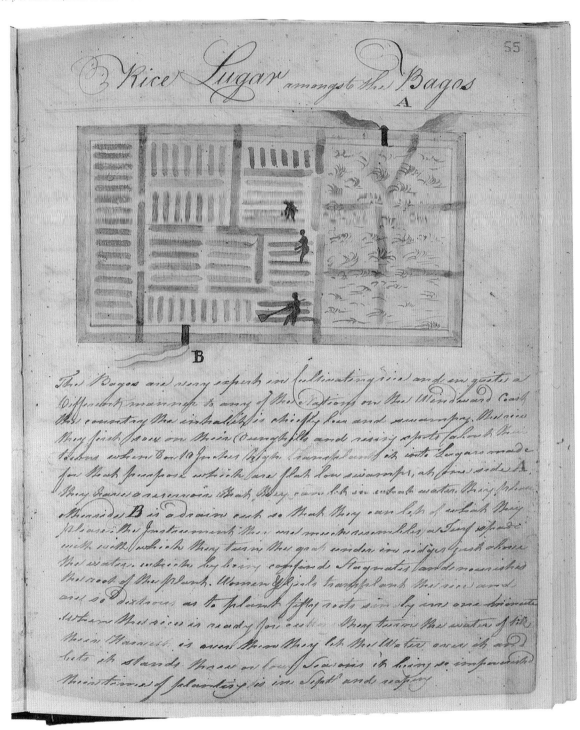

in the seventeenth-century Guianas. The early history of rice as a subsistence staple is documented in the areas where rice plantations subsequently developed—Maranhão, Brazil, and the Guianas. Runaway slaves, known as maroons in Jamaica, the Guianas, and Brazil, also grew rice for their own consumption.[11] A comparative perspective on the beginnings of rice cultivation in the Americas reveals its initial introduction as a food crop among both enslaved and fugitive Africans.[12] The focus on export crops in studies of plantation economies often overlooks the role rice played as a subsistence staple that fed white people as well as black. Plantation owners relied upon the food their laborers produced and they dined upon the dishes enslaved women prepared.

This point is obscured in a recent contention that African contributions to Carolina rice culture are overstated.[13] Marshaling statistical analyses of slave ship movements and manifests, the proponents of this position argue that African rice growers were not relevant to the birth of Carolina rice culture. Instead of acknowledging that the slave import data for the early colonial period is fragmentary in terms of the ethnic origins of slaves and their numbers, they suggest that an African origin of Carolina rice culture can be demonstrated only by a statistically high number of enslaved growers. A numerical approach offers little hope of clarifying the complex processes that led to the establishment of African food staples in colonial America. It does not consider that Africans familiar with the crop's cultivation may have sought to grow and eat the foods familiar to them when they were exiled to the Americas. Instead, the emphasis on numbers diverts attention from the significance of subsistence in the development of plantation economies. Slaves in this period were often left to find their own sustenance or risk outright starvation.[14]

Early in the formative years of plantation economies, Europeans began commenting upon the crops from Guinea that Africans grew for food. The enslaved used multiple strategies to meet their daily food needs. Many variables affected their survival: subsistence options, dietary preferences, environmental knowledge systems, and cultural traditions. The importance of these factors has not been fully appreciated.[15] How did the enslaved establish so many plants of African origin? Even to this day many of the continent's indigenous food staples—yams, okra, benne, *guandú* (pigeon pea)—retain their African names in New World languages. *Malo*, a West African word for rice, is retained in the Gullah lexicon of the South Carolina and Georgia Sea Islands.[16]

Fig. 3.4
Hollowed tree trunk in use as a sluice in a tidal rice field, Casamance, Senegal, 1996. Photo: Judith A. Carney.

Fig. 3.5
Rice farmer with a long-handled hoe, Keneba, Western Kiyang District, The Gambia, 1970. Photo: David P. Gamble.

Fig. 3.6
Mandinka woman cleaning rice with a mortar and pestle, Keneba, Western Kiyang District, The Gambia, 1970. Photo: David P. Gamble.

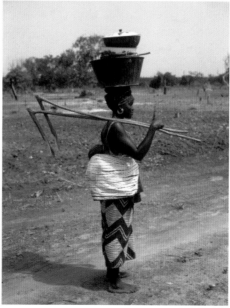
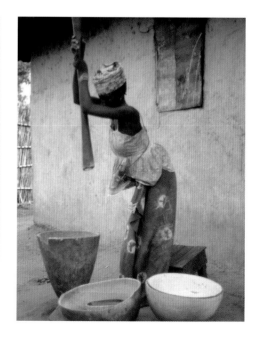

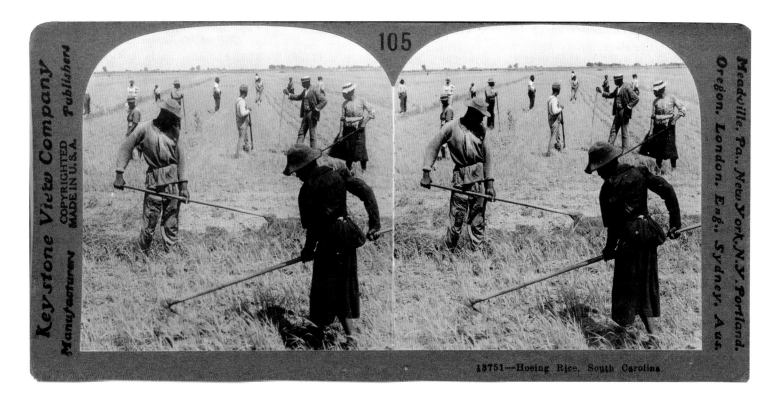

Fig. 3.7
"Hoeing Rice, South Carolina," stereograph, ca. 1904.
Collection of Gene Waddell.

Such considerations bring us to the realization that in the first generations of settlement, Africans profoundly shaped plantation foodways. The arrival of Africans in the Americas can be imagined as an unprecedented exodus of tropical farmers from the Old World to the New. With them came knowledge systems that informed agricultural diffusion, innovation, and food transfers. As the ingenious planter narrative contends, this had much to do with the resourcefulness, skills, hope, and imagination that human beings, including those brought against their will, carried to the American colonies.[17]

THE SPREAD OF KNOWLEDGE

Drawing upon expertise and practices already known to them, Africans transferred time-honored agricultural technologies to the New World. In rice cultivation they applied similar land-use systems to similar environments, seeding rice directly rather than transplanting sprouts on the Carolina floodplains—a procedure that would have been familiar to their ancestors (fig. 3.3). Other signature technologies of West African rice culture, including irrigation systems, also were transferred to Carolina.

The earliest methods of water control in Africa involved the use of hollowed-out logs as sluices (fig. 3.4). A recently excavated rice trunk in South Carolina, hewn from the rot-resistant cypress tree, dates to the eighteenth century and indicates an analogous system in use. Moreover, the indispensable long-handled hoe, still the fundamental implement of African farming systems, served as the basic tool of Carolina rice culture (figs. 3.5, 3.7).

However, the successful transfer of rice culture to the New World depended even more crucially on a method to process the cereal into edible grain. Throughout the colonial period, the African practice of pounding rice in a mortar with a two-ended pestle remained the principal way of breaking the husk that encloses the grain (fig. 3.6 and fig. 4.7, p. 115). The pounded rice was then placed in a wide, flat winnowing basket and either thrown in the air or dropped from a height to a second basket on the ground, to let the wind blow away the chaff. These African techniques still are used by small-scale farmers in remote communities of the Americas to process subsistence rice (fig. 3.8).

Fig. 3.8
Winnowing rice, Mt. Pleasant, South Carolina, 1974.
Photo: Greg Day.

Arthur Manigault, Sr., winnows rice in a fanner basket
made by his wife, Mary Jane Manigault.

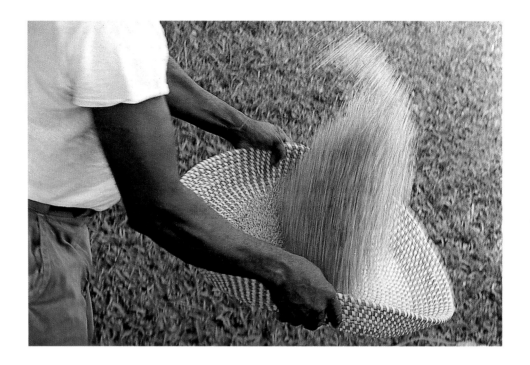

Parboiling, the preferred method for cooking rice in South Carolina, was widely
employed in Africa. Developed to reduce the high moisture content of newly harvested rice
for immediate consumption, parboiling uses steam to drive off excess moisture and keep
individual grains from sticking to each other. This technique has long been practiced in West
Africa's indigenous rice region because it enables the consumption of rice at the end of the
cultivation cycle when food reserves are lowest. The well-known brand name, Uncle Ben's
Rice, subliminally projects through its famous marketing icon the social memory of this
African contribution.

Other African culinary practices that influenced the Carolina rice kitchen involved
cooking the cereal in combination with other foods. One dish, made with black-eyed
peas (another plant of African origin), is called hoppin' John. Prepared across the South
for the New Year, hoppin' John is said to bring good luck to all who share its consumption
on that day. Another popular diaspora dish combines rice with greens and okra (also an
indigenous African plant). Such culinary influences have become signature rice dishes of
the Black Atlantic (see Chapter 5).[18]

While the foundation of rice culture in the Americas was African, once rice became
a plantation crop, Asian rice quickly overtook the African species in importance. There are
several reasons for the dominance of the Asian variety. While African *glaberrima* tolerates
drought, soil salinity, and weeds, its yields are lower than Asian *sativa*. Asian rice was also
preferred because it does not break as readily when mechanically milled. The perfection of
mechanical milling devices in the late colonial period contributed to the disappearance of
African rice in many parts of the Americas. By the time of the American Revolution, the
high-yield Asian rice that came to be known as "Carolina Gold" dominated the rice plantations
of South Carolina and Georgia.[19]

But the African rice species endured in remote locales, in part for its esteemed nutty
taste and its commemorative use in food offerings.[20] Despite the adoption of Asian rice as
the plantation crop, cultivators in the late eighteenth century may have continued growing
glaberrima on their individual fields. "Besides the white and gold rice," John Drayton observed
in 1802, "there are some others . . . of little note or consequence; principally cultivated by
negros. They are called *Guinea rice, a bearded rice, a short grained rice*, somewhat like barley, and a

species of *highland rice*."[21] Any of these may have been African *glaberrima*, especially when it is recalled that in the 1790s Thomas Jefferson distributed upland seed rice to southern agricultural societies from a shipment obtained from Guinea in West Africa. Jefferson hoped to encourage upland cultivation, which was believed to carry fewer health hazards than tidewater rice with its attendant risks of malaria and dysentery.[22]

Rice planters continually tried to increase yields and improve the efficiency of labor. Hanging gates (figs. 8.8, 8.9, p. 208) replaced the earlier sluice trunks and in commercial operations mechanical pounding mills supplanted the African mortar and pestle. New seed varieties were introduced from Africa as well as Asia. Rice culture embraced both black and white ingenuity.

AFRICAN CONTINUITIES IN LATIN AMERICA

Despite its poor yield and unsuitability to mechanical milling, African rice proved highly adaptable to problem soils and was appreciated for its agreeable taste. Growers in isolated regions continued to cultivate the African species long past the abolition of slavery. Botanical collections of rice from the 1930s to 1950s reveal its presence in fields planted by descendants of runaway slaves in Suriname and French Guiana.[23] African *glaberrima* also appeared in collections from former plantation areas of El Salvador and Panama. The British Museum holds another specimen, collected in Cuba in 1877, when slavery on the island had not yet ended.[24]

In pioneering the cultivation of a dietary preference, enslaved Africans made a memorable and enduring contribution to the agricultural history of the Americas. The cereal's initial introduction occurred in diverse plantation economies and colonial settings. Rice flourished as a subsistence food wherever the environmental and social circumstances permitted its cultivation. The grain's early history in the Western Hemisphere is thus inseparable from the enslavement of Africans skilled in its cultivation (figs. 3.9, 3.10). African knowledge systems provided the agronomic and technological basis for developing the cereal into a plantation crop in late seventeenth-century Carolina and for the diffusion of seed varieties to rice plantations in eighteenth-century Dutch Guiana and Portuguese Brazil.[25] While rice has long since vanished from the fields of South Carolina, as well as from its old domains from North Carolina to Georgia and northern Florida, it is still planted in the Amazon region. Mixed race descendants of Africans enslaved in Peru and Brazil continue to cultivate "Carolina White" and "Carolina Gold" varieties.[26] To this day, the United States maintains a prominent export position in the global rice trade, now ranking third among countries exporting the grain. Arkansas is by far the top rice-producing state, followed by California and Louisiana. In recent years, South Carolina culinary entrepreneurs have attempted to revive "Carolina Gold" as an heirloom crop for an upscale market.[27]

While historians, botanists, geographers, and other scholars continue to illuminate the African origins of rice cultivation in the Americas, there is one area of the world where this contribution was never forgotten. Across northeastern South America, in isolated communities separated by considerable distances, there exists a foundation narrative about rice. From the Guianas and across the Amazon to the northeastern Brazilian states of Maranhão, Pará, and Amapá, oral histories link rice to Africa, slave ships, and women. These communities, descended from enslaved rice growers and runaway slaves, place rice at the center of their own diasporic history and identity. Legends collected in a number of maroon communities (as well as one in Carolina) attribute the beginnings of rice cultivation to a female ancestor who hid grains of rice in her hair as she disembarked from a slave ship. The precious seeds escaped detection and this, they explain, is how we came to plant "this crop from Africa."[28]

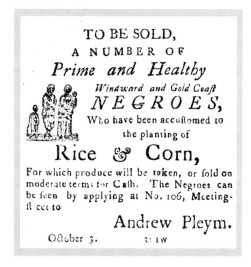

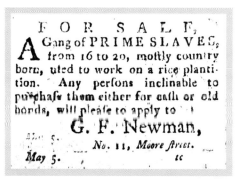

Fig. 3.9
Advertisement for sale of slaves, from *The Charleston Evening Gazette*, November 6, 1785. Early American Newspapers.

Fig. 3.10
Advertisement for sale of slaves, from the *City Gazette and Daily Advertiser*, May 5, 1790. Early American Newspapers.

By the rivers of Babylon
There we sat down…

By the Rivers of Babylon: The Lowcountry Basket in Slavery and Freedom

Dale Rosengarten

By the rivers of Babylon
There we sat down
And there we wept
When we remembered Zion.

When the wicked carried us away in captivity
Requiring of us a song
Now how shall we sing the Lord's song
In a strange land.
 —adapted from Psalm 137

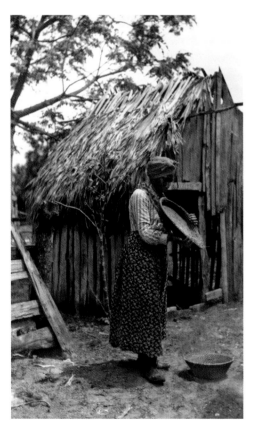

Fig. 4.1
Rebecca Green winnowing rice, St. Helena Island, South Carolina, ca. 1909. Photo: Leigh Richmond Miner. Penn School Collection/Southern Historical Collection, University of North Carolina at Chapel Hill.

Threshed rice is dropped from one basket to another to blow away the "tailings." This is the first winnowing and will be repeated after the grain is pounded in a mortar to break the husk.

AS THEY MARCHED FROM the hinterland to coastal forts and slave ships that would take them across the Atlantic, captive Africans balanced large, coiled baskets on their heads, filled with provisions for the journey. Some number of these baskets must have made the terrible Middle Passage with the people who "toted" them. Arriving on the coast of Carolina, as the British colony was known, many Africans would have noticed similarities with the landscapes they remembered from home. Furthermore, the semi-tropical vegetation, vast salt marshes, and varieties of palm all offered abundant plant material with which to make baskets.

The Carolina Lowcountry is a country of grasses. From the edge of the high ground, which may be only inches above sea level, salt marsh stretches to the horizon. Along the creeks that drain the marsh and on the islands among the creeks grows smooth cordgrass, or spartina, a tough, broad-leafed, green grass equipped with salt glands and specialized cells that allow it to live in soil watered by the tides. Black rush, or bulrush, occupies slightly higher ground. Bulrush's fiercely pointed tip has earned it the nickname, "needlegrass." Its long, round, hollow shafts can tolerate low levels of salinity and withstand intense sun, strong winds, and salt spray. Just out of reach of the tides, in flats between the dunes, or in the transitional zone where marsh meets woods, grow sweetgrass, salt hay (another spartina), broomstraw, and seaside goldenrod. Here, red cedar, live oak, pine, palmetto, yaupon, and wax myrtle have pinned down the sand and stopped it from shifting.

Native Americans found uses for most of these plants. By the end of the seventeenth century, European settlers and their African slaves had adopted many Indian practices and had adapted their own Old World customs and tastes to New World flora. They learned to utilize salt hay to pasture livestock. They made brushes from the fiber of the cabbage palm and ate the heart of the palm as a delicacy. They harvested trees and shrubs for building materials. From longleaf pine they extracted tar to preserve ships' riggings, pitch to caulk wooden boats, and later, spirits of turpentine to make paint and varnish.[1]

In their former habitats, Africans had made baskets by coiling grass, weaving splints, and twining reeds and vines. In Carolina, they continued to practice coiling, binding together bundles of bulrush with thin oak splints or strips from the stem of the saw palmetto. In particular, they sewed a wide, flat coiled tray called a "fanner" that quickly became the standard tool for winnowing rice—throwing the threshed and pounded grain into the air or dropping it from one basket held high over another, allowing the wind to blow away the chaff (fig. 4.1).

Baskets in Africa, even among neighboring people who produce the same crops, vary in shape, stitching technique, materials, and usage. Lowcountry baskets also varied from river to river and between mainland plantations and the Sea Islands, but the range of differences was narrow. Rather than emerge from a long period of experimentation and competition among techniques and forms, African-American coiled basketry developed rapidly and spread up and down the coast as a single "creole" tradition.

Carolina was a crucible of many cultures. "In no other American colony," wrote geographer D. W. Meinig, "were Europeans, Africans, and Indians so equally and intricately involved during the critical experimental period of working out ways of living in a new plantation region. Nor was this vital process simply an encounter among three peoples," he goes on to say, but a confluence of Europeans from several countries, Indians from various tribes, and Africans from many parts of a vast continent, some of whom were "seasoned" by years in the West Indies.[2] Most of these groups converging in the Americas had living traditions of coiled basketry. Europeans from grain-growing regions, for example, made baskets from the straw of their cereal crops, whether rye, wheat, barley, or oats. While this tradition was continued in German settlements of the mid-Atlantic colonies and western North Carolina, white settlers in South Carolina did not make coiled baskets themselves, but could readily appreciate the usefulness of the African-inspired coiled fanner basket.[3]

As plantation agriculture spread, people kept moving—north, south, west, and even east—and the tradition of coiled basketry that had taken hold in the Lowcountry migrated with them. When rice production expanded into Georgia and North Carolina in the early eighteenth century, South Carolina planters led crews of experienced "hands" to break the new ground and plant the crop. By the mid-1840s, rice operations had extended down the coast of Georgia and into northern Florida and the range of the basket followed suit (fig. 4.2).[4] There is evidence that the tradition migrated as far west as Alabama and Mississippi with convoys of enslaved workers from South Carolina plantations who were resettled on what was then a new frontier.[5] Even earlier, refugees from the Lowcountry may have carried coiled basketry to the Bahamas, where planters from South Carolina and Georgia who had sided with England fled after the American Revolution, taking their slaves with them. To this day, on the Caicos Islands southeast of the Bahamas, descendents of this forced migration continue to make coiled grass baskets suggestively similar to South Carolina work.[6]

RICE AND BASKETS

No Lowcountry baskets from the seventeenth century have survived, nor have scholars found written references to baskets in Carolina before 1700. A historian interested in basketry is handicapped by the perishable nature of the vegetable fibers from which it is made, and by the view of the basket as a humble object, useful but replaceable. For the eighteenth century, documentary evidence of basket production is sparse but informative, all of it in texts written by Europeans. Baskets occasionally are mentioned in wills, inventories, account books, and overseers' reports where they are described simply as tools and commodities. Fanners, for example, were listed among the personal effects of Noah Serre on May 18, 1730, and of Joseph Wilkinson on June 10, 1745.[7]

The earliest surviving African-American examples of coiled basketry date to the eighteenth century. A basket fragment from the Revolutionary period was excavated from the bottom of a privy at the Heyward-Washington House in Charleston and is now on permanent display at The Charleston Museum.[8] The new owner of a large, intact work basket that has been in her family for generations found a letter from her grandmother, written in 1955, stating that the artifact was two hundred years old. Analysis suggests that a manufacture date of ca. 1755 is a real possibility which, if accurate, would make the straight-sided piece the oldest Lowcountry coiled basket known today (cat. 55).

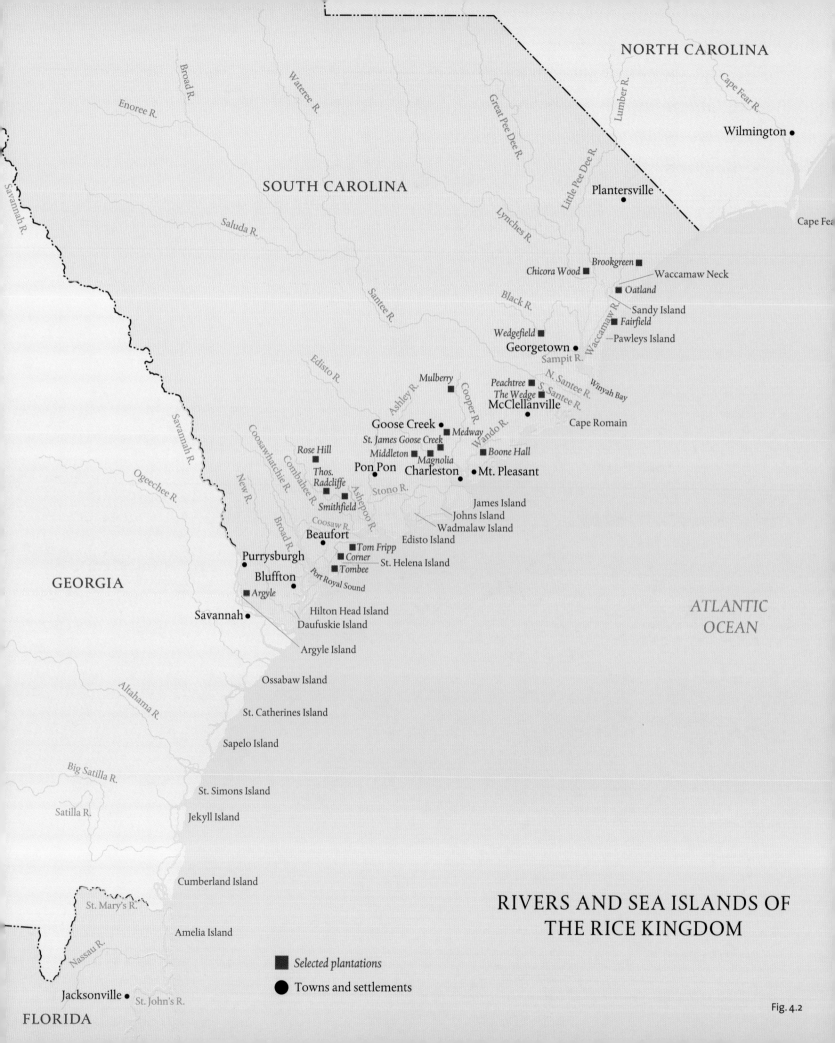

NORTH CAROLINA

Wilmington

SOUTH CAROLINA

Plantersville

Brookgreen
Chicora Wood — Waccamaw Neck
Oatland
Sandy Island
Fairfield
Wedgefield Pawleys Island
Georgetown

Mulberry
Peachtree
The Wedge
McClellanville
Goose Creek
Medway
St. James Goose Creek
Middleton Boone Hall
Rose Hill Magnolia
Pon Pon Charleston Mt. Pleasant
Thos.
Radcliffe
James Island
Smithfield Johns Island
Wadmalaw Island
Beaufort Edisto Island
Tom Fripp
Purrysburgh Corner
Tombee St. Helena Island

GEORGIA Bluffton
Argyle ATLANTIC
OCEAN
Savannah
Hilton Head Island
Daufuskie Island

Argyle Island

Ossabaw Island

St. Catherines Island

Sapelo Island

St. Simons Island

Jekyll Island

Cumberland Island

RIVERS AND SEA ISLANDS OF
Amelia Island THE RICE KINGDOM

■ Selected plantations
Jacksonville ● Towns and settlements

FLORIDA Fig. 4.2

Baskets were commonly traded between plantations. Savannah River rice planter William Gibbons listed in his account book in 1774 various amounts "pade for baskets," ranging from three shillings to eight pounds nine shillings.[9] Knowing how to make a basket added to the value of a slave. Though not as highly esteemed as competence in carpentry, cooperage, blacksmithing, or dressmaking, the ability to make baskets could be cited as a selling point. "A Negro man" described as "a good jobbing carpenter and an excellent basket maker" in the Charleston *Gazette and Advertiser* on February 15, 1791, was "sold for no fault, but that of having a sore leg."[10] In 1856, late in the antebellum period, the Reverend C. C. Jones of Savannah described an individual he offered for sale as a "good field hand, basket-maker, and handy at jobs." Jones asked eight hundred dollars for the man, a figure, he wrote his son, that his wife thought "too low."[11]

Planters' and overseers' records from the nineteenth century provide details about baskets as tools and their place in the plantation routine. Collecting materials for making baskets might occupy a few workers for several days, usually in late summer. Two or three weeks were set aside for making baskets before the harvest began. The overseer on Argyle Plantation, in the Savannah River basin, reported two hands "cutting oak for baskets" in 1828 and four hands "sent for rushes" in 1830. The men spent three days at the task. The next year the overseer needed more baskets—perhaps the rice crop looked exceptionally good—and for two weeks in August he assigned two workers to making them.[12]

Once the rice was threshed and ready for pounding and winnowing, fanner baskets would be issued by the dozen to the field hands. On Argyle, beginning in November, more than fifty hands were engaged in "thrashing and winnowing rice." These men and women appear only as numbers on the daily entry, but are listed by name under the heading "Disbursement of tools and baskets" at the end of the overseer's report.

By the middle of the eighteenth century, planters had begun moving their operations from the inland swamps to the rivers. The idea was to increase the acreage under cultivation, boost production of the grain, and save labor by having the water do the work. A system of trunks and embankments which regulated the flow of tide-driven fresh water onto the impounded fields transformed each rice plantation into what one planter admiringly called a "huge hydraulic machine."[13] Not only would the water be used to irrigate the crop but also to cultivate, weed, kill pests, and hold up the heavy panicles of rice just before the harvest.

Like the coiled basket, the technology for harnessing the energy of the tides had precedents in Africa (see Chapter 3). To tame the rivers required skill and diligence beyond the brute labor of constructing and maintaining the embankments. The rewards for this innovation were great profits for plantation owners but no increase in leisure for the workers. Throughout the eighteenth century, laborious hand techniques continued to be used to process ever larger crops of rice. Though the Lowcountry climate and soil were "admirably suited" to the grain, Dr. E. Elliott declared in *DeBow's Review* in 1851, "the planters encountered incredible difficulty in preparing, or dressing, the rice for market. From the days of its introduction to the close of the Revolution, the grain was milled, or dressed, partly by hand and partly by animal power. But the processes were imperfect—very tedious, very destructive to the laborer, and very exhausting to the animal power."[14]

As early as 1691, French Protestant settler Peter Jacob Guerard patented "a Pendulum Engine," hoping to improve upon the mortar and pestle. Though reputed to perform "much better and in lesse time and labour huske rice" than any other device, Guerard's invention did not catch on.[15] A "pecker" machine worked by oxen was used until after the Revolutionary War.[16] Yet on every plantation, workers continued to pound rice by hand—"a very hard and severe operation," wrote botanist Alexander Garden in 1755, "as each Slave is tasked at Seven Mortars for One Day and each Mortar Contains three pecks of Rice."[17]

Cat. 54

THE THRESHING FLOOR WITH A WINNOWING HOUSE
Alice Ravenel Huger Smith
Ca. 1935
Watercolor on paper
H. 43 x W. 56 cm.
Gibbes Museum of Art/Carolina Art Association, 1937.009.0022

Painted some eighty years after the imagined scene, Smith's watercolor presents an idealized view of a Carolina rice plantation of the 1850s. Even so, the picture accurately recalls the laborious process involved in preparing the grain for market. In the background shadowy figures are threshing rice with two-handled flails—that is, knocking the "heads" of grain off the stalks. The winnowing platform in the foreground, a common feature on rice plantations beginning in the 1700s, shows the critical role fanner baskets played and how many of them would be in use at one time.

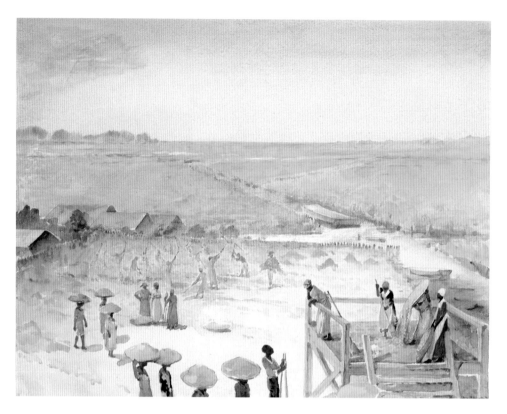

Apart from threshing floors and winnowing houses (cat. 54)—elevated platforms designed to enhance the effect of the wind in blowing away the chaff—no major mechanical advances in processing rice were introduced until 1787 when Jonathan Lucas built the first successful pounding mill, powered by water released from a reservoir, at Peachtree Plantation on the Santee River. Within four years, "Lucas had developed a tide-powered mill and, by 1817, one driven by steam." Pounding mills marked a great step forward in rice production. Their impact had "virtually the same significance for the rice kingdom as Eli Whitney's gin for cotton."[18] Around 1811, a threshing mill was devised, and an era of prosperity ensued.

Yet the new inventions never supplanted the flail, mortar and pestle, and the coiled basket. Only the wealthiest planters could manage to build pounding and threshing mills, and among those who could afford to mechanize some chose not to. Nathaniel Heyward, for instance, "the greatest of all rice planters, . . . long continued to have his crops threshed by hand, saying that if it were done by machines his darkies would have no winter work."[19] Even on rice estates equipped with threshing mills, fanner baskets continued to be used to winnow provision crops and seed grain, and coiled grass baskets of various types remained essential tools in the fields, slave quarters, storerooms, and Big Houses of Lowcountry plantations.

Because large quantities of fanner baskets were produced year after year, examples have survived in barn lofts and attics and several have made their way into museum collections. Other coiled forms from the plantation era that have been preserved include vegetable baskets, covered work baskets, trays and hot plates, bowl-shaped baskets, as well as a few examples of double or triple sewing baskets, described in detail by Santee River rice planter David Doar.[20] This intricate antebellum form is still made by older sewers in Mt. Pleasant, South Carolina, though only on commission (cat. 56).

Coiled basketry thrived along tidal rivers where it was critical to rice production, yet it also took hold on the Sea Islands where long-staple cotton was the chief export crop and the supply of fresh water was insufficient to support commercial cultivation of rice. Here, rice was

Cat. 55
COVERED WORK BASKET
South Carolina
Possibly mid-18th century
D. 44.5 cm.
Private collection

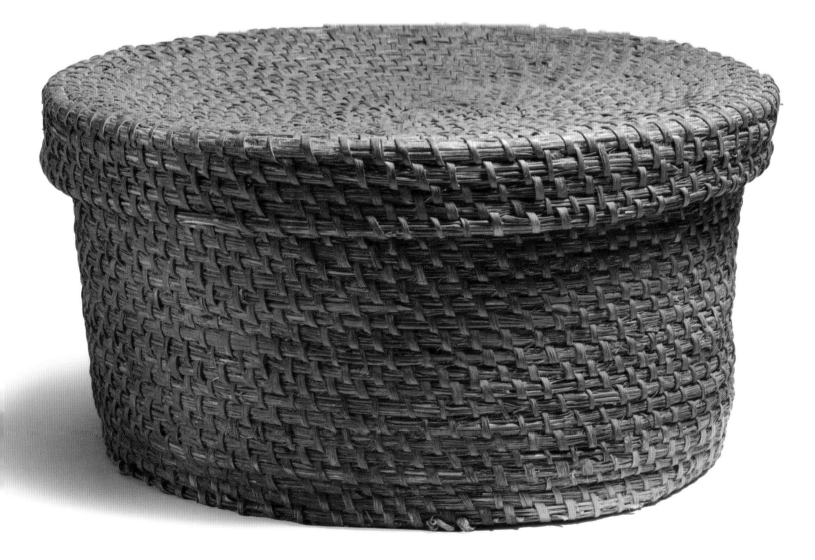

grown only for local consumption; people who came from rice regions of Africa were said to "languish without their favorite food."[21] Also, as in Africa, fanner baskets were used for processing and holding other grains and vegetables, such as corn and peas. On the sandy barrier islands off the South Atlantic coast, the dietary preferences of African workers, rather than the profit motives of the masters, drove the production of coiled baskets.

On the mainland, most rush baskets were bound with oak splints. Employing European tools to work a New World material, Lowcountry basket makers split thin, narrow weavers from white oak boles by the same laborious process used in making oak baskets.[22] In place of oak splints, some mainland and all Sea Island basket makers sewed their rows with strips from the stem of the saw palmetto. The way a basket is started indicates where it was made. For example, basket makers on mainland plantations usually tied a knot in the middle of the bundle of rush. They would bring together both ends of the bundle, bend it around the knot, and stitch it in place. Sea Island sewers would coil the long length of the grass bundle around a knot tied at one end. After a second or third row was sewn, the free end of the grass that emerged from the center was cut flush with the plane of the basket bottom, facing up as the basket lay in the sewer's lap (figs. 4.3, 4.4).[23]

Eyewitnesses give us occasional glimpses of the basket makers themselves—gathering rushes, sewing baskets, wearing rush hats. "Jacob and Jim getting stuff for baskets," a Berkeley County, South Carolina, planter wrote—and indexed—in his journal on August 27, 1836. "Jacob was occupied 3 weeks in making baskets."[24] Basket making might be assigned to workers no longer fit for field labor. In March 1846, Thomas B. Chaplin of St. Helena Island "put old May to making baskets, 2 a week"[25]—though what kind of baskets Chaplin does not say. Workers also produced baskets on their own time, either for sale or for personal use. "After one or two o'clock," wrote Daniel Elliott Huger Smith, recalling his youth at Smithfield, a Combahee River rice plantation, "the hands had the rest of the day to themselves and could work their own fields and gardens, or idle at their will. Many of them were expert basket-makers for which on every plantation there was a demand."[26]

Though Smith viewed his childhood at Smithfield through a rose-colored lens, his observation nevertheless points to the autonomy that rice hands, working on the task system, were able to turn to their advantage. Under the task system, field workers spent the first part of the day tending the staple crop. When they completed their assigned task—a full task was the equivalent of hoeing one-quarter of an acre—they could use the remainder of the day for their own pursuits. After slavery, laborers held tenaciously in their contracts with land owners to the privileges they believed were inherent in the antebellum system.

MOSES IN THE BULRUSHES

Even in conditions of unconditional servitude, workers were able to use basket-making skills as bargaining chips, to make baskets for their own use, or to sell or carry goods to exchange in the open market or the underground economy.[27] Basketry hats literally protected, financed, and physically enabled enslaved people who tried to run away. At the same time, however, the hats and caps runaways wore might be mentioned for purposes of identification in advertisements for fugitive slaves. An ad that appeared in the *South Carolina and American General Gazette* on April 10, 1777, less than a year after the signing of the Declaration of Independence, announced that "a stout black Negro Man, near 6 feet high, named Joe," had absconded. He "had on when he went away, a blue broad cloth coat, a pair of brown German serge breeches, and a rush hat." In 1779, "a Stout young Negro Fellow named Adam," who recently had been brought from Georgia, ran off wearing "a hat made of the same Materials used for Baskets." Would-be slave catchers might also recognize him from the remarkably detailed description of his clothing, down to the color of the buttons on his coat: "a new brown Waistcoat and

Fig. 4.3
Santee River knot from a fanner basket made of bulrush sewn with white oak splints at the Wedge Plantation, Charleston County, South Carolina, ca. 1890.

Fig. 4.4
Sea Island knot from a fanner basket made of bulrush sewn with strips of saw palmetto by Jannie Cohen, Hilton Head Island, South Carolina, ca. 1988.

Fig. 4.5
Runaway slave advertisement mentioning basket making, from the *Charleston Courier*, May 28, 1825. Charleston Library Society.

Trowsers, the Trowsers long and Waistcoat short, double breasted, with yellow Metal Buttons on one Side, except the upper Button which was white: He had with him an old white Coat, and a Pair of Leather Breeches, both much torn."[28]

Baskets could be agents of liberation. Sixteen runaways were able to stay at large by gathering black moss, making baskets, and carrying their handcrafts to town in boats, according to an ad that appeared in the *Charleston Courier* on May 28, 1825 (fig. 4.5).[29] A basketry boat made headlines in the summer of 1864 when the northern press learned of Jack Frowers's escape to the Union side of Port Royal Sound in a vessel he had made from coarse grass twisted into a rope and "bound round, or, as the sailors would term it, 'served' with other grass." "I got an axe and knife—no matter how," Frowers told a journalist, "and I cut a lot of rushes, and went to work in the woods and made this boat." He spent two days weaving, then caulked the boat with cotton and waterproofed it inside and out with pitch collected "by cutting into a tree and catching the gum." He fastened three pieces of pine wood to the floor and nailed an old shutter to the bottom, perhaps as a keel. When the boat was ready, Frowers hid out one more day, then paddled to freedom, "too glad to get away."[30] In the fanfare that followed his escape, the straw boat was sent to Massachusetts Governor John A. Andrews, who presented it to the Prince Hall Grand Lodge of Free Masons in the South End in Boston, along with Frowers's account of the adventure.[31]

The Civil War marks a decisive shift in written accounts of Lowcountry baskets. While planters had tended to take a strictly pragmatic view, abolitionists and Yankee missionaries were more likely to cite basket making to illustrate the capacity and determination of people struggling to be free. Elizabeth Hyde Botume, appointed in 1864 by the New England Freedman's Aid Society as "a teacher of freed people at Beaufort, South Carolina," mentions baskets three times in her published narrative, first as a gift from one of the "contrabands," second as an agricultural tool, and third, as the boat that carried Jack Frowers to freedom.[32]

Frowers's escape is a variant on the biblical account of the Hebrews' exodus from Egypt. The bulrush basket as a vessel of liberation was deeply embedded in the religious imagination of Lowcountry rice hands. On the Combahee River in the years before the Civil War, a verse

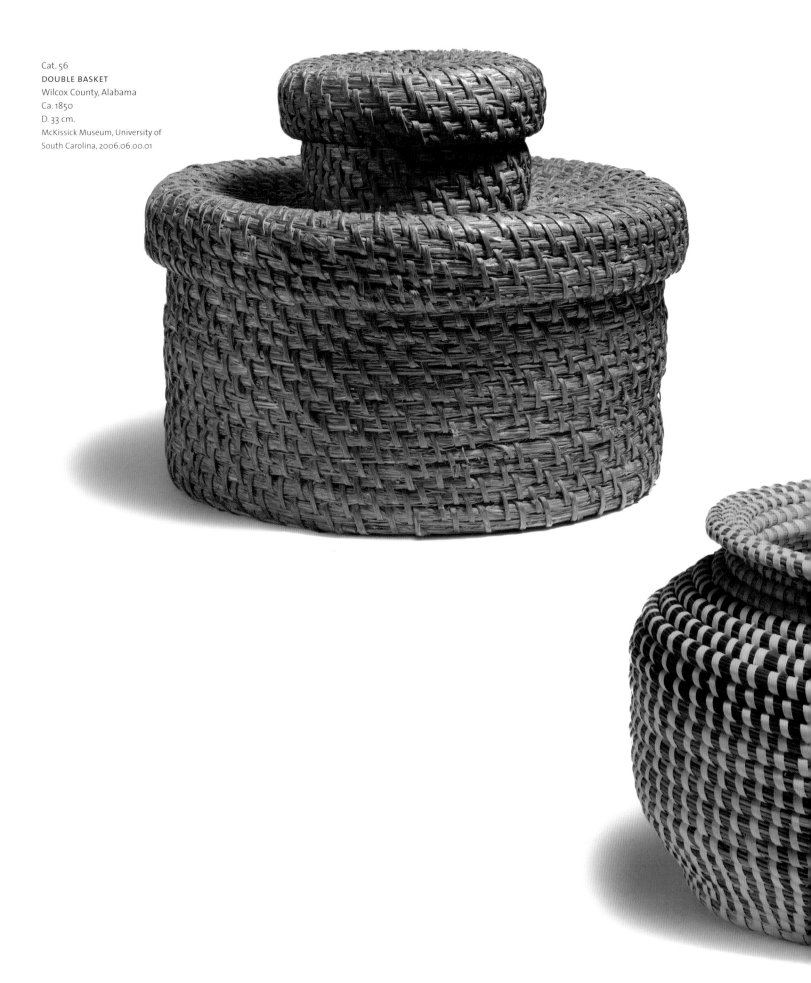

Cat. 56
DOUBLE BASKET
Wilcox County, Alabama
Ca. 1850
D. 33 cm.
McKissick Museum, University of
South Carolina, 2006.06.00.01

Cat. 57
MOSES BASKET
Joseph Foreman, Jr.
South Carolina
2007
L. 51 cm.
Collection of the artist

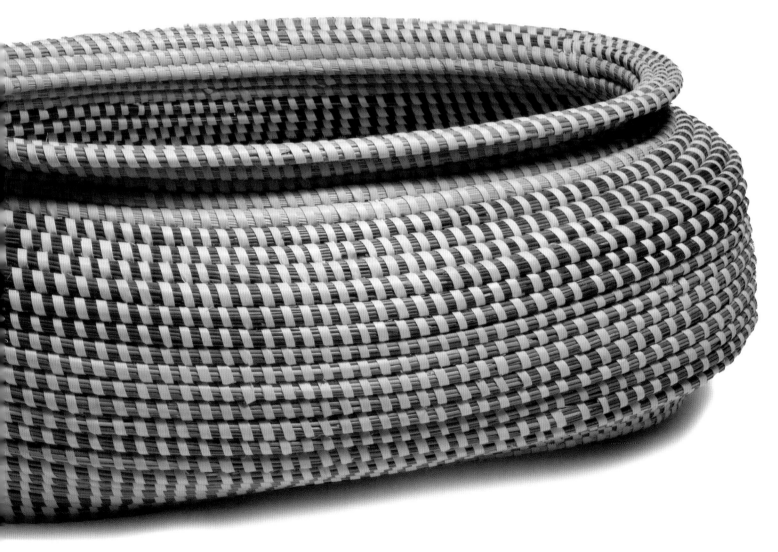

Fig. 4.6
Planting sweet potatoes, James Hopkinson's plantation, Edisto Island, South Carolina, 1862. Photo: Henry P. Moore. The New-York Historical Society.

Moore's image is the earliest known photograph of a coiled basket in use in South Carolina.

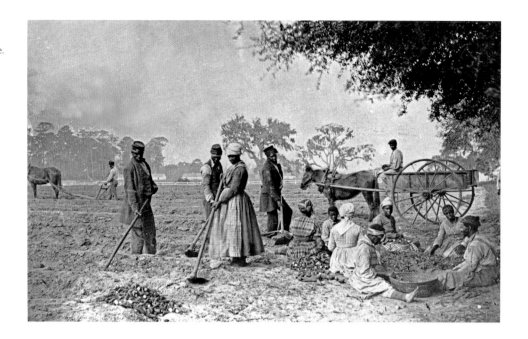

chanted at "shoutings" told the story this way: "Moses in de bull-rushes fas' asleep!/Playing possum in de two bushel basket!"[33] Indeed, Moses plays a central role in African-American folklore—both as the patriarch who delivers his people from slavery and as the trickster who escapes in a bulrush basket. He is alluded to all the time by contemporary basket sewers because of his association with bulrush. Calling bulrush "the blessed straw . . . a holy straw," Mary Jane Bennett, who was a midwife and a Pentecostal minister as well as a basket sewer, recalled how Pharaoh's daughter saved the "blessed baby" in a basket made of bulrush (cat. 57). "And that's how come," Mrs. Bennett explained, "the bulrush become to be in the basket."[34] "They made a basket for Moses, when Moses was born," another sewer reported. "Made it of palmetto and 'rushel'—bulrush—just like we use. Some say it started from Africa but I think it started before that, in Moses' time."[35]

In November 1861, just seven months after the Confederate bombardment of Fort Sumter, northern forces occupied the Sea Islands around Port Royal Sound in the southeastern corner of South Carolina. Plantation owners fled their estates, leaving behind their personal property and their slaves, whom the Federals designated as "contrabands of war." Almost immediately, an experiment was launched by philanthropic northerners, under the direction of Federal military officers, to prepare the newly freed people for full participation in post–Civil War society. The goals of the effort, which came to be known as the Port Royal Experiment, were economic independence, literacy, and civil rights.

On April 8, 1862, five months after Edisto Island was occupied, a number of freed men and women were photographed planting sweet potatoes on James Hopkinson's plantation (fig. 4.6). Some of the men are wearing Union army caps. Men and women are seated around a pile of potatoes, sorting slips to plant. In the foreground sits a wide vegetable basket—the first known photograph of a Lowcountry form—and barely visible behind it lies another smaller coiled basket.

Three months after this historic photograph was taken, Union troops were pulled from Edisto and ordered to Virginia to save General George B. McClellan's army. As a consequence, sixteen hundred freed people, "with their pigs, chickens, and personal effects," were loaded aboard flatboats and taken to St. Helena Island.[36] Brigadier General Rufus Saxton was charged with organizing production on the liberated plantations. Concerned that the refugees would

fall prey to "the evils of idleness" and convinced that there was "a profitable market at the North for the products of their industry," Saxton proposed "to introduce the manufacture of *Rush Baskets* and *Cedar Tubs*." He ordered his superintendents to "immediately set [people] to work in gathering and curing rushes" and to assign "the more skilful" to make them into baskets.[37]

Saxton, a committed abolitionist, thought the baskets and tubs would "find a ready sale" because they were so useful, and also because "of the laudable object sought to be attained by their manufacture." Making baskets would keep the freed people busy, demonstrate their willingness to work for themselves, and raise money to support the "experiment" in liberation. Thus, at the moment of transition from slavery to freedom, baskets were still being mass produced under the direction of white overseers—now in the guise of Federal superintendents. In the migrations that accompanied the upheavals of war, the Edisto basket, along with its makers, had been transplanted twenty-five miles to St. Helena, where the two island traditions met. Over the next century, under the tutelage of the northern teachers and missionaries who carried the Port Royal Experiment forward, the St. Helena basket, now of mixed lineage, would take on a life of its own as a commodity and an icon of Africa in America (see Chapter 6).

At the end of the Civil War, plantation facilities lay in ruins. Emancipated workers wanted to farm for themselves and demanded land they felt they had earned. Meanwhile, rice planters lacked the resources to rebuild. Even before 1860, competition from colonial economies in southeast Asia and from large tracts in Louisiana and Texas, where rice growers could take advantage of firmer soils and employ animal power and machinery in the fields, had begun to undermine agricultural prices.[38] When cultivation resumed after 1865 it was on a new basis. Plantations frequently were leased or run by managers employed by absentee landlords. The labor was done by free men and women working under contract for wages, for a share of the crop, for land, or some combination of these. Under a common contractual arrangement called the "two-day system," workers exchanged labor for a few acres of land, living quarters, and fuel.

Free and mobile, many black families were able to purchase ten- to fifty-acre plots. The plantation that had been the milieu of the Lowcountry basket for almost two hundred years was now supplanted by the family farm. Half the acreage might be planted in cotton, the other half in foodstuffs, including rice, corn, sweet potatoes, millet, and a host of vegetables.[39] No longer under compulsion to mass produce fanners, basket sewers continued to make agricultural work baskets and household forms as their own needs dictated. In the shift from coerced labor to family farming, growers relied on their old hand tools to process their crops. Gone were the days when schooners docked at plantation levees to load barrels of rice destined for waiting mills, yet rice-growing on a small scale continued. The last rice mill shut down in South Carolina long before the last mortar, pestle, flail, and fanner basket were laid to rest (fig. 4.7).

A LOST CIVILIZATION AND A NEW CENTURY

Fanners and vegetable baskets continued to be an everyday sight on the streets of Charleston and Savannah. Farmers rode in ferries, small boats, or wagons, bringing their produce to market. Seafood was typically carried in sacks or split oak baskets with handles. Vegetables, as a rule, were transported in coiled rush baskets balanced on the head. By the turn of the twentieth century, the figure of a stately woman with a head-tote basket had become a staple in the repertory of a group of artists and writers whose work would collectively come to be known as the Charleston Renaissance. Fueled by nostalgia for a lost civilization, sons and daughters of antebellum rice planters memorialized the world of their parents' childhood in paintings, prints, drawings, prose, poetry, and drama.

Elizabeth W. Allston Pringle, for example, daughter of a South Carolina governor and herself one of the last rice planters on the Waccamaw Neck in Georgetown County, recounted

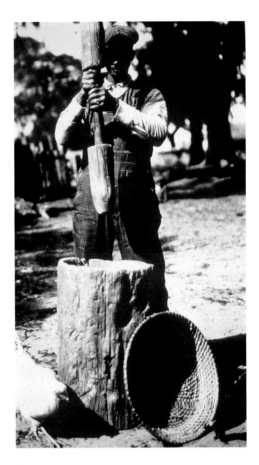

Fig. 4.7
Abraham Herriot pounding rice, Sandy Island, South Carolina, ca. 1930. Photo: Frank G. Tarbox, Jr. Brookgreen Gardens.

Cat. 58
**IN THE SHADOW OF ST. MICHAEL'S, CHARLESTON,
SOUTH CAROLINA**
Elizabeth O'Neill Verner
Ca. 1928
Etching on paper
H. 25.3 x W. 20 cm.
Gibbes Museum of Art/Carolina Art
Association, EL1.56.48

Cat. 59
LOADING A RICE SCHOONER
Alice Ravenel Huger Smith
Ca. 1935
Watercolor on paper
H. 43 x W. 55.5 cm.
Gibbes Museum of Art/Carolina Art
Association, 1937.009.0024

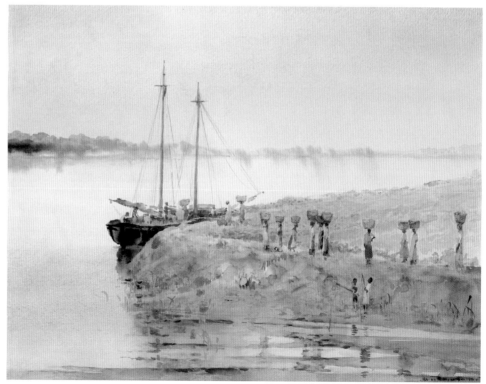

her mother's memories of an upcountry girlhood in *Chronicles of Chicora Wood*. Adele Petigru Allston had admired the beauty of the handwork produced on Badwell Plantation in the South Carolina Piedmont, where African-born "Maum Maria made wonderful baskets and wove beautiful rugs from the rushes that grew along Long Cane Creek." In Pringle's account, Maria had come from royalty in Africa, been taken in battle by an enemy tribe, and sold to a slave ship with her kinsmen, Tom and Prince. These "three quite remarkable, tall, fine-looking, and very intelligent Africans," wrote Pringle, "occupied an important place in my mother's recollections of early childhood."[40]

Pringle's first volume, *A Woman Rice Planter*, was a collection of articles that had appeared in the *New York Sun* between 1904 and 1907. Published in 1913 under the pseudonym Patience Pennington, the book was illustrated with line drawings by Alice Ravenel Huger Smith (fig. 8.10, p. 209), who would go on to paint a series of watercolors that today are the most frequently consulted views of the Carolina rice plantation. In thirty paintings and innumerable sketches, Smith faithfully rendered her father's recollections of his boyhood spent at Smithfield Plantation. Her images of colorfully dressed, compliant, basket-toting, dark-skinned people evoke a harmonious world of productive laborers working under the benign gaze of genteel masters, their wives, and children (see Chapter 8).[41] Suffused with pastel sweetness, her paintings nevertheless provide evidence about material culture and technology, including basket making and the functions of baskets.

In *The Threshing Floor* (cat. 54), a queue of women and girls with fanners full of rice waits to climb the stairs to the winnowing platform. Fanners also appear in unexpected places. Smith's *Plantation Street or Settlement* (cat. 118, p. 214) shows babies "sunning in blanket-padded 'fanner baskets,' supervised by a 'mauma,' or nurse." "On fine days," wrote her father, "there might be seen on the open ground" in front of the sickhouse, which doubled as a nursery, "a large number of 'fanner-baskets,' and on each basket a folded blanket, and on each blanket a baby."[42]

In *Loading a Rice Schooner* (cat. 59), Smith creates a classical frieze of women with huge baskets on their heads walking along an embankment toward an awaiting ship. "It was always a great pleasure to watch the loading of one of these schooners," wrote D. E. Huger Smith, recalling the line of women "boarding the schooner by one plank and going ashore by the other. Close to the open hatchway stood the ten-bushel tub with the captain or mate on one side and the overseer or key-keeper on the other. As each darkey passed the tub," the elder Smith noted, as if describing an automaton pouring gold into his coffers, "she would tilt the basket and pour the golden rice into the tub."[43]

Alice Smith is unique among artists of the Charleston Renaissance in the attention she paid to baskets as tools on Carolina rice plantations, but many other resident and visiting artists who wanted to capture the essence of the Lowcountry made use of the coiled grass basket as a prop or symbol. In countless street scenes etched by Elizabeth O'Neill Verner, for example, a faraway figure of a street vendor balancing a head-tote basket provides scale and perspective and signals unmistakably where the picture comes from (cat. 58).

Nothing produced in the Lowcountry has had the power to evoke South Carolina's African inheritance over such a long period of time as has the coiled basket. "One of the most interesting sights of Charleston," touted the caption of a turn-of-the-century postcard, "is the negro vegetable vendor." On the streets of the city, visitors could see vendors "of both sexes and of all ages . . . bearing on their heads enormous round baskets of produce," and hear them "singing their wares in quaint dialect cries that sound to the unfamiliar ear like utterances of a foreign race."[44] In the competition for tourist dollars that were going to watering holes in the Caribbean and pueblos in the Southwest, Charleston promoters were making the point that their city had exotic people, too (figs. 4.8, 4.9 and 5.4, p. 126).[45]

The image of the vegetable vendor, however, did not sit well with everyone. When the

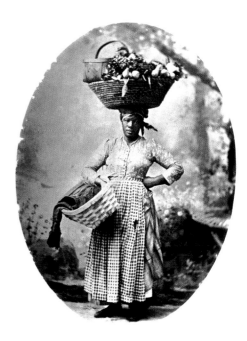

Fig. 4.8
Vegetable woman, Charleston, South Carolina, ca. 1910. Photo: George W. Johnson. Gibbes Museum of Art/Carolina Art Association, AIN1903.18.398.01.

Fig. 4.9
Woman with two baskets, Rutledge Avenue, Charleston, South Carolina, 1940s. The Charleston Museum.

Fig. 4.10
The *Negro Group* at the South Carolina Inter-State and West Indian Exposition, with two of the photographer's daughters, Ruth and Lois Johnson, Charleston, South Carolina, 1902. Photo: George W. Johnson. Gibbes Museum of Art/Carolina Art Association, AN1963.18.676.

Cat. 60
POUNDING RICE
Alfred Hutty
Ca. 1930
Drypoint
H. 23.5 x W. 25.7 cm.
South Carolina State Museum
Collection, 87.95.2

South Carolina Inter-State and West Indian Exposition of 1901 unveiled a sculpture in front of the "Negro Building," educated blacks protested that the work represented "the Negro in a too menial guise." The piece, called the *Negro Group* (fig. 4.10), was designed by Mexican-American sculptor Charles Albert Lopez. The original conception by the Exposition's Architect-in-Chief, Bradford Lee Gilbert, called for a cluster of "Negro types" around a "central bale of Cotton or Tobacco," with an "old-time negro," a younger man with a banjo, and "a 'piccaninni'. . . with a piece of watermelon" on one side, and the figure of Booker T. Washington, "the representative negro of his race today," on the other.[46]

Lopez dropped the "piccaninni" but did model a figure after Washington—a muscular man holding a plow and leaning on an anvil. The crowning symbol of the group was a stately black woman, her chin held high, with a basket balanced on top of her head. The basket itself was a mélange of two craft traditions. Shaped like a coiled vegetable basket, its texture appears to be that of splintwork.

The sculpture "created quite a commotion among the so-called 'new' negroes of Charleston."[47] The real Booker T. Washington was chief commissioner of the executive committee governing the Exposition's Negro Department. He tried to mollify the dissidents "by pointing out that most members of the race were tillers of the soil or in menial positions." But the objectors would not relent. Dr. Thomas E. Miller, President of South Carolina State College (the State Colored College at Orangeburg) and an assistant commissioner, urged Washington to look especially at the figure of the boy, whose expression was that of a "blank idiot."[48] The protest succeeded in having the sculpture removed from the Negro Building, but not from the Exposition. The *Negro Group* was relocated to a more central site in the Court of Palaces, where it was immortalized by the Exposition's official photographer, G. W. Johnson.[49]

As Charleston boosters were busy promoting the city as a prime tourist destination, artists Smith and Verner and other luminaries of the Charleston Renaissance, including Alfred Hutty (cat. 60), Anna Heyward Taylor (cat. 61), Prentiss Taylor, and Birge Harrison, established a Lowcountry art scene comparable to such movements as the Harlem Renaissance in New

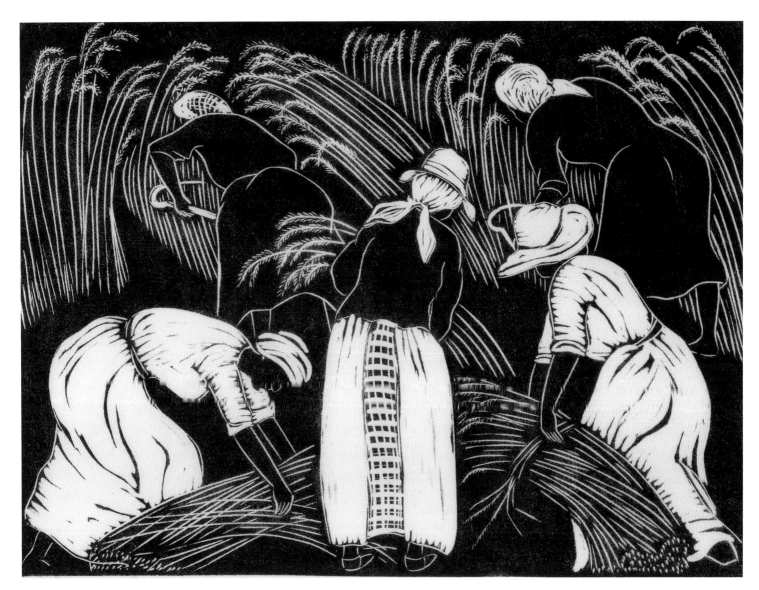

Cat. 61
CUTTING RICE
Anna Heyward Taylor
1937
Linoleum block print on rice paper
H. 19 x W. 25.7 cm.
McKissick Museum, University of
South Carolina, 1A0310

Fig. 4.11
Basket stand on Highway 17, Mt. Pleasant, South Carolina,
1938. Photo: Bluford Muir. Francis Marion National Forest,
U.S. Department of Agriculture.

York City and the Southern Literary Renaissance, more or less centered in Nashville. Like the "Agrarians," as the Tennessee group was called, the Charleston Renaissance was famously ambivalent to artists of African descent. In one particularly shameful episode in 1926, The Charleston Museum first offered and then withdrew an invitation to Edwin Augustus Harleston, the city's "sole black academically trained painter," to exhibit his paintings and drawings.[50]

Yet for visiting artists, Charleston's salons and societies, exhibitions and publications made the city a mecca.[51] Edward Hopper completed several drawings and eleven watercolors on a visit to Charleston in 1929. Jules Pascin, George Biddle, Rockwell Kent, Charles Smith, Childe Hassam, and Andrew Wyeth all were drawn to the Lowcountry. Photographer Doris Ulmann, working in collaboration with novelist Julia Peterkin, made soft-focus portraits for a volume called *Roll, Jordan, Roll*. Recording what appeared to them as both exotic and distinctly American, Bayard Wootten, Berenice Abbot, Walker Evans, Marion Post Wolcott, and, a decade later, Robert Frank photographed South Carolina street scenes and country roads (figs. 9.8–9.10, pp. 224, 226).[52]

Travelers made their way to the Lowcountry by sea, rail, and automobile. In August 1929, the first bridge opened over the Cooper River between Charleston and Mt. Pleasant, launching new prospects for basket makers in the vicinity of Boone Hall Plantation. In the plantation era, it was the men who were the chief producers of bulrush "work" baskets. Now women came to the fore as makers and sellers of sweetgrass "show" baskets. With the demand for agricultural containers in decline, baskets continued to be made from a different kind of necessity—the need to earn income in a cash economy. The sewers' proximity to Highway 17 positioned them to take advantage of the increased traffic on the major coastal artery. In a stroke of inventiveness, basket makers devised a way to reach this moving market. They began displaying their wares on the edge of the road.

The first basket stands were nothing more than a chair or overturned box, but they quickly evolved into a novel architectural form consisting of posts or saplings set upright in the ground with thin strips of wood nailed horizontally between them. Nails served as pegs for hanging baskets (fig. 4.11). On these simple structures extended families invested their labors and their economic hopes. A basket maker could be her own boss, at a time when cleaning house for white people was one of the very few alternatives. Behind the scenes, men and women harvested the sweetgrass, pine needles, and palmetto that went into a basket, while children learned to sew at the knees of their mothers and grandmothers and contributed to the family economy by making basket bottoms. The basket stand displayed the end products of their collaboration. Adapting traditional forms and inventing new ones, sewers developed a large repertory of functional pieces—bread trays and table mats, flower and fruit baskets, shopping bags, knitting baskets, thermos bottles or wine coolers, ring trays, and wastepaper baskets. Since the reintroduction of bulrush around 1970 (fig. 4.12), there is a noticeable trend toward big sculptural forms that feature elaborate surface decoration and meticulous stitching. Now, as then, the stands appear flimsy and make-shift when unattended, but in use they hold lively exhibitions of original art.

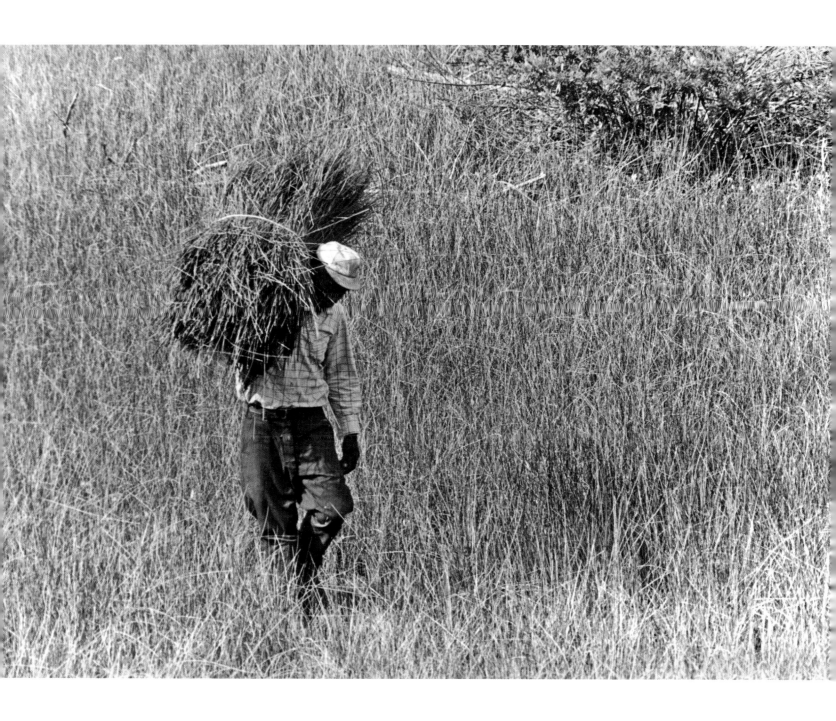

Fig. 4.12
Joseph Foreman, Sr., carrying a bundle of bulrush,
McClellanville, South Carolina, 1985. Photo: Theodore
Rosengarten.

5 Carolina's Gold: Three Hundred Years of Rice and Recipes in Lowcountry Kitchens

Jessica B. Harris

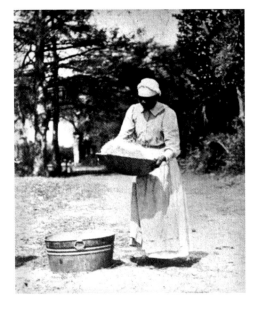

Fig. 5.1
Fanning rice at Wedgefield Plantation, Georgetown County, South Carolina, ca. 1890. Library of Congress.

Rice been money, them day and time…
—Ben Horry, former slave and plantation foreman,
Murrells Inlet, South Carolina[1]

IT'S A SMALL IMAGE, a faded photograph depicting a woman, head wrapped in a pristine white turban, wearing a calico dress covered by a well-worn apron, standing in a clearing, concentrating on her toil (fig. 5.1). The photograph is blurred where the rice moves slightly in the air, grain separating from chaff with the flicking motions of her hands. She is winnowing rice on Wedgefield Plantation on the Black River in Georgetown County, South Carolina, and the wide, flat basket with which she is working is a coiled fanner, an indispensable tool like one her ancestors may have used in Africa. The disappearing image is haunting, for here is the invisible female rice worker, made visible after the defeat of slavery and becoming invisible again as the photo fades with time. The coiled basket is equally evocative; seen in early twentieth-century images from rice-growing regions of West Africa, similar baskets are used in the same ways. As in Africa, the coiled baskets of South Carolina were central to all aspects of food preparation from planting to harvesting to processing, preparing, storing—and serving.

"Carolina Gold" is the name that was given to rice in the Lowcountry to honor the importance of the grain in the building of the colony's economy and culture. Today, diners in

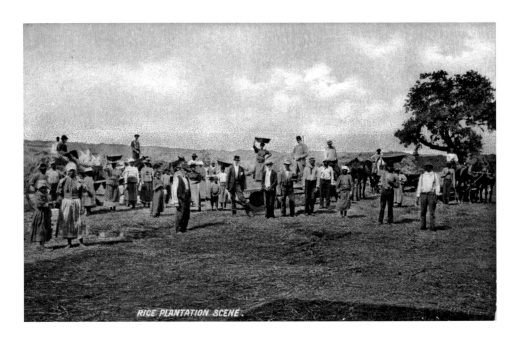

Fig. 5.2
"Rice plantation scene," postcard, Georgetown County, South Carolina, early 20th century. Collection of Jessica B. Harris.

Charleston, South Carolina, who stroll down King Street or Market Street can choose from countless restaurants touting authentic Lowcountry food. In March 2005, the city's first Charleston Food and Wine Festival attracted thousands of visitors all wanting to learn more about—and taste—the region's signature rice-based cuisine. Menus at eateries grand and humble boast such classic Carolina dishes as shrimp and okra stew, Frogmore stew, and roux-less Charleston gumbo.

Virtually no meal is complete without a rice dish of one sort or another, whether the tomato-hued, onion- and bell pepper-flecked Charleston red rice, or plain fluffy white rice with grains steamed so carefully each pearl can stand on its own, under a variety of gravies and sauces. There is a wide array of pilaus or purloos from limpin' Susan (an okra and rice recipe, or "receipt" as Charlestonians say) to tomato pilau. For Lowcountry folks and indeed most African Americans south and north, there would be no good luck for the New Year without a heaping dish of hoppin' John on the table. Traditionally eaten by people of all hues around all size tables, this mixture of black-eyed peas, rice, and ham hocks has one African root in the use of the black-eyed pea (*Vigna unguiculata*), a West African favorite, another root in the rice, and a third root in the method of mixing the grain with the vegetables and meat.

Rice Cookies
One pint of soft boiled rice. Add as much rice flour as will make a
batter stiff enough to be made into cakes. Fry them in nice lard. Salt to taste.
Sarah Rutledge, *The Carolina Housewife*, 1847[2]

Where did Carolina rice come from? Some scholars believe the original seeds can be traced to a ship bringing slaves from Madagascar in 1685. Others suggest that it came from Africa's west coast and, as in the Madagascar theory, entered the colony on a slave ship (fig. 3.2, p. 96).[3] No matter what the origins of the grain, it quickly became the staple crop of the young colony's economy. Historian Peter Coclanis reminds us in his introduction to *Seed from Madagascar*, Duncan Heyward's 1937 nostalgic memoir of rice planting, that "long before there was a race season or a St. Cecilia Society or a South Carolina College or a St. Michael's Church, there was rice and there were slaves, the twin pillars upon which the low-country aristocracy was built."[4]

In fact, among Britain's mainland American colonies, only Carolina called explicitly in its charter for an economic regime based on racial slavery, thus equating African with slave. In the early period, Carolina did not follow the dour practical models of colonies to the north. In the wetlands and coastal high ground of the Lowcountry, Carolina's settlers created a society that in a brief time became the colonial jewel in the crown. At the top of the white caste, planters lived a lifestyle of luxury and profligacy that was equaled only in the Caribbean from where many had come, including the prominent Middleton and Drayton families,[5] and where some still retained land and slaves (fig. 5.3).

Nothing was too rich or *outré* for the wealthy. European taste prevailed in the drawing rooms of Charleston that were painted in fantastic hues mirroring the latest fashions in London and Paris. Dinner tables of polished mahogany were laden with blue and white China trade tureens and Angoulême-sprigged French porcelain platters filled to overflowing with the bounty of the region. Meals were prodigious and featured multiple courses of dishes like *boeuf à la gardette*, a round of beef larded and slowly stewed with a bottle of claret, a pint of vinegar, sliced onions, allspice, and pepper.[6] Then there were creamed oysters—"five hundred of the largest finest oysters" quick simmered in a sauce thickened with butter and flour, enriched with three pints of heavy cream, and seasoned with grindings of fresh nutmeg. In Charleston's town houses on Tradd, Church, and East Bay streets, planters dined nightly on delicacies such as a curry-like fried chicken dish called Mulacolong,[7] turkey hash, shrimp from the estuaries,

Fig. 5.3
Medway Plantation, Goose Creek, South Carolina, 1974. Photo: Greg Day.

Built in 1686, only sixteen years after the founding of the colony, Medway is the oldest house on record in South Carolina. Its plan and siting are typical of plantation houses constructed in the Lowcountry for the next hundred years.

and venison from the forests. Shrimp pies, baked shad, and pigeon ragout were customarily set out, accompanied by artichokes, green peas, salsify, and more.[8] On each table was a bowl of steamed rice and an ornate silver rice spoon for serving it.

In the countryside, the overwhelming predominance of Africans in the population inspired a Swiss immigrant named Samuel Dyssli to comment, in 1737, that "Carolina looks more like a Negro country than like a country settled by white people."[9] In the rice fields, as well as in the kitchens of the plantation Big Houses and the hearths and outdoor fireplaces of the slave quarters, African tastes and an African way of doing things were applied to the elements of a new environment. One result was a distinctive cuisine centered on rice. By the time of the American Revolution, rice's culinary importance to the colony—soon to be a state in a new country—was documented and enshrined in the region's earliest cookbooks. Harriott Pinckney Horry's 1770 "receipt book" gave instructions for making rice breads and also a rice "pye."[10] More than seven decades later, *The Carolina Housewife* by Sarah Rutledge offered an expanded rice menu with entries for such dishes as rice journey cakes, rice breads, rice soup, rice cheese cake, rice flummery, rice blancmange, and several rice puddings, pilaus, and cakes. Judging from the abundance and range of Rutledge's recipes, rice was prepared for the Big House table several times a day.

The African impact on American cookery was deeply felt in the Lowcountry. Only in the Mediterranean basin with its North African influences was rice eaten with the frequency, gusto, and variety of preparations as in coastal Carolina. The hands that stirred the pots of the Big House kitchens were African. Katie Brown recalls her grandmother, a daughter of the legendary Bilali Mohammed, who had lived as a slave on Sapelo Island, Georgia:[11]

> She wash rice, an po off all duh watcuh. She let wet rice sit all night, an in mawnin rice is all swell. She tak dat rice an put it in wooden mawtah, and beat it tuh paste wid wooden pestle. She add honey, sometime shuguh, an make it in flat cake wid uh hans.[12]

In the grand houses of Charleston and on the plantations, those manning the kitchens were not the fine ladies of the colony, but rather corps of enslaved Africans under the directorship of a slave head cook. While the white mistress might organize the meals and no doubt had a hand in preparing some of the specialties, the bulk of the cooking was handled by African women and men who came to exercise what historian Eugene Genovese calls "the culinary despotism of the quarters over the Big House. . . ."[13] Under the task system employed on coastal rice plantations, as well as on plantations growing indigo and, beginning in the 1790s, long staple cotton, the enslaved man or woman who completed the daily task of work could use the rest of the day to tend his or her own provision grounds. Some individuals even had their own small plots of rice along with vegetables—guinea squash (eggplant), tomatoes, okra, and field peas of several types, some of African, some of American, and some of European origin—that would have gone into the rich one-pot meals cooked in the yards of their houses. These provision grounds provided not only more nutritious diets than people would have had otherwise; they also gave the enslaved leverage for determining their culinary destiny. Furthermore, rice hands who traded their homegrown provisions to their masters for other goods and privileges inadvertently added African ingredients to the masters' diets, shaping their culinary destinies, too.

Studies suggest that Lowcountry rice planters expressed a preference for slaves from rice-growing areas in western Africa (figs. 1.8, 1.9, p. 25).[14] The landed elite, however, could not control the variables of the oceanic trade, and they often had to settle for captives from other places. Yet while the majority of Africans sold into slavery in Charleston may have had

no experience growing rice, some undoubtedly did. People from the region known today as Senegambia had a long relationship with rice and a tradition of rice recipes that may account for some of South Carolina's favorite foods.

In its ingredients and method of preparation Charleston red rice is close kin to the tomato-based rice that is the foundation of Senegal's national dish, *thiebou dienn*, made with red rice and fish. A similar dish appears, under the name "Mulatto Rice," in the 1933 *Savannah Cook Book* by Harriet Ross Colquitt. The author explains, with the politically correct prejudice of her time, "This is the very chic name given to rice with a touch of the tarbrush."[15] The Senegalese black-eyed pea pilau called *thiebou niébé* bears a startling resemblance to hoppin' John except that it uses mutton instead of the pork that is traditional in the Lowcountry. A rice of the English-speaking areas of West Africa known as Joloff rice makes reference to its Senegalese inspiration in its name (Joloff refers to Senegal's Wolof empire), and also in its tomato-induced reddish-orange color—which makes it a relative of the red rice integral to both *thiebou dienn* and Charleston's red rice. Joloff rice may include minced onion and bell pepper, which are found in some versions of Charleston's red rice. These and other derivative rice dishes turned up regularly on the tables of Lowcountry elites and have become a part of the general food-ways of the region.

Describing the foods prepared in the slave quarters is a bit more difficult, for bondsmen and bondswomen left behind few testimonials other than those collected well after the period from individuals who lived in the twilight of slavery. The oral nature of African-American culture, enforced illiteracy, and the traditionally improvisational character of cooking all suggest that, for the slavery period, we are not likely to find recipe books neatly tied with fraying ribbon containing a black family's culinary heritage. What recipes we have are gleaned from travelers' accounts and planters' diaries, from snippets of living memory and flashes of intuition inspired by research and bound by the constraints of academic methodology.

One avenue of inquiry is extremely promising. If we want to know what the slaves ate we can turn for enlightenment to the developing field of African-American archaeology. At research sites in the Carolinas, Virginia, Georgia, and Florida, archaeologists have been excavating former plantations, sifting the soil and looking for fragments of tools, nails, glass, kitchenware, and animal bones that might reveal how the enslaved lived day to day and night to night, what they valued, how they entertained themselves, what they did when they weren't working for the master, how they prepared their food, and what they ate. Leland Ferguson, a pioneer in the field, discovered that "Colono-ware" pottery shards found along the South Atlantic coast were fragments of bowls used for cooking as well as for eating. Recovered objects as small as broken grains of rice have a story to tell.[16] Historian Charles Joyner reminds us that rice was a commodity of trade and would have been distributed to the enslaved only if it was to the planter's economic advantage. Slaves regularly received rations of broken rice, a discarded part of the crop.[17] While broken rice may seem to be a poor ration, it ironically might have been desired if that was what Africans were used to eating before they crossed the sea. In Senegambia broken rice still is reputed to better hold the sauce. The African innovation of combining broken rice and corn meal, or corn in the form of hominy, may explain dishes in the Lowcountry repertoire that mix the grains, including numerous bread recipes in the Rutledge cookbook.

A holiday connection with the distribution of rice may account for one of the most fascinating examples of rice in the diet of the enslaved—the Saraka, a rice cake eaten in the Lowcountry. In her book, *Servants of Allah: African Muslims Enslaved in the Americas*, French-born Sylviane A. Diouf, a writer on the culture and history of Africans transported to the Western Hemisphere, details the importance of the Islamic community among the enslaved in the

Fig. 5.4
"Female Vegetable Vendors," postcard, Charleston, South Carolina, 1895. Collection of Jessica B. Harris.

Lowcountry. The ranks of the captives sold into slavery included people who were practicing Muslims, in particular natives of Senegambia and the Guinea Coast.[18]

One pillar of the Islamic faith is *zakah*, to give alms. In many parts of the Islamic world, alms may take the form of food. Diouf's cultural perspective allows her to make a connection between the rice cakes that were served as a treat to children in the Lowcountry and the cakes prepared in western Africa. She affirms that the cooking method of the traditional West African rice cake remains the same as that recorded by the great-granddaughter of Bilali Mohammed of Sapelo Island and adapted for the Big House kitchen:[19]

> Take any cold dinner rice and fry in butter until brown; or boil rice soft, pour into a dish to cool, then cut into strips, dip into egg and fry in butter.[20]

Rice-eating continued to define the Charleston and Lowcountry diet into the post–Emancipation years and on down to the present. The *Carolina Rice Cook Book* compiled by Mrs. Samuel G. Stoney for the Carolina Rice Kitchen Association appeared in 1901, and most recently in a facsimile edition with an introduction by food historian Karen Hess. The book contains 237 recipes for rice dishes or dishes that require rice as the main accompaniment. Recipes ranging from rice waffles and okra soup to food for invalids like rice jelly and rice gruel appeal to cooks for whom cooking without rice is like breathing without air.

> *There was a time when folks has cooks*
> *Who never did depend on Books.*
> *To learn the art of cooking*
> *The help knew all the tunes by ear,*
> *And no one dared to interfere:*
> *They brooked no overlooking.*[21]

These opening lines of doggerel from the ever-popular 1950 *Charleston Receipts* collected by the Junior League pay back-handed tribute to the slave cooks and their descendants who ran the city's kitchens until the middle of the twentieth century and in some places still do. Sallie Ann Robinson, in *Gullah Home Cooking the Daufuskie Way*, maintains that while the physical plantation as the basis of "rice culture largely ended with the Civil War . . . for most of us rice culture lives on in our pots, not our fields."[22] It lives on, as well, in modern versions of the coiled baskets that were once essential to processing the grain and now are stored in museum collections or kept as precious family heirlooms (cats. 62, 63). Old and new forms are prized reminders of the creativity of the "ancestors," who made baskets because they were told to, and because making them kept alive a link to Africa, family, and tradition. In their vitality, variety, and artistry the baskets teach us that African people and their descendants were the true gold of the colony. Their labor and knowledge, initiative and ingenuity, not only produced fabulous wealth in a malarial, waterlogged region, but also endowed their new homeland with a cultural and culinary diversity that remains a vital part of its patrimony.

Cat. 62
VEGETABLE BASKET
Kinloch Plantation, Georgetown
County, South Carolina
Ca. 1900
D. 58.4 cm.
McKissick Museum, University of
South Carolina, 14.133

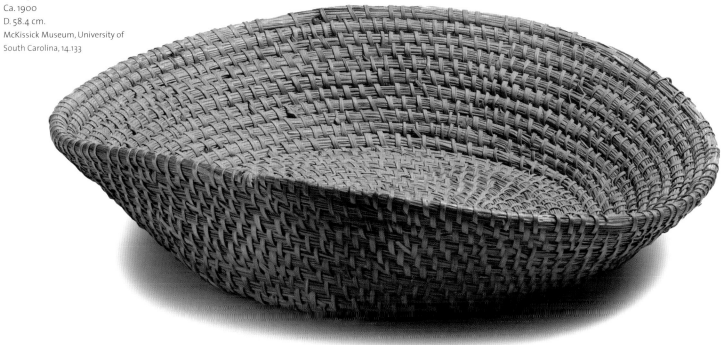

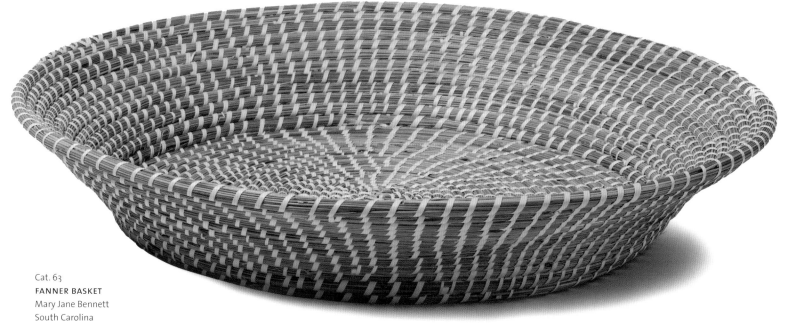

Cat. 63
FANNER BASKET
Mary Jane Bennett
South Carolina
1986
D. 62.2 cm.
South Carolina State Museum
Collection, 86.121.13

6 Missions and Markets: Sea Island Basketry and the Sweetgrass Revolution

Dale Rosengarten

AS JOB OPPORTUNITIES GENERATED by World War I lured tens of thousands of rural black southerners to the northern states, Lowcountry baskets could have gone the way of gourd and earthenware vessels, wooden mortars and pestles, palmetto fans and thatching. The bulrush "work" basket, once essential to rice production and traditionally made by men, almost disappeared. Sweetgrass "show" baskets, on the other hand, based on household forms and made primarily by women, began to be produced for a new market, leading to the artistic efflorescence taking place today.

Both men's and women's baskets had their champions. Seventy-five miles south of Charleston, the Penn School on St. Helena Island, founded by missionaries early in the Civil War, introduced bulrush basket making into the curriculum for Sea Island boys in the early 1900s. Enrollment in Penn's Basketry Department peaked in 1918, but the program remained an important part of the school's offerings for another three decades. Meanwhile, in the vicinity of Mt. Pleasant, across the Cooper River from Charleston, sweetgrass basket makers seized opportunities offered by retail merchants and a budding tourist trade to increase their output and expand their repertory. The two revivals developed independently. One was self-consciously conservationist—a school curriculum initiated by missionaries from outside the culture. The other was community-based and market-driven, highly adaptive, and decidedly entrepreneurial.

THE GOSPEL OF INDUSTRIAL EDUCATION

"Native Island Basketry," as it was called at Penn School, began as a manual training program that drew upon a complex of ideas percolating at the turn of the twentieth century for promoting traditional crafts. Penn's founders embraced basket making as a way to improve the lives of the islanders while demonstrating their competence and ability to support themselves. Over three eventful decades, in which freed people acquired land and won citizenship rights, only to lose them in the era of Jim Crow, Sea Islanders continued to make baskets—with Penn's endorsement—for use in the house and on the farm.

In a letter dated January 3, 1894, Penn's assistant principal, Ellen Murray, thanked her friend Abigail Holmes Christensen for sending "Miss Kimball's pretty basket which I shall keep as you suggest for a pattern for our basket makers."[1] Christensen, a pioneer collector of African-American folklore, was living across Port Royal Sound in Beaufort and would soon start her own "industrial" school for Negroes on the model of Booker T. Washington. Penn's focus on craft production, late in the tenure of Laura Towne, the school's first principal, reflected a belief in the unity of art and labor that was at the core of the Arts and Crafts Movement.[2] Instruction in basketry, along with such recognized vocations as carpentry, cobbling, harness making, blacksmithing, and wheelwrighting, conformed to the program that Washington and his disciples had pioneered at Hampton Institute in Virginia. By 1901, Penn was employing a basketry instructor, paying him $1.00 every two weeks for four lessons (fig. 6.1).[3]

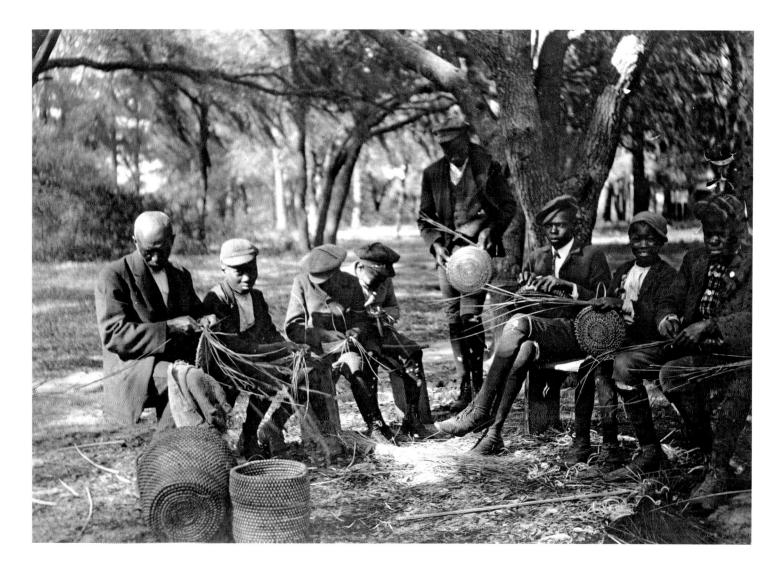

Fig. 6.1
Basket-making class of Alfred Graham, Penn School,
St. Helena Island, South Carolina, ca. 1905. Photo: Leigh
Richmond Miner. Penn School Collection/Southern
Historical Collection, University of North Carolina at
Chapel Hill.

When Hampton's Rossa Cooley, a graduate of Vassar College in Poughkeepsie, New York, arrived on St. Helena in 1905 to assume the reins at Penn, she discerned only one "native domestic craft" still in practice—"the making of baskets similar to those found in some parts of Africa today, artistic and durable, soft brown in color." The new principal was puzzled to discover that basketry was men's work. "Why don't the women make baskets?" she asked. In addition to thirty-eight boys enrolled in the Industrial Department, eleven women were recruited for instruction in basketry, and "the old basketmaker" was invited "to come in and give them pointers." At first all went well. "Off we started and they were a happy, busy, picturesque crowd." Yet something was amiss. Although the women finished their work, "they did not rejoice in their baskets." Years later, Cooley heard from a missionary who was visiting the school "that women do not make baskets in Africa! And so," she concluded, on the basis of this erroneous premise, "women don't make baskets on St. Helena." It was a man's craft and would remain so, she surmised, "until the race changes by many more decades of contact with a new environment."[4]

In the setting of the Sea Islands, "industrial" had nothing to do with preparing people for factory jobs. Penn's avowed aim was to keep people on the land by giving them reasons to stay. Teaching them updated agricultural methods, supplementing farm work with income from craft production, and extending financial credit would create an environment of "economic independence and dignified living in their rural communities."[5]

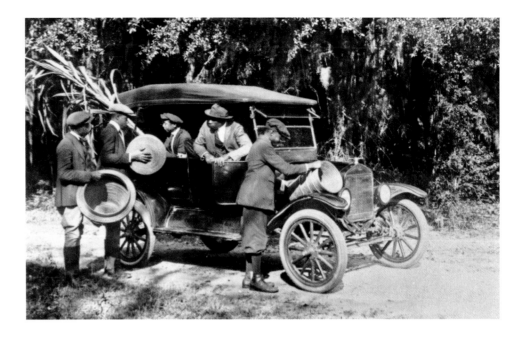

In the school's annual reports, Cooley expressed both optimism that there was "a real commercial demand for . . . native island baskets," and alarm that Native Island Basketry would become "a lost art . . . unless Penn School can keep this shop open and interest the younger generation in it."[6] She took every opportunity to point out the St. Helena basket's link with Africa. Basket making, declared the *Annual Report* of 1910, "was brought from Africa in the early slave days" and belongs "as truly to the Negro as the Indian basket belongs to the Indian." Cooley wanted Penn to do for African-American basketry what Indian schools were doing for Native American crafts.

In fact, Penn's link to Africa was direct. Alfred Graham, the school's first basketry instructor, had learned the craft from his African-born father.[7] Graham in turn taught his grandnephew, George Browne, who ran the basket shop from 1916 until 1950. "This is the only real Negro craft inherited from African forefathers," the 1930 *Annual Report* remarked, "and is so beautiful it seems important to preserve it. These baskets were useful in the field in plantation days and have been adapted for home use" (figs. 6.2, 6.3).

Baskets were a "necessity for daily life," explained George Browne's son, Leroy, who graduated from Penn in 1934. "Every type of basket they made was a useful basket."[8] As for the heritage idea, he suggests that the basket's connection to Africa was not on the minds of the makers in his father's day.[9] But to the northern white women who led the school and raised funds for its operation, Africa was emphatically the source of the expressive culture sewn into Sea Island baskets.

Tucked away in the Penn School files of historian Edith McBride Dabbs at the South Caroliniana Library in Columbia, South Carolina, is a list entitled "BASKET-MAKERS— Recognized as best on St. Helena." The document dates from about 1915 and includes three names: July Moultrie, from Corner Plantation; Chance Rivers, from Tom Fripp Plantation; and Prince Polite, born in 1847 or 1848, "grandson of 'Big Pa' who came from Africa."[10] "Big Pa" was said to be the son of an important African chief. *His* son, the father of Prince, was a body-servant who accompanied his white master when he went to fight in the Civil War. "They were killed together," the paper relates, "in one of the first big battles," and were commemorated on stones set side by side—a small one for Prince's father and a big one for the master. When Prince had a son he named him Vaberlee for Big Pa's brother, who, according to Island elders, had "flown away back to Africa."

Dabbs's file also contains a typescript of what purports to be the recollections of Prince Polite. The basket maker was setting down his story at the request of "a man from the North" who had visited Penn the month before. The white man was young and sickly looking and asked endless questions. He was "boss of a great paper" (a reference, perhaps, to the *Southern Workman*, where Penn's Associate Principal, Grace Bigelow House, published a version of the story in April 1916), and he told Polite that the people who bought his baskets wanted to know who made them and how they were made.[11]

Polite sat down to make a basket and tell his tale. "This is a gift basket," he said. Then he revealed a custom his grandfather taught him. In Africa, "silk grass" is sewn in with the rushes as a sign of friendship. A basket that incorporates this special grass is an "offering which the sun and sea and the tides and the hand of man done helped God to make." It is given with a blessing that brings joy to the giver and luck to the one who receives it (fig. 6.4 and cat. 67).

Here were the makings of myth, and House made myth out of them. She may have recorded the actual recollections of Prince Polite or perhaps of Alfred Graham. Or the story may have been pieced together from bits of folklore House had collected on St. Helena. As a literary figure, Prince Polite was Penn's equivalent of the Appalachian patriarchs, "Uncle Sol Everidge" of the Hindman Settlement School (est. 1902) in eastern Kentucky and "Uncle Luce Scroggs" at the John C. Campbell Folk School (est. 1925) in Brasstown, North Carolina. Everidge and Scroggs were real people, as Polite certainly was, but the island Basket-maker (always spelled with a capital and hyphen) was also a cultural archetype and stereotype. Like "Uncle Sol" and "Uncle Luce," Prince Polite carried the full freight of what David E. Whisnant, scholar of vernacular culture, describes as the "northeastern agenda" of the founders and staff of the settlement schools. Untutored but wise, yearning for education for their "grands and greats," Sol, Luce, and Prince were local legends who saw the light of Christianity and carried on the traditions of their ancestors.[12] With the benefit of the most rudimentary ethnography, House wanted to clothe Sea Islanders in an identity that had been stripped away in slavery. She recognized the sorrows and longings of the people she had come to "uplift," and she played on the heartstrings of patrons and philanthropists.

Penn's administrators dreamed of taking their mission one step further. They wanted to spread the gospel of industrial education to Africa. Over a three-year period in the 1920s, missionaries and teachers from forty-six African outposts visited St. Helena. Cooley kept a map of Africa on the wall, marking with colored tacks the places visitors came from. She also published their testimonials in pamphlets soliciting funds for the school. By 1930, enough money had been raised to develop four institutions in South Africa modeled on Penn.[13]

"Every African missionary ought to see this fine work," wrote W. N. Edwards of the United Christian Missionary Society station in the Belgian Congo. "Everywhere I am asked what place in the South impressed me most, and every time the answer darts out spontaneously, Penn School," professed H. S. Keigwin, director of Native Development, Salisbury, South Rhodesia. Gladwyn M. Childs, from Bailundo, Angola, effused, "Far from being a side eddy on the edge of life's ocean, I've found in this little Island a laboratory, a demonstration of the strongest and best of the great sweeping currents of the world's life. . . . I only hope that we may be able to do the same sort of thing overseas."[14] "Above all others," fund-raisers for Penn avowed, "educators and missionaries from Africa find its work an object lesson in meeting their own difficult problems."[15]

Dr. Charles T. Loram, a member of the Native Affairs Commission of the Union of South Africa and former Inspector of Native Education in Natal, visited Penn in October 1926, while on a tour of "those American institutions most likely to serve as models for Africa." His report, "Adaptations of the Penn School Methods to Education in South Africa," was published six months later by the Phelps-Stokes Fund, a major backer of industrial training in America and Africa. Penn School, Loram declared, "more than any other I had seen, exemplified my ideal

Fig. 6.4
Leroy E. Browne, Sr., holding a gift basket made by his father, George Browne, St. Helena Island, South Carolina, 1997. Collection of Rosalyn Browne.

George Browne taught basket making at Penn School from 1916 to 1950.

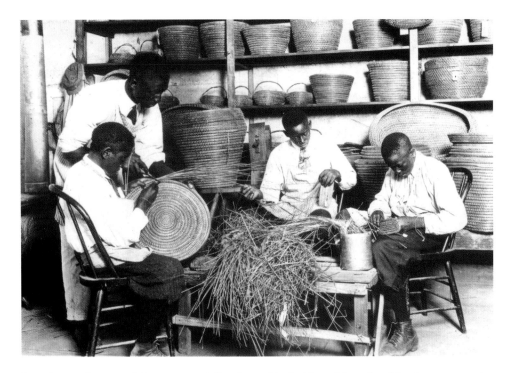

Fig. 6.5
George Browne instructing students in Penn's basketry shop, St. Helena Island, South Carolina, ca. 1920. Photo: Leigh Richmond Miner. Penn School Collection/Southern Historical Collection, University of North Carolina at Chapel Hill.

for African education." He was especially taken with the idea of the school "as the centre and chief factor of village development," and asked Phelps-Stokes to distribute in Africa copies of Cooley's book, *The Homes of the Freed*. Analyzing "certain similarities and unlikenesses in the conditions which obtain in the two continents," Loram noted the advantages on the American side. He found, first of all, "that the Negroes of America are Christians, inured to regular work, accustomed to daily and even hourly contact with the white man, owners or renters of their own clearly defined portions of land, and individualistic in their social life." Christianity and capitalism, in his view, had laid the groundwork for success. "Conditions generally in Africa at present are," he lamented, "the exact opposite of these." He urged educators to "begin to work on Penn lines" in communities "where two or three generations of Christian civilised Africans have produced conditions not unlike those of St. Helena Island."[16]

In 1916, George Browne took over Penn's Basketry Department, following Franklin Capers, who had replaced Alfred Graham as basket-making instructor in 1913 (fig. 6.5). Remembered as a man with good eyes and incredibly strong hands, Browne roamed the island in search of materials. He would spend entire days, sometimes in the company of his son Leroy, traveling by horse and buggy from one end of St. Helena to another. From the woods, he would cut fronds from saw palmetto plants, preferring the tall ones—five and a half feet or more—so that once the stems were stripped into "threads" he wouldn't have to join them so often. He would harvest palmetto in cooler seasons, fall or early spring. Submerged in water, the strips would keep for months.[17]

Of two kinds of rush found on St. Helena Island, the fresh water variety is abundant but too brittle to use for baskets. Leroy Browne recalls that his father sought out the green, salt-water rush, which was harvested with a "marsh" or "reef" hook. George Browne would "sift" a bundle, holding the rush upright in one hand, letting the gray, dead blades fall out. Then he would cure the rush outdoors in the sun until it turned a golden color, gathering and drying enough to keep a good supply on hand.

In 1916–17, corn-shuck mat making was introduced to the curriculum. Sixteen of the forty-two boys in the Basketry Department were taught this new skill. Appealing to "all boys who hope to add to their earning capacity," Penn's administrators paid cash for baskets the boys made at home and resold them along with products of the school's shop, through the

mail and through craft outlets in Charleston as well as in Philadelphia and Boston.[18] The income from making baskets might go to pay property taxes and enable people to hold onto their land.

The lure of higher wage jobs in the postwar economy proved irresistible to many, and by the early 1920s, the shop's enrollment fell by fifty percent. At the same time, claimed the *Annual Report* for 1924, the demand for baskets was "steadily increasing"—148 baskets and 24 corn-shuck mats were sold that year. This special issue featured five basket-related photographs by Hampton Institute art teacher Leigh Richmond Miner. And, for the first time, the *Annual Report* included a price list for St. Helena baskets (figs. 6.7, 6.8).[19]

In the fall of 1927, Roosa Cooley invited German-American artist Winold Reiss to come to Penn and draw portraits of the Sea Islanders.[20] Described by Alain Locke as "a folk-lorist of brush and palette,"[21] Reiss produced some sixteen portraits, including a pastel entitled *The Young Basket Maker* (fig. 6.6), in which a boy in overalls gazes straight ahead, about to take the next stitch on a coiled bulrush basket. Reiss had contributed pastels to *The New Negro*, an anthology of literature and art that became the manifesto of the Harlem Renaissance. For Locke and other philosophers of the movement, the way forward for artists of African descent was "to return to the ancestral arts of Africa for inspiration."[22] Cooley, meanwhile, hoped to stimulate northern financial support for her school by raising its public profile. Whether the publication of Reiss's St. Helena work in *Survey Graphic* in 1928 translated into increased demand for baskets is uncertain, but one consequence was to dignify the image of the Sea Islanders and bring them into the iconography of the Harlem Renaissance.

Basket sewers on islands south of St. Helena looked to markets in Savannah, Georgia.[23] Caesar Johnson was Hilton Head Island's best-known basket maker. Born in 1872, he learned the craft as a "tiny boy." Besides vegetables, he carried fish, oysters, strings of dried mullet, and baskets to sell in the city. He recalled one customer in particular, Judge Gordon Saussy, who bought two of his big baskets to show his children how things used to be "in ol' days gone by." Explaining to a reporter in 1960 that "today's Negroes make more money at jobs" and don't want to practice a skill "that marks them as 'backwoods' or 'country,'" Johnson mourned "the passing of the art." Indeed, he attracted "many of the crafts-minded to his cabin," notably collectors from nearby Bluffton who knew that his carefully sewn and sturdy baskets soon would become bona fide antiques (fig. 6.9 and cat. 68).[24]

North of St. Helena, farmers and fishermen from the islands below Charleston rowed thirty- to forty-foot "picket boats" to Adgers Wharf, with produce and oysters in jars to trade at the old firm of Hurkemps, and bulrush baskets for merchant Nathan Yaschik. Yaschik had

Fig. 6.6
The Young Basket Maker. Winold Reiss. St. Helena Island, South Carolina, 1927. Pastel on board, H. 61 x W. 40.6 cm. Fisk University Museum of Art.

Fig. 6.7
Prize display of Penn School baskets, St. Helena Island, South Carolina, ca. 1920. Photo: Leigh Richmond Miner. Penn School Collection/Southern Historical Collection, University of North Carolina at Chapel Hill.

Fig. 6.8
Price list from the Penn School *Annual Report*, 1924. South Caroliniana Library, University of South Carolina.

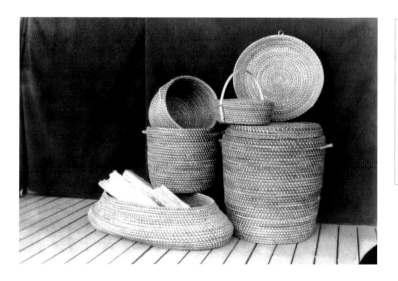

PRICE LIST
(Not including transportation charges)
ST. HELENA BASKETS

Scrap baskets, about 10″ x 13½″	\$2.50
Scrap baskets, about 12″ x 16″	3.25
Wood baskets, about 16″ x 24″	6.50
Rice fanners (trays), about 2″ x 18″	2.50
Lunch baskets	2.50
Clothes-hampers	10.00 to 12.50
Table mats, 6 in set	per set 3.00
Covered sewing baskets, about 8″ across top	2.00
Corn shuck door mats	.80

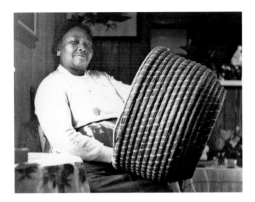

Fig. 6.9
Jannie Cohen, Hilton Head Island, South Carolina, ca. 1988. Photo: Gary Stanton. McKissick Museum, University of South Carolina.

Jannie Cohen was the last of the Sea Island basket makers to sew traditional bulrush baskets. She learned the craft from her father, who had been born in slavery. Besides the monumental "trash" or laundry basket shown here, she made fanners, round baskets with deep sides, and oblong "egg-shell" baskets.

come to Charleston in 1913, via Argentina and Poland. He would give the islanders credit slips or merchandise in exchange for their wares and twice a year he took his stock to sell wholesale at the Baltimore Bargain House.[25]

At the northern end of the former Rice Kingdom, on Waccamaw Neck in Georgetown County, white people nostalgic for the old days and souvenir seekers would stop at the Pawleys Island Hammock Shop on Highway 17. The shop's first brochures featured the fanner basket as a relic of the past in danger of being "relegated to the lost arts." The business opened in 1938 and carried bulrush work baskets made by Welcome Beese, who had been born in slavery on Oatland Plantation in All Saints Parish. Pictured sitting next to an old mortar and pestle, against which are propped seven rush baskets, Beese is described as "patiently weaving" and meditating on these "changeful times" (fig. 6.11 and cat. 122, frontispiece).[26] Proprietor "Doc" Lachicotte knew his clientele well. His customers included northern owners of nearby plantations who spent winters on their new coastal estates and summers on safari in Africa. One brochure quotes "an old white hunter," veteran of big game hunts in Africa, who declared that Lowcountry baskets so closely resemble "those made by certain tribes today," he could tell "from which of these Ancestral tribes some of the Carolina descendants had sprung."[27]

But while the Hammock Shop promoted the bulrush basket as a thing of the past, Lachicotte was aware that something new was happening sixty miles down the highway. There, basket makers in the vicinity of Boone Hall Plantation had embarked on a revolution in coiled grass basketry (fig. 6.10). Lachicotte asked his friend Judge Dennis Auld, in Mt. Pleasant, to send him an assortment of sweetgrass baskets with "ingenious pine needle trim" to sell at the Pawleys Island store. At $1.50 retail, a "Cocktail Tray" with seven coasters fastened to the base was the top of the Mt. Pleasant line.

THE SWEETGRASS REVOLUTION

Utilizing sweetgrass accented with pine needles for the bundle and strips from the frond of the cabbage palmetto for the binder, Mt. Pleasant sewers continued to make traditional forms while inventing new ones. One center of sweetgrass basket making was Hamlin Beach, a settlement that dated back to Reconstruction, when recently freed people acquired small parcels of land from the property owners they worked for.[28] It was at a weekly prayer meeting, according to local historian Joyce V. Coakley, that Sam Coakley, a patriarch of the Hamlin community and forebear of many of today's sewers, announced "that businessmen were looking for baskets to send to New York and other places in the North."[29] Acting as a go-between, Sam

Fig. 6.10
Former slave "street" at Boone Hall Plantation, Mt. Pleasant, South Carolina, ca. 1935. Photo: Albert Sidney Johnson. McKissick Museum, University of South Carolina.

The slave quarters at Boone Hall were still inhabited in the 1930s when this photo was taken by plantation manager Albert Sidney Johnson, a son of the famous Charleston photographer, G. W. Johnson.

Fig. 6.11
The Hammock Shop brochure, Pawley's Island, South Carolina, ca. 1938. Collection of A. H. and Martha Lachicotte.

LIST PRICES

Style A: Round Baskets with Covers

						PER DOZ.
1.	A	Diameter, 5 inches	Depth, 3	inches		$ 4.25
2.	A	Diameter, 6 inches	Depth, 3	inches		5.50
3.	A	Diameter, 7 inches	Depth, 3½	inches		6.25
5.	A	Diameter, 8 inches	Depth, 4	inches		8.00
6.	A	Diameter, 9 inches	Depth, 4½	inches		10.00

Style A-O: Oval Baskets with Covers

300	A—O	Size 6x7 inches	Depth, 3½	inches	$ 6.25
500	A—O	Size 8x9 inches	Depth, 4	inches	10.00

Style C: Round Flat Baskets with Covers

3—C	Diameter, 7 inches	Depth, 2	inches	$ 6.25
5—C	Diameter, 8 inches	Depth, 2½	inches	8.00
6—C	Diameter, 9 inches	Depth, 3	inches	10.00

Style C—O: Oval Flat Baskets with Covers

No. 300 C—O	Size 6x7 inches	Depth, 2	inches	$ 6.25
No. 500 C—O	Size 8x9 inches	Depth, 2½	inches	10.00

Style B: Plate Shaped Trays

No. 1—B	Diameter, 6 inches	Depth, 2	inches	$3.00
No. 2—B	Diameter, 7 inches	Depth, 2	inches	3.75
No. 3—B	Diameter, 8 inches	Depth, 2	inches	4.50
No. 4—B	Diameter, 9 inches	Depth, 2½	inches	5.00

Style T: Oval Shaped Tray with Straight Sides

No. 1—T	Size 8x10 inches	Depth, 1 inch	$6.00
No. 2—T	Size 9x12 inches	Depth, 1 inch	8.00

Style AD: Double Basket. Two Compartments

No. A—D	One Size Only, 8 inches Diameter on base	$15.00

TABLE MATS

Round		Oval		
No. 1-M	Diameter 7 inches	No. 11-M	6x7 inches	$2.50
No. 2-M	Diameter 8 inches	No. 12-M	7x8 inches	3.00
No. 3-M	Diameter 9 inches	No. 13-M	8x9 inches	3.50

STYLE S: Round Tray with Handles

No. S- 8	Diameter 8 inches	$ 8.75
No. S-10	Diameter 10 inches	11.75

STYLE CB: Cord Baskets

No. CB-1	Cord Baskets, 5 inch base	$6.00

STYLE AP: Pointed Cover Baskets

No. A-P	One Size Only Diameter 8 inches on base	$10.00
No. H-12	Wall Pocket, 12 inches long	$8.00
No. HB-1	Hand Bag with handles	$8.75
No. HB-2	Round Covered Basket with long handles	$15.00

NOTE—As these baskets are all hand-made, sizes may
vary slightly from given dimensions

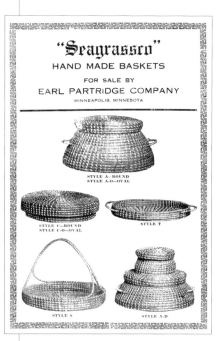

Fig. 6.12
Seagrassco catalog cover and wholesale price list, ca. 1920.

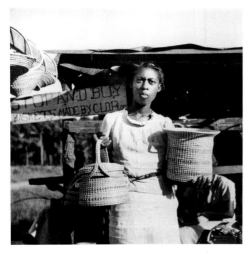

Fig. 6.13
Viola Jefferson at her family's basket stand on Highway 17, Mt. Pleasant, South Carolina, 1938. Photo: Bluford Muir. Francis Marion National Forest, U.S. Department of Agriculture.

Coakley negotiated an arrangement with Charleston merchant Clarence W. Legerton, remembered today by basket makers as "Mr. Lester" or "Mr. Leviston."

Trained as a civil engineer, Legerton had come to Charleston to run his uncle's book and gift shop on King Street. Around 1916, with European imports in short supply, he began commissioning Mt. Pleasant baskets to sell wholesale through his Sea Grass Basket Company and retail from the store.[30] Coakley would relay orders for baskets and every other Saturday sewers would bring their wares to his house for Legerton's inspection.[31] Basket maker Mary Jackson, whose grandmother "sewed for Legerton," recalls being told that the merchant would examine each basket "thoroughly all over" and "bang" on it "with his knuckles." He could tell by the sound if "it was a well-made basket."[32] Under his patronage, coiled grass baskets became a reliable cash crop in a cash-poor economy. People who had never made baskets before, or who used to make them but had stopped, were encouraged to learn from one of the "originals."[33]

In Phillips Community, on the Boone Hall side of Highway 17, James and Maybell Turner served as "basket agents,"[34] but in scope and scale the Legerton/Coakley connection was unrivaled. For the first several years, Legerton bought between three and four thousand dollars worth of Mt. Pleasant baskets each year. In 1920, he changed the name of his wholesale operation to "Seagrassco" and stepped up his advertising. Although he purchased fewer baskets, he increased his markup to more than ninety percent and continued to turn a handsome profit (fig. 6.12).[35]

Fifteen years after Legerton entered the picture, sewers found a way to bypass middlemen and reach customers directly. With the completion of the Cooper River Bridge in 1929 and the paving of Highway 17, basket makers began displaying their work on chairs or overturned boxes along the side of the road. There is some debate about who deserves credit for taking this step. One candidate is Lottie "Winee" Moultrie Swinton, who, according to one source, was followed by Lydia Spann Graddick.[36] Another account attributes the origins of the basket stand to a "fierce argument" between an overseer and a woman who lived "in one of the former slave quarters at Boone Hall." While working in a strawberry field, Ida Jefferson Wilson was ordered off the property. To make up for the loss of income, Wilson's husband Jack had an idea. Motorists driving down Highway 17, he speculated, "might stop and buy a basket." The next day Ida "hung several pieces from a ladder-back chair clad with a white sheet and sold a fruit basket."[37]

Edna Mae Rouse and her mother Betsy Johnson took the roadside sales operation to the next level. Rouse and a caretaker of Boone Hall Plantation by the name of Simmons were in the habit of placing tomatoes and baskets for sale on a table outside her home. Elaborating on

Fig. 6.14
Maebell Foreman, Mt. Pleasant, South Carolina, 1959. Photo: William C. Sturtevant. Collection of Sally McLendon.

Fig. 6.15
Pearl Dingle at her family's basket stand on Highway 17, Mt. Pleasant, South Carolina, 1959. Photo: William C. Sturtevant. Collection of Sally McLendon.

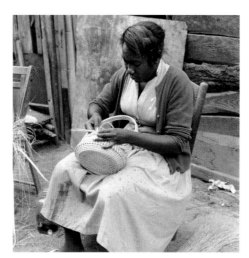

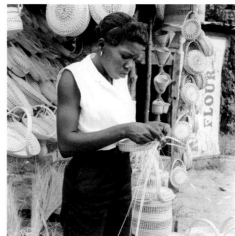

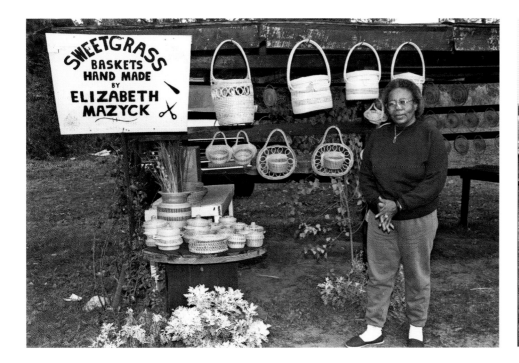

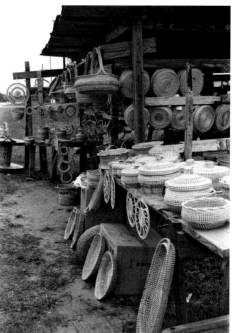

Elizabeth Mazyck at her basket stand on Highway 17, Mt. Pleasant, South Carolina, 1994. Photo: Dale Rosengarten.

Fig. 6.17
Janie Mazyck's basket stand on Highway 17, Mt. Pleasant, South Carolina, 1994. Photo: Dale Rosengarten.

the idea, Johnson hammered nails "along the outside of her store (known as Betsy's Stand) and hung her baskets.[38] Soon she was purchasing sweetgrass baskets from other makers and offering them for sale.

The practice of "hanging out" on the highway quickly caught on (fig. 6.13). Basket makers and family members might walk a mile or more from their houses to the road, carrying baskets in bags or strung together with rope. Joseph Mazyck remembers hiking "a mile with strings and strings of baskets on our shoulders to get to the highway. . . . That's why I quit sewing baskets—all that walking. But I'd still have to go and take the baskets to help my sister." He describes the hard work and tedium of packing and unpacking the baskets, then sitting all day "waiting for somebody to come buy a basket. And sometimes it'd be two or three days and don't sell a basket."[39]

Some sewers have happy memories of accompanying their mothers to the stand. "As a child," recalls Eva Wright, "you were glad to just walk along the highway, and you would stop at every little stand . . . to communicate with the people as they were sewing baskets, and everybody welcomed you. Everybody was friendly and it was a joy to just be in their company, even though they were older people."[40] For Annie Scott, going to the roadside stand meant bringing her mother good luck. "My mother always liked when I go because she said I guarantee you that I will get a sale. I will make some money."[41]

As a stage in the marketing of baskets, the stands were a great advance. They allowed sewers to sell their work with minimal overhead and, more important, to charge the retail price. "I set up a stand back when there weren't hardly any stands on the highway," recalled the late Irene Foreman. "Me and Hessie Huger set up a stand in 'Four-Mile.' We figure we could make a whole lot more money than just sewing for Mr. Leviston. He'd pay 20 cents for a 12-inch piece. If you sell them yourself you can get double that, all of 50 and 75 cents for a basket" (cats. 69, 70 and fig. 10.3, p. 234).[42]

The stands freed basket makers from the constraints of commission work, which called for specific quantities of a limited number of styles. "You can make your basket the way you want and you can make 'em the price you want," said Evelyina Foreman, who helped her mother fill orders for Legerton.[43] By 1949, thirty-one stands were counted along a two-mile stretch of Highway 17 near Christ Church. "Gleaming" automobiles would pull up in front of

Cat. 64
SEWING BASKET
Maggie Mazyck
South Carolina
Ca. 1930
D. 26 cm.
Collection of Mrs. Jervey D. Royall

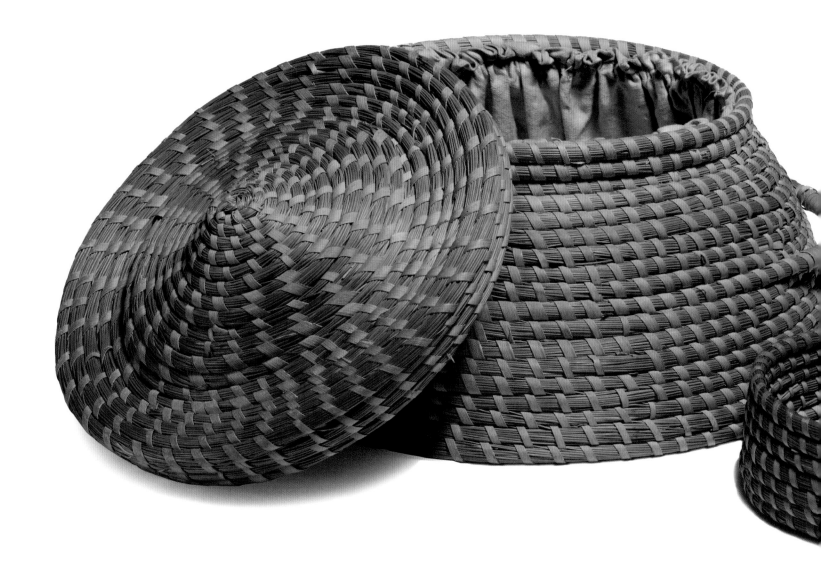

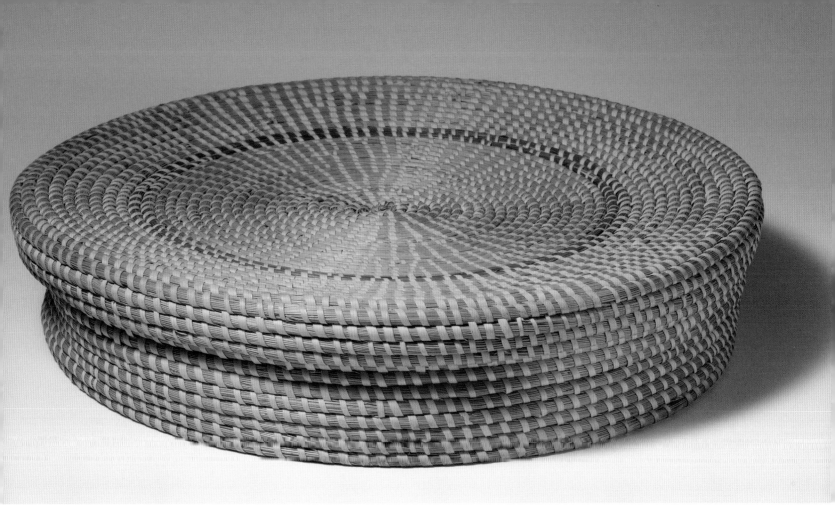

Cat. 65
CAKE BASKET
South Carolina
Ca. 1930
D. 43.2 cm.
The Charleston Museum,
HW89ab

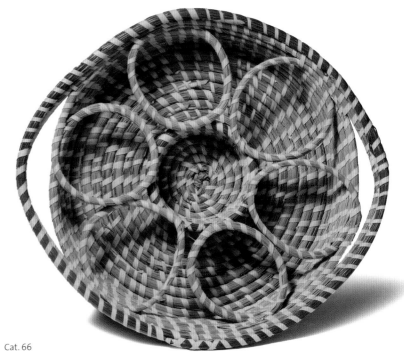

Cat. 66
RING TRAY
Anna Robinson Swinton
South Carolina
1950s
D. 28 cm.
Collection of Mrs. Jervey D. Royall

Fig. 6.18
Sue Middleton, Mt. Pleasant, South Carolina, 2006.
Photo: Jack Alterman.

Fig. 6.19
Mary Catherine Stanley, Mt. Pleasant, South Carolina, 2007.
Photo: Karin Willis. Museum for African Art.

 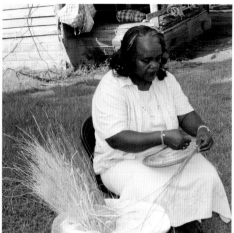

the improvised structures, reported the Charleston *News and Courier*'s Jack Leland, appreciating the contrast. "Persons from the large and modern centers of this country's industrial areas" would stop to look at "an importation of the artistry of African workers" (figs. 6.14, 6.15 and cats. 64–66).[44]

The success of the sweetgrass revolution can be attributed to the strategic location of the community and the invention of the basket stand, which gave Mt. Pleasant sewers direct access to their market (figs. 6.16, 6.17). Making the most of sweetgrass, a finer and more flexible fiber than bulrush, they produced an ever broader range of forms (fig. 6.18 and cat. 72). To provide a contrast in color, they laid longleaf pine needles on the outside of their rows, and for textural accents they tied the pine needles in knots. Like their mothers and grandmothers who gathered flowers and wild plants from the fields and woods to sell in downtown Charleston,[45] sewers were able to make "something from nothing," creating beautiful, saleable baskets from materials found in nature.

STATE OF THE ART

In the early 1960s, three decades after the advent of the highway stand, a small number of Mt. Pleasant basket makers began to display their wares at downtown locales, notably the Charleston Market and the "Four Corners of Law" at the intersection of Meeting and Broad Streets. Sewers still sell in these prime locations—though the main points of sale remain the basket stands along Highway 17 (fig. 6.20). Sewers also compete for coveted spots, some awarded by lottery, in the city's Visitor Center, the Farmers' Market, and in the lobbies of luxury hotels. Some enterprising individuals travel to craft shows and a few sell their work in art galleries or through organizations such as Historic Charleston Foundation or the Charleston Preservation Society. The transition from "craft" to "art" has been in the works for decades. As early as 1980, basket maker Jannie Gourdine told a Charleston reporter, "I think the biggest change is that people look at us as artists now instead of just basket weavers."[46]

Mary Catherine Stanley shows her work in the downtown Market (fig. 6.19 and cat. 74). Lowcountry baskets, she remarks, have become "one of Charleston's signature pieces." She distinguishes between tourists shopping for an "authentic" souvenir and "buyers who look for genuine works of art."[47] Media attention has helped raise the profile of sweetgrass sewers. A few "have gone abroad [and] made big bucks or whatever [but] there are still some of us," says Annie Scott, with a touch of irony, "who have not arrived to that point yet." The impact of the "art market" can be seen in the movement toward bigger baskets, innovative shapes, meticulous stitching, and elaborate surface decoration. "Today," Scott explains, "we add a little bit to it. Like for instance we do the roller coaster or the elephant ear. We do the love knots on the

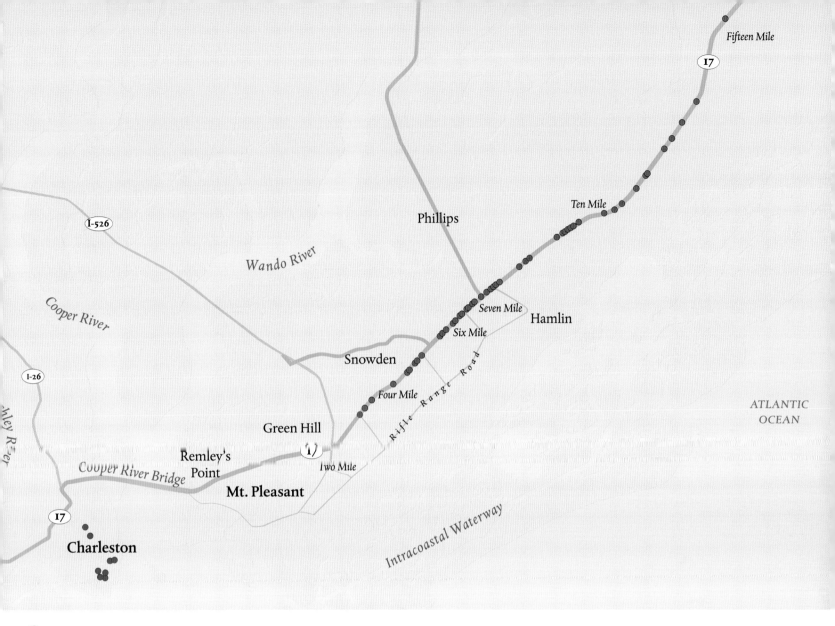

Fifteen Mile

17

I-526

Phillips

Wando River

Ten Mile

Seven Mile

Hamlin

Six Mile

Cooper River

Snowden

I-26

Four Mile

Rifle Range Road

ATLANTIC
OCEAN

Green Hill

17

Two Mile

Remley's
Point

Ashley River

Cooper River Bridge

Mt. Pleasant

17

Charleston

Intracoastal Waterway

● Highway 17 basket stands

● Downtown basket sales locations

Fig. 6.20
Mt. Pleasant, South Carolina, and vicinity

Based on research by Patrick T. Hurley, College of Charleston,
and Cari Goetcheus, Clemson University

Fig. 6.21
Mary Jackson testifying at a hearing on the National Endowment for the Arts, sitting next to Folk Arts Program Director Bess Lomax Hawes, Washington D.C., 1989.

Fig. 6.22
Raymond Manigault gathering sweetgrass, Mt. Pleasant, South Carolina, 1972. Photo: Greg Day.

outside. We do wrap edging. They didn't do that years ago." The basket is no longer simply an everyday tool. "It's an art piece," declares Scott, "and we make it as such."[48]

Undoubtedly, the best-known contemporary sewer is Mary Jackson, who sells her baskets exclusively from her studio and at prestigious craft shows (cats. 76–81). Jackson learned to make coiled sweetgrass baskets as a child, then put it aside for a number of years while she was living in New York. A turning point came when she encountered the city's vibrant art scene, including Op, Pop, and Minimalism. "This gave me a new vision for my own tradition," she recounted in 2002. "I realized that I could continue making baskets with traditional materials but could do it in a different way, making designs that no one had ever done before."[49]

Jackson returned to Charleston in the late 1970s at an opportune moment. Bulrush had recently been reintroduced into baskets to offset a diminishing supply of sweetgrass, and Jackson embraced the change. More rigid than sweetgrass, wider-gauged but hollow, bulrush allowed her to create large, sculptural shapes with smooth contours and a broad palette. "I've always seen [basketry] as an art and felt that it should be expressed that way," she says. "The baskets are simple; the form and the handwork create the beauty." For inspiration she does not "look at pictures or study other basketry to come up with an idea." Rather, she turns to traditional styles, "the same source that I already have."[50] She builds on what has "been there all along," conserving and inventing simultaneously. "Some of these old forms look as modern . . . as some of my newer ones," she observes. "I would look at them and visualize a totally different shape from that base."[51]

The old criteria of usefulness and strength are still important, but the market has stimulated a new appreciation of expressive styles. "An African craft that began with functional intentions," wrote folklife scholar John Michael Vlach, "has become an art medium with primarily aesthetic motivation."[52] No one can say, however, how many sewers the demand for baskets as art will support, and sales at the stands are seasonal and sporadic. "Sometimes you'll be out there all weekend and don't make a dime," reports Joseph Mazyck.

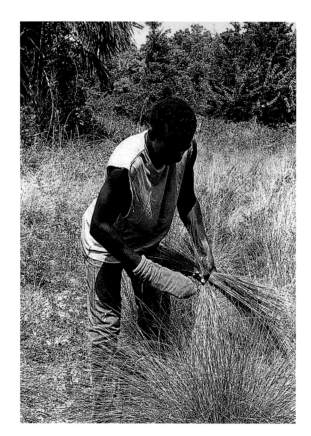

"The next week, you may make $1,000. But it's a gamble. That's all it is." Moreover, it's hard to make back what you put into a basket. "You take a month to make a basket, and then when you put them on the stand for $200, somebody says, 'Oh, that's too much money.' You can't charge for your labor, because if you're going to charge for your labor, nobody going to buy a basket because it takes too long to make one." By the time you figure in the cost of traveling to gather sweetgrass or buying your material from someone who has driven miles to harvest it, "you're just trying to break even."[53]

Few Lowcountry sewers have been able to make a comfortable living from basket sales. "Basket money," as Barbara McCormick puts it, "is an iffy money"[54]—okay if there are other incomes in the family, or to tide you over between jobs, or to supplement a retirement pension, but not something you can count on to pay the mortgage. Yet, since the 1990s, the field of sewers has expanded noticeably and there has been a marked increase in the number of men making and selling baskets. After careers spent as teachers, nurses, or medical technicians, Mt. Pleasant natives are returning to the tradition with the enthusiasm of converts. "There's just so many positive things about it," explains Mary Catherine Stanley, who retired from school teaching in 1998. "It gives you peace, it keeps you calm, it keeps you focused. It promotes creativity. You can make a living doing it. And even if those things were not there, if I couldn't feel the effect of those things, I still would do it because when one gets through making them and look at them and say, wow, did I do that?"[55]

The new breed of basket maker is articulate and comfortable in a lecture hall, an art gallery, or a legislative hearing (fig. 6.21). Many sewers have websites and e-mail addresses, nearly all have cell phones. Some have entered the political arena to defend their interests. They see themselves caught in a paradox of "sun belt" development: tourists and new residents have boosted the economy and ought to boost basket sales too, but the infrastructure built to accommodate them cuts off buyers from sellers. Highway 17 has expanded to six lanes with high curbs separating bumper-to-bumper traffic from shopping centers and strip malls on both sides. It has become dangerous for motorists to pull off the road and stop at a basket stand.

Furthermore, new gated subdivisions and commuter condos are encroaching on sweetgrass habitats and on the very communities where basket makers live. Sewers are unanimous in identifying their number one problem: the growing scarcity of sweetgrass. "There's no doubt about it," declares Raymond Manigault. "It's not a hype. It is getting very, very difficult to find the sweetgrass" (fig. 6.22).[56] "The grass is really getting hard to find," echoes Elizabeth Mazyck, "and that's the scary part" (fig. 6.23 and cat. 75).[57] Serious efforts are underway by botanists, landscapers, and basket makers to cultivate the plant, but the consensus is that grass that grows wild in its natural habitat is best for making baskets.

Through Thomasena Stokes-Marshall, a representative on the Mt. Pleasant Town Council who returned to South Carolina in the early 1990s after a career as a New York City police detective, basket makers have successfully lobbied for a Sweetgrass Pavilion to be built in the Waterfront Park at the base of the new Cooper River Bridge. The Pavilion will relocate a number of basket sellers from their traditional stands along Highway 17 into a central market place. Though the move will be voluntary, sewers will have to weigh carefully the benefits and risks of leaving the highway. Will a centralized point of sale attract sufficient tourists and buyers? Will putting many sewers under one roof increase competition or cooperation, innovation or imitation, or all of the above? Will the move be good for sales and good for the tradition?

On the brink of another sea change in marketing, comparable perhaps to the introduction of the basket stand in 1930, Mt. Pleasant baskets, with their conical covers and big-bellied shapes, appear more "African" than ever. This has to do, in part, with the reintroduction of bulrush, but also with the growing importance of Africa in the consciousness of the sewers. Basketry is a tangible connection to the past, not a lost and found tradition but a continuous

Fig. 6.23
Elizabeth and Joseph Mazyck, Mt. Pleasant, South Carolina, 2006. Photo: Jack Alterman.

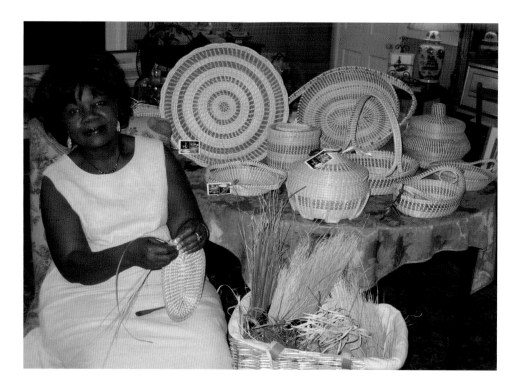

Fig. 6.24
Henrietta Snype at the Charleston Preservation Society,
Charleston, South Carolina, 2006.

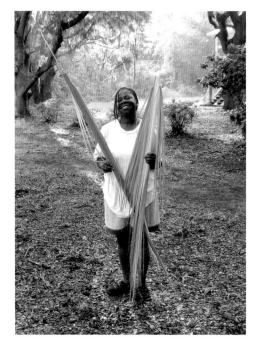

Fig. 6.25
Nakia Wigfall, St. Helena Island, South Carolina, 2007.
Photo: Christian Sardet.

activity that reaches right back to the first immigrants from Africa. "My ancestors were far away from their homeland against their will," explains Mary Jackson. "The intent of the plantation owners was to separate families so that they would lose their identities. . . . It's very difficult for me to refer to my ancestors as slaves, because they weren't to us; they were people."[58]

Henrietta Snype belongs to the middle generation of sewers who grew up on family farms and, without moving an inch, now live in a bustling suburb. Snype has left "the road" for the sanctuary of her house, preferring to sell her baskets through the Preservation Society in Charleston and at craft and heritage festivals. "I travel and teach [basketry] all over the world," she says. "This is a new time and a new century we live in." Ever the innovator and entrepreneur, in the mid-1980s she started making coiled grass earrings, belt buckles, and bracelets. The "founder of basket jewelry" takes pride in "a clean finish" to her work "and a nice symmetry."[59] No loose strands of grass or untucked ends of palmetto binders disrupt the pleasing pattern of her rows (fig. 6.24 and cat. 82).

Prices of sought-after baskets have increased a thousand fold from the piddling amounts older sewers received when they were starting out and place mats sold for as little as ten and fifteen cents.[60] Despite the improved economic return, basket makers report widespread disinterest on the part of the younger generation. "They're just not interested in it," says one sewer. "They just seem to want everything fast and easy, and that cannot be applied to baskets."[61] At the same time there's a general expectation that young people will come back to the craft when they mature, as long as "they know it's very important and that it's our heritage," and as long as they have been taught how to sew.[62]

A basket maker today may also be a buyer and collector of baskets herself; she may be a documentarian or historian of the craft (fig. 6.25 and cat. 83). She worries that young people will not care enough to preserve the art and maintain ancestral connections, that others will profit from the exploitation of basket makers, because that's how it was in the past, and that the building boom that has turned Mt. Pleasant from a sleepy backwater into one of the fastest growing municipalities in the country will push the basket stands off the highway.

The generation of sewers who came of age in the 1960s experienced firsthand the demise of legal segregation and an unprecedented expansion of job and career opportunities which lured some people away from the pursuit of basket making. Other market forces and family dynamics, however, may assure the tradition's transmission. Practical and imaginative forms made today and displayed by sewers at their stands and other venues appeal to the hand and the eye as the products of a vibrant artistic culture. Yet the humble coiled basket remains what it always was: a vessel, sewn of bundles of grasses held together by a flexible stitching element, and answering a myriad of human purposes.

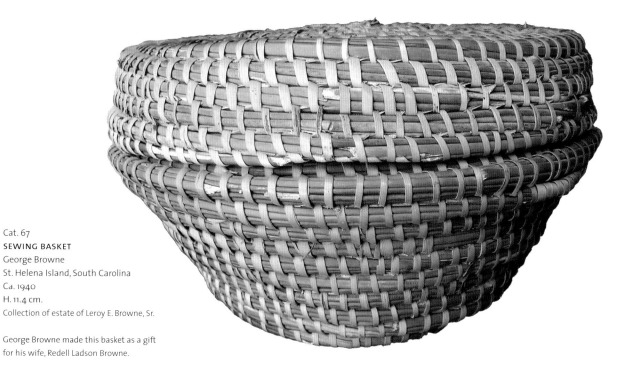

Cat. 67
SEWING BASKET
George Browne
St. Helena Island, South Carolina
Ca. 1940
H. 11.4 cm.
Collection of estate of Leroy E. Browne, Sr.

George Browne made this basket as a gift
for his wife, Redell Ladson Browne.

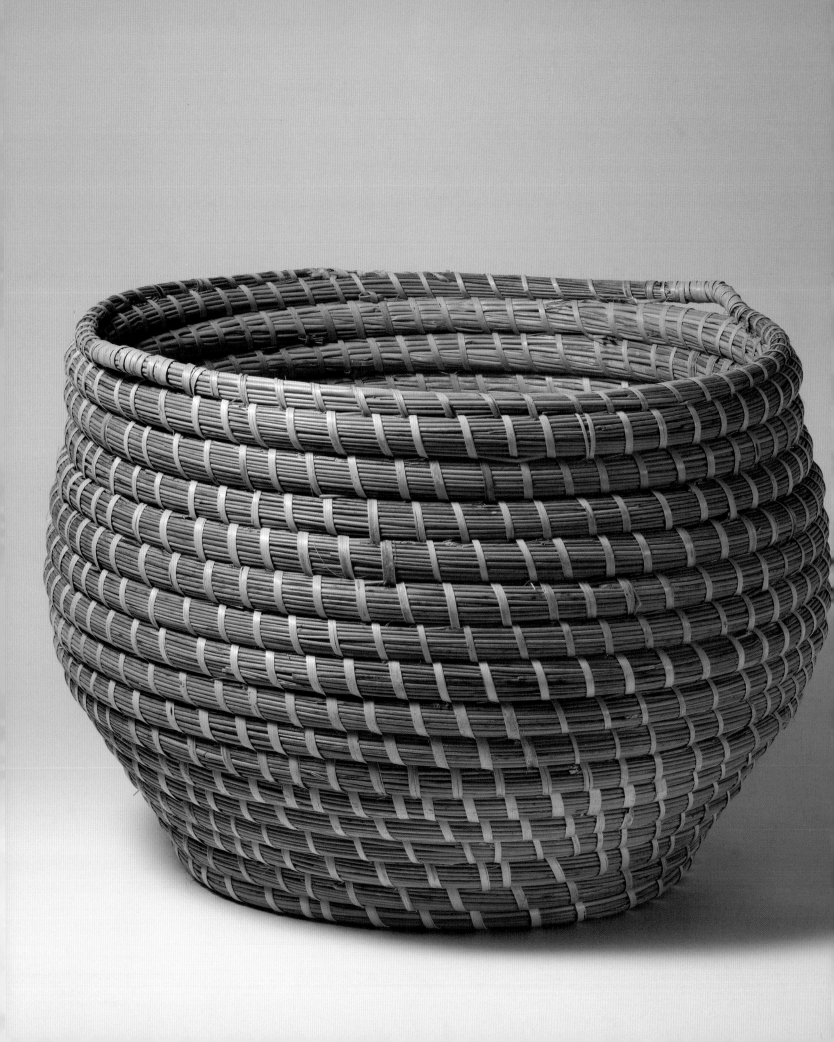

Cat. 68
LAUNDRY BASKET
Jannie Cohen
Hilton Head Island, South Carolina
1986
D. 57 cm.
South Carolina State Museum
Collection, 86.118.7

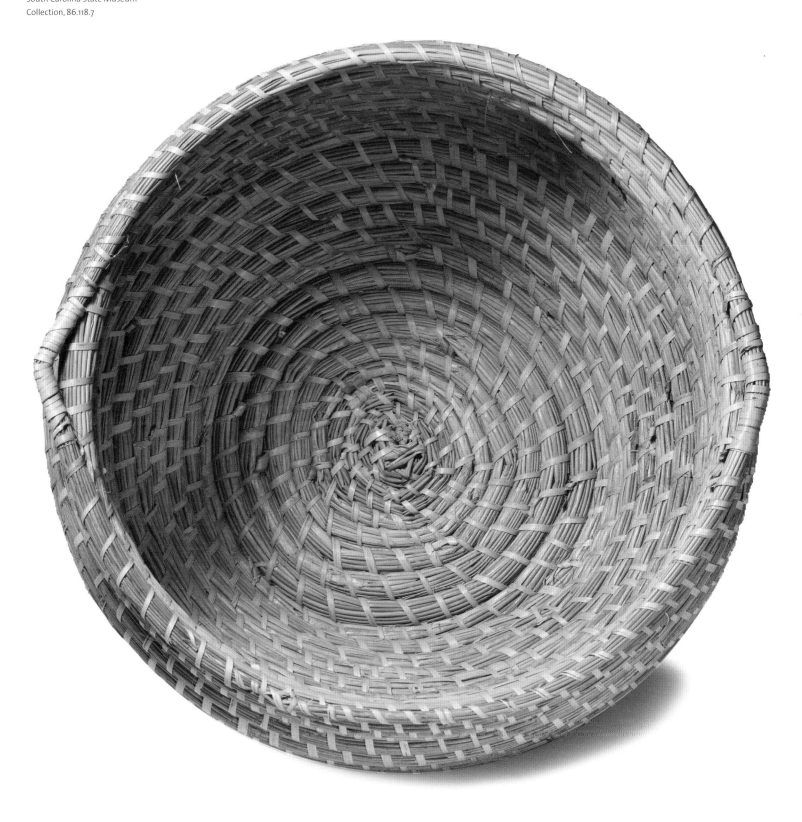

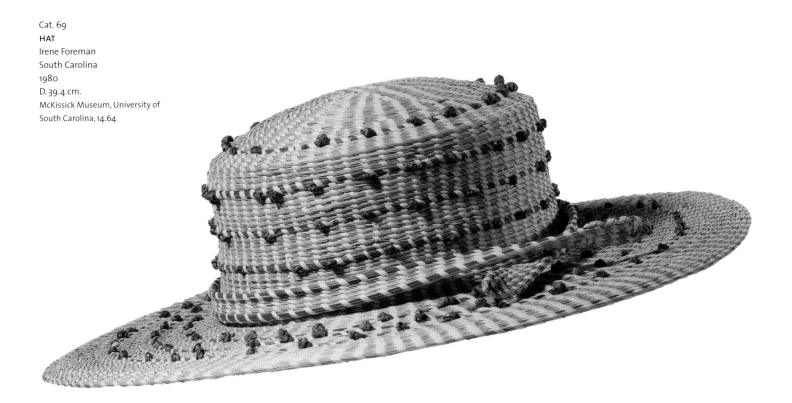

Cat. 69
HAT
Irene Foreman
South Carolina
1980
D. 39.4 cm.
McKissick Museum, University of
South Carolina, 14.64

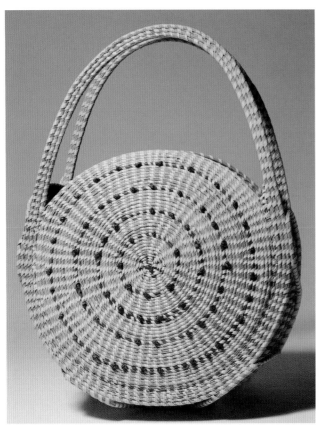

Cat. 70
MISSIONARY BAG
Irene Foreman
South Carolina
1980
H. 42 cm.
McKissick Museum, University
of South Carolina, 14.63

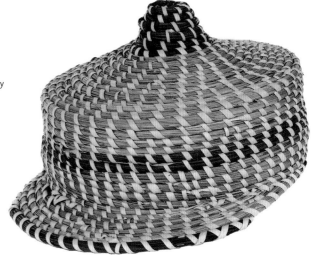

Cat. 71
BASEBALL HAT
South Carolina
1972
H. 25.4 cm.
Collection of Greg Day

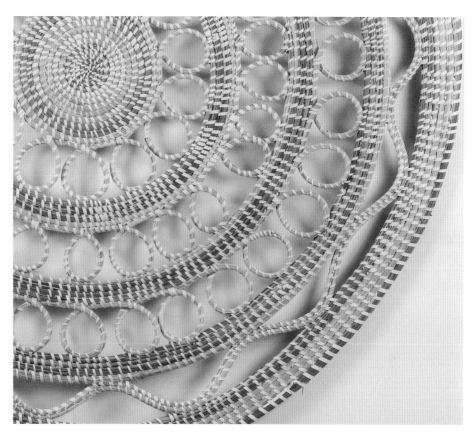

Cat. 72
WALL HANGING
Sue Middleton
South Carolina
2007
D. 89 cm.
Contemporary Carolina Collection, Medical
University of South Carolina Foundation

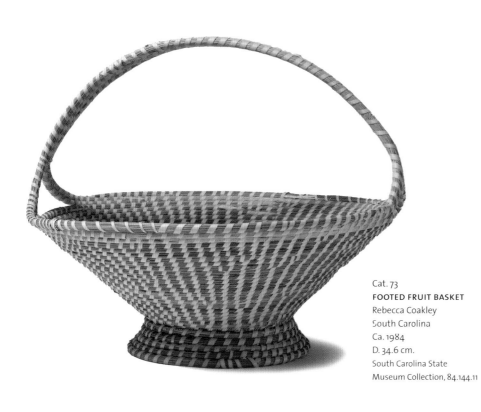

Cat. 73
FOOTED FRUIT BASKET
Rebecca Coakley
South Carolina
Ca. 1984
D. 34.6 cm.
South Carolina State
Museum Collection, 84.144.11

Cat. 74
COVERED JUG
Mary Catherine Stanley
South Carolina
2006
H. 43 cm.
Collection of the artist

Cat. 75
EGG BASKET
Elizabeth Mazyck
South Carolina
2002
H. 38 cm.
American Museum of Natural
History, 26/1065

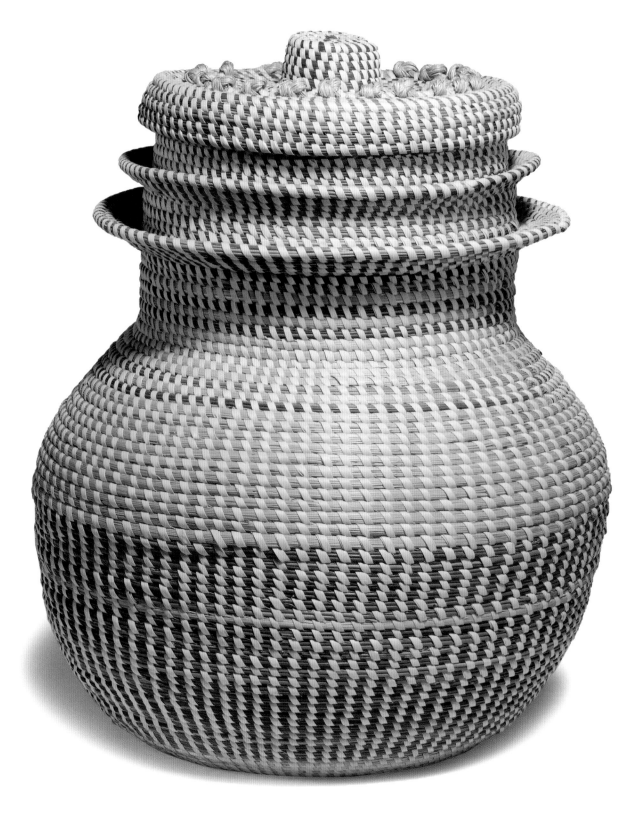

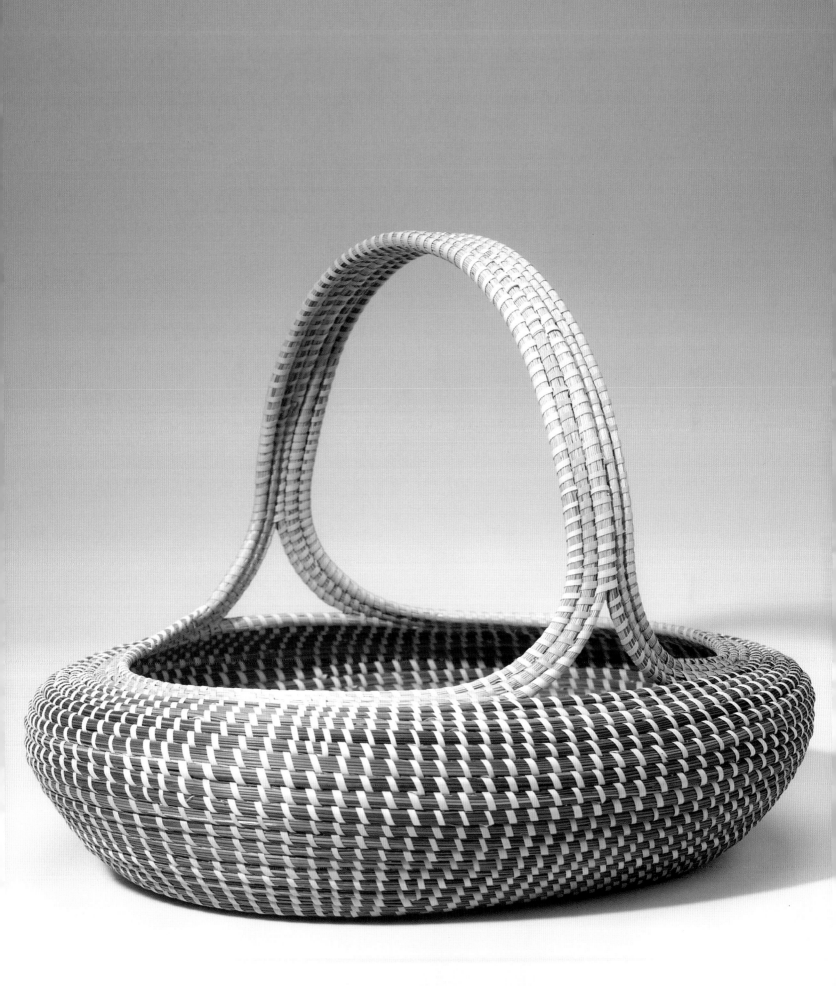

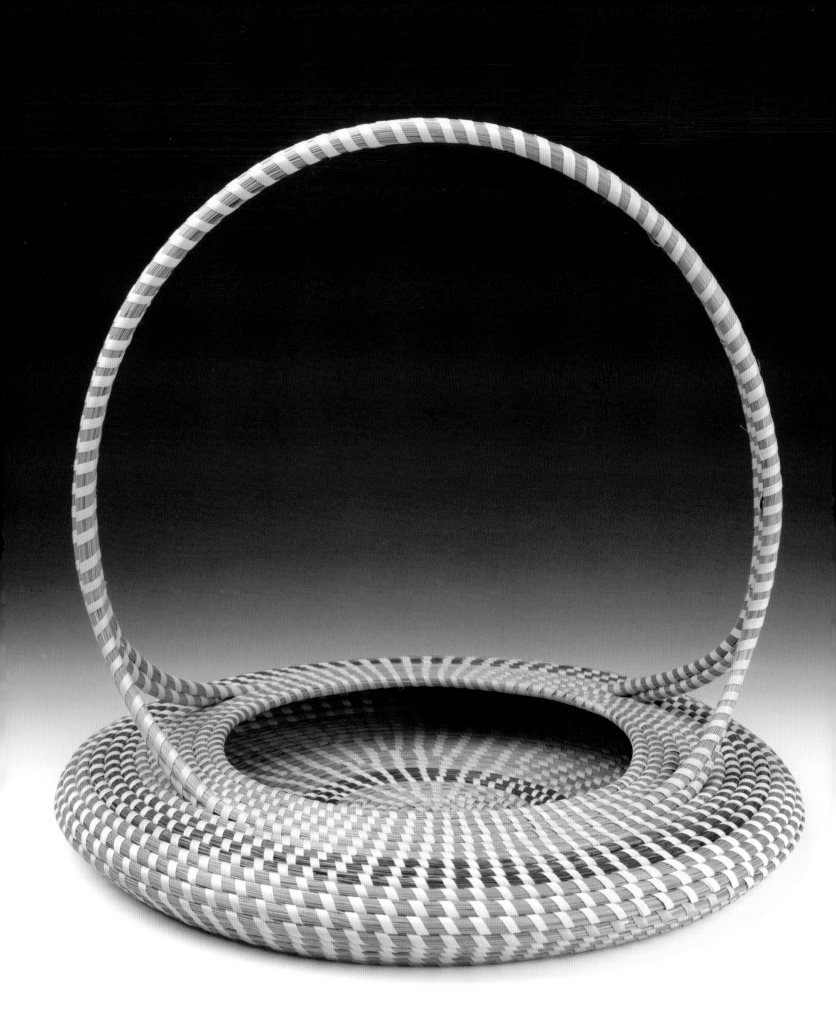

Cat. 76
LOW BASKET WITH HANDLE
Mary Jackson
South Carolina
1999
H. 43.2 cm.
Smithsonian American Art Museum,
gift of Marcia and Alan Docter, 2001.61

Cat. 77
GINGER BASKET
Mary Jackson
South Carolina
Ca. 1984
D. 40 cm.
Charleston County Aviation Authority/
Charleston International Airport

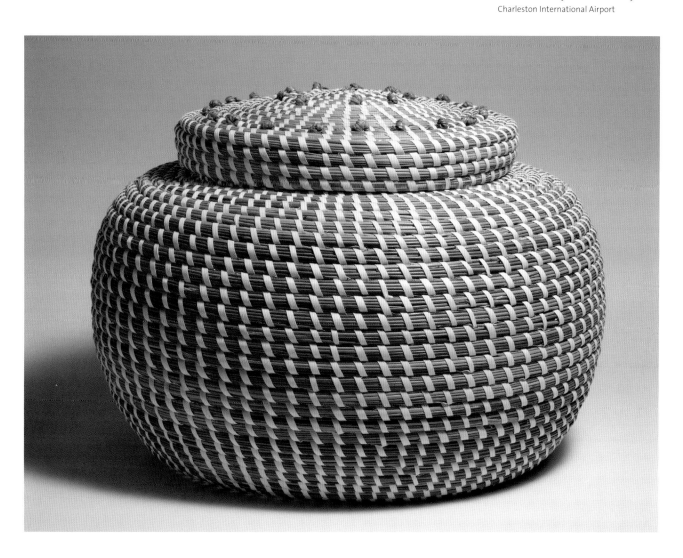

Cat. 79
TWO LIPS BASKET
Mary Jackson
South Carolina
1984
D. 48.3 cm.
South Carolina Arts Commission
State Art Collection, 3963

Cat. 78
MEMMINGER DIPLOMA BASKET
Mary Jackson
South Carolina
1989
L. 58.4 cm.
McKissick Museum, University of
South Carolina, 1989.06.00.26

Mary Jackson based this basket on
a historic example used to hold
diplomas at the Memminger High
School in Charleston, South Carolina.

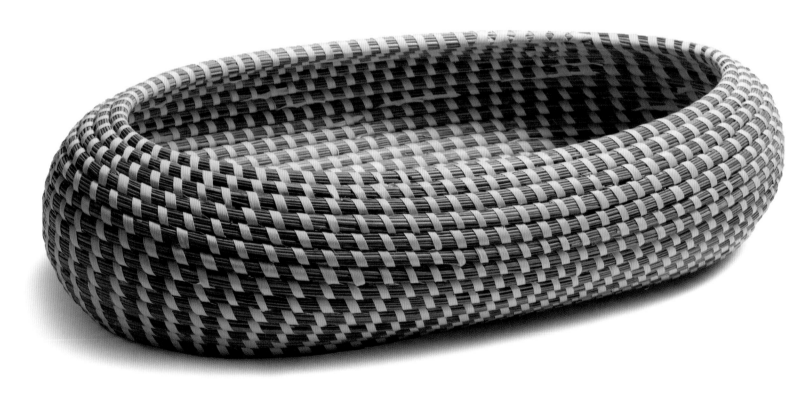

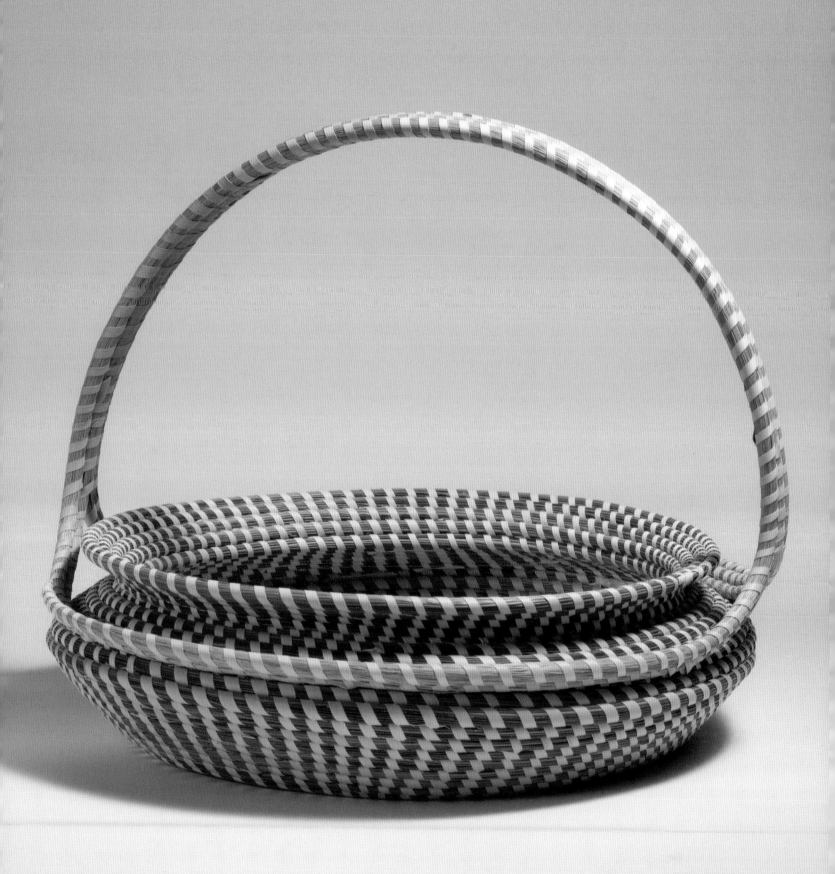

Cat. 80
SEWING BASKET
Mary Jackson
South Carolina
1985
D. 33 cm.
McKissick Museum, University
of South Carolina, 14.87

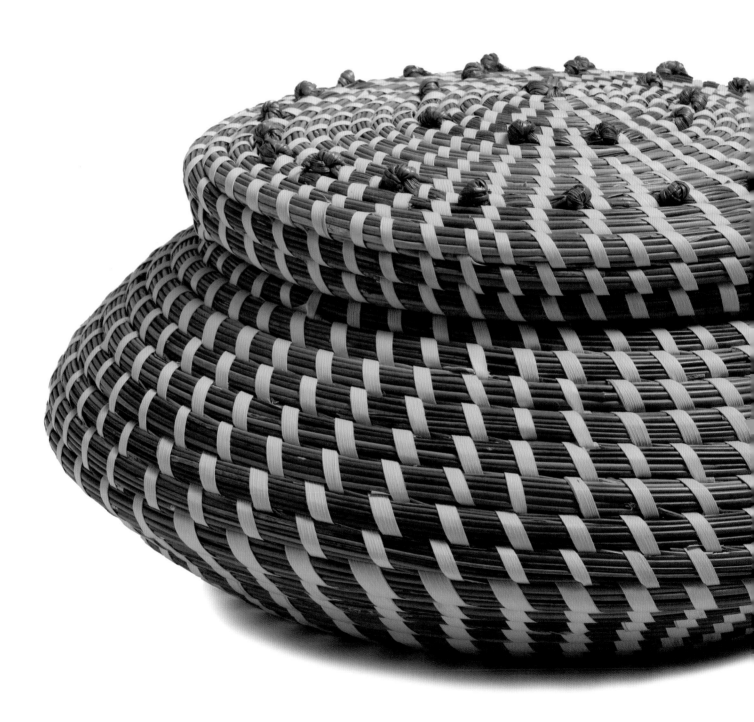

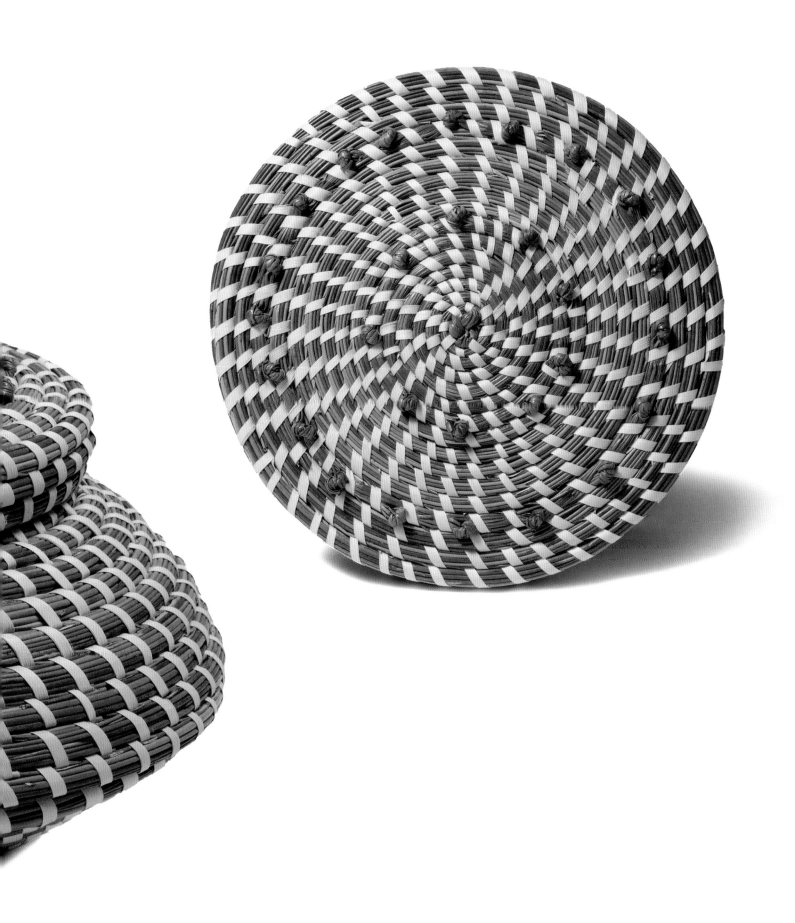

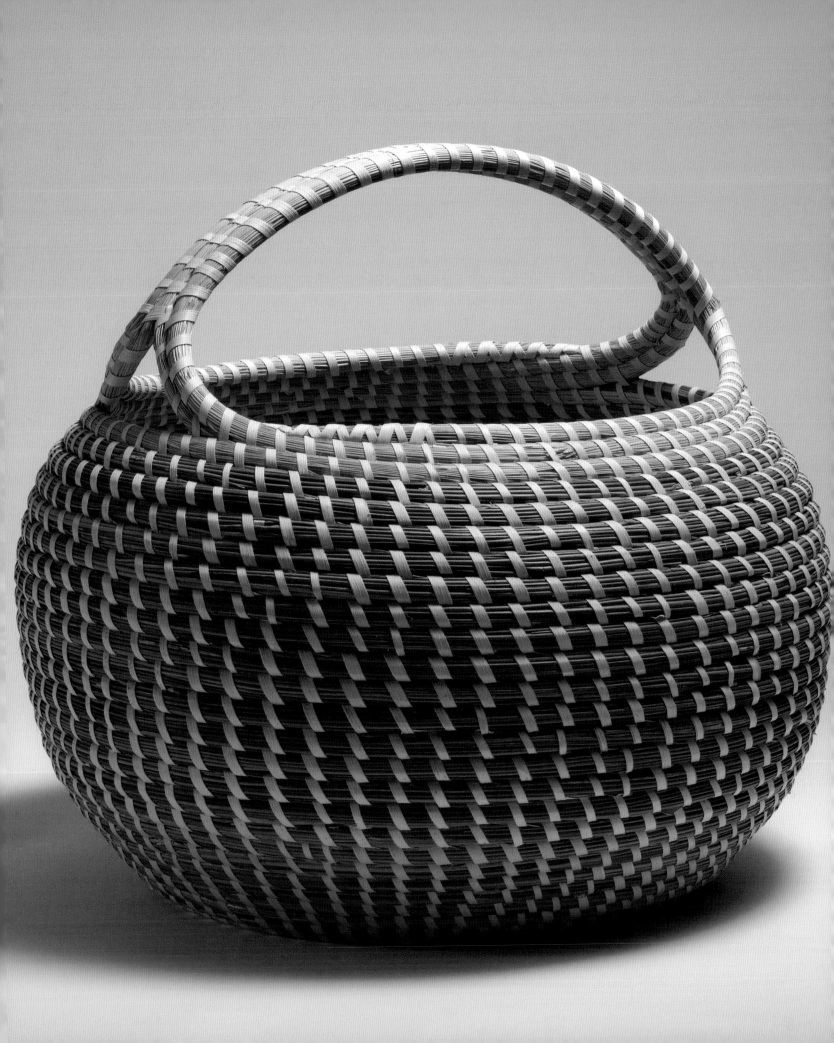

Cat. 81
COBRA BASKET
Mary Jackson
South Carolina
Ca. 1980
H. 38 cm.
McKissick Museum, University
of South Carolina, 1984.26

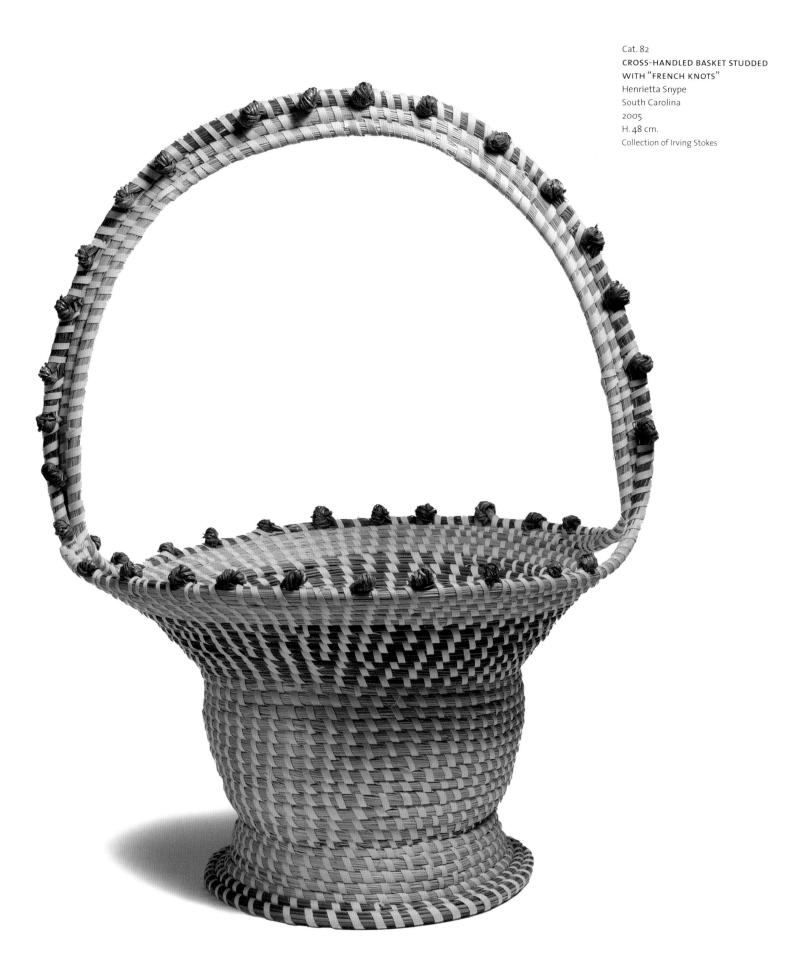

Cat. 82
**CROSS-HANDLED BASKET STUDDED
WITH "FRENCH KNOTS"**
Henrietta Snype
South Carolina
2005
H. 48 cm.
Collection of Irving Stokes

Cat. 83
COLLECTION BASKET
Nakia Wigfall
South Carolina
2006
H. 20.5 cm.
Collection of Dana Sardet

The tight-fitting cover of this church
collection basket has slots through
which dollar bills can be inserted.

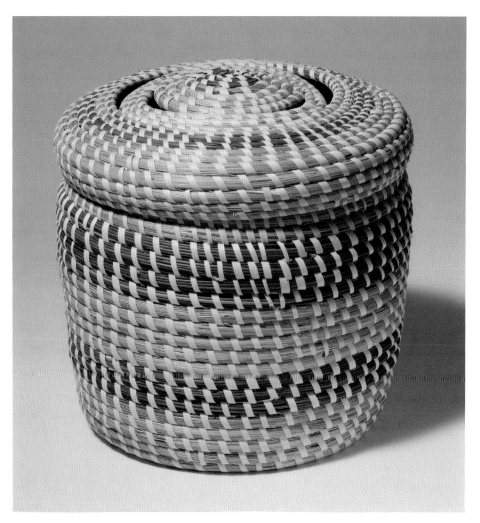

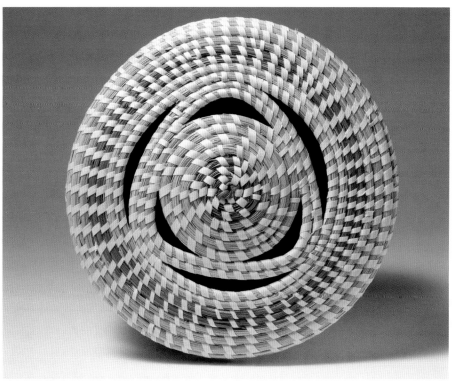

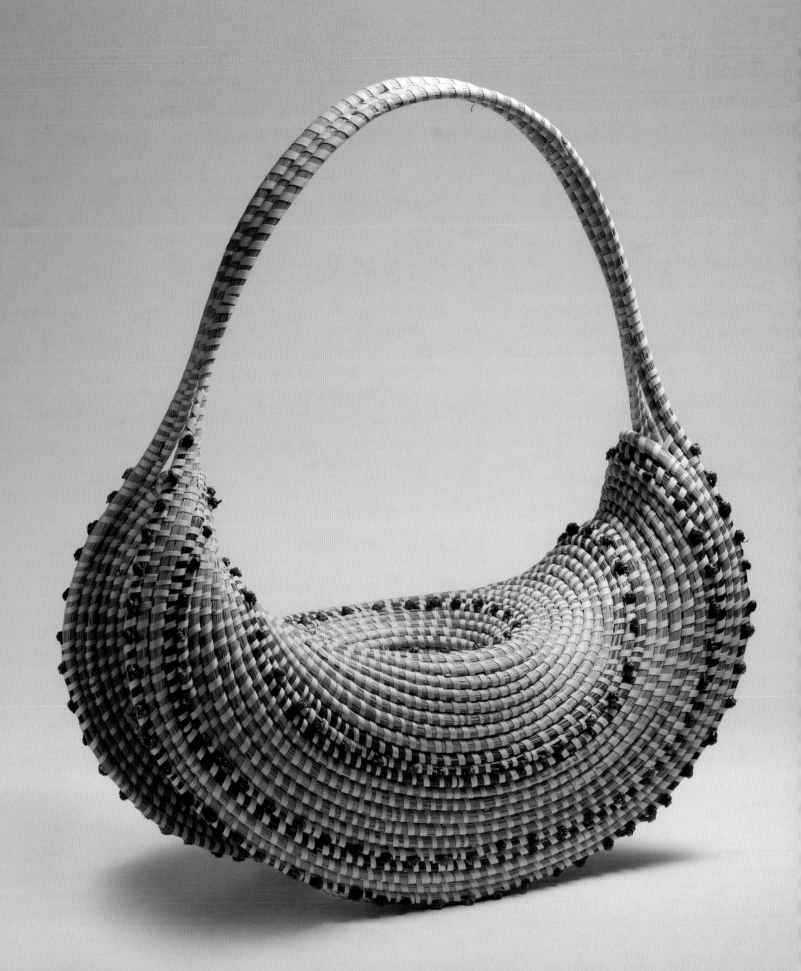

Cat. 84
BASKETRY COWBOY HAT
Leola Wright
South Carolina
1986
H. 54.6 cm.
McKissick Museum, University
of South Carolina, 1996.18.00.01

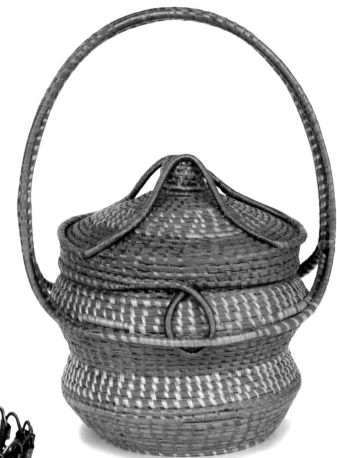

Cat. 85
**COLORFUL BASKET WITH
CROSS HANDLE**
Ethel Snipe
South Carolina
1974
H. 38 cm.
Collection of Greg Day

Cat. 86
POP-TOP BASKET
South Carolina
1973
H. 23 cm.
Collection of Greg Day

Cat. 87
KEEPSAKE BASKET WITH PEARLS
Annette Mazyck
South Carolina
2006
H. 10 cm.
Collection of Edith Howle and
Rick Throckmorton

Cat. 88
STRIPED VASE
Adell Mazyck Merisier
South Carolina
2005
H. 27 cm.
Collection of Timothy and Pearl V. Ascue

The construction of this vase is unique;
two coils ascend simultaneously to the
rim creating the striped effect.

Cat. 89
WEDDING BASKET WITH PEARLS
Annette Mazyck
South Carolina
2006
H. 25.5 cm.
Collection of Rafael D. Rosengarten

Annette Mazyck is the first Mt. Pleasant
basket maker to decorate her baskets with
strings of pearls. She sews them onto the
lids of keepsake baskets or ties them in
knots to create a border. This flower basket
is made to be carried in a wedding.

Cat. 90
SEWING BASKET
Linda Blake
South Carolina
1993
D. 29.2 cm.
South Carolina Arts
Commission State Art
Collection, 4090

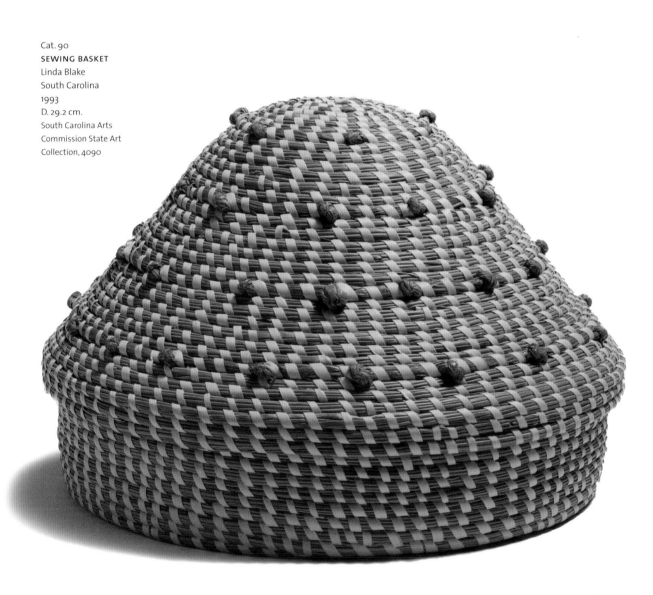

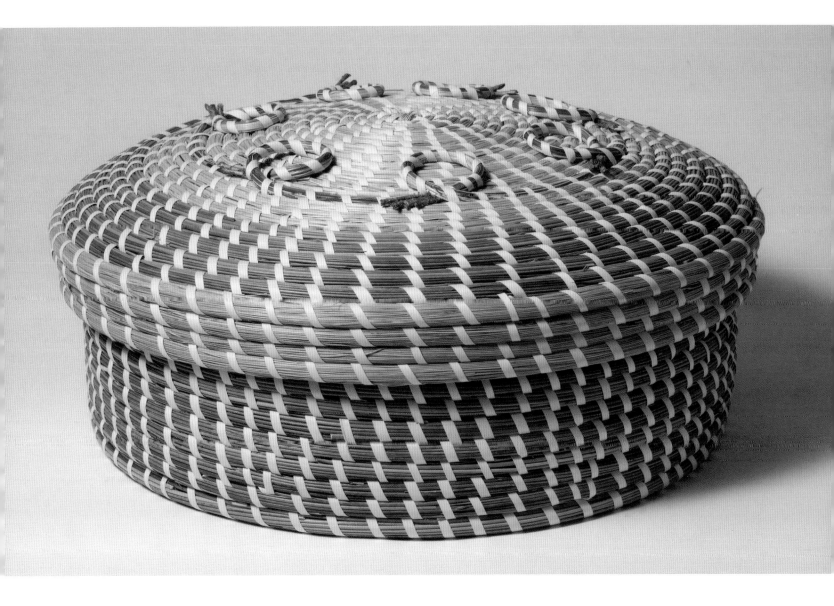

Cat. 91
STORAGE BASKET
Marguerite Middleton
South Carolina
1993
D. 41.9 cm.
South Carolina Arts
Commission State Art
Collection, 4099

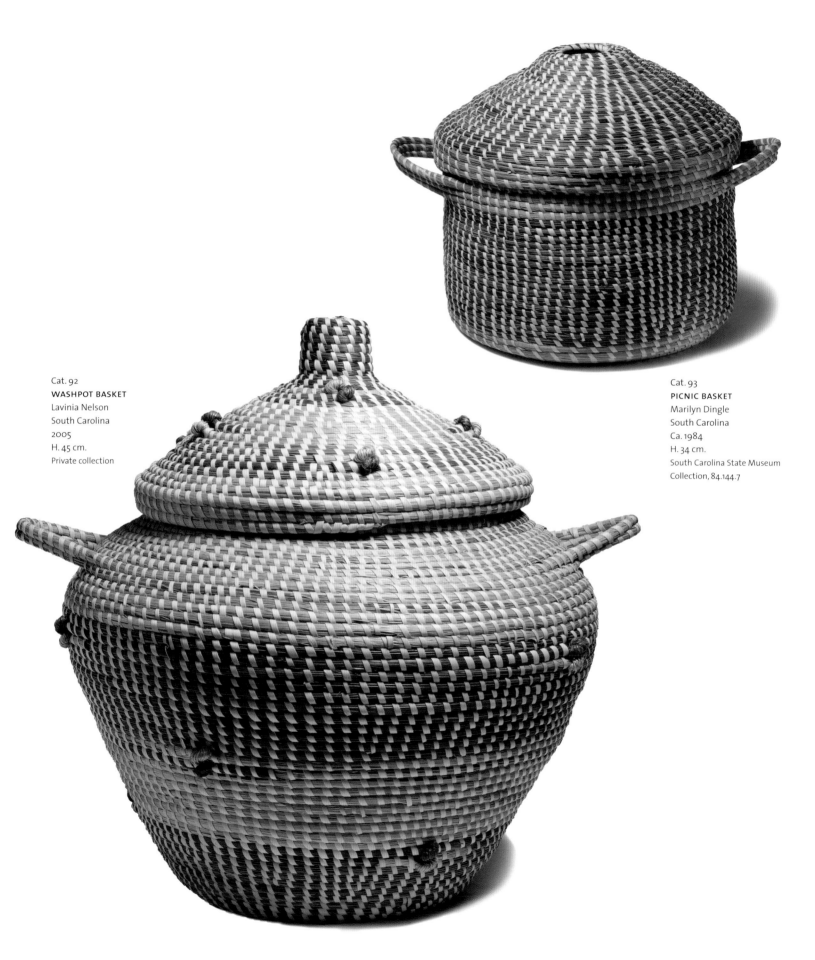

Cat. 92
WASHPOT BASKET
Lavinia Nelson
South Carolina
2005
H. 45 cm.
Private collection

Cat. 93
PICNIC BASKET
Marilyn Dingle
South Carolina
Ca. 1984
H. 34 cm.
South Carolina State Museum
Collection, 84.144.7

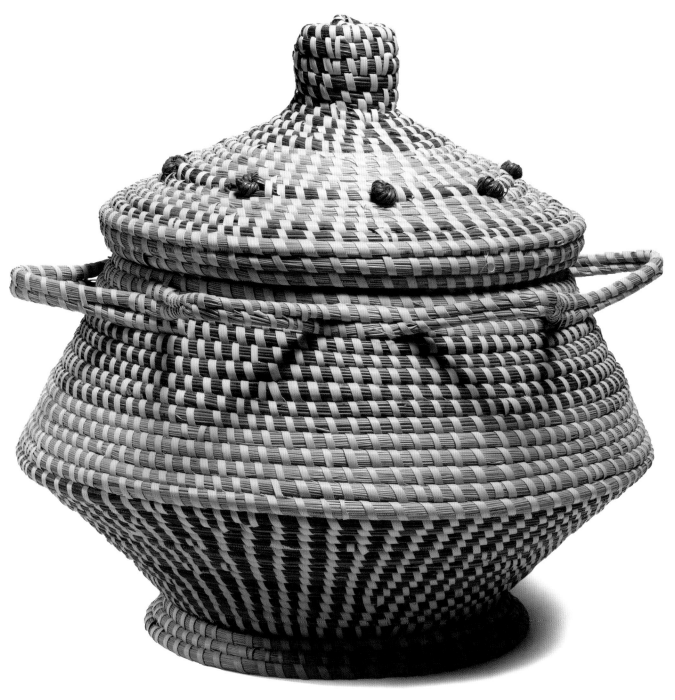

Cat. 94
SIX-STAR SEWING BASKET
Sarah B. Graddick
South Carolina
Ca. 1988
H. 33.5 cm.
Avery Research Center, College
of Charleston, 014

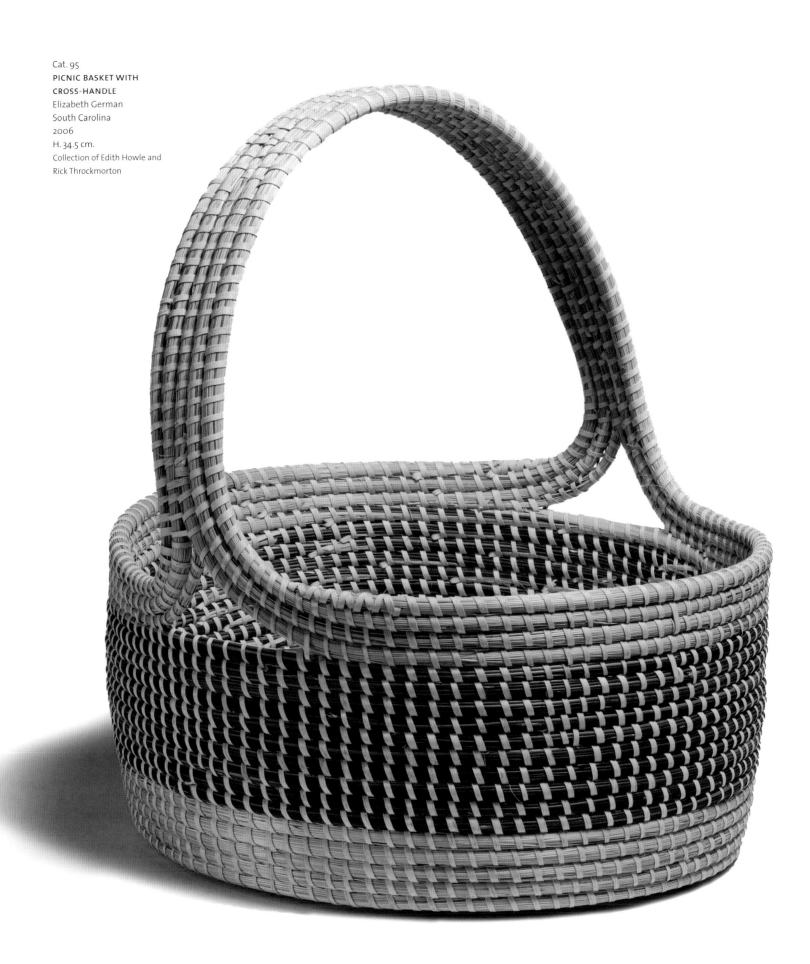

Cat. 95
PICNIC BASKET WITH
CROSS-HANDLE
Elizabeth German
South Carolina
2006
H. 34.5 cm.
Collection of Edith Howle and
Rick Throckmorton

Cat. 96
PAIL BASKET WITH DOUBLE
HINGED HANDLES
Althea Tiller Washington
South Carolina
Ca. 1985
H. 18 cm.
Collection of Dale Rosengarten

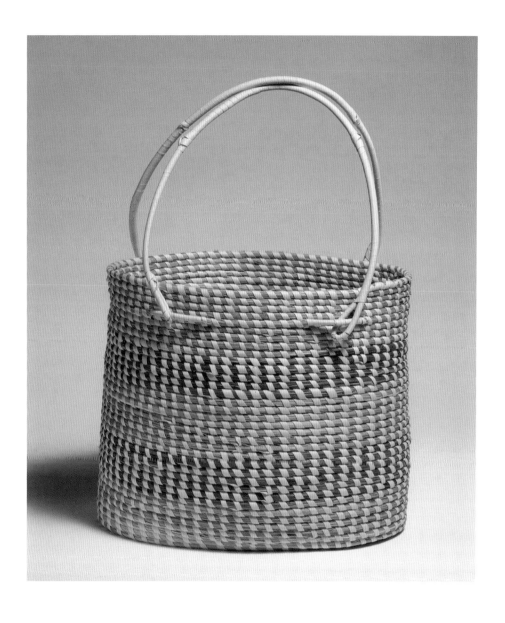

Necessity and Invention: The Art of Coiled Basketry in Southern Africa

Sandra Klopper

ABOUT TWO THOUSAND YEARS AGO, iron-using agro-pastoralists from East Africa began to migrate to southern Africa in fairly large numbers, initially settling along the Indian Ocean coastline and its immediate hinterland. From there, these communities gradually moved further inland, where they established increasingly complex technologies and social structures over the course of the second millennium A.D. While there were no comparable migrations from the west, two small groups of West African slaves also ended up in southern Africa following the arrival at the Cape of Dutch traders in the mid-seventeenth century.[1] The first group, which was captured by the Dutch from a Portuguese slave ship on its way to Brazil, originated from present-day Angola, while the second group came from Ghana. There is also evidence to suggest that the *mfecane*, the violent unrest in Southeast Africa which culminated in the emergence of the Zulu kingdom in the early nineteenth century, may have been fueled by European slave traders and settlers, who appear to have contracted local leaders to supply slaves to the Portuguese at Delagoa Bay in present-day Mozambique.[2] The hypothesis remains controversial, yet it is possible that some of the similarities between coiled basketry from southern Africa and South Carolina reflect a more complex history of African slavery than is commonly assumed. At the minimum, basket making in South Africa offers a comparative case that at times runs parallel to the Lowcountry tradition.

When H. P. N. Muller and J. F. Snelleman published their handsomely illustrated *Industrie des Cafres du Sud-Est de L'Afrique* in 1892, they included three baskets from southeastern Africa, two of which are coiled (fig. 7.2 and cat. 97).[3] The first of these, a lidded vessel described by the authors as urn-like in shape, had been collected in the Delagoa Bay region; the other, a finely woven example used to store liquids like milk and water, was said to be from the Zambezi area, presumably a reference to the Upper Zambezi floodplain which was recaptured by the Lozi in 1864, after their defeat in 1838 by the Kalolo.[4] Here, baskets are still commonly made from the roots of the woodland tree, *combretum zeyheri* (cat. 98).

Other nineteenth-century European observers showed an even greater interest in baskets from the southern African region. Thus, for example, when the artist-explorer George F. Angas published his folio volume, *The Kafirs Illustrated*, in 1849,[5] most of the hand-tinted plates recording his visit to the Zulu kingdom in 1847 included prominently displayed coiled baskets. The majority of these vessels were decorated with simple, over-sewn geometric patterns that are used to this day. Unfortunately, early observers like Angas seldom recorded the source of the vegetable dyes for these decorations, but particular shades or colors appear to have been obtained from a variety of plants, usually by boiling or simmering the leaves, stems, bark, or branches.[6]

Contemporary records suggest that the sources of vegetable dyes have varied considerably. Among Ndebele communities living in Matabeleland in present-day Zimbabwe, brown shades are obtained from the roots and bark of the *umnyi* tree, while black shades are produced from the *isigangatsha* tree.[7] Other dyes, like that extracted from the root of *Euclea divinorum*, are

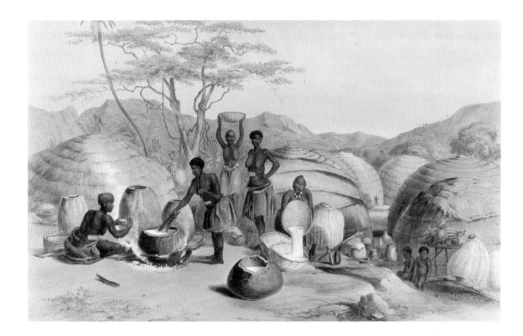

used throughout the region. This root dye has more than twenty vernacular names across Africa.[8] In Botswana, the fruit of the tree is used for making both beer and a purple dye,[9] while in Namibia weavers now extract dyes from old tin cans and rusty chains.[10]

The materials used to make coiled baskets vary from place to place, and in the past often depended on function. Large grain storage baskets usually were made from coarse thatching grass, while the ilala palm fronds (*Hyphaene coriacea*) commonly used to over-sew the baskets coiled from grass ropes (*Rhynchelytrum setifolium*) in present-day KwaZulu-Natal have a waxy surface that makes this material ideal for weaving watertight containers. (In some communities, basket makers seal their vessels with a paste of corn.) Palm is also favored in the Nata River region of Botswana, where the leaves of the mokol(w)ane tree (*Hyphaene ventricosa*), a fan palm, are commonly used in the production of coiled baskets.[11] Elsewhere, sisal is employed for durable baskets such as the Swazi *titja* (or *sitja*) that traditionally were given as gifts and are said to symbolize a long and productive life. In the Matabeleland region, sisal has become a common basket-making material, replacing the indigenous "mother-in-laws' tongue" (*sansevieria*) because it has longer threads.[12]

Although the qualities of available materials have always determined the type of coiling techniques used by particular communities, with few exceptions a simple over-sewing method is standard across southern Africa.[13] Several types of coiling, like the fine furcate sewing that appears formerly to have been used for all baskets among the Xhosa and Thembu, have disappeared altogether.[14] In some parts of southern Africa, such as the Matabeleland area in present-day Zimbabwe, not all communities make coiled baskets. The baskets produced among the Ndebele to the south and east of this region, where coiling is favored, differ radically from the woven baskets made by Tonga communities in the Binga and Hwange districts to the north.[15]

TRADITIONS AND TRADE

Historically, baskets were made for innumerable uses. Angas's plate depicting women making beer in a homestead near the Thukela River (previously called the Tugala River), formerly the border between the Zulu kingdom and the colony of Natal, includes several large grain storage baskets along with baskets used in the production of a fermented millet beverage that is still consumed (fig. 7.1).

Fig. 7.1
"Zulu women making beer at Gudu's Kraal, on the Tugala River," plate 27 from George F. Angas, *The Kafirs Illustrated*, 1849

In the accompanying text, Angas writes the following description of this common domestic activity: "The large earthen jars over the fire contain the beer which, after boiling, is set aside for some days to ferment. One woman is stirring the millet about with a calabash spoon, whilst another is testing its quality in a little cup; a third woman is advancing with a basket of millet on her head, and a fourth is pouring out the liquor in waterproof baskets."

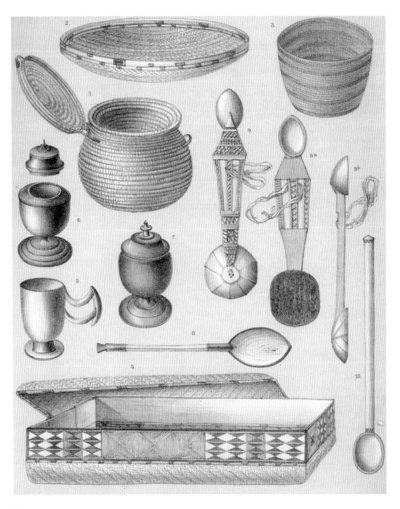

Fig. 7.2
Plate 12 from H. P. N. Muller and J. F. Snelleman,
Industrie des Cafres du Sud-Est de L'Afrique, 1892.

PICTORIAL COVERED BASKET
Lozi. Zambia
Early 20th century
L. 39.3 cm.
American Museum of Natural
History, 90.0/706

This basket was produced
in a craft workshop started
in 1905 by King Lewanika of
Barotseland (western Zambia).

Cat. 97
COILED BASKET WITH HINGED LID
Zulu. South Africa
Late 19th or early 20th century
H. 15.3 cm.
American Museum of Natural History,
90.1/8016

An identical basket appears in plate 12 of
Industrie des Cafres du Sud-Est de L'Afrique,
above.

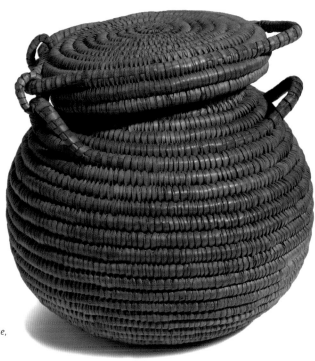

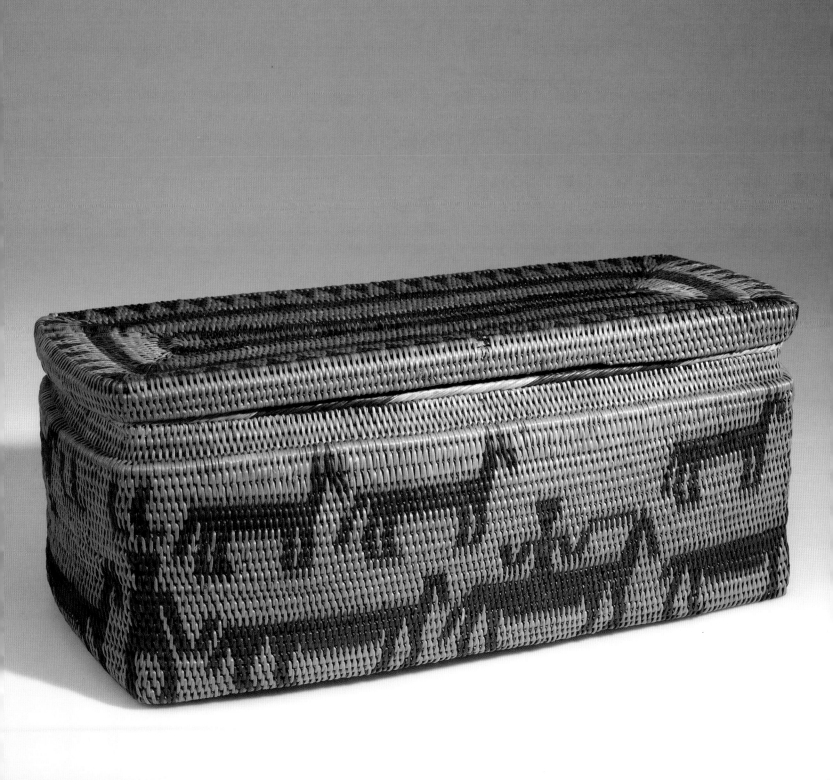

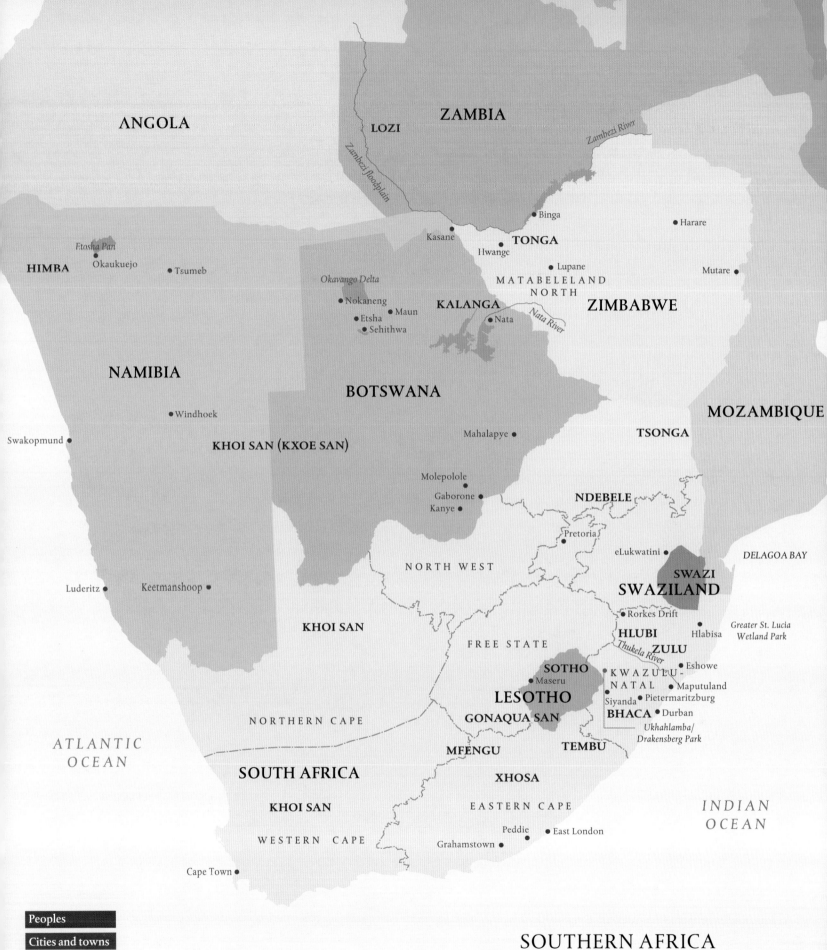

ANGOLA

ZAMBIA

LOZI

Zambezi floodplain

Zambezi River

• Binga

• Harare

Kasane •

TONGA

HIMBA

Etosha Pan

Okaukuejo •

• Tsumeb

I Iwange

ZIMBABWE

• Lupane

• Mutare

MATABELELAND
NORTH

Okavango Delta

• Nokaneng

KALANGA

• Nata *Nata River*

• Etsha Maun •

• Sehithwa

NAMIBIA

BOTSWANA

MOZAMBIQUE

• Windhoek

Mahalapye •

TSONGA

Swakopmund •

KHOI SAN (KXOE SAN)

• Molepolole

NDEBELE

Gaborone •

Kanye •

• Pretoria

DELAGOA BAY

eLukwatini •

SWAZI

SWAZILAND

NORTH WEST

Luderitz •

Keetmanshoop •

Rorkes Drift •

*Greater St. Lucia
Wetland Park*

KHOI SAN

FREE STATE

HLUBI

• Hlabisa

ZULU

Thukela River

SOTHO

K W A Z U L U -
N A T A L

• Eshowe

• Maseru

LESOTHO

Siyanda • • Pietermaritzburg

• Maputuland

ATLANTIC
OCEAN

NORTHERN CAPE

GONAQUA SAN

BHACA • Durban

*Ukhahlamba/
Drakensberg Park*

MFENGU

TEMBU

SOUTH AFRICA

XHOSA

INDIAN
OCEAN

KHOI SAN

EASTERN CAPE

• Peddie • East London

WESTERN CAPE

Grahamstown •

Cape Town •

Peoples

Cities and towns

Regions

Countries

SOUTHERN AFRICA

Fig. 7.3

In the Eastern Cape, people used narrow, waterproof baskets when milking cows,[16] while "large garden baskets were used for carrying produce from the fields, for winnowing and for general purposes."[17] Flanged open from a narrow base, these baskets were designed to facilitate carrying heavy loads on the head, in some cases by hollowing the base to fit the head more firmly (fig. 7.4). Hollowing the base has the additional value of allowing air to circulate beneath the basket when it is placed on the ground (fig. 7.5).[18] Carrying-baskets with handles also are fairly common. Among the Kxoé San of Namibia, where the tradition of making coiled baskets with handles almost disappeared, the intervention of craft advisor Annie Symonds has led to the revival of these forms, which are used both to collect wild fruits and to store dry foods.[19]

To meet the demands of a growing external market, basket makers from various southeast African communities now create receptacles for virtually every household requirement. The Himba of Namibia not only refrain from covering baskets intended for sale to outsiders with fat and ochre, as they normally do for their own use, but also add extra leather strips, cowrie shells, and metal beads to attract the interest of buyers.[20] Likewise, in Zimbabwe, baskets historically decorated with figurative motifs, depictions of male aprons, spears, and shields, all of which have long since disappeared from village life, are still favored by outsiders.[21] Similar responses to forms preferred by buyers have been recorded elsewhere in the region, including Angola, where basketry inspired by European models is made for sale to Portuguese expatriates and wealthy Angolans. Reflecting on the Angolan experience, cultural anthropologist Sónia Silva suggests that it would be appropriate to view these transformations as examples of Jan Vansina's notion of changing continuities, that is, the capacity of traditions to adapt to new needs and circumstances.[22]

In South Africa, new styles had been introduced to mission school pupils by the early nineteenth century. The emphasis on vocational training favored by these missions from the very beginning[23] was actively reinforced by the 1854 Constitution Ordinance of Sir George Grey, which announced the Cape Government's decision to subsidize missions that undertook to train African youths either for industrial occupations or to be interpreters, evangelists, or schoolmasters.[24] Other early basketry adaptations appear to have been dictated by trade relations with white settler communities. By the 1830s, Xhosa-speaking producers were trading baskets and mats at the Fort Willshire Fair in the Eastern Cape.[25] A growing external market following the allocation of land in this region to British settlers in 1820[26] inspired Mfengu artisans living in the Peddie district near present-day East London to start making "coiled sewn baskets of split palm-leaf or sedge, with lids and handles."[27]

The practice of trading baskets with neighboring groups was common even before the twentieth century. Some early examples of Xhosa basketwork now in museums were collected from the Gonaqua.[28] Likewise, while San communities historically used animal skins for carrying and storing foods, at least by the mid-twentieth century some of these groups had begun to acquire Tswana-style garden baskets for this purpose.[29] Other southern African communities may have adopted basketwork techniques from their near neighbors, among them Hlubi, some Thembu, and some Bhaca sewers, all of whom use a comparatively heavy coil employed by South Sotho basket makers.[30] Materials for making baskets also were traded. For instance, in areas where riverine and coastal sedges were not available, these grass-like materials were supplied by indigenous traders and, later, rural shopkeepers.[31]

Among neighboring southern African communities, the exchange of both basketwork technologies and commodities can be seen in Muller and Snelleman's observation that the basket from the Delagoa Bay region illustrated in *Industrie des Cafres* was fashioned in the "Zoulou" style (fig. 7.2). Its distinctly hybrid form suggests that it was made to meet a demand for lidded vessels from Portuguese traders who first settled in the region in the eighteenth century. The reference to the Zulu presumably pointed to the coiling technique used in the production of this basket. Either way, Muller and Snelleman's comment indicates the complexity

Fig. 7.4
Amakosa woman returning from work, Thomas Baines, early 1870s. Oil on canvas, H. 61.5 x W. 45 cm Iziko Museums of Cape Town, 1291.

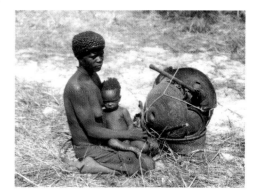

Fig. 7.5
Muluchazi farmer and her child with baskets, one with an indented base, Zambia, 1930s. Duggan-Cronin Collection, McGregor Museum, Kimberley.

of trade relations among communities in the region, which in many cases were shaped by social and political inequalities sustained through the extraction of tribute, in the form of both raw materials and manufactured items like baskets.

In the case of the Zulu kingdom, which actively exploited not only its Tsonga tributaries to the north, but also other Zulu-speaking communities to the south of the Thukela River, this pattern of appropriation is vividly captured in Bikwayo kaNoziwawa's 1903 account of his travels with his father to the Delagoa Bay hinterland as a young boy a half-century earlier. He remembered going there to collect, among other things, skins for the warriors' dancing girdles and headbands; imported blue cloth for women living in the king's royal homestead; large red beads and lion and leopard claws reserved for important office bearers; elephant tusks, which the king exchanged for other commodities with European traders at Port Natal; rhinoceros horns for making snuff boxes; and calabashes, gourds, beer baskets, and food baskets. Bikwayo concluded his account of these journeys by noting that "when the things were ready, the Tonga king would furnish men to accompany us with the things to Zululand, they acting as the carriers. Things were fetched from Tongaland year by year. No year passed without this being done."[32]

In Botswana, former hunter-gatherer communities from the Nata River region, northwest of Francistown, who over time had become master basket makers, sometimes traveled in large caravans carrying goods on their heads and on donkeys to neighboring Kalanga villages. "In return for Nata goods Kalanga people gave old clothes, tobacco, sorghum and money." Since the price of a basket was often determined "by filling it once with sorghum, or sometimes twice in the case of an especially fine specimen,"[33] the Kalanga clearly appreciated not only the use value of these baskets, but also the skills involved in producing them. With the growth of a cash economy and an increase in the local population, these baskets have come to be offered for sale either at Bangwato or Kalaga cattle posts or to nearby villagers.

The availability of commercially made vessels has not necessarily discouraged the use of local manufactures, especially in places where women have historically been responsible for making most types of baskets. In the 1970s, anthropologist Melinda Ebert found that with the exception of some winnowing baskets made by men—interestingly these are more often woven than coiled—it was the older women from the Nata River region who tended to produce coiled baskets. Although younger women were in some cases also skilled basket makers, these older women monopolized basket production because they were expected to do lighter and more prestigious work than their younger counterparts.[34] Here, baskets continued to play an important role in the daily routine of village compounds, where they were used in nearly all aspects of the production and manufacture of food.[35] Because they attached considerable value to these baskets, women were careful to protect them from rough use. In some cases leather or a heavy cloth was used to repair or reinforce the base or rim of a worn basket.[36]

In the Eastern Cape, men now tend to assist with the harvesting of sedges, but even so, prejudice against male involvement in this activity remains widespread.[37] Here, baskets are still associated with important ceremonies, notably the initiation rites of girls and rituals linked to the end of the mourning period prescribed for widows,[38] and it is common for basketry to be traded rather than bought. In some cases, baskets are made as gifts for neighbors in appreciation of their assistance or cooperation.[39]

In other parts of southern Africa, notably among communities in present-day Angola and Zambia, baskets continue to play a crucial role in the *ngombo ya cisuka* (or *kusekula*) method of divination—literally, shaking the basket. The objects placed in these baskets include figurative carvings, animal parts, shells, and other found objects (cat. 37, p. 68).[40] Viewed as a microcosm of life "that is activated by the diviner to find the cause and resolution of personal and social problems,"[41] this method of divination is restricted to male diviners, but the baskets they use presumably are made by women.[42]

MEN'S WORK AND WOMEN'S WORK

In KwaZulu-Natal, basket traditions historically associated with men were gradually taken over by women in the course of the twentieth century (fig. 7.6).[43] Hastened by the departure of men in search of work in the mines and in large cities such as Durban and Johannesburg, female involvement in the basket industry received renewed impetus in the late 1980s following the breakdown of the apartheid state's influx control regulations.[44] Rural women flocking to the cities to join their husbands sought new forms of employment. Some found work in cottage industries serving the burgeoning tourist market in coastal centers. Forced to flee the violence in townships on the outskirts of Durban, these same women moved to the Siyanda informal settlement, which has since become noted for the production of large coiled platters made from multicolored telephone wire.

First among these female wirework artists was Zodwa Maphumulo, who moved to Durban in 1980. She was soon followed by others, including Ntombifuthi Magwaza, who also came from a rural background and relocated to Siyanda in 1988 (cat. 99). The winner of a highly respected national craft award in 1998, Magwaza, along with many of her fellow wirework basket makers, has since traveled abroad on many occasions to participate in international exhibitions. In 2004, several wirework basket artists visited the International Folk Art Market in Santa Fe, New Mexico, while others participated in an exhibit at UCLA's Fowler Museum showcasing the HIV/AIDS crisis facing South Africa.[45] To this day most continue to live in Siyanda, where producers assist and teach one another, and serve as role models for neighbors, many of whom have also begun to support themselves by making and selling large wirework platters. Siyanda affords an extraordinary example of the development of networks of trust—or social capital—for the mutual benefit of its inhabitants.

The use of color and pattern in many of the wirework platters currently produced in Siyanda is demonstrably influenced by the design principles underlying local beadwork traditions. Wirework platters evolved from the making of coiled beer pot lids (cats. 100–105), a practice which survived the migration of men to the cities partly because many of those who were able to earn wages as night watchmen in urban centers spent the long hours of the night making beer pot lids and decorating the shafts of the knobsticks they carried as defensive weapons. The widespread and often-repeated assumption that KwaZulu-Natal's contemporary wirework renaissance can be traced back to these watchmen is supported by the fact that colonial legislation prevented all other migrants from entering urban areas with potential weapons. In the late nineteenth and early twentieth centuries, magistrates in Natal debated the correct interpretation of the decree, some arguing that migrants should be allowed to carry at least one stick for the purpose of self-defense, while others maintaining that only certain types of sticks were affected by these laws. In practice the sticks carried by those entering urban areas were commonly confiscated. The only migrants who were excluded from this legislation were night watchmen and members of the "native" police force.

As time passed, it became increasingly difficult to obtain the copper and brass wire commonly used to decorate the shafts of knobsticks. Similarly, city dwellers found it almost impossible to locate reliable sources for the ilala palm (*Hyphaena coriacea*) used in making beer pot lids (*izimbenge*). Telephone wire—initially covered with brittle synthetic materials—began to fill this gap as early as the 1930s, but the range of colors available to producers was extremely limited until the early 1990s when Marisa Fick-Jordaan of the BAT Centre in Durban[46] convinced Intercable, a plastic-coated copper telephone wire manufacturer, to supply weavers at the Centre with an expanded range of colors. Fick-Jordaan attributes her success in achieving this objective to the desire of suppliers to stem the growing theft of underground telephone cables used to make a variety of wirework artifacts, including baskets.[47]

(continued on page 188)

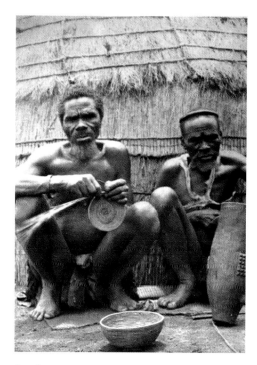

Fig. 7.6
Men making baskets, from A. T. Bryant, *Olden Times in Zululand and Natal*, 1929.

Cat. 99
WIRE BASKET
Ntombifuthi Magwaza
South Africa
Ca. 2004
D. 49.5 cm.
American Museum of Natural
History, 90.2/9789

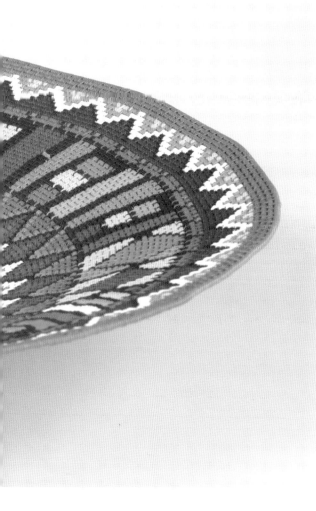

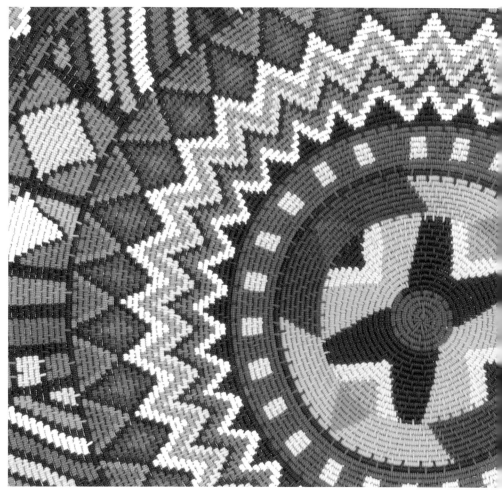

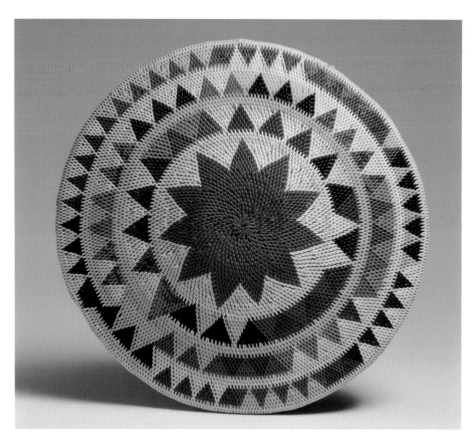

Cat. 102
BEER POT LID (*IMBENGE*)
Zulu. South Africa
20th century
D. 20 cm.
Collection of Bill and Gale Simmons

Cat. 100
BEER POT LID (*IMBENGE*)
Zulu. South Africa
20th century
D. 20 cm.
Collection of Kim Sacks

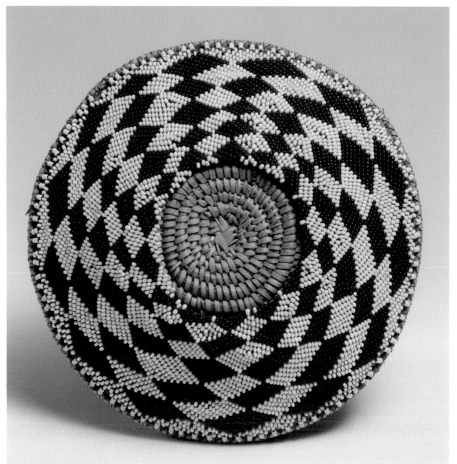

Cat. 101
BEER POT LID (*IMBENGE*)
Zulu. South Africa
20th century
D. 17 cm.
Collection of Kim Sacks

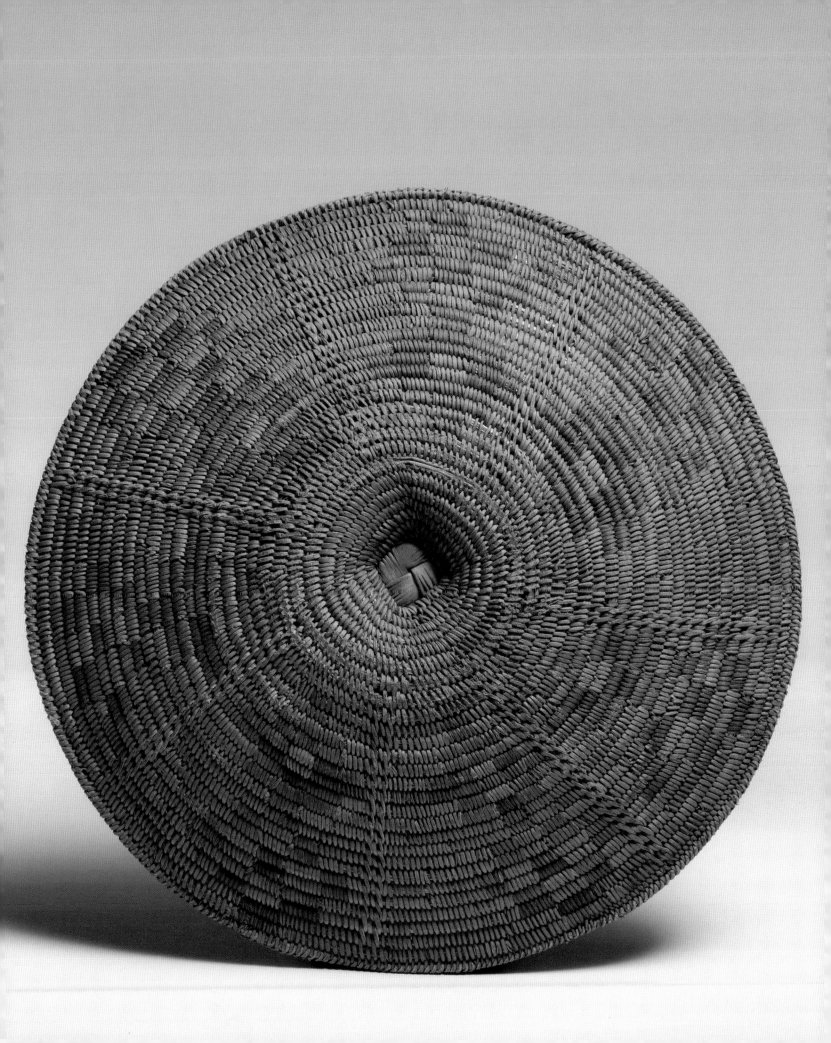

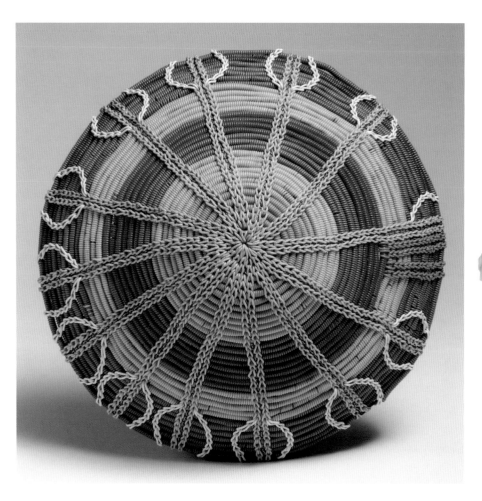

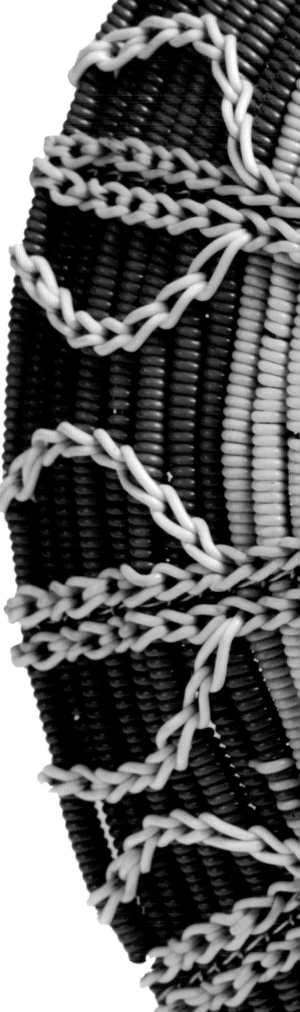

Cat. 103
BEER POT LID (*IMBENGE*)
Zulu. South Africa
20th century
D. 19 cm.
Collection of Kim Sacks

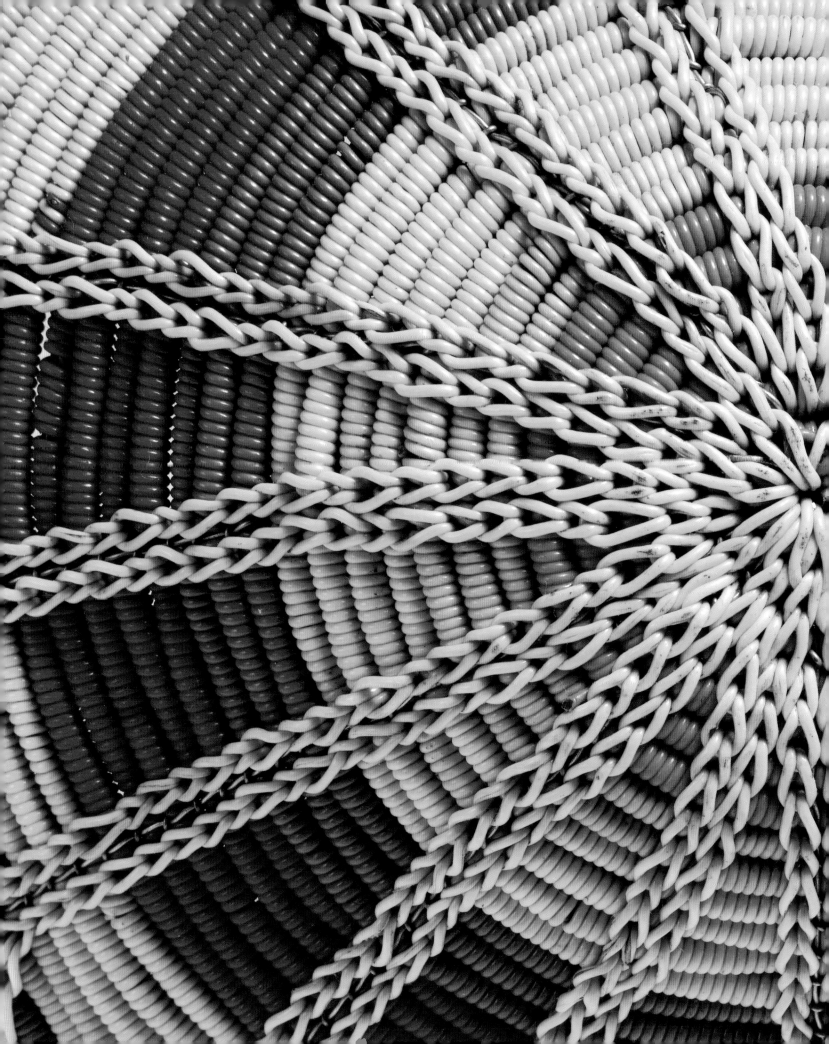

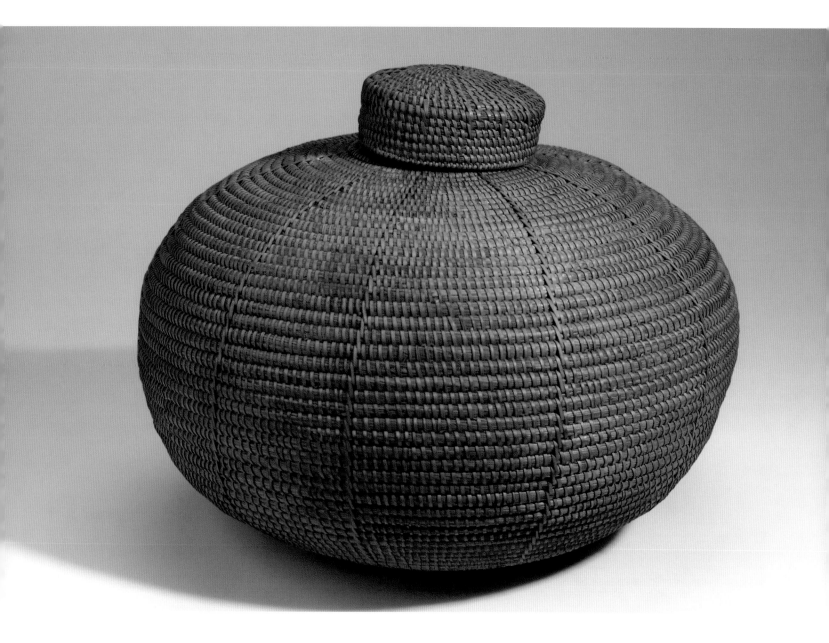

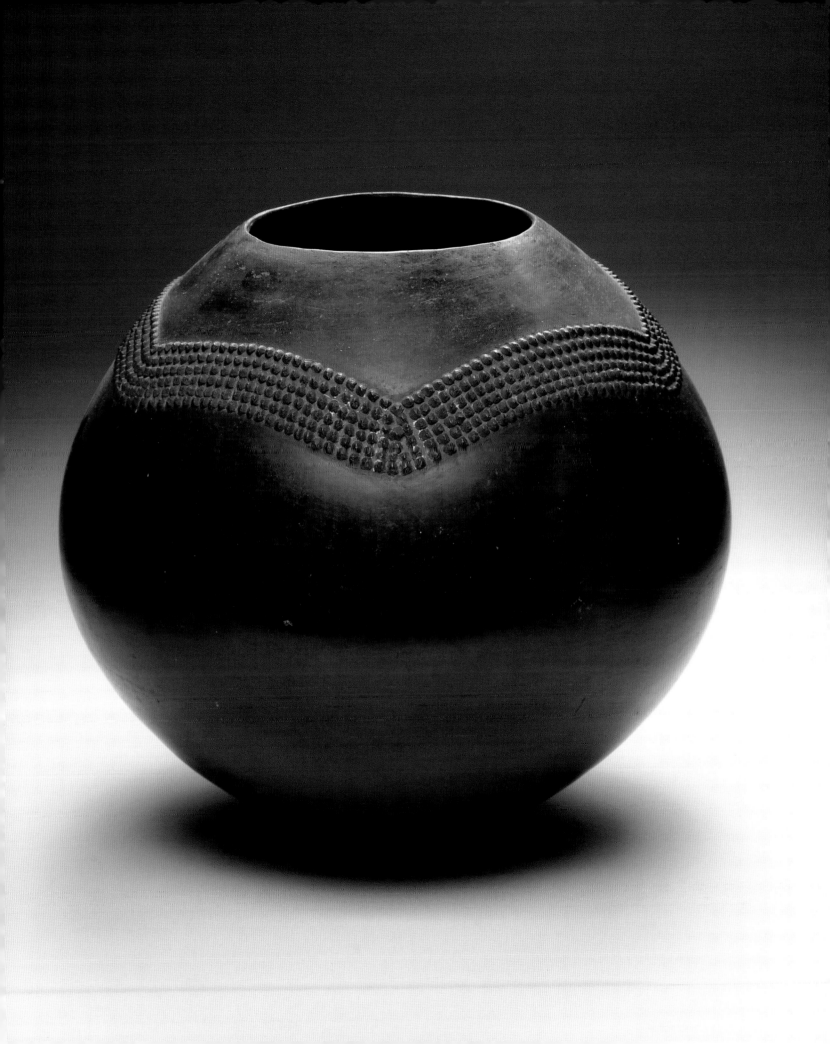

Mdegi Elliot Mkhize, the self-styled father of the contemporary plastic-coated wirework tradition, claims to have begun the practice of decorating sticks with multicolored telephone wire while guarding the stage doors at the Natal Performing Arts Council in the early 1970s.[48] It is virtually impossible to reconstruct the recent history of wirework production in Durban and other urban areas, or Mkhize's role in it, partly because Mkhize tends to highlight his own contribution to the exclusion of both earlier practitioners and others, like Bheki Dlamini, who once worked with Mkhize at Fast Sales, a Durban-based company specializing in automobile reupholstery. Dlamini later became an acclaimed wirework platter artist who celebrated his love of soccer in his works. His career was cut short by his death from cancer in 2003.

Mkhize maintains to this day that it requires strong hands to produce baskets—especially when they are made from plastic-coated telephone wire—and therefore that it is not easy for women to succeed. Yet, women entering the greater Durban area in the course of the 1980s have come to dominate this market, forming cooperative networks that now also include male producers like Ntombifuthi Magwaza's husband, Bheki Sibiya, and Vincent Sithole, a construction worker who moved temporarily from northern KwaZulu-Natal to Siyanda in 1996 to live with his sister. Sithole learned to make wire platters by watching others. Ntombifuthi Magwaza was taught by her neighbor, Anna Maria, wife of Bheki Dlamini, the now deceased artist who once worked at the same factory as Mkhize. Already in the early 1990s, efforts were made to place the informal transmission of these wirework skills among residents of Siyanda on a more formal footing through the intervention of Jo Thorpe, then director of the African Art Centre in Durban. Thorpe had encouraged Mkhize to make plates that could be marketed by the Art Centre, and subsequently convinced him to run workshops to teach others to make wire baskets.

While Mkhize is exceptionally skilled, the idea of producing large, densely decorated coiled plates or platters rather than shallow bowls or izimbenge appears to have originated with Bheki Dlamini. This shift in scale was suggested to Dlamini by an American buyer, now only remembered by his first name—Ned—who visited the BAT Centre in 1995, soon after Marisa Fick-Jordaan began to work there. At that stage, most of the plates were not only small, but by far the majority were decorated with comparatively simple geometric designs in a limited color range dictated by the plastic-coated wire that could be found at local Durban scrap yards.

Ned's request was the first of many interventions that have impacted this art form, including the willingness of Intercable to supply producers with a wide range of colors and a request by the French artist, Hervé Di Rosa, for several wireworkers to fabricate large coiled discs based on his designs. Determined to "reconcile African heritage to contemporary art," Di Rosa adapted his designs to the technical constraints of the wirework medium.[49] Five weavers who agreed to work on his project—two women, Alice Gcaba and Zodwa Maphumulo, and three men, Simon Mavundla, Elliot Ndwandwe, and Vincent Sithole—have continued making work influenced by his ideas, in particular certain color combinations and the inclusion of concentric circles overlaid by larger motifs. Ultimately, however, Di Rosa's project served to underscore the resilience of already established formal and iconographic solutions. Rather than illustrating Edouard Glissant's notion of a "critical bricolage"—a creolizing process predicated on the idea of infinite cultural transformation through entanglement[50]—his intervention demonstrates the selective ways in which local communities appropriate design solutions from outsiders.

Today, many of these solutions reflect the gender biases and concerns of the wirework artists. Whereas male producers typically weave platters that rely on the use of simple designs similar to those found on wirework izimbenge dating to the 1960s, or, like Bheki Dlamini, introduce references to contact sports like rugby and soccer, the work of female producers is often lyrically colorful and contains nostalgic references to life in and around the thatched rural homesteads of their youth. Others, like Ntombifuthi Magwaza, who was born in 1965 in

Nongoma and raised by her grandmother, a skilled beadworker, produce abstract designs that initially were inspired by aesthetic principles evidenced in local beadwork traditions. According to Magwaza, these designs are not planned in advance, but emerge organically through the juxtaposition of different colors.[51] As early as 1996, soon after Magwaza began to make coiled platters, Fick-Jordaan was so impressed by her work that she lent her a book on embroidery and showed her images of kilim carpets in an effort to nurture her remarkable creativity.

INVENTIONS AND INTERVENTIONS

Inspired by the success of Siyanda telephone-wire basketry, Telkom, South Africa's telecommunications giant, began in 2001 to encourage other communities to produce baskets using commercially manufactured insulated wire. In the first phase of this project, the company provided 200 kg of scrap plastic-coated copper wire on a monthly basis to the Kusile crafters from Elukwatini in Mpumalanga Province. In partnership with the National Crafts Council of South Africa, Telkom also undertook to train twenty previously unskilled women with a view to enabling them not only to produce high quality, marketable craft products, but to pass their skill on to other women. While Telkom sought to demonstrate its commitment to community empowerment through these initiatives, it also used this platform to join forces with other partly privatized companies and the South African Chamber of Mines to lobby for greater control over the scrap copper market with the aim of curbing the widespread theft of telecommunications cables.[52]

The state has also been involved in ventures to promote awareness of local artistic traditions through projects such as the 1997 Year of Cultural Experiences stamp collection issued by the South African Post Office to commemorate May 17th as National Museums' Day. Similarly, following the country's first democratic election in 1994, the Department of Arts and Culture has played an increasingly active role in promoting craft traditions. For example, it launched the Cultural Industries Growth Strategy (CIGS) in an effort to maximize the economic benefits to artists through programs that support "innovative and creative human capital."[53] Between 2001 and 2003, the department also secured funds from the National Treasury's Poverty Alleviation Programme and distributed the money to craft projects and initiatives under the mantle of the "Investing in Culture Programme."[54]

The reality, as arts educator Joseph Gaylard notes, is that the government policy of translating investment "into self-sustaining craft businesses" has been severely hampered by a variety of factors. For reasons usually beyond their control, craft producers have been unable "to adapt their work, modes of organization and production to market demands and opportunities." Facing the "absence of any meaningful interface between producers and markets," contemporary basket makers often manage to secure buyers for their work only by accident.[55] The experience of Elias Mtshengu, the recipient of the first prize in the copper section at the "Contemporary Zulu Basketry Exhibition" held in Johannesburg in 2000, bears this out. A highly acclaimed practitioner, Mtshengu was nevertheless dependent on a sporadic market for selling his baskets until he unexpectedly received a large order from Paris.[56] Other producers have benefited from unforeseen changes in local circumstances. For example, the decision to declare South Africa's uKhahlamba/Drakensberg Park a world heritage site for the viewing of San rock art provided local women from this area with an opportunity to market their baskets and figurines to visitors at the Ndumeni Craft Shop.[57] All proceeds from these sales go to the women themselves. The dedication of this heritage site has significantly increased the capacity of some women to generate income to buy clothing for their children and pay their school fees.

The growth of tourism throughout Africa and, more especially, southern Africa, has provided intermittent marketing opportunities for basket makers whose wares are now often used to decorate game lodges, hotels, and guest houses. The use of local materials seems to play a significant role in promoting a feeling of authenticity in the construction and decoration of

tourist accommodations. Thatch and natural stone are used as primary building materials, and the indigenous crafts that stock the buildings are made from natural resources such as grass and wood. Described in promotional brochures as "rustic African" or "Afro-ethnic" in theme, these establishments lay claim in one way or another to "capturing the culture and spirit of Africa."[58] Yet the origins and makers of locally produced artifacts, including baskets, are seldom if ever identified. Ironically, the strategy of promoting African products to bolster tourism obscures the lives of the individuals whose ingenuity and ambition keep craft traditions like coiled basketry vibrant to this day.

THE LEGENDARY LÖFROTHS

The undeniable role that ingenuity has played in the survival of basket traditions in southern Africa must nevertheless be measured against the intervention of missionaries and various non-governmental organizations that have encouraged the revival of coiled—and other—basketry, in many cases transforming the art form into a thriving cottage industry. While most rural communities have continued to use locally manufactured baskets, often in combination with plastic containers, in some areas the production of baskets was revived in direct response to the emergence of new markets.[59] Efforts to enhance the income-generating capacity of rural households have in many cases also strengthened relations between producers and their families, thereby contributing to a greater sense of social cohesion among economically marginalized groups.

The social and economic networks fostered through these initiatives have been particularly beneficial to highly skilled individuals, some of whom have received international acclaim for their work. Those who have continued to use traditional materials, such as Reuben Ndwandwe and Beauty Ngxongo—both of whom worked initially from Hlabisa in northern KwaZulu-Natal—are also widely admired by other craft specialists in their own communities. Writing in the early 1990s, the Senior Subject Advisor for Arts and Crafts in KwaZulu's Department of Education and Culture noted, "Whenever one travels . . . with a few of Reuben's baskets in the car, you are always stopped by other basket weavers who insist on handling his work and who express their admiration loudly."[60] Ndwandwe, who developed a distinctive method of sewing raised patterns over the base color of his coiled baskets, was one of many artists linked to the Vukani Association, founded in the late 1960s by Swedish missionaries Reverend Kjell and Bertha Löfroth (cats. 106–108).

The Löfroths' role in regenerating basketry traditions among rural Zulu-speaking communities from present-day northern KwaZulu-Natal is legendary. But since most accounts of their efforts to assist local crafters are couched in anecdotal detail, the significance of their work to enable economically marginalized groups to develop and refine marketable skills has in many cases been lost.[61] Partly for this reason it is worth pausing briefly to consider not only how the Löfroths came to found the Vukani Association, but also why their initiative has continued to benefit producers in northern KwaZulu-Natal to this day.

Kjell and Bertha Löfroth moved to South Africa in 1951, and worked for five years at the Ceza Mission Station in northern KwaZulu-Natal. They were associated with the Evangelical Lutheran Church Art and Craft Centre at Rorkes Drift in the mid-1960s,[62] but are best remembered for their role in establishing the Vukani Association and for their decision to donate their own collection of Zulu baskets to South Africa following the unbanning of the African National Congress and other outlawed political organizations in 1990.[63] This collection, reputedly the largest of its kind, was assembled as part of the Löfroths' campaign to revive basket production among impoverished Zulu households. At the time, the apartheid regime and its supporters were unwilling to allocate state funds to meet the minimum requirements set out by the 1955 Tomlinson Commission for the development of South Africa's segregated rural black communities.[64] Although today it is sometimes difficult to grasp the realities of

apartheid South Africa, in a 1969 nationwide poll of white attitudes, roughly forty percent of urban respondents felt that the state was spending far too much on the political and economic development of these malnourished, under-resourced, and under-educated communities.[65]

Largely in response to the ruling whites' disregard for the plight of marginalized black people, a new theology of liberation, spearheaded by the South African Council of Churches (SACC), emerged in the 1970s. In its challenge to the state, the SACC adopted a number of strategies to resist the policies of separate development. These included both the promotion of sanctions and disinvestments abroad and the introduction of programs at home aimed at assisting the rural and urban poor.

Because of its historic links to the area,[66] the Evangelical Lutheran Mission played a par-ticularly active role in the implementation of the SACC's anti-apartheid policy in KwaZulu, one of the so-called Bantustans founded by the apartheid regime in the 1960s. Then, as now, this region was inhabited mainly by elderly people and the wives and children of migrants working in the mines and large cities. Relying partly on the sporadic remittances they received from their husbands, and partly on the meager state pensions paid to the elderly on a bi-monthly basis, residents of these communities had to supplement their incomes through subsistence farming, planting crops like maize, sorghum, and pumpkins for household use.

Initially, the Löfroths' labors to assist some of these women through the Vukani Association were little more than a desperate attempt to support starving families in the wake of a severe drought that had crippled northern KwaZulu in 1966 and 1967. Their attempts to distribute food to needy households had to be abandoned when funds for this purpose dried up. Interviews with those who had benefited from this scheme revealed that what people really wanted was work. These interviews "always ended with two questions: Would you be prepared to make things at home and bring the produce to us and we try to sell them for you?" to which the response was invariably positive. On this advice, the SACC undertook to assist producers to market the skills they normally employed to make household items for themselves.[67]

At first, women brought basketry beer strainers to the Löfroths, but there was virtually no external market for these items. So the Löfroths decided in 1970 to help the women develop a market for grass place mats similar to the grass eating-mats used by Zulu-speaking communities in the nineteenth century. In a subsequent phase of this project, producers were encouraged to make other items such as grass lamp shades and roller blinds. In 1972, greater attention began to be paid to the production of coiled baskets, which eventually became a lucrative source of income for countless women, as well as for a few men like Reuben Ndwandwe.

Under the guidance of Kjell and Bertha Löfroth, the Vukani Association established a set of clear principles for the production of baskets, first outlined in a letter Kjell Löfroth wrote to priests who headed parishes in the region. Affirming the need to develop close links with "the people concerned," he expressed the conviction that it was essential to find "their interests, abilities and then to establish their involvement in running the project . . . as well as to take care of their creative gifts." This, he maintained, would secure their commitment to the venture.[68] Insisting that "production should concentrate on useful articles, both for the local market and outside the area concerned," he mused, in retrospect, that his preliminary thoughts on how to proceed included a decision not to complain about any of the work offered by the women.[69] Instead, these women "were asked to bring their homemade articles, even used ones." These items were then discussed and evaluated "from the point of view of form, size and colour" before potentially saleable articles were bought and further examples ordered. Always respectful in his dealings with rural basket makers, Löfroth nevertheless intervened subtly but firmly whenever he felt the need to do so: "Shoddy work is returned, fine work praised, new designs encouraged."[70]

Cat. 106
SIGNATURE BASKET
Reuben Ndwandwc
South Africa
Ca. 2004
H. 31 cm.
Private collection

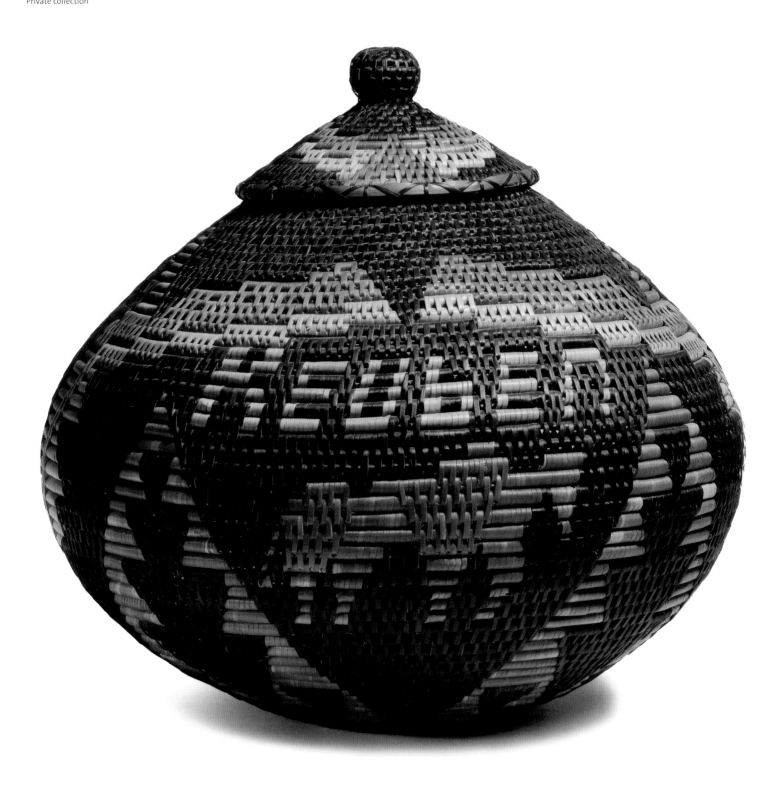

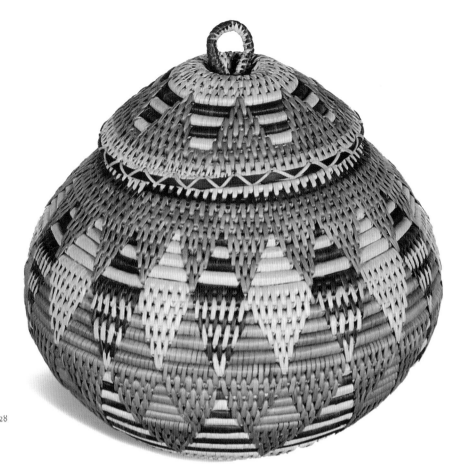

Cat. 107
BASKET (*IQUTHU*)
Reuben Ndwandwe
South Africa
Late 20th century
H. 19.5 cm.
Durban Art Gallery, SC 28

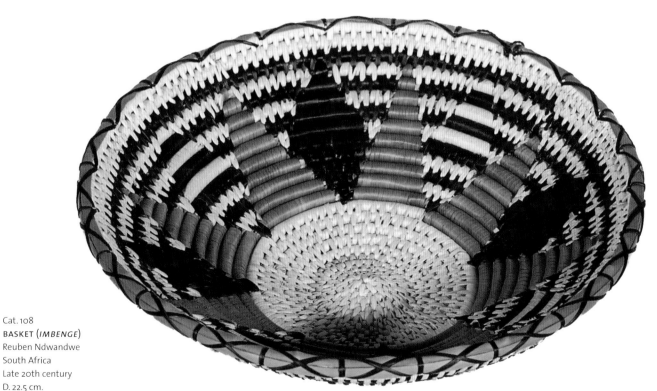

Cat. 108
BASKET (*IMBENGE*)
Reuben Ndwandwe
South Africa
Late 20th century
D. 22.5 cm.
Durban Art Gallery, SC 618

The following year, 1973, the Vukani Association—in Zulu, *vukani* means "wake up and go"—was formally founded with the support of members of the Anglican, Congregational, Lutheran, Methodist, Presbyterian, Catholic, and independent churches. By then, the project was facilitating the sale of baskets by an increasing number of women and also had begun to organize short courses run by already skilled individuals who were able and willing to impart their knowledge to other producers.[71] Established as an independent, non-profit organization, Vukani was at first owned by 1,050 craft-workers on a cooperative basis, with each of the sixty groups belonging to the association electing a committee "to supervise, guide and help producers to assess quality and to price their own work."[72]

During 1974, seven hundred producers were selling their handicrafts through the Vukani Association, three hundred on a regular basis. Some of this work was marketed at the association's retail outlet in Eshowe, which by 1975 was being visited regularly by the producers themselves. In the years to follow, Vukani Association baskets and other items began to develop a regular clientele at the annual Zululand Agricultural Show and at exhibitions in Durban, Cape Town, and abroad. This increasingly positive reception is reflected in the association's annual report of 1976, which noted that "the desire to work, create articles and make use of time, talent and materials has brought many improved articles into regular production and also new articles into being."[73]

A NEW GENERATION

By the time the Löfroths returned to Sweden in 1986, the Hlabisa district near the Hluhluwe Game Reserve had become a major center for the production of baskets by skilled practitioners such as Reuben Ndwandwe and Beauty Ngxongo. Elsewhere in the region, access to natural resources like *Hyphaene coriaea* had become more difficult. This second generation of Vukani artists has since given rise to the emergence of new, equally striking talents, like Zanele Ntuli and Nelisiwe Mlotshwa, and also Angeline and Nomusa Masuku, whose baskets are characterized by increasingly complex over-sewn decorations (cats. 109–112). According to the Vukani practitioners, these designs are not symbolic, but reflect the inspiration of a host of sources, including beadwork and printed fabrics.[74]

Although technically Vukani baskets are identifiably similar, several individual artists who became associated with this project have developed distinctive styles. Commenting on the success of Reuben Ndwandwe, Jannie van Heerden pointed out as early as 1993 that this acclaimed artist's beer pot lids and woven pots (*izinkamba*) are always "delicately and intricately woven." While noting that Ndwandwe never veered from producing these traditional shapes, van Heerden observed that "his technique of intricate overweaving and his use of multicoloured designs" placed his work above that of other producers. Already, the sales generated by Ndwandwe's exceptional talent had "enabled him to establish a very successful and well equipped farm" in the Empangeni district of KwaZulu-Natal.[75] Born in 1943 in Mahashini, Ndwandwe had learned both carving and weaving at school, but it was only as an adult, when he spent time at Hlabisa Hospital after contracting tuberculosis, that he took up basket making in response to the encouragement of social workers trying to assist chronically ill patients to lead productive lives.

Beauty Ngxongo, who also has attained international fame, in her case for her boldly patterned *isichumo*—narrow-necked, often lidded baskets for holding liquids—has had a somewhat different career (cat. 113). Ngxongo learned to weave doormats and table mats when she was in primary school in the late 1950s, but it was only much later that she was taught to weave *isichumo* by one of her neighbors, Laurencia Dlamini, whose father had shown her how to make beer pot lids when she was a child. The bottle-shaped baskets produced by Beauty Ngxongo have become collectors' items due in part to her expertise in the art of over-sewn decorative detailing. Interestingly, a similarly shaped basket that presumably had been

Fig. 7.7
Woodcut from Rev. Joseph Shooter, *The Kafirs of Natal and the Zulu Country*, 1857.

inspired by contact with early European travelers was recorded by Reverend Joseph Shooter, an Anglican missionary stationed at Albert in the mid-nineteenth century (fig. 7.7).[76] In contrast to these nineteenth-century predecessors, Hlabisa basket makers have developed a wide palette of natural colors to decorate their commercial work.

While there is probably no single explanation for the decades-long success of the Vukani Association, Walter Morris suggests in his study of craft development models in South America that the sustainability of contemporary craft projects is predicated not only on the capacity of producers to generate an income, but also on the degree to which they are invested in and take pride in their work.[77] Viewed from this perspective, Vukani's focus on community empowerment and personal development likely was a key factor in transforming this initially modest venture into a viable, long-term enterprise. This thesis is confirmed by several of the interviews researcher Katarina Pierre conducted with women associated with the project in the late 1980s. Reflecting on her experience of producing baskets for Vukani, Reginah Nsele told Pierre, "I like my work very much. That's why I try by all means to spend more time in making baskets so that they will be beautiful. The more time I spend on making a basket, the more the basket . . . is nice." Nsele noted further that while Vukani's fieldworkers were "critical people . . . this is good because it is the way of improving on standards of work."[78] Nsele's commitment to excellence included improving on various aspects of the design of the baskets, such as the use of color for over-sewn patterns. By the late 1980s, she had abandoned the colors she had used at the beginning of her career. "I have acquired many colors that have made the quality of my work become very good," she acknowledged. "When I compare my today work with that of the early days, I realize that one cannot be an expert if one sticks to the same colors."[79]

Other commercial basketwork cooperatives also arose in response to economic necessity, notably a project started by Malcolm Thomas to provide employment for Angolan refugees who settled in the Etsha region on the edge of the Okavango Swamps between 1967 and 1969.[80] This endeavor expanded rapidly through the efforts of two American Peace Corps volunteers who managed to establish a market for these baskets in Europe and the United States. Soon thereafter, the Botswanacraft Marketing Company (Pty.) Ltd. was founded with

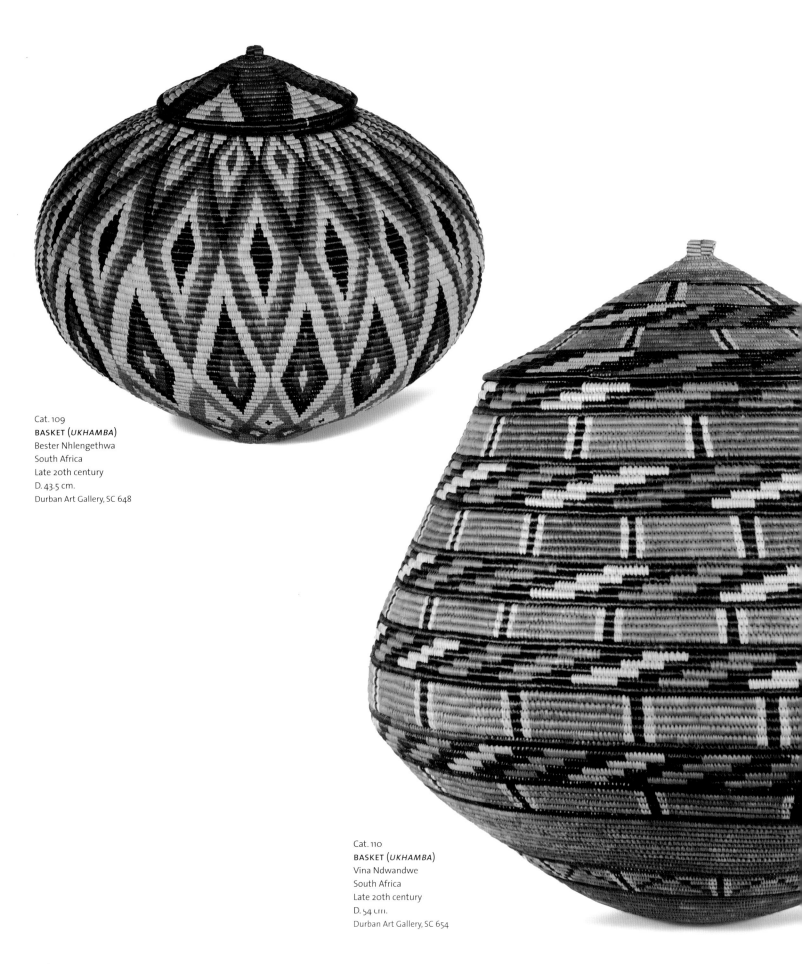

Cat. 109
BASKET (*UKHAMBA*)
Bester Nhlengethwa
South Africa
Late 20th century
D. 43.5 cm.
Durban Art Gallery, SC 648

Cat. 110
BASKET (*UKHAMBA*)
Vina Ndwandwe
South Africa
Late 20th century
D. 54 cm.
Durban Art Gallery, SC 654

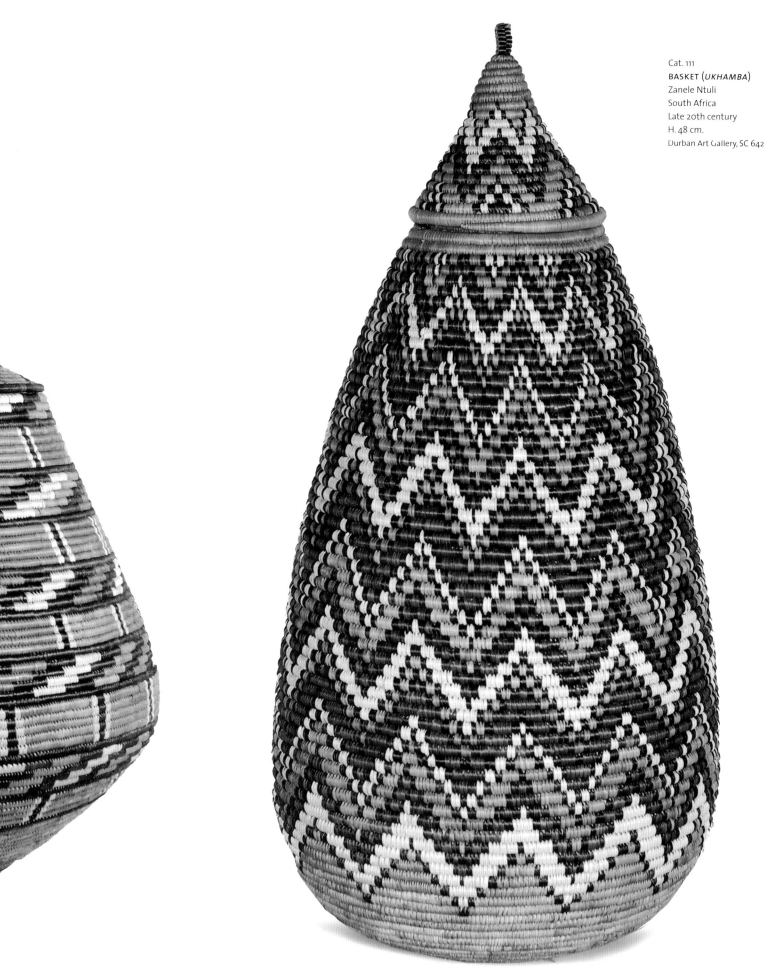

Cat. 111
BASKET (*UKHAMBA*)
Zanele Ntuli
South Africa
Late 20th century
H. 48 cm.
Durban Art Gallery, SC 642

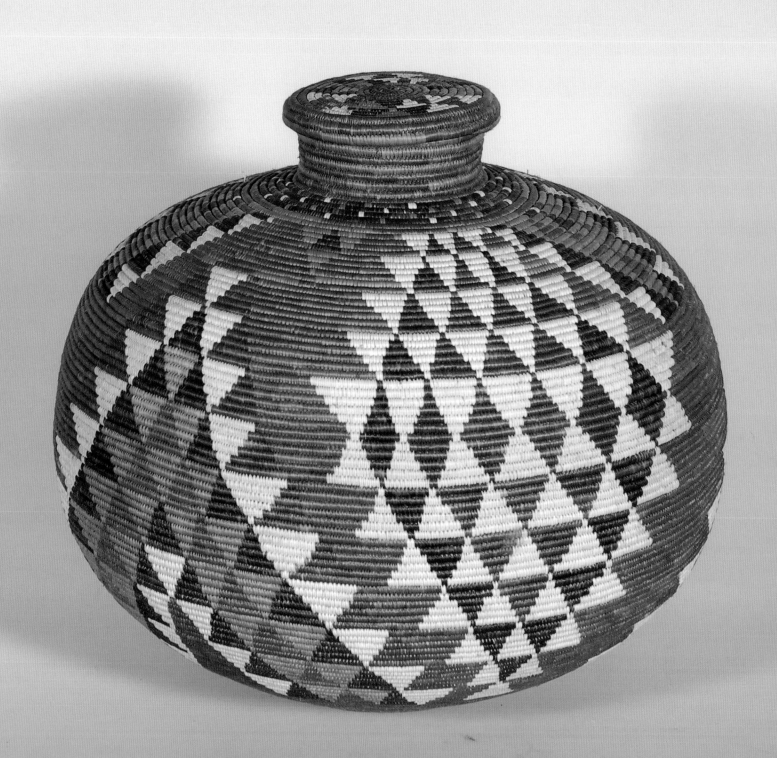

Cat. 112
BASKET (*IQUTHU*)
Nelisiwe Mlotshwa
South Africa
Late 20th century
D. 39.4 cm.
Durban Art Gallery, SC 644

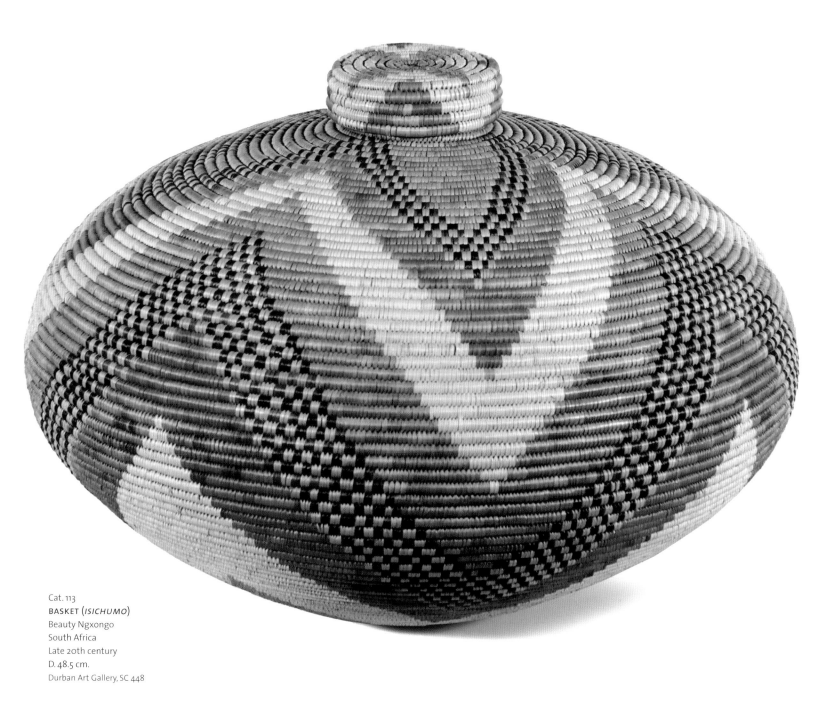

Cat. 113
BASKET (*ISICHUMO*)
Beauty Ngxongo
South Africa
Late 20th century
D. 48.5 cm.
Durban Art Gallery, SC 448

the intentions of buying baskets from villagers and, like the Vukani Association, encouraging the production of finely executed, innovative work.

The Etsha area has since been transformed through a tar road linking these villages to Maun, and through the introduction of a microwave communications tower that has made it possible for Etsha schoolchildren to "view international websites selling baskets from their village, complete with photographs of the basket makers."[81] Thanks to the worldwide revolution in communications technologies, skilled basket producers—here and elsewhere in the southern African region—have over the past few decades entered the global economy and attained a new status as artists. They have shed their identity as anonymous craft specialists and, largely through the marketing strategies of self-help schemes and development agencies, have lived to see their artistry valued not only in their own communities, but throughout the world.

ECOLOGICAL IMPACTS

In the early 1970s, when basket production was first encouraged as an income-generating activity, one advantage was that the plant materials used to make these baskets were generally close at hand. But in recent years, practitioners have in many cases been forced to go far afield for their needs, or to import materials from elsewhere.[82] By the 1980s, the rapid rise in basketry as a commercial craft or home industry was beginning to cause anxiety over the depletion of the materials used to make this work. The impact of commercial production on the resource base of basket makers was intensified by an increase in the number of women taking up the craft. Production swelled and resources declined as the Vukani Association's sales increased more than tenfold between 1973 and 1982, while Botswanacraft's receipts shot up four times in roughly the same period.[83] By 1984, over fifty percent of the women living in Etsha were making baskets.[84] Since then, sales have grown steadily, primarily through the efforts of both Botswanacraft and the Botswana Christian Council.[85]

Initially, no one seems to have anticipated the ecological impact of this boom in production. But following fieldwork in the early 1980s on the Maputuland coastal plain in the Ingwavuma district of present-day KwaZulu-Natal, botanist Tony Cunningham found that, in addition to exotic and imported materials,[86] twenty-five indigenous plant species were used for the production of craftwork linked to the Ngezandla Zethu project, sixteen of these as sources of dye.[87] Under the growing commercial demand for heavily decorated baskets, the scramble for dye materials had led in this area to the practice of ring-barking rather than the removal of only some of the roots of the plants used for making dye.[88] By 1990, factors such as the high demand for dyestuffs and destructive harvesting techniques had forced Parks Board officials in the St. Lucia Estuary and Umlalazi Nature Reserves to implement restrictive control measures, including banning sickle harvesting techniques and shortening the gathering season.[89]

A similar depletion of local resources used for making natural dyes has occurred in Botswana where, by the early 1980s, the over-harvesting of two indigenous species of plants in the Etsha region had led to their near extinction. Here, the change from subsistence to commercial exploitation of the leaves of the vegetable ivory palm (*Hyphaene petersiana*) had led to its decimation within a day's walk from the villages where the producers lived and worked.[90] The depletion of key natural resources and the tendency to ignore regulations that had been established in the 1950s and 1960s for harvesting vegetable ivory palm were confirmed by a recent assessment of Botswana's Okavango Delta region, which suggests that basket-making resources are becoming increasingly scarce in traditional harvesting areas. By 2002, Etsha respondents indicated that the labor time required for collecting and extracting raw materials had increased fourfold since 1984.[91]

In post-apartheid South Africa, the campaign to alleviate poverty through self-help projects has been characterized by increasingly active efforts to link economic growth with

development *and* the management of natural resources. While this integrated approach to poverty has in many cases been quite successful, it often fails to embrace the livelihood strategies of rural communities, which, in the interests of managing financial risks, are generally multiple and diverse.[92] In recent years, access to natural resources has been improved through various Acts of Parliament[93] and in some cases producers have begun to grow the materials they need to make the baskets and other items they sell to outsiders.[94]

It was only in the mid-twentieth century that politically motivated missionaries and others first mounted efforts to assist rural communities to achieve economic independence by utilizing the people's indigenous skills. In this respect, their endeavors differ significantly from those of their nineteenth-century predecessors who actively frustrated the ambitions of Africans to participate fully in the colonial economy by insisting that technical and manual training become a compulsory component of the curriculum for African school-goers.[95] By the 1950s, long-established Christian missions were abandoning this approach and beginning to rely instead on the cooperative networks of rural Christian communities to promote economic independence through a variety of craft and agricultural projects. Reflecting on this complex history, Gambian-born divinity professor Lamin Sanneh points out that "as religious agents, Western missionaries [have] some of the most important categories for understanding intercultural encounters, whether or not such encounter[s] conformed to their motives and intentions or in other ways was to their credit."[96] Forced to dismantle their own cultural prejudices, over time they began to initiate development projects "as a substitute for witness" in their efforts to serve the communities they had initially set out to convert.[97]

While the post-apartheid state's attempts to build on this tradition of empowering communities through the development of indigenous skills have not always achieved success, the Department of Art and Culture continues to emphasize the need to recognize an emerging economy based on the utilization of "human capital, creativity, innovation and knowledge." To foster rural wealth and employment, it has proposed that, where appropriate, public sector contracts should contain a craft production component.[98] If implemented, this proposal will have the added benefit of exposing increasingly large numbers of people to the artistry of indigenous producers, and encouraging collectors of African art to treasure heretofore mundane household items like baskets.

Art is a way…

Documentary Images and Devotional Acts: Plantation Painting as Propaganda

John Michael Vlach

> Art is a way of possessing destiny.
> —singer Marvin Gaye, quoting a 1936 speech by André Malraux,
> French novelist and statesman

DURING THE LATER YEARS of the Reconstruction era, *Scribner's Monthly* sent Edward King out to report on the economic and social conditions of the southern states. King traveled for almost two years, logging more than twenty-five thousand miles, and his monthly dispatches were a regular feature of the magazine in 1873 and 1874. He was accompanied on his zigzag path across sixteen states by James Wells Champney, a Massachusetts-based artist best known for his images of domestic life. Over five hundred of Champney's diligently rendered pastel sketches were converted into engraved images and used as illustrations for King's articles. Written with a decidedly pro-southern slant, King's essays were well received by southern and northern readers alike. Pleased with the popularity of the series, *Scribner's* publishers decided to reprint King's articles in a book format. That volume, entitled *The Great South*, was read widely by audiences in the United States and England, garnering further acclaim for both King and Champney.[1]

The use of the word "Great" in the title of the book immediately signaled King's positive view of a formerly rebellious region, a view that was celebrated as well in Champney's careful illustrations which delineated facets of southern life ranging from the monumental to the mundane. While this capacious anthology contained only one article focused on South Carolina rice plantations, that piece was accompanied by nine images that offered a thorough overview of rice production through a combination of landscapes, character studies, and sketches of intriguing agricultural devices. Champney set the scene with a horizontal vista,

Fig. 8.1
James Wells Champney, "View of a Rice-field in South Carolina" (1873), from *The Great South*, 1875.

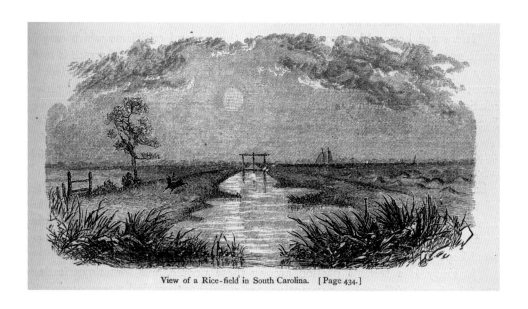

View of a Rice-field in South Carolina. [Page 434.]

"View of a Rice-field in South Carolina," (fig. 8.1) traversed by an irrigation canal or "trunk" that carried water from an unnamed river across a grid of rice paddies. This same canal also brought the harvested product to a central threshing yard or "floor," as shown in an image entitled "Unloading the Rice-Barges." Even some of the smallest details of equipment used during the rice harvest were noted. For example, Champney rendered the ingenious boots used to cover a mule's hooves and prevent the animal from sinking too deeply into the mud. Attention to such specialized pieces of farming gear inspired reader confidence in the veracity of the essay's assembled images. Champney's drawings of a raised winnowing platform and the line of cabins in a slave quarters (fig. 8.2) would also be accepted as true to life.[2]

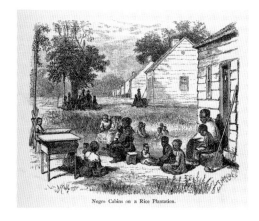

Fig. 8.2
James Wells Champney, "Negro Cabins on a Rice Plantation" (1873), from *The Great South*, 1875.

EIGHTEENTH-CENTURY AND ANTEBELLUM VIEWS

Detailed depictions of Carolina rice production had appeared as far back as the late eighteenth century. Italian botanist Luigi Castiglioni, who visited South Carolina in 1785, included in an account of his travels a drawing of a distinctive type of winnowing platform that consisted of an enclosed room standing on posts about twenty feet above the ground (fig. 8.3).[3] Subsequent recorders of the rice landscape rarely failed to mention such structures in their reports as they were both markers of production and tangible signs of the extraordinary monetary wealth being amassed by the planters. Regarded as a signature emblem of rice planter identity, the rice platform and other structures peculiar to processing the staple were regularly incorporated in paintings of planters' residences.

Inspired by a popular book of English estate views compiled by British landscape artist William Watts, Charleston printer and engraver Thomas Coram developed a similar folio of vistas of Carolina rice plantations. Although his proposed volume was never published, he did leave a number of "oil sketches" that he had hoped would be transformed into bound sets of finely etched prints. In his preparatory painting for *The Seat of Thomas Radcliffe* (ca. 1792), a winnowing platform and a rice barn partially block our view of Radcliffe's mansion. Coram used a similar configuration in his *View in St. James' Goose Creek – Chas. Glover Esqr.* (ca. 1792).[4] Clearly, he thought it appropriate to obscure the view of a prominent client's house with a humble functional structure. In a later painting of Mulberry Plantation on the Cooper River titled *View of Mulberry, House and Street* (ca. 1800), one of South Carolina's most distinctive dwellings is consigned to the background while the two rows of slave houses dominate the foreground (fig. 8.4). Similarly, in the celebratory image of Rose Hill Plantation on the Combahee River by an unknown painter (fig. 8.5), the planter's house sits well back in the scene and the viewer's attention moves to a large barn, winnowing house, and stacks of recently harvested rice sheaves clustered in the foreground.[5] Consequently, the functional aspects of agricultural production in this painting contend for visual prominence with the planter's residence.

Two tendencies are apparent in all of these paintings: the importance of the precious grain and a perceived need to include the distinctive structures used in its production. In a territory where rice was "king," it made sense for artists seeking to capture the region on canvas or paper to include in their images the buildings that were connected expressly to rice.

T. Addison Richards, well-known as a member of the Hudson River School of landscape painters, also proved to be a compassionate advocate for the aesthetic value of southern scenery. He argued that the South constituted a superb subject for art with its varied scenes that he claimed could match any of the celebrated vistas of New York and New England. Using the pages of *Harper's New Monthly Magazine* as his forum, he encouraged his New York colleagues to consider southern locations as worthy places to capture on canvas. The South, he wrote in 1853, "has the loveliest of valleys, composed and framed like the dream of a painter. . . . Above her are skies soft and glowing in the genial warmth of summer suns, and beneath her lie mysterious caverns, whose secrets are still unread."[6] Six years later, in a second *Harper's* article

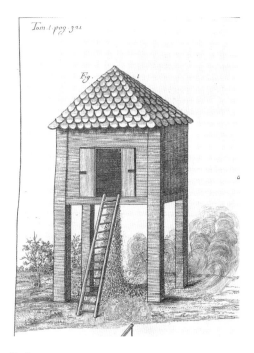

Fig. 8.3
Winnowing house from Luigi Castiglioni, *Viaggio Negli Stati Uniti dell' America Settentrionale: fatto Negli Anni, 1785, 1786, e 1787*, 1790.

Fig. 8.4
View of Mulberry, House and Street, Thomas Coram, ca. 1800. Oil on paper, H. 10.2 x W. 17 cm. Gibbes Museum of Art/Carolina Art Association, 1968.18.01.

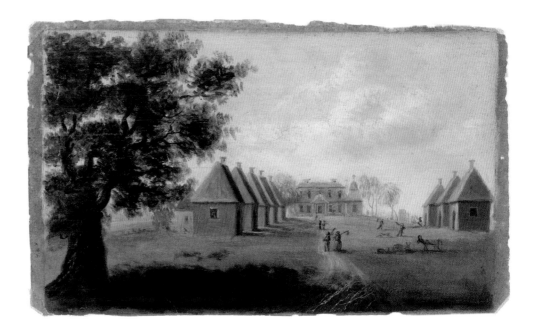

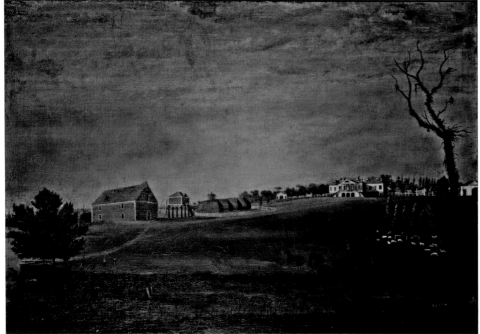

Fig. 8.6
T. Addison Richards, "Harvesting the Rice" (1853), from *Harper's New Monthly Magazine*, vol. 19, 1859.

Fig. 8.5
Rose Hill, anonymous, ca. 1820. Oil on canvas, H. 90 x W. 130.8 cm. The Charleston Museum, MK20884A.

Fig. 8.7
Basil Hall, "Rice Fields in South Carolina," from *Travels in North America, in the Years 1827 and 1828*, 1829.

focusing expressly on the "Rice Lands" of South Carolina, he included among his illustrations five vignettes of rice production and slave life (fig. 8.6).[7] Richards makes it crystal clear that enslaved workers were responsible for the annual harvest and thus were the ultimate source of a planter's wealth and reputation.

In most of the earlier images of rice plantations, human figures were generally absent. But even if plantation scenes lacked the presence of the obligatory human scale figure, those images could still be rigorously drawn with a convincing sense of perspective if one used a sketching apparatus like a camera lucida. Professional traveler Captain Basil Hall availed himself of such a device to provide images for his book, *Travels in North America, in the Years 1827 and 1828*.[8] His "drawing machine" employed a prism that was attached by a fixed rod to his drawing board. When a prospect was viewed with this apparatus, the whole vista was seemingly projected onto a sheet of paper so that its key features could be readily outlined in their true scale and exact position.

"Rice Fields in South Carolina" (fig. 8.7), a view of Nathaniel Heyward's rice field as seen from his Rose Hill plantation house, is one example of Hall's "assisted" sketches. While Hall would comment in his accompanying text that the carefully constructed fields surrounded by dikes and crisscrossed with canals had "no beauty whatsoever," he was suitably impressed by the vast engineered landscape. Learning that the rice was irrigated when the tidal flows raised the height of the river to the point where water could be directed onto the fields, he commented with some fascination that the river, at certain times, seemed to run "backwards." Hall was one of many visitors captivated by rice cultivation, a mode of farming that in its techniques, routines, and human relationships often seemed more industrial than agricultural in character. While some men like T. Addison Richards were in awe of the beauty of the Carolina Lowcountry, others were clearly more taken by the displays of technological ingenuity that they encountered. Both motives ensured that rice plantations would be depicted with accuracy and precision.

POSTWAR PANORAMAS

National interest in the South was particularly intense in the years immediately after the Civil War. Major journals and newspapers offered their readers panoramic illustrations of southern scenery, horizontal images so wide that they were run vertically in order to fit on the page; readers had to rotate their newspapers ninety degrees to see them. James E. Taylor's

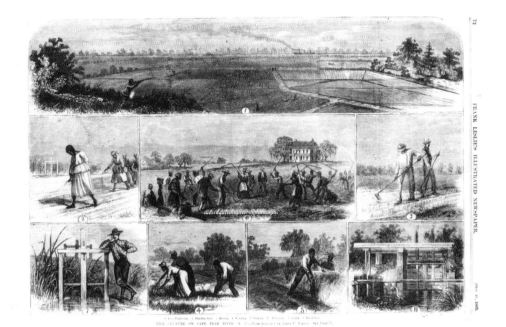

Fig. 8.8
James E. Taylor, "Rice Culture on Cape Fear River, N.C.," from *Frank Leslie's Illustrated Newspaper*, October 20, 1866.

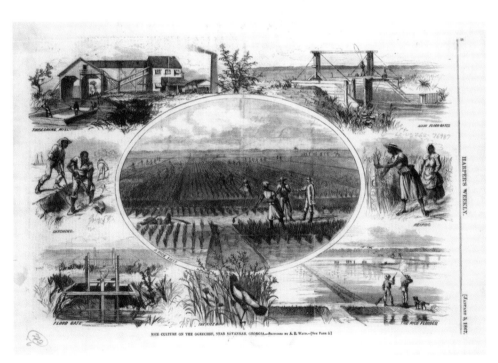

Fig. 8.9
Alfred R. Waud, "Rice Culture on the Ogeechee, near Savannah, Georgia," from *Harper's Weekly*, January 5, 1867.

"Rice Culture on Cape Fear River, N.C." (fig. 8.8) appeared in *Frank Leslie's Illustrated Newspaper* in 1866. His montage, consisting of eight scenes, begins with a vista of a North Carolina rice field that offers a deep view back to the far horizon where a passing steamship can just be glimpsed. Subsequent images detail the cycle of rice production with a set of close vignettes that depict planting, weeding, reaping, and threshing. Taylor notes in his accompanying essay that this plantation was so close to the ocean that the high tide carried salt water up the river beyond the estate's boundaries. Observing further that "salt is poison to rice," he concludes with a description of how large inland reservoirs were created to provide water for irrigation as needed.[9] Two views of the large wooden gates designed to release that valuable rainwater bracket the page.

Three months later a similar set of scenes drawn by Alfred R. Waud appeared in *Harper's Weekly*. Titled "Rice Culture on the Ogeechee, near Savannah, Georgia," (fig. 8.9) his images closely parallel Taylor's sketches. But where Taylor arranged his pictures into three horizontal bands, Waud opted to place an oval-shaped vista of rice cultivation at the center of his composition. He then surrounded this view with close-up details that highlight various tasks emblematic of the work required to grow rice. Waud focused primarily on the black field hands as they tend the rice paddies from planting through harvest. Images of irrigation works and a steam-powered threshing mill are also included, but it is the army of black workers who hold center stage as the makers and maintainers of this carefully wrought environment. Views like those produced by Waud and Taylor signaled that even though much of the South had been devastated by four years of bloody warfare, the rice empire along its southeastern edge was still largely intact and capable of satisfying the demands of national and world markets. Indeed, commercial rice planting persisted until the second decade of the twentieth century when a series of hurricanes finally shattered the intricate system of levies, dams, reservoirs, and canals that once had enabled rice planters to produce their astonishingly bountiful crops.[10]

Fig. 8.10
Alice Ravenel Huger Smith, "One or two hands in the barn-yard," from Patience Pennington (Elizabeth W. Allston Pringle), *A Woman Rice Planter*, 1913.

A LOST TIME AND PLACE

Born in 1876, Alice Ravenel Huger Smith did not have direct experience of either plantation life or slavery. But she was descended from three lines of plantation-owning families who could trace themselves back to the era of the American Revolution and beyond. Educated by local tutors in Charleston, she was passionately attracted to art. After experimenting with several media she would concentrate primarily on watercolor landscapes of Carolina scenery. Combining impressionist techniques with Orientalist sensibilities gained from the writings of ancient Asian philosophers, her paintings convey a feeling of hushed anticipation. According to one of her friends, she would begin a painting by sloshing colors over a thoroughly soaked sheet of paper and finish by adding a few brush strokes here and there to suggest such details as blades of grass or a bird in flight. It seemed that she worked in a trance-like state: "the paint flows, glides, dances or is suddenly checked as she desires."[11] Over her long career as a painter she would complete hundreds of works using this spontaneous technique and eventually be

Cat. 114
A CAROLINA RICE PLANTATION OF THE FIFTIES
Alice Ravenel Huger Smith and Herbert Ravenel Sass
1936
Avery Research Center, College of Charleston

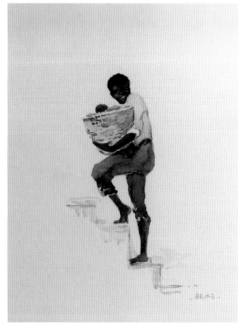

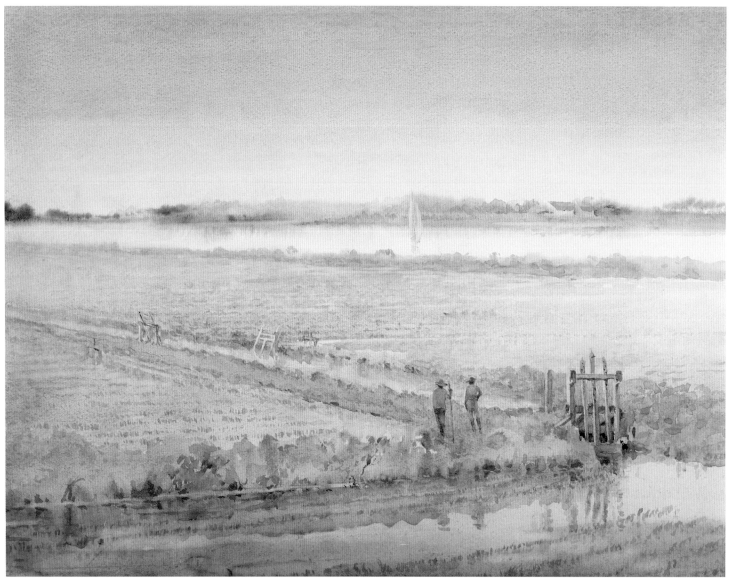

Cat. 115
THE POINT FLOW OR STRETCH WATER
Alice Ravenel Huger Smith
Ca. 1935
Watercolor on paper
H. 43.2 x W. 55.9 cm.
Gibbes Museum of Art/Carolina Art
Association, 1937.009.0014

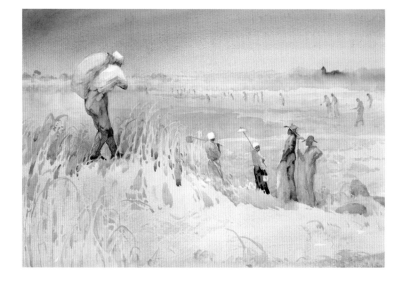

Cat. 116
**TAKING SEED-RICE DOWN TO
THE FIELDS**
Alice Ravenel Huger Smith
Ca. 1935
Watercolor on paper
H. 34 x W. 49.5 cm.
Gibbes Museum of Art/Carolina Art
Association, 1937.009.0011

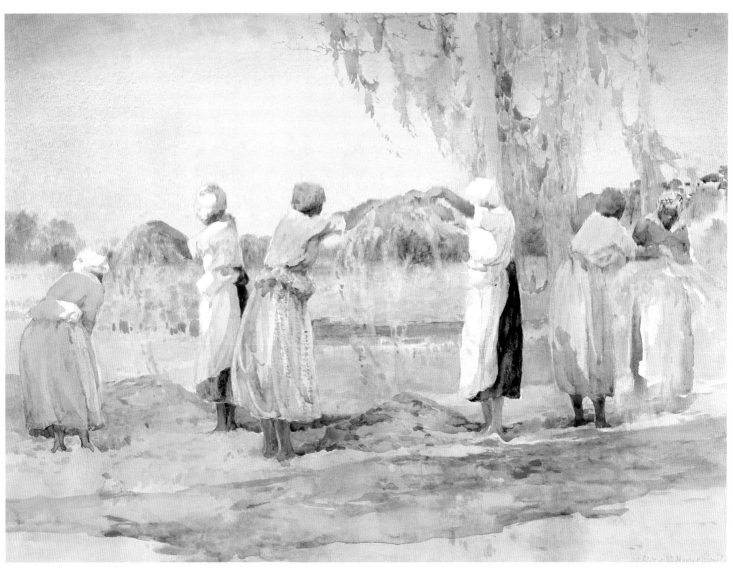

Cat. 117
**SHAKING THE RICE FROM THE STRAW
AFTER THRESHING**
Alice Ravenel Huger Smith
Ca. 1935
Watercolor on paper
H. 43 x W. 56 cm.
Gibbes Museum of Art/Carolina Art
Association, 1937.009.0023

celebrated by Mount Holyoke College in South Hadley, Massachusetts, with an honorary doctorate in art for her stunning achievements.[12]

From the early years of childhood, Smith was preoccupied by the history of Charleston and the plantations lost by her family and other landowners as a result of the Civil War. "I have always been grateful," she declared in her *Reminiscences*, "that it was given to me to grow up in the shadow of the shade of the great civilization that had produced the generations of the past."[13] Her first images of the places associated with the era of these forebears were rendered in pen and ink. Perhaps the accuracy of detail that could be achieved with this medium—and its apparent finality—seemed to her especially suited for these ancestral subjects. In 1913, she prepared more than eighty illustrations for Elizabeth W. Allston Pringle's *A Woman Rice Planter*, a memoir that describes the year-long cycle of rice production at Pringle's Chicora Wood Plantation on the Pee Dee River in Georgetown County, South Carolina. Smith's images (fig. 8.10) included rural vistas, portraits of individuals and groups of people at work, and renderings of plantation buildings.[14] In 1914, Smith partnered with her father, Daniel Elliott Huger Smith, to produce the first of two works of architectural history: *Twenty Drawings of the Pringle House on King Street, Charleston, S.C.*, to be followed by *The Dwelling Houses of Charleston, South Carolina* in 1917. A pronounced documentary feeling governs the illustrations which accompany *Twenty Drawings*, as Smith shows the famous residence from varying perspectives and captures its structure in an array of detailed views. In *The Dwelling Houses*, the same sorts of images are combined with photographs and scaled plans provided by architect Albert Simmons. Yet Smith's drawings, which range across much of the city, seem more nostalgic, as if formed by a deepening conviction that the way of life she was illustrating was not likely to return.

In *A Carolina Rice Plantation of the Fifties* (1936), Smith attempted what might be termed the recovery of a lost time and place (cat. 114). Working mainly from her father's recollections of the family's Smithfield Plantation in Colleton County, South Carolina, she developed a suite of thirty watercolor paintings.[15] She said that she "threw the book back to the Golden Age before the Confederate War so as to give the right atmosphere."[16] Twenty years after the publication of the meticulous drawings that had filled *The Dwelling Houses*, Smith turned to soft, pastel-hued impressionist paintings. What Smith deemed to be "right" for these rice plantation scenes were dreamy views of a land shown as if veiled in a golden haze. Created to honor the efforts of her rice-growing ancestors, these paintings diminished the presence of the large African-American community which, if depicted accurately, would have dominated every vista. When field hands had to be included to advance the story line about the various stages of rice production, Smith drew them almost as natural features of the landscape rather than as autonomous human beings (cats. 115, 116 and cat. 59, p. 116). Shown essentially as bodies that provide labor, only a handful of the workers are rendered with facial features (cat. 117). Smith painted them as the plantation's machinery, as the necessary equipment for growing rice.

In his introductory essay for the book, Smith's cousin, Herbert Ravenel Sass, declared that slavery had "worked wonders for the negro race, lifting millions of negroes out of barbarism in a shorter time than any other barbarous people had been so lifted in the history of mankind."[17] In this claim he was following the line of reasoning offered by Georgia-born historian Ulrich B. Phillips, who had asserted that not only was slavery a practical way to educate "inert and backward people," but that a plantation was best understood as "a school constantly training and controlling pupils who were in a backward state of civilization."[18] Sass parallels Phillips by offering a beneficent vision of the plantation wherein the planter is rendered as a kind and loving father figure who never even uses the word "slave." Sass cheerily suggests that the plantation master "called them his *people* and as he spoke of them—they were his people, not his chattels, and many of them were his loved and devoted friends."[19] Such sweet words

when joined with Smith's pleasant images thoroughly neutralized the violence and brutalization that were hallmarks of the plantation system.

Because *A Carolina Rice Plantation of the Fifties* was compiled principally to offer homage to a passing ancestral generation, the rigorous documentary impulse seen in Smith's other history projects was set aside as she constructed what might best be termed an expression of romantic apology. Here, in effect, she enhanced her father's recollections by connecting them to soft-focus images that would veil any unpleasant and problematic information. The golden glow of a bright sun glinting off acres of rice as far as the eye can see suggests the potential for great wealth via a bountiful harvest, but not the human cost to those forced to do the work. By showing African Americans in most instances as people without faces, she reduces them to little more than dark bodies available for compliant service. Such figures recall Mary Boykin Chesnut's Civil War–era description of the slaves at Governor William Aiken's Charleston home who provided what she called "noiseless, automatic service."[20]

PAINTING AS PROPAGANDA

Smith never commented explicitly about why she chose to render the plantation home of her forebears with a soft-focus technique. Yet impressionism had by then become her signature style and the mode of painting for which she was, and is, most highly praised. Clearly, the pastels of the watercolorist's palette suited her purposes. She deliberately sought to valorize her homeland by concentrating on "its soft haze and quiet distances, its usually gentle character and simple friendly intimacies."[21] A Carolina rice plantation, a hard-won tract of land engineered into a vast growing machine, when viewed through Smith's aesthetic lens, became a setting where nature trumps culture. Land and sky, water and vegetation were what most often held Smith's eye—save for a few human figures rendered in a diminutive scale. In Smith's plantation paintings white people are presumed to stand above blacks even when there are no whites in the scene. Embedded in her plantation paintings was a desire to soothe the feelings of failure and disappointment expressed by Charleston elites during the decades after Reconstruction—particularly the angry complaints of her father.

The North's victory in the South's war for independence transformed D. E. Huger Smith from a would-be rice planter into a cotton broker. His dismay over his region's defeat was compounded by his considerable economic losses. All of this, and more, he reflected upon when his artist daughter cajoled him into writing *A Charlestonian's Recollections, 1846–1913,* a memoir that was not published until 1950, almost two decades after his death. Smith began his account with happy reminiscences of the family's plantation in the years prior to 1860. Tracing the arc of his career after the grim years that followed the war, he vents a litany of complaints about the behavior of the newly freed people who were no longer subject to the imperatives of whites. Almost fifty years after Lee's surrender at Appomattox, Smith makes the astonishing claim that emancipation was an act of "bitter cruelty" *toward* the enslaved. In his view, freed blacks were loathsome: a swarm of "carrion crows" who had settled upon a prostrate country.[22] Finding liberated African Americans contemptible, he types them all as detestable criminals lacking moral judgment. The idea that blacks and whites might marry and produce children nearly drives him crazy, and he brands all Negro men as likely rapists deserving "stern and violent punishment." He concludes with the observation that black people have "deteriorated frightfully since 1865." Against the backdrop of this tirade, Alice Smith decided to paint the rice plantation as a charming lost world where the sun shines brightly and the slaves tend diligently to their assigned tasks. If there were aspects of life at Smithfield Plantation that might trouble the modern viewer's conscience, improvements and adjustments could be made on paper to ensure that the achievements of the white ancestral generation would be duly appreciated.

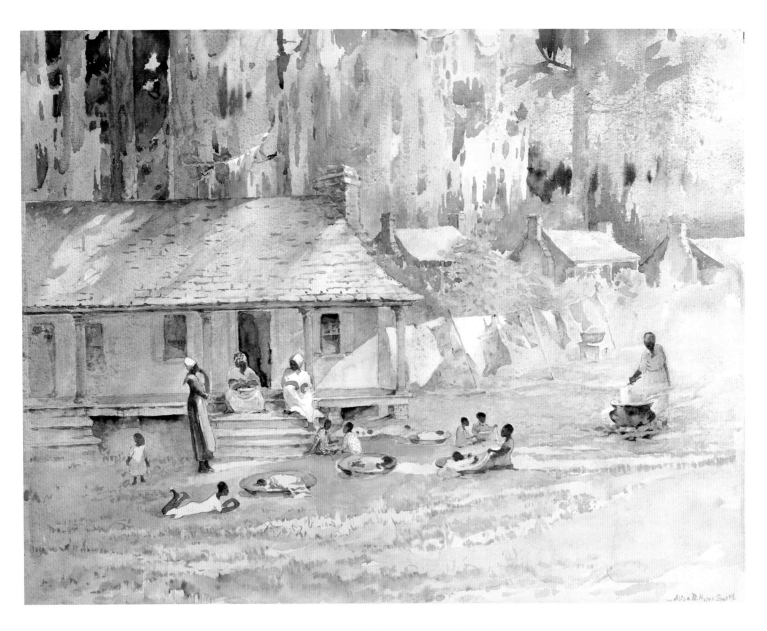

Cat. 118
THE PLANTATION STREET OR SETTLEMENT
Alice Ravenel Huger Smith
Ca. 1935
Watercolor on paper
H. 44.5 x W. 55.9 cm.
Gibbes Museum of Art/Carolina Art
Association, 1937.009.0005

Smith filled her portfolio with buildings and scenes which were painted at several locales far from the banks of the Combahee River. The building shown in *The Parish Church*, for example, was not near Smithfield but sixty miles away on the western branch of the Cooper River in Berkeley County, South Carolina. Similarly, the rice mill scene depicts not the Smithfield mill but one that she saw at Fairfield Plantation on the Waccamaw River in Georgetown County. *The Plantation Church* was an upgraded rendering of a country church in Plantersville, a small crossroads town again in Georgetown County.[23] When Smith was preparing to paint *The Harvest Flow, When the Rice Is Barreling*, which shows the crop just before it is harvested, she traveled to Middleton Plantation on the outskirts of Charleston to capture a view framed by tall old-growth trees. Since rice was no longer being grown in South Carolina when she was assembling her portfolio, Smith sought the advice of former rice planters on the agricultural practices she wanted to depict. Consequently, while the scenes which she painted do indeed present key features in the cycle of rice cultivation, any resemblances to the plantation that was owned by her family could only be approximate. In Smith's watercolors the specific details of experience are overlaid by the feeling of a pleasant, passing moment, scenes recently described as creations of "rainbow hued

fantasy."[24] In her paintings the bitter experience of loss and failure is cloaked with the sweet veneer of a delightful vista.

Whether Smith was motivated by obligations of filial piety or her own convictions, her work has enjoyed remarkable success as visual propaganda on behalf of the public memory of plantation owners—the people from whom she was descended. What is surprising is the extent to which her images, and others like hers, continue to inform current understandings of southern history in general and the Carolina Lowcountry in particular. That her images remain so popular is especially noteworthy given that over the last half a century the academic interpretation of the past promoted by Phillips and Sass has been dismantled, brick by brick. The Gibbes Museum of Art in Charleston reports that Smith's rice plantation images are, by far, the most sought-after paintings among the ten thousand works in its collection. Writers of history textbooks, producers of educational television programs, and directors of major motion pictures continually request permission to use her public-land scenes.[25] Two images from the series, *The Plantation Church* and *The Plantation Street or Settlement* (cats. 118, 119), are available via several Internet-based vendors, including the shopping mall giant, Wal-Mart, and surprisingly even the Baghdad Museum in Iraq.[26] The pairing of these two particular paintings implies, perhaps unintentionally, an unsettling connection between divine blessings and lifelong captivity. The image of the church softens the reality of bondage by implying that God looked favorably on the southern system. Implied here is a tacit promise that obedience on the part of the enslaved would be rewarded in the afterlife.

In *The Plantation Street or Settlement*, Smith's only painting of slave quarters, a nursery for infants stands in the foreground partially obscuring the view of a row of cabins. Each baby lies in its own coiled basket tended by young girls, who in turn are supervised by a group of watchful elders. The sweet scene makes us forget the absent mothers who have been sent back into the fields too quickly. Who would know from this gentle image that on rice plantations an average of twenty percent of all slave women's pregnancies ended in miscarriages and stillbirths or that on some Lowcountry estates almost forty percent of all slave children died before their first birthday? No wonder that when asked about slavery times freedman Ben Horry from Brookgreen Plantation referred to the period as "them dark days."[27] The cruelties of slavery were not a matter that Alice Smith was willing or prepared to recognize. No hint of the slaves' sorrows intrudes into her plantation scenes. The current popularity of her paintings suggests that many Americans likewise remain unprepared for a rigorous and honest assessment of their nation's history. There are many gritty images from the past that can effectively carry our imaginations back to the time when black people were treated like disposable pieces of equipment, but most of us would rather not see them or consider the story that they could tell.

Cat. 119
THE PLANTATION CHURCH
Alice Ravenel Huger Smith
ca. 1935
Watercolor on paper
H. 44.5 x W. 55.9 cm.
Gibbes Museum of Art/Carolina Art Association, 1937.09.04

9 The Paradox of Preservation: Gullah Language, Culture, and Imagery

Fath Davis Ruffins

OVER THE LAST CENTURY AND A HALF, African Americans of the coastal Carolinas, Georgia, and northern Florida have been at the center of a unique historical paradox. While described nearly from the beginning as vanishing, these people, now often known as Gullahs or Geechees, have maintained their distinctive culture over many generations. The documentation of this particular group of African Americans has been uniquely complete and continues to the present. Yet at every moment the key impetus for preserving Gullah language and culture emerged from the expression of impending loss.

Starting with Federal military officers, government officials, and civilian photographers during the Civil War, an unprecedented diversity of preservationists feared that this distinctive culture was disappearing. Though their motivations varied widely, nostalgic planter elites, Farm Security Administration photographers, leftish folklorists, and Afrocentric scholars have all devoted themselves to recording the coastal region's African-derived speech, songs, stories, customs, and material culture. Each of these preservation groups was an outsider to the Afro-Carolinian community it sought to record and protect. The history of Gullah imagery has included paternalistic condescension, socio-political misrepresentation, African romanticism, unabashed artistic celebration, and outright stereotyping—sometimes by black outsiders.

Fig. 9.1
"Slaves of the rebel Genl. Thomas F. Drayton, Hilton Head, S.C.," 1862. Photo: Henry P. Moore. Library of Congress.

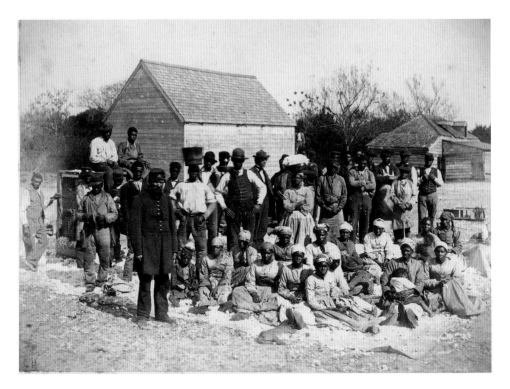

Coastal Afro-Carolinians have been the subject of detailed field research since the 1890s and meticulous academic investigation since the late 1920s. As a result, the Gullah communities of South Carolina and the Geechee communities of Georgia have become the best documented group of African Americans in history. Most recently, in recognition of their longevity and distinctiveness, the Sea Islands have been designated as part of the "Gullah-Geechee Cultural Heritage Corridor" by the National Heritage Areas Act signed into law by President George W. Bush in December 2006. The Corridor is managed by the National Park Service and is thereby included in the official cultural narrative of the nation.

For most of the preservationist era, coastal Afro-Carolinians were not in control of the abundant images documenting their lives. These photographs and prints, paintings and illustrations, were used to promote tourism and real estate sales, aiding in the creation of wealth for individuals and the Lowcountry as a whole, though few Gullah people managed to reap any financial rewards themselves. Meanwhile their vernacular culture has come to exemplify the persistence of African cultural forms within the United States. Such cultural "survivals" or "transformations" have frequently been observed in the Caribbean and Brazil. Gullah coiled grass baskets and other forms of material culture have now risen from the status of ordinary utilitarian objects to high-value artworks, a transformation more commonly associated with Native American baskets, blankets, and beadwork than with material culture objects that originated among enslaved African Americans. This essay analyzes the complex and enlightening preservation history of the Gullah/Geechee people.

NORTHERN INVASION OF THE SEA ISLANDS

On November 7, 1861, the United States Navy silenced the Confederate battery at Port Royal, and immediately Federal troops occupied the southern-most Sea Islands in South Carolina. White planter families had already fled, and the remaining Gullah people became some of the first slaves freed during the Civil War. Northern abolitionists and adventurers flooded into Port Royal. Photographers Timothy O'Sullivan and Henry P. Moore set up field studios in 1862 and, even as the war raged, published images of the newly freed people and the occupying forces (fig. 9.1).[1]

Thomas Wentworth Higginson, a staunch abolitionist, had volunteered to go south to lead the Colored Massachusetts 54th Volunteers. Upon arriving, he became an officer of the first troop of newly freed men to fight in the war, the First South Carolina Colored Infantry. During his time on the Sea Islands, Higginson heard the religious songs soon to be known as spirituals. In the June 1867 issue of *Atlantic Monthly* magazine, he published his annotated version of the spirituals.[2] Another abolitionist, William Francis Allen, arrived in 1863 as the St. Helena Island Freedman's Aid Commissioner. In 1867, Allen and two co-editors published *Slave Songs of the United States*.[3] Each collector was careful to distinguish his work from performances given by white men in blackface minstrel shows. Both Allen and Higginson assured their readers that these sacred songs were not parodies of the culture of the enslaved, but came "from the lips of the colored people." Now familiar tunes such as "Michael Row the Boat Ashore" and "Cumbayah" were included in these earliest publications. In his magisterial work, *The Souls of Black Folk*, historian W. E. B. DuBois called these lyrics "Sorrow Songs." Though we cannot pinpoint their origin or authorship, it can be said for certain that these songs were created over generations of enslavement. Most people do not know that the original versions were recorded on the Sea Islands of South Carolina.

The visual expression of the abolitionist interest in Gullah life was limited by the technical difficulties of photography and printing. Photography was relatively new; outdoor, wider angle, and composite photographs were pioneered during the Civil War. Newspapers did not yet have the capability to print photographs. The public had to be satisfied with prints, line drawings, or engravings. During the 1860s and 1870s, national publications such as *Harper's*

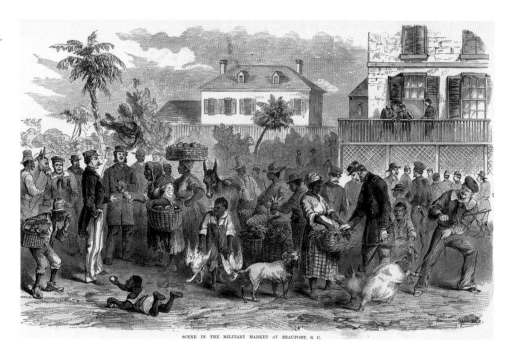

Fig. 9.2
"Scene in the Military Market at Beaufort, S.C.," W. T. Crane, ca. 1862. Avery Research Center, College of Charleston.

Weekly and *Frank Leslie's Illustrated News* published many distinctive images of the coastal region (figs. 8.8, 8.9, p. 208), including black and white soldiers, and various "negro characters." In "Scene in the Military Market at Beaufort, S.C.," (fig. 9.2) black men and women are selling all manner of fruits and vegetables, pigs and recently shot game, while white soldiers are milling through the crowds. In this print alone, eight baskets, large and small, some no doubt made of coiled grasses and used to transport and sell a variety of items, can be counted. Drawn from a sketch probably taken from life, this bustling scene gives a hint of the energy and vitality, excitement and disorder that could not be captured by photography, then requiring stillness and long exposures. For the majority of Afro-Carolinians, this may have been the first time in their lives when they could openly sell their wares and use all of the profits to support their families.

POSTWAR PLANTER PRESERVATIONISTS: THE GULLAH PEOPLE AS THE OLD SOUTH
New printing techniques in the 1880s made it possible for photographs of various types to be more easily reproduced. Companies such as Underwood and Underwood and the Detroit Publishing Company serviced a large market for stereographs and photographs of historic locations, city streets, monuments, and other sites (fig. 9.3). Many Americans attended after-dinner lectures illustrated with magic lantern slides. They peered through stereoscopes at three-dimensional stereographs, and pored over albums of *cartes de visite* and photographs and printed souvenir booklets in order to see places across the country or around the world that they might not be able to visit or perhaps wanted to remember after having visited. By the 1890s, picture postcards documenting their trips began to be sent by travelers to friends and loved ones. The streets, gardens, and plantation homes in Charleston and its vicinity were perfect subjects for these many forms of photographic and printed ephemera.

As early as the 1890s, local businesses, elected officials, and even the poorer of the planter families began to promote the South Carolina Lowcountry as an authentic surviving piece of the Old South. Although much of Charleston had been reduced to ruins during the Civil War and again by a massive earthquake in 1886—a natural disaster well documented in souvenir booklets and postcards—the architectural character of the port city remained. The Battery needed refurbishing, but the grand old mansions of the wealthiest planter elite

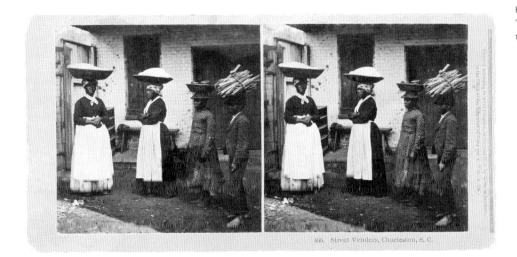

Fig. 9.3
"Street Venders," stereograph, Charleston, South Carolina,
1879. Collection of Gene Waddell.

in the antebellum South still stood. Slowly but surely, many Charlestonians realized that the
Lowcountry could be marketed to wealthy northern tourists looking for winter vacation
retreats and hunting estates.

By 1900, specific destination spots, including Magnolia Gardens and the Pine Forest Inn,
had opened to the public. Each place issued postcards, pamphlets, booklets, and souvenir
photographs suitable for framing, some even in hand-tinted color. In the winter and spring,
visitors could view the flowers at lovely Middleton Place or Cypress Gardens. The marketing
of Charleston and the Lowcountry as a tourist destination for the twentieth century was in full
swing. Manicured lawns, formal gardens, romantic overlooks, and views of Charleston's his-
toric residences and public buildings were pictured in real estate advertisements and in publi-
cations of the city's Chamber of Commerce, banks, restaurants, and retail establishments.

Overwhelmingly these images are devoid of life—there are no people or animals in
them. The streets are empty; the lakes have no boats; the mossy green pathways beneath
the oak trees are totally quiet. In part, quietude was a scrupulous photographic convention
that invited the viewer to imagine him or herself in the scene. However, this convention also
masked a significant reality. These hotels, gardens, and historic plantations were being main-
tained by extensive staffs of black people. Yet out of hundreds of images, only a handful show
the Afro-Carolinians who worked there (fig. 9.4). Several photographs picture the homes of
the "Negro caretakers" which look virtually the same as the slave cabins seen in photographs
from the 1860s (fig. 9.5). Such visual contrasts between the beautifully tended rose gardens
and the falling-down houses of the caretakers illuminate the continuing economic and racial
oppression.

As the Lowcountry revival gathered steam, the first romantic "folk" portraits appeared
in painting, sketches, and photography. George W. Johnson's striking photographs of local
subjects form the most important visual record of the late nineteenth and early twentieth
centuries. His images of the "ground nut vendor," "vegetable seller" (fig. 4.8, p. 117), "flower
girl," "street criers" (peddlers), and other city "characters" document a colorful part of
Charleston's social world.[4] Even today, many books reproduce Johnson's photographs, often
uncredited, to illustrate the history of the Lowcountry and the exotic "colored" street vendors
of "Old Charleston."

During Johnson's working life, American popular imagery was filled with ugly
stereotypes of black men stealing chickens or performing in minstrel shows and fat black
women toiling in the kitchen. Johnson's posed portraits of Afro-Carolinian adults are much
more dignified. The photographs commonly contain a figure standing or sitting alone against

Fig. 9.4
"Aunt Phoebe, Magnolia Gardens, Charleston, S.C.," ca. 1901.
Photo: William Henry Jackson. Library of Congress.

Fig. 9.5
"Cabin homes of the Negro caretakers, Magnolia Gardens,
Charleston, S.C.," 1900–20. Library of Congress.

Fig. 9.6
"Negro musicians," ca. 1910. Photo: George W. Johnson
Gibbes Museum of Art/Carolina Art Association,
AN1963.18.676.

Fig. 9.7
"Boy and girl vegetable vendors," Charleston, South
Carolina, ca. 1910. Photo: George W. Johnson. Gibbes
Museum of Art/Carolina Art Association, AN1963.18.390.01.

a background in a studio with the tools of his or her trade: a man holding a sawyer's bench on his shoulder or women balancing baskets of vegetables on their heads. Most look poverty stricken. Their clothes have holes in them and they are almost never smiling. Instead, they stare warily and wearily straight at the camera as the white photographer takes their pictures.

Many white people felt an emotional connection between their families and these "old-time darkey" peddlers and family servants. Beginning in the 1890s and continuing well into the 1940s, elite Charlestonians published pamphlets about their families, city houses, and ancestral plantations. These works often included tributes to the house servants, along with photographs of the people who had served the whites, in many cases for generations. Typically, the older "retainers" look apprehensive in their unsmiling portraits. This stance is even more striking when compared with Johnson's photographs of children. Some show youths working as street vendors or chimney sweeps (fig. 9.7); a few show children playing and dancing (fig. 9.6). The children are exuberant; they are hamming it up for the camera. Perhaps they are too young to question why they are being photographed and too carefree to feel they have to veil themselves as the adults have clearly done.

By the 1920s, efforts to celebrate, preserve, and market the culture of the Old South coalesced in a movement. In *A Golden Haze of Memory: The Making of Historic Charleston*,[5] historian Stephanie Yuhl explains that the antebellum era was seen through a golden haze which left out all the bad parts, such as chattel slavery, slave markets, and the domestic slave trade, and extolled the charming, harmonious, pleasantly hierarchical plantation family. Within that larger story, the roles played by the loyal family servants were of psychological as well as social importance.

Between the world wars, during the literary and artistic revival known as the Charleston Renaissance, different types of planter preservationists emerged. In general, men tended to make up the membership of the literary societies, though women as well as men were represented among published authors. By and large, women were the creators of plantation tours and "street strolls" or walking tours. While these gender distinctions were not rigid, they

reflected customary patterns of public presentation. Three elite white men were central to the literary preservation of Gullah culture. Each saw himself as an authentic recorder and interpreter of Gullah speech, stories, and songs.

Ambrose E. Gonzales, the oldest of the three, was one of the few preservationists who actually was born before Abraham Lincoln became president. Born in 1857 to an elite family whose daughter married a Cuban general, the Gonzaleses lost everything during the Civil War. Gonzales grew up nearly penniless and became a telegraph operator before founding an important regional newspaper, *The State*, in Columbia, South Carolina. Beginning in the 1910s, Gonzales published stories he said he had learned from his Gullah nanny. Near the end of his life, he produced four books recounting the lives of the Gullah people of the "Black Border."[6] Though to contemporary ears Gonzales's books reek with racism, his notebooks and stories contain some of the best records of how the Gullah language sounded in the late nineteenth century.

John Bennett was a northerner, born in Ohio a month before the Civil War ended. For health reasons, he moved in 1891 to South Carolina, where he married into the Charleston elite. He was a co-founder of the Poetry Society, a central institution for writers during the Charleston Renaissance, many of whom used Gullah characters and settings in their poetry and fiction. Bennett began his avocational fieldwork among the Gullah people about 1900 and eventually amassed a large number of notebooks documenting Gullah speech and stories.[7] He first published this research in 1908 and lived so long that, well into the 1950s, he was regularly consulted by writers wanting to get the right language and tone for their own Gullah literary productions.

Samuel Gaillard Stoney, the scion of a rice plantation family, like Gonzales claimed to have learned Gullah from an old "auntie" who had served his family for generations. Stoney was the most prolific of the three men, publishing numerous books on Charleston and Lowcounty architecture, plantation histories, and family genealogies. Gullah was said to be his "preferred" language and he made many recordings of Gullah tales, some of them now available on the Internet.[8] Stoney was considered so authentic that when Columbia University created its recorded language collection in the 1920s, he was asked to make the Gullah recordings.

The most bizarre example of planter preservationism was probably the Society for the Preservation of Spirituals. Founded in 1922, its membership was strictly limited to the descendants of Charleston's planter elite. For their performances, these children and grandchildren of the antebellum aristocracy dressed in hoop skirts and frock coats. They preserved the culture of the "old-time darkey" by singing Gullah religious songs in concerts as far away as Boston and Ohio. To guarantee the genuineness of their material, the Society produced field recordings of Sea Island people, compiling a major archival resource of Gullah language and songs for the early twentieth century. By 1930, the Society had become the nation's primary clearinghouse for the authentication and publication of spirituals.

Two white women prominent in the public presentation of Gullah life and language were Janie Screven DuBose Heyward and Julia Mood Peterkin. Heyward, a daughter of the aristocracy and mother of novelist DuBose Heyward, published *Songs of the Charleston Darkey* in 1912. Publishing, however, was not her chief calling. Janie Heyward became a major raconteur of Gullah culture. "In drawing rooms, college auditoriums, and hotel parlors across the South," reports Yuhl, "tourists and locals paid to hear her present poems, stories, street cries, superstitions, tales and jokes in her own version of the 'Unique Dialect of the Disappearing Type of Negro.'"[9]

Julia Peterkin was born and raised in the South Carolina midlands. Daughter of a small-town doctor, she married into a family that vacationed by the sea. Peterkin built a fictional world located on the Gullah coast and in many ways was the first white American writer to

take black society seriously.[10] She published three novels and a book of short stories in which nearly all the characters speak Gullah. Her second novel, *Scarlet Sister Mary*, won the Pulitzer Prize for fiction in 1929, the year William Faulkner's *The Sound and the Fury* and Thomas Wolfe's *Look Homeward, Angel* appeared. The Gullah language as Peterkin rendered it was a complete language, every bit as capable of expressing abstraction and deep emotion as the standard English of white people. Her Gullah characters demonstrate the "underside" of sexual obsession and violent relationships even in a remote rural setting. In 1930, *Scarlet Sister Mary* was made into a moderately popular stage play with dialogue in Gullah. Ethel Barrymore played the lead role and the actors performed in blackface.

The most famous of the novels and plays to emerge from the Charleston Renaissance was DuBose Heyward's *Porgy*. A member of a once-affluent family, it was DuBose's mother who, to make ends meet, appeared in costume enacting Gullah stories for tourists.[11] Published in 1925, *Porgy* was not about the moonlit plantation staffed by elderly, loyal servants singing old songs. Heyward's Gullah characters are urban and cunning. His novel includes drug addicts, music makers, street vendors, and prostitutes living the "Sportin' Life" on Catfish Row. *Porgy* was an immediate success and Heyward was designated an authentic interpreter of Gullah culture. Some people thought that Heyward was actually black when they invited him to speak.

Heyward and his wife, Dorothy, turned the novel into a play which appeared on Broadway and toured the country. Composer George Gershwin proposed collaborating with the Heywards on a musical version. In the summer of 1934, George and his brother Ira joined DuBose and Dorothy at the couple's house on Folly Beach to work on the project. *Porgy and Bess* premiered in New York in 1935 and, though it was not greeted warmly, George Gershwin always felt that this was among his masterpieces. In the seventy years since his death, *Porgy and Bess* has become a classic American "folk opera," performed in theaters all over the world. The work was made into a controversial feature film in 1959 starring Sidney Poitier, Sammy Davis, Jr., and Dorothy Dandridge. Alarmed by alterations to the musical score, Gershwin's executors sued to stop it from being shown.

After the success of the play, and despite the infamy of the movie, stores, restaurants, and saloons appeared all claiming some relationship to the fictional "Catfish Row" and Heyward's made-up characters. These locations were added to Charleston walking and driving tours and featured in magazine articles about the city. They were quite popular well into the 1960s and even today tourists ask guides to point out Porgy's old haunts.

While the street vendors were recorded in photography and painting and their "street cries" collected in books and presented in plantation tours and on the stage, there was very little interest in the Gullah people's material culture, including coiled grass baskets. Miriam Bellangee Wilson was the only person known to have assembled a significant collection of "slave-made" objects. A native of Hamilton, Ohio, she homesteaded a tract of land in Missouri before moving to Charleston in 1920 at the age of forty-one. Thus, her preservation work did not come with a pedigree and was never accepted by the planter preservationists or mentioned in any of their publications.

Wilson became interested in the last generation of people born into slavery. She began traveling to nearby plantations, particularly those that were being put up for sale, and collecting "slave-made" artifacts. She investigated the buried history of slave markets and slave sales in Charleston and found one remaining building that had definitely been the site of slave auctions.[12] In 1922, Wilson began self-publishing guided walking tours of Charleston called "Street Strolls," and continued to do so for thirty years.[13] These maps and pamphlets led people to the expected churches, Confederate monuments, and cemeteries. They also led people to 6 Chalmers Street, the cobblestone relic she identified as "Ryan's Mart," a slave auction site notably absent from standard tours.

Wilson purchased the building and in 1938 opened it as the Old Slave Mart Museum.[14]

The "Museum" seems to have been a combination gallery and curio shop, selling benne candies and probably coiled baskets, as well as displaying objects from her growing collection of plantation artifacts, including quilts, carvings, and rough-hewn furniture. Among white Charlestonians, Wilson was virtually alone in focusing on the preservation of African-American material life.

Ultimately, planter preservationists reflected the racial ideologies of their time. In an effort to preserve the "vanishing" culture of the "old-time darkeys," they made recordings and transcribed notes to document what actual Gullah people said and sang. The novels, songs, and even dances like the Charleston that derived from Gullah culture have influenced wider American popular culture in countless ways. Songs from *Porgy and Bess*, such as "Summertime," are part of the American canon and are sung worldwide. Planter preservationists loved and eulogized this distinctive Gullah culture, never imagining that it would survive their paeans to Old Charleston.

Gullah culture helped make Charleston special. As rice and Sea Island cotton production came to a halt, blue-blooded Charlestonians with big houses and small incomes began to offer house and plantation tours as part of a growing tourist economy. Novels and stories by Gonzales, Stoney, and others aided in the development of plantation tours and the larger project of tourism as a whole. While much of Charleston's "golden haze" was developed to appeal to outsiders, none were more susceptible to its magic than members of the Charleston elite themselves.

FOLKLORISTS AND PHOTOGRAPHERS: THE GULLAH PEOPLE AS FOLK ARCHETYPES
By the 1920s, young folklorists and anthropologists with no connections to the antebellum world began showing up on the Sea Islands. Indeed, the list of scholars, collectors, and photographers who passed through the region between the late 1920s and the 1940s is so long one wonders that they did not bump into each other all the time.

Why were people such as Alan Lomax, Zora Neale Hurston, William Bascom, Doris Ulmann, and Marion Post Wolcott drawn to the Sea Islands? Some travelers were influenced by the radical politics of the Popular Front in New York and other northern cities. Some had personal reasons for feeling marginalized in their places of origin and sought out other people on the margins of American life. Still others began their fieldwork in Africa and were drawn to the Sea Islands as part of what we now call the "African diaspora." Bayard Wootten and Guy B. Johnson were white southerners who discerned archetypical qualities of endurance, dignity in the face of suffering, and weathered wisdom in the older Sea Islanders.

Sociologists Johnson and his wife Guion were professors at the University of North Carolina at Chapel Hill and among the first researchers to explore in depth the history and culture of the Sea Islands. A southern liberal in the years before the modern Civil Rights Movement, Guy Johnson nevertheless reached conclusions consistent with those of his political opposites such as Georgia-born historian Ulrich B. Phillips, who crafted the image of the Old South, and the Lowcountry planter preservationists. In *Folk Culture on St. Helena Island* (1930), he maintained that the Gullah language was simply incomplete and incorrect English, and that the stories he heard on the Sea Islands were merely distorted versions of old English ballads and tales.

During the 1930s, however, a few scholars emerged who challenged this view. Of these, anthropologist Melville Herskovits was probably the most influential. While Herskovits never conducted research on the Sea Islands himself, his colleagues William Bascom and Lorenzo Turner did. Bascom's findings were included in Herskovits's seminal book, *The Myth of the Negro Past*—a path-breaking work that attempted to refute the myth that the Negro had no past.[15] Herskovits became the first American scholar to argue that African peoples in the Americas had come to these shores with cultural values and practices, beliefs, and languages.

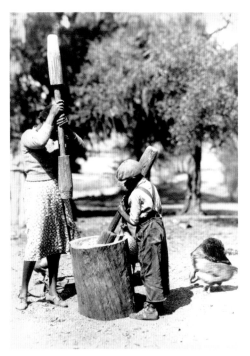
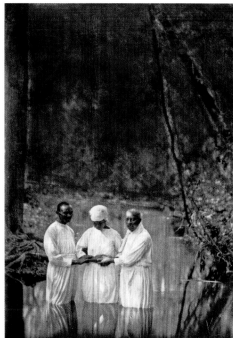

Furthermore, these African peoples had brought entire worldviews with which they mapped their harsh new reality of enslavement and nurtured their struggle for freedom. Herskovits's ideas were slow to take hold and, for many years, he and his students who argued for the significance of African connections were in a distinct minority.

The first academically trained linguist to turn his attention to the Gullah language and stories happened to be a southern Negro. Lorenzo Turner was a native of North Carolina. He earned a B.A. from Howard University and a Ph.D. in English from the University of Chicago. Turner was attracted to Gullah as a field of research while working as a teacher in a secondary school in South Carolina in the summer of 1929. Twenty years later, after exhaustively comparing languages in Africa, the Caribbean, and the South Carolina Sea Islands, he published *Africanisms in the Gullah Language*.[16]

Turner had approached the subject of African retentions with a deep distrust in the notion that Negroes in general and Sea Islanders in particular had no history worth remembering, or had made a clean break with Africa. His own relatively easy entry to the homes of his Gullah subjects made him question the dominant view that these people had lived in isolation, cut off by geography and cultural differences from the rest of the world. His work strongly suggested that the Gullah people were never as isolated as their many documentarians have argued. In fact, most of the Sea Islands are not far offshore and all are within sight of the mainland. It was easy to cross the rivers and inland waterways that divided the islands from one another. Children commonly took boats to school (fig. 10.4, p. 235).

In Turner's view, the uniqueness of Gullah language and culture was the result of conscious choices that insiders made to keep others neatly outside the cultural loop of understanding. Sea Islanders chose what to say and what not to say to outsiders. Turner may have been the first outsider to learn that Gullah people give their children "basket names" at birth—names used only among family and friends—in addition to the names they go by in public. What other scholars and lay people attributed to a lack of education, a kind of stunting due to isolation, may well have been a strategy to preserve a space of cultural freedom within the context of crushing poverty and repression.

Among the photographers who came south to document the Negroes of the Sea Islands

were three marvelously talented women: Bayard Wootten, Doris Ulmann, and Marion Post Wolcott. Wootten, a daughter of the North Carolina gentry, started taking photographs in the 1910s after a failed marriage left her having to support herself and her son. She took many trips into the hollows of Kentucky and western North Carolina and Georgia, as well as to predominantly black regions in both of the Carolinas. Doris Ulmann was an affluent New Yorker of German Jewish descent and a graduate of the Ethical Culture Fieldston School. She was nearly a generation younger than Wootten. Hoping to make a mark in the competitive art world of New York, she sought out distinctive rural subjects, in contrast to the urban environment depicted by leading photographers of the time.

Wootten and Ulmann were strongly influenced by an early twentieth-century photographic movement known as "pictorialism."[17] Pictorialists sought to make photographs that looked like paintings, employing some of the same qualities of light dispersal to mimic brushwork and produce soft-focus images. Mainstream American photography quickly veered away from pictorialism towards realism. Wootten and Ulmann, however, worked within the pictorial style for the rest of their careers.[18] Because they visited the same regions, traveling among the white people of the Appalachians and the Negro people of the Carolinas and Georgia, their photographs share certain qualities. Unlike George W. Johnson, who shot his pictures on the streets of Charleston or more typically in his studio, Wootten and Ulmann went to where their subjects lived. They photographed women and children pounding rice (fig. 9.8), farmers with their animals in the field, men and women sitting in front of their humble homes and taking part in religious activities (fig. 9.9). Their subjects are deliberately posed, often with dramatic lighting effects. Both women saw something noble and proud in the poor people they photographed. Wootten concentrated on people's faces. Elderly men and women, black and white, look directly into her camera or deliberately away from it. Their lined faces show the effects of hard work and meager food. These images do not evoke the nostalgia of "old times" the way that Johnson's work does. Rather, they present people in a timeless moment, profoundly human and deeply archetypical.

Compared to the sense of timelessness and symbolism in the work of Ulmann and Wootten, Marion Post Wolcott's images look downright naturalistic. Sent south by the Farm Security Administration (FSA), Wolcott was part of an emerging group of documentary photographers interested in social conditions as they actually were, without idealization.[19] Wolcott stood at a distance from the culture she recorded; many of her compositions show groups of people doing something together. While most FSA photographs are in black and white, Wolcott experimented with color. She took a series of brilliant color photographs of a July 4th celebration and picnic on St. Helena Island in 1939 (fig. 9.10). These images portray people dressed up in nice clothes and hats, carrying picnic baskets. They are part of the modern world and at least for the moment they are enjoying it. Wolcott's photographs convey a vibrant Sea Island social scene rarely glimpsed by outsiders.

THE CIVIL RIGHTS MOVEMENT: THE GULLAH PEOPLE AS THE AFRICAN DIASPORA

In the well-known history of the Freedom Movement on the Sea Islands, three local leaders in particular won national recognition: Septima Poinsette Clark, Esau Jenkins, and Bernice Robinson. Their efforts to bring modern-day schools and health care to a majority-black region neglected by a Jim Crow state government, and to encourage people to struggle for their political rights, also bore fruit in the area of culture. Sea Islanders and their mainland kin began to shed the stigma of backwardness and take pride in their traditional cultural expression.

During the most confrontational times in Georgia, Alabama, and Mississippi, civil rights activists would repair to the Carolina Sea Islands for rest and rejuvenation. St. Helena's Penn Center, local churches, and individual families provided sanctuaries for Freedom Movement

Fig. 9.10
"A Fourth of July celebration, St. Helena Island, S.C.," 1939.
Photo: Marion Post Wolcott. Library of Congress.

gatherings. The Movement also brought to the Sea Islands a new generation of folk enthusiasts who came with an explicit political purpose. One of these was musician and song collector Guy Carawan. Carawan was born in California of parents who had migrated from North and South Carolina. In the early 1950s, he toured with leading folksingers, including the legendary Pete Seeger. In 1959, Carawan became the music director at Highlander Folk School in Monteagle, Tennessee.[20]

Two years later, he took a song that had originated on the Sea Islands and began teaching it to college students working for the Student Nonviolent Coordinating Committee (SNCC), which had been formed after a group of students from all-black North Carolina A&T University refused to leave a Woolworth's lunch counter in Greensboro, North Carolina, where they had been denied service. The song, "We Shall Overcome," dated to 1945, when a group of predominantly Negro women from the Food and Tobacco Workers' Union went on strike in Charleston and changed the words of the old hymn, "I'll Overcome Someday," to make it more collective and urgent—"We Shall Overcome." Some of these women later went to Highlander and taught the song to Zilphia Horton, wife of the school's co-founder, who began singing it with people who came for workshops and organizing meetings. Over time, many activists who passed through Highlander learned the song, changing the words as situations changed. The SNCC Freedom Singers taught it to others and the song eventually became the anthem of the Civil Rights Movement. In a sense, "We Shall Overcome"

recapitulates the role that Sea Island songs played during the Civil War when the lyrics of spirituals were first transcribed on the islands.

By the mid-1960s, Guy Carawan and his wife Candie began compiling, and Folkways Records began publishing, a series of books and albums documenting the vitality and power of Sea Island culture. In *Ain't You Got a Right to the Tree of Life?*, the first of these productions, Sea Islanders narrated their own stories and gave their own interpretations of their songs, tales, and spiritual beliefs. *Ain't You Got a Right to the Tree of Life?* was the first book about the Sea Islands to attach the names of actual people to photographs and excerpts of oral history. Mrs. Janie Hunter, Mrs. Mary Pinckney, Mr. Willie Hunter, and Mr. Esau Jenkins spoke directly to the reader. Instead of anonymous or archetypical Gullah folk, these people emerged as full-blown individuals with particular voices and points of view.

Between 1964 and 1973, Folkways released a series of albums recorded on the Sea Islands, including *Sea Island Folk Festival: Moving Star Hall Singers and Alan Lomax; Been in the Storm So Long: A Collection of Spirituals, Folk Tales and Children's Games from Johns Island, South Carolina;* and *Johns Island, South Carolina: Its People and Songs.* In 1966, the Smithsonian Institution's Ralph Rinzler organized the first Folklife Festival on the Mall in Washington, D.C. Sea Island singers eagerly took part in the annual festivals and were among the first recipients of grants given by the Expansion Arts Division of the newly created National Endowment for the Arts (NEA).

The 1976 Folklife Festival was a high point in the process of attaining national recognition for Sea Island culture. In this bicentennial year of the Declaration of Independence, the celebration lasted three months, not just two weeks. The theme of the festival was a "nation of immigrants." The idea was problematic for people of African descent whose ancestors had come unwillingly to this land and were then subjected to enslavement and poverty for generations. Nevertheless, Rinzler was determined that African-American culture be featured and he hired Bernice Johnson Reagon to curate this section. Reagon, a former SNCC Freedom Singer, had visited Johns Island in 1961 and sang with the island's Moving Star Hall singers at the Newport Folk Festival. A visionary curator, Reagon made her theme the "African diaspora." She sought to demonstrate that there were strong cultural continuities between America and Africa. She brought basket makers and weavers from Nigeria and Sierra Leone to meet their counterparts from coastal Carolina and also from Brazil. Singers, basket makers, blacksmiths, and carvers had a special place in the festival.

Reagon based her curatorial choices on an emerging body of scholarship that was itself an outgrowth of the wider cultural impact of the Civil Rights Movement. The crisis over race relations in America had led to the establishment of Black Studies departments in universities such as Harvard and Yale in the late 1960s and early 1970s. Journals like *Freedomways, Black Scholar,* and *First World* (later *Third World*) and other black media outlets had begun to produce a variety of scholarly and popular works on the cultures of the people across the African diaspora.

It is within this larger context of the growth of Black Studies that we should view the astonishing discovery of Leigh Richmond Miner's photographs of St. Helena Island, and their publication in 1970 in Edith Dabbs's *Face of an Island*. Miner, who taught art at the Hampton Institute and directed Hampton's Camera Club, visited St. Helena several times between 1900 and 1923. The Connecticut-born Miner was a contemporary of George W. Johnson, whose work in urban Charleston complements and contrasts with his own. A guest of Penn School, the sympathetic white visitor photographed adults and children at Penn, as well as community people farming, fishing, grinding corn, winnowing rice, or simply walking down the road (fig. 9.11). His subjects look directly into the camera with firmness and clarity. There are no picturesque vendors and chimney sweeps in service to white people, but rather farmers, fishermen, students, and teachers standing on their own ground and looking resolutely at the camera with a sense of belonging and self-possession.

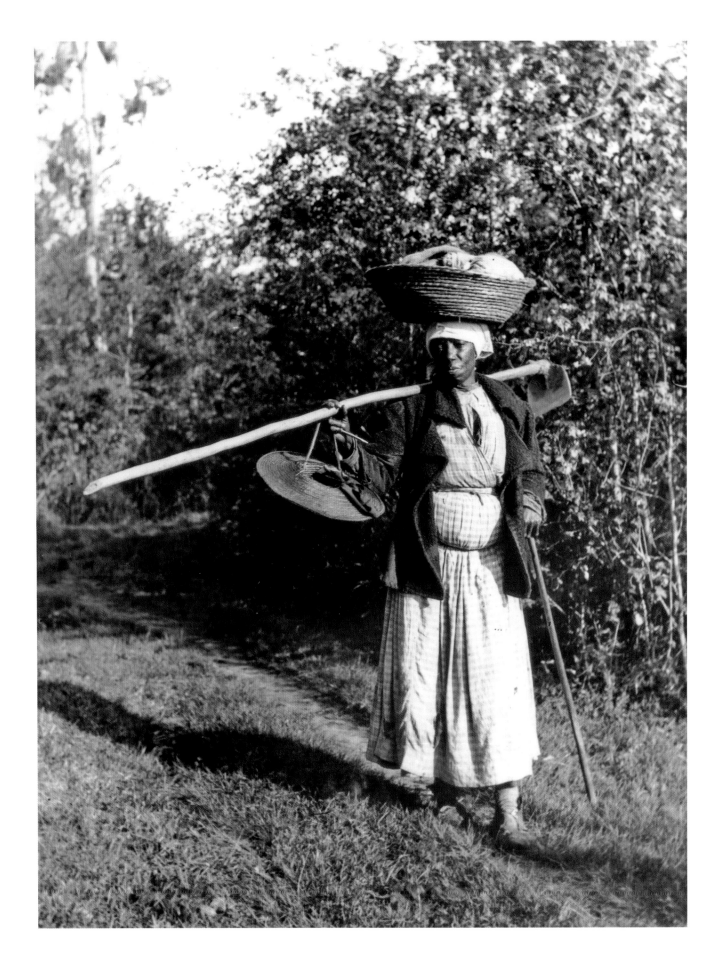

HERITAGE TOURISM: THE GULLAH PEOPLE AS AN OFFICIAL AMERICAN CULTURE

In 1956, developer Charles Fraser persuaded the South Carolina legislature to build a bridge between Hilton Head Island and the mainland. The next year, Fraser founded the Sea Pines Plantation Company and commissioned internationally known Harvard professor Hideo Sasaki to design a master plan to reconfigure the land and its uses. By the early 1960s, the Sea Pines Resort was nearly sold out. Sea Pines became a model of how to build vacation havens and second home communities, and Charles Fraser was hailed as a business visionary.

The Sea Pines Resort website tells the developer's version of Hilton Head's history. When Sea Pines was conceived, "Hilton Head Island didn't have electricity, phone service, gas stations, or convenience stores. Only one paved road existed, and that was on the north end of the island." Perhaps the one paved road served the three hundred African Americans who lived on the island just fine, but you would never know it from this source. The resort history does not mention black people whatsoever. But the black inhabitants, descendants of enslaved men and women who once grew the finest Sea Island cotton in the world, must have pricked at the developer's conscience. The same website informs us that the word "plantation" was dropped from the company name in the 1970s "because of its negative connotations to slavery."[21]

The development of Hilton Head was the opening salvo of a profound socio-economic change that has transformed many of the Sea Islands and coastal communities. Marsh and beachfronts are now enclosed by gated properties cutting off access to familiar fishing grounds and to grasses used for making baskets. Forested areas that sheltered small chapels known as praise houses have been thinned out and cut down. Displaced African Americans have moved to less valuable real estate in the center of the island or have moved off the island entirely. Black people with long traditions on the land have given way to wealthy whites often from other regions, drawn to the sunny climate, beaches, fishing, and luxury recreational activities centered around the Sea Pines PGA golf course.

The new demographics coincided with a subtle change in tourist and resort promotional literature: the black boatmen and servants at historic houses and gardens who had been a vital element of local imagery almost completely disappeared. But very soon, by the early 1980s, African Americans began to reappear in these same publications, not as servants but as craftsmen and artists, bearers of the very age-old traditions whose survival was being threatened by development. Features on the wrought ironwork created by master blacksmith Philip Simmons and on sweetgrass baskets made by individually named artists each with distinctive styles and forms became *de rigueur*.

This new approach may reflect changes in the tourist audience. Charleston's earlier tourism industry had consisted largely of wealthy businessmen looking for winter vacation spots, hunting enthusiasts, yachtsmen, and people on cruise lines coming up the coast from the Caribbean. Now the interstate highway system was bringing a new breed of tourists—working and middle-class families from northern and midwestern cities whose ancestors hailed from Poland or Sicily and who were not as interested in reliving the traditional social hierarchies of the Old South. Swimming, waterskiing, sunbathing, and motor boating at a reasonably priced beach cottage did not require servants. Buying a basket from a stand on Highway 17 did not take a lot of money. Tourist interests shifted from seeking older forms of social assurance to enjoying aesthetic but utilitarian objects. Indeed, basket makers met consumers as independent entrepreneurs selling their handmade wares—not as dependent servants. Buyers valued the handmade object as a memento of their travels and a product of a regional craft tradition rather than just one more of the mass-produced objects that fill American homes.

Museums were suddenly interested in African-American baskets as well. In 1971, Richard Ahlborn, a Smithsonian Institution curator, began to build a collection of coiled

Fig. 9.11
Adelaide Washington, St. Helena Island, South Carolina, ca. 1909. Photo: Leigh Richmond Miner. Penn School Collection/Southern Historical Collection, University of North Carolina at Chapel Hill.

baskets aided by anthropologist Greg Day. Scholars such as Day and his partner, Kate Porter Young, as well as Mary A. Twining, Keith E. Baird, Gerald L. Davis, Doris Adelaide Derby, Charles Joyner, and Patricia Jones Jackson studied the material culture of coastal black communities. In 1978, John Michael Vlach curated a national traveling exhibition entitled "The Afro-American Tradition in Decorative Arts," with a catalog of the same name, that featured coiled baskets among other Afro-Carolinian craft traditions. In 1986, McKissick Museum at the University of South Carolina mounted "Row Upon Row," the first in-depth exhibition concentrating on Lowcountry baskets. At the urging of the show's curator, Dale Rosengarten, McKissick convened a conference on sweetgrass basketry, bringing together historians, ecologists, developers, politicians, and basket makers to assess the state of the tradition and threats to its survival.[22]

In this era of museum activism, it may be useful to analyze what happened to the Old Slave Mart Museum, in Charleston, as it tried to cope with the changing landscape of tourism. Miriam Bellangee Wilson, who had founded the institution in 1938, died in 1959. She left the collection to The Charleston Museum but the museum turned it down. Wilson's church was about to auction the objects when two women stepped in. Louise Wragg Alston Graves, a close friend of Wilson, and Graves's sister, Judith Wragg Chase, rented the property and ran the museum. In 1964, they bought the building.

Inspired by the First World Festival of Negro Arts in Dakar, Senegal, in 1966, Chase began to acquire African objects that she felt were related to the Lowcountry "slave-made" objects Wilson had collected. Charlestonians with money, however, were not interested in establishing the connections between the Lowcountry and the wider African diaspora. Chase could not generate local support for her enterprise. Concerned about the disposition of her life's work and her legacy, she tried to sell the collection intact to a major institution, but failed. In the era of the post–Civil Rights generation, the Old Slave Mart Museum seemed like a throwback to an earlier form of tourism. Furthermore, Charleston as a city was not prepared to embrace its prominence in the slave trade and in slavery itself. The Old Slave Mart Museum was somehow both ahead of its time in 1938, and behind the times when it closed in 1987.[23]

Just as the Old Slave Mart Museum was going under, the Avery Research Center was being born. Like the Penn School founded on St. Helena Island in 1862, Avery Normal Institute was organized in 1865 with money from northern white philanthropists and missionaries. The first free secondary school for African-American children in Charleston, Avery operated as a private institution until 1947 when it became a public school. In 1954, in response to Brown vs. Board of Education, Avery merged with Burke High School. The old Avery campus was occupied by a business school, which subsequently became part of the state college system. In 1978, alumni and friends of Avery formed the Avery Institute of Afro-American History and Culture—an initiative that flowed directly from the Civil Rights Movement and reflected the amazing growth of African-American community museums. Seven years later, under the auspices of the College of Charleston, Avery re-opened in its original building as a research center and archives.

Under the leadership of founding director Myrtle G. Glascoe, Avery became increasingly interested in Sea Island culture and craft traditions. Glascoe began to purchase coiled grass baskets for the Avery collection, thus simultaneously stoking and bridging the friction between town and country visions of African-American attainment. In 1988, the Carawans donated the photographs and materials related to *Ain't You Got a Right to the Tree of Life?* to the research center.

By the late 1980s, Gullah culture had achieved a kind of celebrity status. Earlier in the decade, Charleston blacksmith Philip Simmons and Mt. Pleasant basket maker Mary Jane Manigault had been awarded National Heritage Fellowships by the NEA (fig. 10.2, p. 234). Culinary anthropologist Vertamae Grosvenor republished her *Vibration Cooking, or the Travel*

Notes of a Geechee Girl, and became a frequent commentator on National Public Radio. In 1991, African-American director Julie Dash released *Daughters of the Dust*, a dreamy, atmospheric film about children of a Sea Island family, ca. 1900, who have turned away from African-based rituals and are about to "cross over" to the mainland, to the distress of those who choose to stay behind. A thematic tension between the traditional and the modern, between magical realism and clearheaded pragmatism, characterizes the film's mood. Many people, especially women, call *Daughters of the Dust* the first truly beautiful film about black people they have ever seen.

Since the early 1970s, with ever greater velocity, the culture of coastal Afro-Carolinians has been promoted as the purest example of the "African origins" of a certain kind of American community. "Gullah" is a designation with increasingly positive connotations. The Gullah people are seen as both the inheritors of African traditions and as innovators who created new language, lore, and crafts out of recollections and retentions from Africa, under the shaping influence of their experiences in America. Once an artifact of a cruel upheaval, the coiled grass basket has come to represent cultural tenacity and artistic resolve.

Islands Are Not Isolated: Reconsidering the Roots of Gullah Distinctiveness

J. Lorand Matory

IN THE EXPLANATION OF THE ENDURING Africanness of Gullah/Geechee culture along the South Atlantic coast, perhaps no word arises more often than "isolation."[1] In his classic 1949 study of African retentions in Gullah speech, linguist Lorenzo Turner wrote, "the African speech habits of the earliest Gullahs were being constantly strengthened throughout the eighteenth century and the first half of the nineteenth by contact with the speech of native Africans who were coming direct from Africa and who were sharing with the older Gullahs the *isolation* of the Sea Islands."[2] Echoing Turner, as well as the famous studies conducted on the Sea Islands in the 1920s and 1930s by researchers from the University of North Carolina and current promotions sponsored by the giant retailer Wal-Mart,[3] the most comprehensive study of Gullah/Geechee culture to date also makes the most comprehensive and absolute claim: "The *isolation* of sea island communities from outsiders," declare the authors of the National Park Service *Special Resource Study* (2005), "was vital to the survival of Gullah/Geechee community cultures."[4]

The term "isolation" summarizes geographical realities and historical developments. The distance of the Sea Islanders from the mainland, the flight of colonial-era planters during the season of mosquito-borne diseases, the year-round paucity of whites, until recently, and legal segregation are understood to have created a major obstacle to the Euro American influence that would otherwise, it is assumed, have wiped out African-inspired culture in the Lowcountry. African culture and the creolized forms in which it is most evident are thus represented as products of conservatism and as inherently less appealing or powerful than the Europeanized cultural forms that—had they been highly visible to the ancestors of the Gullah/Geechees—would have replaced their African-inspired culture.

Fig. 10.1
"A rice-raft with plantation hands, near Georgetown, South Carolina," stereograph, ca. 1890. Collection of Gene Waddell.

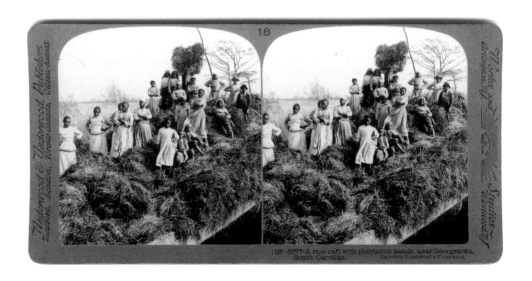

The argument that isolation contributes to linguistic distinction seems intuitively strong, but various real-world comparisons undermine it. Around the globe, it is common for dialects to diversify and proliferate at their small but densely populated origins. For example, England hosts a vastly greater number of accents and dialects than does the larger and less densely populated United States. Linguistic difference does not depend upon isolation. Moreover, creole languages such as Haitian Kreyòl, Jamaican Patois, and Cape Verdean Kriolu thrive in poor black neighborhoods of the eastern United States, where they are transformed from symbols of poverty and low status in the homeland into symbols of national pride in the diaspora and of superiority to the immigrants' more racially stigmatized African-American neighbors. In such cases, interaction with people of other languages and cultures, rather than separation from them, has fortified African-influenced creole languages.

Furthermore, rather than impede communication, the creeks and rivers that supposedly cut off the islands from each other and from the larger world are the very "roads" that once facilitated the traffic of huge crops of rice, indigo, and long staple cotton from outlying plantations to port cities and markets across the sea (fig. 10.1). Through antebellum South Carolina's early provisioning of ships and Caribbean sugar plantations, its heavy dependence on the Atlantic slave trade, and the exportation of its staple crops, this region was more actively engaged with the global economy than most other British North American colonies.[5] In the seventeenth and eighteenth centuries, far from being unvisited and left to itself, the area received major shipments of people and ideas from diverse ports of western and west-central Africa, as well as from the English-speaking Caribbean and Haiti, as islanders of all colors fled the Saint Domingue Revolution between 1791 and 1804.[6] During and after the American Civil War and into contemporary times, a steady flow of curious outsiders has poked and prodded "the Gullah people of the Georgia and South Carolina coast," making them "among the most studied populations in the United States."[7]

"Isolation," therefore, is a causal principle in serious need of revision. It does not reflect the best of what we know concerning history, the nature of culture, and the formation of ethnic identity. It mistakes common sense for cross-culturally observable patterns and, most unfortunately, it embodies an unspoken prejudice about the relative appeal and power of African-inspired and European-inspired cultures. In fact, a more accurate scenario is that it has been the Gullah/Geechees' history of interactions with black and white "persons of all sorts"[8] from all parts of Europe and Africa that has produced a proudly distinctive, African-inspired, and modern identity.

Just who are the Gullah/Geechees? Where do they live and what is distinctive about their way of life?

The term "Gullah" has long been used to describe the creole language spoken, at its height, by approximately half a million people of African descent on the Sea Islands and in the tidewater region of the South Atlantic coast. Its origins have been alternately attributed to a corruption of "Angola," a major source of Africans brought to South Carolina, or to the Gola, a group of people from the area now known as Liberia. According to anthropologist William Bascom, the Gola were identified with "the 'Gula negroes' of the southern states" by an American Baptist missionary, T. J. Bowen, who visited Liberia in 1850. But despite Bowen's categorical attribution, Bascom insisted that "the question still remains open."[9] Assumed to derive from the Ogeechee River, "Geechee" applies to Gullah-speakers who live along the Georgia coast.

In the early nineteenth century, "Gullah" was used to describe someone from Angola—for example, "Gullah Jack," who was named as a co-conspirator with Denmark Vesey in the 1822 slave insurrection in Charleston. Researchers in the twentieth century applied "Gullah" not only to the distinctive coastal language but also to a whole range of customs and beliefs related to religion, cuisine, domestic architecture, basketry and other crafts, as well as

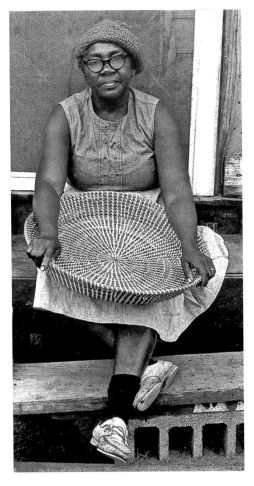

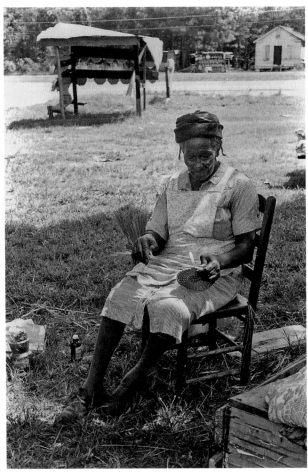

Fig. 10.2
Mary Jane Manigault, Mt. Pleasant, South Carolina, 1974.
Photo: Greg Day.

In 1984, Mary Jane Manigault was awarded a National Heritage Fellowship by the National Endowment for the Arts.

Fig. 10.3
Irene Foreman at her basket stand on Highway 17, Mt. Pleasant, South Carolina, 1972. Photo: Greg Day.

"intangible traits, such as motor habits, modes of behavior, and social institutions."[10] At the urging of anthropologist Melville Herskovits and following in the footsteps of Work Projects Administration researcher Mary Granger,[11] Bascom spent two months in 1939 searching for "Africanisms" on the Georgia Sea Islands. Among the local cultural traits that he identified were "the formality of friendship, the functions of clubs and societies, matrilinealism, an emphasis on special circumstances of birth, naming practices, interpretation of dreams, burial rites, beliefs in multiple souls and the intercession of ghosts," all of which, in his view, recalled African precedents more than they did European.[12]

Outside the academic community, the terms "Gullah" and more so "Geechee" have had pejorative associations, with implications of backwardness, poverty, and illiteracy. Thus, in 1971, when South Carolina Educational Television interviewers approached basket makers along Highway 17 for a film entitled *Gullah Baskets*, some sewers resented the term. "I'm no Gullah," protested one woman, while another, who had crafted baskets for forty years, denied ever having heard them called "Gullah baskets."[13]

Since the early 1990s, however, "Gullah" and "Geechee" have gained acceptance among the people so described. They may not use the terms in the sense of ethnic identity, but coastal people of African descent understand that when others use the words they are talking about them. In 2006, Congress officially designated the southeastern coast and its islands as a cultural and ecological preservation zone to be known as the "Gullah-Geechee Cultural Heritage Corridor" and established a commission for its management.[14] The stated purpose of the Corridor, steered through Congress by the current Majority Whip, S.C. Representative James E. Clyburn—who as a young man narrated the film *Gullah Baskets*—is to "preserve and

interpret [the] unique language, arts and crafts, religious beliefs, folklore, rituals and foods . . . of the Gullah/Geechee people."[15] The assumption that even relative isolation—and, by extension, ignorance about non-African alternatives—is the normal condition for the "retention" of African culture in the Americas belies not only the particulars of Gullah/Geechee history, including Gullah/Geechee rice technology and commerce, but also overall historical patterns in the Black Atlantic world. The eighteenth-century incubator of Gullah/Geechee culture hosted the bearers of a vast array of African traditions, as well as settlers from the British Isles and German states, French Huguenots and English Quakers, Swiss, Dutchmen, Sephardic and Ashkenazic Jews, Bahamians, Barbadians, and Creek and Cherokee Indians.[16] The proximity of the Spanish in Florida, where runaways could find safe haven, was well known to the ancestors of the Gullah/Geechees.[17] Among the Africans could be found fluent speakers of English, Spanish, Portuguese, French, German, Dutch, and Chickasaw.[18] For example, one 1763 runaway slave advertisement describes "a Negro man named LUKE . . . [who] has been used to the seas [and] speaks English, French, Spanish and Dutch."[19]

Furthermore, the enslaved were mobile. Few slaves belonged from birth to death to one master; therefore any given captive might know, influence, and be influenced by several plantation sub-cultures.[20] Captives sometimes moved long distances—as a condition of their service to their masters, as a function of their social lives, and sometimes in temporary or permanent flight from slavery.[21] In the eighteenth century, mariners constituted an astonishing nine percent of South Carolina's skilled slaves, and they greatly facilitated the mobility of black non-sailors as well.[22]

Swept up in the currents of the day, Gullah/Geechees participated actively in a circum-Caribbean maritime flow of people and revolutionary ideas.[23] Denmark Vesey, for example, was reported to be "familiar with the Haitian slave revolt and kept in touch with black leaders there." He is alleged to have "recruited a band of between 6,600 and 9,000 Negro men during the four years of planning. They met in secrecy at a farm which could be reached by water so that they could avoid the slave patrols."[24]

Enslaved and free people could not be kept from moving about and navigating the numerous waterways that drain the Lowcountry. Indeed, the local economy depended on their

Fig. 10.4
Ben Brown and two companions come to Penn School by boat from Palwana Island, South Carolina, ca. 1909. Photo: Leigh Richmond Miner. Penn School Collection/ Southern Historical Collection, University of North Carolina at Chapel Hill

Fig. 10.5
Palmetto View juke joint, Hamlin Beach, South Carolina, 1974. Photo: Greg Day.

Fig. 10.6
Child dancing at the Palmetto View juke joint, Hamlin Beach, South Carolina, 1972. Photo: Greg Day.

mobility. The rivers, bays, and salt and fresh water creeks of what would become Gullah/Geechee country afforded its inhabitants considerable freedom of movement among the Sea Islands and between the islands and the mainland ports. African-American cultural historian Richard A. Long describes the Charleston Market, for example, as a "geographical extension and high profile site" of "the Gullah world."[25] A coastal people whose homeland encompasses a major port and is traversed by highly navigable creeks and rivers can hardly be considered isolated relative to, say, people in the inland mountains, forests, and prairies where other black settlements are found. Navigable water does not isolate islands, and islands are not really insular (fig. 10.4). Like the Mississippi River, the Mediterranean Sea, the Indian Ocean, the Niger River, and even the Sahara Desert, the tidewaters of the Lowcountry facilitate commerce and exchange.

Most writers who specify a time period suggest that the Sea Islanders and their coastal kin experienced their deepest separation from national life after the Civil War, when time apparently stood still, not to start up again until the construction of bridges between the Sea Islands and the mainland in the 1950s. This period of self-containment was reputedly ended by a boom in resort development and suburban expansion, resulting in the Gullah/Geechees' displacement from self-employment as fishermen and farmers to wage employment in low-paying industries.[26]

Yet throughout the long epoch of the Gullah/Geechees' alleged isolation, non-Gullah/Geechee clients from distant states sought out root doctors in their island redoubts.[27] Root doctors employed herbs and performed rituals to heal their clients physically, to protect them from harm, and to harm their own and their clients' enemies. The most famous Gullah/Geechee "root doctors" are said to have possessed imported African ritual objects,[28] which fact suggests contact and commerce with people far "abroad"—to use the local word for the world beyond the islands.[29] Gullah/Geechee magic was amplified as well by European and Euro-American spell books, such as *The Great Book of Magical Art, Hindu Magic, and East Indian Occultism* (1902) by Lauren William DeLaurence, and *The Sixth and Seventh Books of Moses* (1910), which had likely arrived in the mail from Chicago.[30]

Still, the appearance of remoteness and exotic origin is a nearly universal element of credible magic—no less among Gullah/Geechee root doctors than among West African Yoruba healers. Despite his mystique of isolation, Dr. Buzzard (Mr. Stepheney Robinson), the famous Gullah/Geechee root doctor profiled by Roger Pinckney in *Blue Roots: African-American Folk Magic of the Gullah People*, specialized in resolving court cases and possessed a sophisticated knowledge of how to circumvent the state's efforts to restrict his practice.[31] Dr. Buzzard's colleague and contemporary Dr. Bug (Mr. Peter Murray), however, was caught supplying "roots" to cause his clients heart palpitations. Of this case, Pinckney writes: "After the arrest and incarceration of Dr. Bug for helping Gullah draftees fail their physicals for induction into the military, dozens, perhaps hundreds, of young men went to root doctors in an effort to foreshorten World War II before their inductions. It is commonly believed that the atomic bomb was the result."[32] Thus, Gullah/Geechee root work, in the twentieth century at least, thrived in the context and consciousness of international politics, history, and business.

During and after the Civil War, the Gullah/Geechees experienced a more intensive engagement with northern military officials, administrators, missionaries, and teachers —through the famous Port Royal Experiment—than virtually any other southerners. No African-American population has participated in the social, scientific, musical, and literary projects of a more diverse array of partisan outsiders. Starting with the occupying Union troops, the strangers spoke varieties of mainstream English, and brought with them books and the promise of literacy. The collapse of Reconstruction led to other sorts of movement in and out of the Gullah/Geechee zone—by nostalgic southern whites (such as Ambrose Gonzales, DuBose Heyward, and Julia Peterkin), by Afro-Philadelphian teacher and writer

Charlotte Forten, by University of North Carolina folklorists and social scientists, by Afro-North Carolinian linguist Lorenzo Turner, by basket wholesalers and retailers, and by the Gullah/Geechee purveyors of Sea Island produce and seafood, who sold their merchandise in Charleston.

From the first days of European and African settlement, Gullah/Geechee workers themselves repeatedly left and returned to the region. Since the Civil Rights Movement, some have left and returned as the most vociferous spokespersons of Gullah/Geechee cultural nationalism.[33] Nor has the flow of ideas into the Lowcountry been an enemy. Schooling at missionary-sponsored institutions, such as Penn, Avery, Laing, and Mather, as well as at universities far away, has done more to staff the leadership of revival movements than to encourage the abandonment of distinctive Gullah/Geechee ways.[34] The current acceleration of communication, transportation, and migration, which is blamed or credited for reducing Gullah/Geechee isolation and therefore endangering the people's cultural survival, actually has inspired an increase in the Africanness of Gullah/Geechee basketry. Basket sewers of Mt. Pleasant, South Carolina, now model some of their baskets on forms seen in books about Africa or on crafts brought from Africa by Gullah/Geechee travelers.[35] Indeed, the recent proliferation of lobbying organizations devoted to the rescue of Gullah/Geechee culture is less evidence that the culture is in danger than a manifestation of the enduring cosmopolitanism and growing political strength of an ethnic group ever more comfortable with its distinctiveness.

SHARED SPACES AND SEPARATE IDENTITIES

Despite abundant evidence to the contrary, some scholars of the African diaspora have described the "retention" of African culture in the Americas as exceptional and reflexively attribute cultural persistence to isolation. Roger Bastide, for example, describes Bahia as atypical in being a large city that retained its African religion with relative purity.[36] Herskovits recognizes Paramaribo, Port-au-Prince, and Bahia as similarly special, and Newbell Niles Puckett represents New Orleans as exceptional. Rather than "exceptions," these numerous urban cases might better be seen as disproving any simple rule.[37]

The persistence of the isolation thesis is based in part on a misjudgment about African culture: that people choose African ways of doing things only when they are unaware of non-African alternatives. Two generations of scholarship on the importance of African technology in South Carolina—by Peter H. Wood, John Michael Vlach, Daniel C. Littlefield, Judith A. Carney, and others[38]—ought, by now, to have eliminated this notion from the intellectual toolkit of African diaspora scholarship.

Moreover, the emphasis on isolation in the genesis of Gullah/Geechee identity places the cart before the horse in explaining how ethnic identities come about in the first place. The isolation model posits that people recognize their difference from others primarily when and where those others are absent. In fact, one population tends to recognize and classify its difference from another only when the first group interacts and competes or cooperates enough with the second for the imagined differences to matter—that is, when the populations are close enough to each other to need and value the same things, and yet different enough in resources, specialties, or political status to become rivals or allies in pursuit of them.[39] Ethnicity emerges, by its very nature, in shared spaces, while cultural distinctions are often invented or reinforced in order to legitimize novel claims of privilege.

It might be argued that cultural difference typically arises from the differential use of overlapping knowledge and resources. William Bascom observes that the most prolific retentions of African culture among the Gullahs and other African diaspora populations show up not in practices and beliefs that distinguish Africans from Europeans but in areas of overlap.

"There were a number of institutions common to both regions [Africa and Europe]," writes Bascom, "including a complex economic system based on money, markets, and middlemen, as well as . . . a common stock of folklore and a common emphasis on moralizing elements and proverbs."[40]

African-inspired culture in the Americas often draws strength from its similarity to European-inspired culture and/or, as in the case of rice cultivation, its superiority in the service of Euro-American needs—in short, from its proximity to, rather than distance from, non-African overlords, neighbors, and clients. Various authors even argue that conversion to Christianity facilitated, rather than impeded, the spread of African-inspired magico-religious practices.[41] In many settings, African-inspired medical care has been regarded as more effective and more trustworthy than Euro-American alternatives.[42] Whites who live alongside Gullah/Geechees frequently have embraced African-inspired beliefs, behaviors, and expressive genres.[43] The Euro-American appropriation of the banjo, rhythm and blues, and hip-hop are parallel and widely discussed examples.

In some multi-ethnic contexts, distinctive foods and ways of preparing them can separate groups of people from one another, since it is difficult to befriend or marry people bound by different dietary rules. Thus, as in the case of kosher dietary protocols, culinary differences are often part of a people's deliberate strategy to remain a social community apart from even their next-door neighbors. In general, the "survival" of foodways seldom depends on the isolation of the people who invented them. For example, Carney demonstrates the West African origins of the much-advertised, cross-racial preference for grain separation—as opposed to stickiness—in American rice cuisine (see Chapters 3 and 5).[44] Moreover, in virtually all societies, ethnic and regional diversity structures the marketing of prepared food. And recipes travel. Thanks to my friend Henrietta Snype, a basket maker in Mt. Pleasant, South Carolina, my Massachusetts friends and family have recently acquired a powerful penchant for "swimps and gwits," seasoned to traditional perfection with Lipton Onion Soup Mix. Consequently, we now help propagate an ethnic identity, cuisine, and language that few of us previously knew existed.

Even the meaning and usefulness of Africanisms in the Gullah/Geechee lexicon rely upon the co-presence of whites and other non-Gullah-speakers. By far, the most numerous cognates of African words in Gullah—as identified by Turner and his Niger-Congo-speaking collaborators at London's School of Oriental and African Studies (SOAS) —are "basket names." These are Gullah/Geechee personal names known only to family members and other Gullah/Geechees, in contrast to the "English" names that are used with strangers, at school, or in written communications.[45] Thus, the semantic meaning and pragmatic function of "basket names" depend on the existence of a nearby outsider audience that insiders have occasion to exclude. According to Salikoko S. Mufwene and Charles Gilman, Gullah/Geechees are "generally bidialectal in various varieties of local or standard English."[46] In other words, Gullah/Geechee names and language generally are used not for lack of an alternative but, rather, to convey in-group intimacy or to prevent monolingual English-speakers from understanding a private communication.[47] A Gullah-speaker may use the contrast between Gullah words or phrases and English words or phrases of similar meaning to convey finely nuanced messages about his or her thoughts, social status, and intentions. Just as multiple Iberian dialects have survived centuries of Castilian dominance, Gullah is likely to survive and remain useful in countless projects of meaning-making and community-building in a multi-ethnic and multicultural world.[48]

FOLK CULTURES AND WHITE IDENTITY

The most vibrant and populous African-inspired cultures in the Americas generally are not the ones isolated from mainstream Euro-American cultures but those that have most

effectively employed Western communication and transportation technologies to stay in touch with Old World Africans.[49] Moreover, because these African-diaspora cultures may look very different from urban Western culture, they become available as emblems of a seemingly primordial and authentic local autonomy, often in the service of local white elites who are resisting political and economic domination by more metropolitan whites. In Brazil, for example, members of the socially powerful white elites of the Northeast, such as Raymundo Nina Rodrigues, Gilberto Freyre, and Édison Carneiro, championed Afro-Bahian culture as a badge of their own legitimacy—and that of Brazil as a whole—in contrast to the economically dominant white elites of São Paulo, with their European pretensions.[50] The Northeast had once been the economic, political, and cultural center of Brazil. White Northeastern Regionalists answered their own marginalization by proclaiming the unique authenticity of Northeastern black culture and its superiority to the black cultures of São Paulo and the United States. They also often touted the Northeast's allegedly exemplary embrace of racial hybridity.[51]

Similarly, in the wake of the 1898 United States invasion of Cuba, Fernando Ortiz made Afro-Cuban culture into a symbolic pillar of Cuban autonomy. Postbellum New Orleanians George Washington Cable, Robert Tallant, and Lyle Saxon, among others, documented and purposely exaggerated the mystery and sensuality of creole New Orleans. Subsequent generations of white New Orleanians have marketed themselves to tourists as the scions of a sybaritic aristocracy—French-inspired, African-seduced, and just too sophisticated to embrace the moral and racial purism of Protestant America. In the face of United States domination and racial chauvinism, Mexican indigenism and the Haitian Bureau d'Éthnologie recounted similar allegories, inferring from their distinctive "folk" cultures the dignity and autonomy of their nations.[52]

Like the conquered or superseded white elites of southern Louisiana, northeastern Brazil, and Mexico—and even the elite, Francophone blacks and mulattoes of Haiti—the conquered whites of Charleston have avidly documented, celebrated, protected, and at times even subsidized the "folk" cultures of the dark people whom they regarded as their subordinates. Important cultural figures—such as Georgian Joel Chandler Harris (1848–1908), Mississippian Newbell Niles Puckett (1897–1969), South Carolinian DuBose Heyward (1885–1940), and Charleston's all-white Society for the Preservation of Spirituals—linked their longing for a mythic antebellum civilization to a careful documentation of a distinctly black regional culture (see Chapter 9). Though cast as in some ways inferior to European or metropolitan white

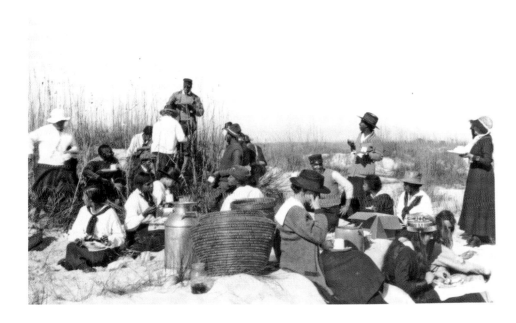

Fig. 10.7
Penn School teachers' outing, St. Helena Island, South Carolina, 1921. Photo: Leigh Richmond Miner. Penn School Collection/Southern Historical Collection, University of North Carolina at Chapel Hill

Fig. 10.8
Alfred Graham, St. Helena Island, South Carolina, 1909. Photo: Leigh Richmond Miner. Penn School Collection/ Southern Historical Collection, University of North Carolina at Chapel Hill.

Alfred Graham, Penn School's first basketry teacher, working on a basket. His wife, Susan, sits on the porch of their house. To the right of Graham is his grandson and to the left lie bundles of bulrush and saw palmetto splints. Penn used this photo on the "Trademark Tag" attached to baskets the school sold and shipped.

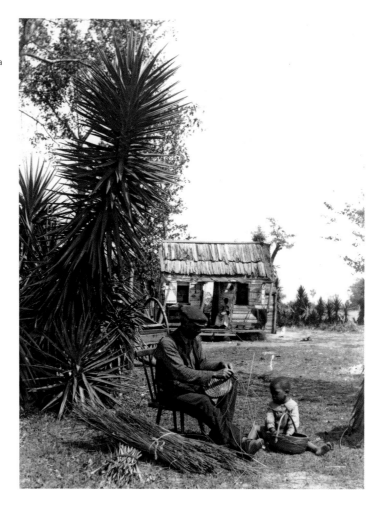

culture, the black subcultures they revered were regarded as traditional, authentic, sincere, and, best of all, characteristic of a noble past.[53]

REARRANGING ROOTS

Lorenzo Turner's emphasis on the Yoruba antecedents of Gullah language[54] is probably indebted to the overrepresentation of certain British-colonized peoples among the SOAS scholars whom Turner asked for help in identifying the African origins of Gullah terms. In historical fact, while the plurality of the Gullah/Geechees' African ancestors has been identified as "Angolan" and "west-central African," the scholarly literature demonstrating the African origins of South Carolina's rice culture offers little incentive to pay special attention to this demographic fact. The best-studied African rice-producing region—between the Senegambia and Liberia—has, since Turner, become the more prestigious ancestor. In Sierra Leone, anthropologist and former Peace Corps volunteer Joseph Opala has argued that coastal South Carolina and Sierra Leone share a unique family tree. Scholarly emphasis on the "Rice Coast" and on these recently perceived social ties is the basis of a selective but nonetheless powerful idea. The narrative of Gullah/Geechee kinship with the peoples of Sierra Leone has now been reinforced by several official visits between these two communities and by two deeply moving films—*Family Across the Sea* (1990), produced under the sponsorship of South Carolina Educational Television, and *The Language You Cry In* (1998).

Considering the West African focus of Melville Herskovits, Peter H. Wood, and Joseph Opala, one might ask why Daniel C. Littlefield's inventory of the eighteenth-century African runaways in South Carolina[55] includes no Yoruba people (though the one "Nego" might be a

"Nago" Yoruba), no Gola people (the Sierra Leoneans sometimes credited with the origin of the term "Gullah"), no Mende people (the most populous ethnic group in Sierra Leone), and no Baga people (the ethnic group from Guinea-Conakry credited with the most likely precedents for the rice-growing techniques that made South Carolina prosper).[56] One reason might be that these ethnic terms are modern and their meanings today are not what they were to observers who used them in the eighteenth century. Another possibility is that twentieth-century researchers have, for twentieth-century reasons, focused on the most accessible evidence and the most prestigious of the Gullah/Geechees' likely ancestors. The local appropriation of outsider scholarship (including the works of Turner, Bascom, Wood, Littlefield, Opala, and Rosengarten) has actually turned the course of history—by re-shaping the self-understandings, priorities, and community-building efforts of contemporary Gullah/Geechees and other peoples of the African diaspora. Moreover, this outside influence has increased, rather than decreased, the Africanness of Gullah/Geechee culture and ethnic identity.

Fig. 10.9
Marquetta L. Goodwine, Chieftess of the Gullah/Geechee Nation, at the Foreign Press Center, Washington D.C., January 30, 2003.

DIALOGUE

Both the local language and a lively long-distance "dialogue" with other peoples have created the Gullah/Geechee identity as we know it today. Most Gullah and Geechee children have grown up believing that the language of their forebears and, by extension, their own, is just a substandard version of American English. Indeed, coastal Georgian Clarence Thomas attributes his relative silence on the Supreme Court bench to his having attended schools where his Gullah/Geechee language was considered inferior.[57] Alphonso Brown, owner of Gullah Tours, reports that when he was growing up he thought he was "just speaking bad English."[58]

Outsider scholarship has played a major role in the recent Gullah/Geechee embrace of Africa and the recognition of Gullah/Geechee as a creole language rather than as a deficient form of English. Gullah/Geechee lifeways, for so long linked to poverty and backwardness and to people in need of "uplift," now garner appreciation as the hallmarks of a valuable culture and self-ascribed ethnic identity. The Penn School, founded on St. Helena in 1862 to educate the islanders when Federal forces occupied the area of Port Royal Sound, was a leader in propagating and defining production standards for Gullah/Geechee crafts and folk arts, such as "native island" basketry, and has been a major player in making St. Helena the capital of an emergent Gullah/Geechee culture (fig 10.7–10.8).[59]

In 1988, Penn Center, successor to the Penn School, hosted the visit of Sierra Leone's President Joseph Momo, which established the stateside momentum for the visit of two Gullah/Geechee delegations to West Africa during the 1990s. These transatlantic journeys fostered the popular impression that Sierra Leonean Krio is the origin of Gullah/Geechee language and provided the impetus for the lobbying efforts of Gullah/Geechees to assist Sierra Leoneans during their recent civil war, and even for the declaration that the Gullah/Geechees are the "Mende people of South Carolina."[60] Such examples of a trans-oceanic dialogue have helped solidify the dignity and African rootedness of Gullah/Geechee identity.

Lorenzo Turner himself was a major agent of this dialogue. His transformative scholarly work in the 1930s and 1940s did not begin and end with his research stint on the Sea Islands. As an African American, he achieved a level of access to private Gullah practices and parlance that had been denied to previous white researchers. Yet his unique access demonstrates not that the Gullah/Geechees lived in a world apart from whites, but that they lived close enough to mistrust them and to have established a convention of excluding them from certain information. In their centuries-old and highly active exchange with their masters and managers, employers, customers, neighbors, teachers, missionaries, researchers, and so forth, Gullah/Geechees have learned to communicate one way with ethnic insiders and another with ethnic outsiders. Far from having "preserved" their African culture in isolation, Gullah/Geechees discovered their Africanness, amplified it, and gave it a new social reality as a result of their

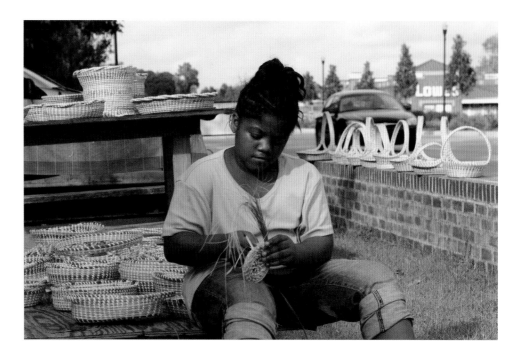

conversations with geographical outsiders like Turner.

This discourse is the root of what might be called a Gullah/Geechee Renaissance, which, like all renaissances and revitalization movements, is as much a new fabrication as a rebirth.[61] Among its most remarkable inventions is that a Gullah returnee from New York has been "enstooled" as "Chieftess of the Gullah/Geechee Nation" (fig. 10.9).[62] In 1996, Marquetta L. Goodwine, a native of St. Helena Island, then residing in Brooklyn, founded the Gullah/Geechee Island Coalition, an organization designed to promote and preserve Gullah/Geechee culture through "land re-acquisition and maintenance," and to celebrate this culture "through artistic and educational means, electronically and via 'grassroots scholarship.'" Describing the southeastern coast as the "Gullah/Geechee nation," Ms. Goodwine—also known as "Queen Quet"—took her people's case before the First International Conference on the Right of Self-Determination and to the United Nations in Geneva in 2000.[63]

The backdrop of this dramatic development is a boom in Gullah/Geechee literary and cultural production since the early 1990s.[64] Often educated and media-savvy, Gullah/Geechee writers, singers, painters, craftspeople, educators, and lobbyists have taken their message of Gullah/Geechee peoplehood and cultural distinctiveness to the press, television stations, Internet, municipal and county governments, Congress, the United Nations, public schools, tourism bureaus, and commercial galleries.

Without minimizing the tragedy of Gullah/Geechee land loss, one might say that Gullah/Geechee culture and ethnic identity are more alive today than ever before. The ability to promulgate and pass national legislation and a range of local laws demonstrates the growing skill of Gullah/Geechee organizations at educating the public, lobbying regional officials to secure Gullah/Geechee land holdings, and pressuring non-Gullah/Geechee landholders and businesses to allow Gullah/Geechee access to ancestral sites to gather raw materials for their basketry. For some individuals, these successes are a step in the direction of nation-building.

Gullah/Geechee culture has undergone a further, characteristic moment in the consolidation of ethnic groups and the canonization of their cultures—the publication of a vernacular Bible. Appropriately, *De Nyew Testament* (2005) places the Gullah text alongside the King James English version.[65] Gullah/Geechee culture is, after all, characterized by a bilingual field or creole continuum—that is, a range of forms between the most creolized, or basilectal, and the

most "standard," or acrolectal. What makes the production of *De Nyew Testament* a canonical act is not just that it legitimizes the language, which until recently took written form only in the works of scholars, folklore collectors, and fiction writers, but also that it establishes a single version of the internally heterogeneous Gullah/Geechee language as a standard worthy of the sacred and of the official. In practice, Gullah varies from island to island, just as in Nigeria the so-called dialects of Yoruba vary from one region to another. Similarly, the translation of the Bible into Yoruba required an artificial homogenization of dialects and thus created a previously non-existent and now school-taught standard around which the Ekiti, the Ọyọ, the Ijẹbu, the Ẹgba, the Ẹgbado, and so forth can rally collectively in the face of rivalry with, for example, Igbo and Hausa people—Nigeria's other dominant ethnic groups.[66]

Through 1861, the livelihood of the Gullah/Geechees' ancestors as enslaved farmers of rice and long-staple cotton made an in-group language useful as the medium of communication to exclude the oppressor class. After the Civil War, the freed people's shared status as family farmers under continual threat of land expropriation, and as fishermen and merchants—and not their isolation from whites—preserved the utility of their distinctive crafts, their in-group language, and their church-based form of self-government. As long as some islands, such as Johns, Wadmalaw, Edisto, and St. Helena, retain major Gullah-speaking populations, and the mainland community of Mt. Pleasant continues to profit from its African-inspired basketry (fig. 10.10),[67] even the unscrupulous displacement of some island populations is unlikely to result in the disappearance of the Gullah/Geechees. Ironically, the ongoing threat posed by the loss of some islands, such as Daufuskie and Hilton Head, to development pressures may have strengthened Gullah/Geechee culture. Alongside the return of émigré cultural nationalists and the emergence of a professional class of Gullah/Geechee cultural educators (including choirs, storytellers, and school presenters), this threat has inspired Gullah/Geechee leaders to articulate, dignify, centralize, standardize, and canonize a culture that, in the early twentieth century, had not considered itself worthy of the name.

It is in the context of an interracial, interregional, and international dialogue that the recently self-recognized Gullah/Geechee people have transformed the shame born of slavery into cultural capital. Thus, Gullah/Geechee "isolation" is a misnomer, if not a contradiction in terms. Three centuries of deftly managed inter-ethnic struggle, amid highly unequal power relations, has prepared the Sea Islanders and their mainland kin to defend their land and culture against the newest demographic, political, and economic threats.

In the film *Family Across the Sea*, a Gullah/Geechee cultural delegation visits Bunce Island, off the coast of Sierra Leone, where captives from the mainland had trodden for the last time on African soil (figs. 1.8, 1.9, p. 13). There the visitors tearfully receive a lecture from Joseph Opala about the horrors that their ancestors had experienced on the island. One visitor reports that she has finally discovered her culture, a culture that she had never known about. The irony of "cultures" these days—and perhaps as long as there have been diasporas and cultural canons—is that they are not always daily lived or known by their members but instead are often "discovered" or "revealed" in dialogue with outsiders. Cultures regularly find their most ardent champions among erstwhile members of the group who have moved away and returned in the role of spokespersons for an identity with far less salience, pride of place, and usefulness among those who had stayed at home.

Unlike mountains and forests, islands tend to have points of entry and exit all around, leading to and from every direction. The ancestors of the Gullah/Geechee people did not decide how and when they entered and left Bunce Island, or what they could carry with them. After years of struggle, today's Gullahs and Geechees can decide when and how they enter and leave Bunce or St. Helena. They can also decide what to take with them and what to take away from the experience.

Cat. 120
ESPRESSO CUP AND SAUCER
B. Cousette
South Carolina
2005
H. 6 cm.
Collection of Dale Rosengarten

Cat. 121
TEAPOT
B. Cousette
South Carolina
2006
H. 13 cm.
Collection of Edith Howle
and Rick Throckmorton

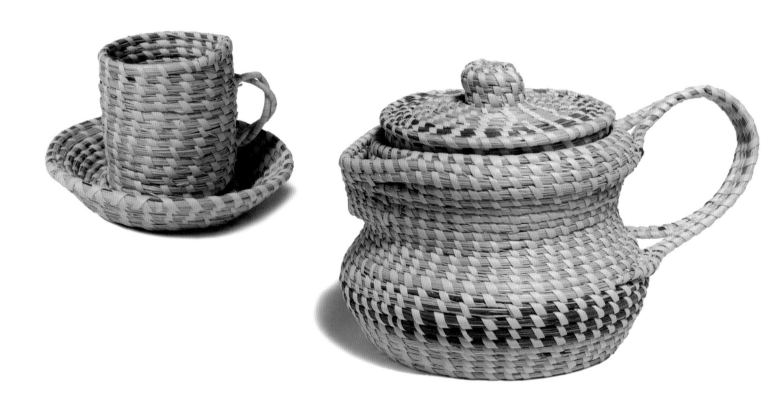

ENDNOTES

CHAPTER 1
AFRICAN ORIGINS: ANCESTORS AND ANALOGUES

1. Elizabeth Isichei, *Igbo Worlds* (London: Macmillan Education Ltd., 1977).

2. Originally a single colony run by eight entrepreneurs and friends of the King known as the Lords Proprietors, Carolina was formally divided in 1729 into two separate royal colonies, North and South Carolina.

3. For more on the contrast between rice winnowing baskets in South Carolina and Louisiana, see Dale Rosengarten, "Social Origins of the African-American Lowcountry Basket," Ph.D. diss., Harvard University, 1997, 141–42, 145–47.

4. For a call to reexamine the American plantation system using the metaphor of the gulag—the Soviet network of forced labor camps—see Peter H. Wood, "Slave Labor Camps in Early America: Overcoming Denial and Discovering the Gulag," in *Inequality in Early America*, eds. Carla Gardina Pestana and Sharon V. Salinger (Hanover, N.H.: Dartmouth College/University Press of New England, 1999), 222–38.

5. Dorothy Hartley, *Lost Country Life* (New York: Pantheon Books, 1979), 164.

6. Every year, three or more registered ships left Cacheu, south of The Gambia, each laden with more than four hundred quintals of wax—one quintal weighing 112 pounds, and three quintals equivalent to the price of one slave. Walter Rodney, *A History of the Upper Guinea Coast, 1545–1800*, 1970 (reprint, New York: Monthly Review Press, 1980), 158.

7. "The Portuguese currency value of wax delivered at Angolan ports during the eighteenth century . . . rose much higher than the value of ivory exports." Joseph C. Miller, *Way of Death: Merchant Capitalism and the Angolan Slave Trade, 1730–1830* (Madison: University of Wisconsin Press, 1988), 114.

8. For further discussion of basketry beehives, see Rosengarten, "Social Origins," 246–49.

9. "Brewers are normally very reluctant to use any honey that has been separated from the wax, as they believe that crude honey makes the best beer. . . . When fermentation is completed, the brew is strained through long bags of woven reeds, or some more modern device; the waxy residue is either discarded or rendered for wax." P. D. Paterson, "The traditional making of honey beer throughout tropical Africa," in *Honey: A Comprehensive Survey*, ed. Eva Crane (London: William Heinemann Ltd., 1975), 405–7.

10. Merran McCulloch, *The Ovimbundu of Angola*, Ethnographic Survey of Africa, ed. Daryll Forde (London: International African Institute, 1952), 14.

11. William Bosman, *A New and Accurate Description of the Coast of Guinea, Divided into the Gold, the Slave, and the Ivory Coasts*, 1705 (reprint. London: Frank Cass & Co. Ltd., 1967), 120. The published recollections of Osifekunde, an Ijebu man from Nigeria, provide a detailed description of the types of headgear worn by people in the hinterland of Lagos, ca. 1810. Quoted in *Africa Remembered: Narratives by West Africans from the Era of the Slave Trade*, ed. Philip D. Curtin (Madison: University of Wisconsin Press, 1967), 264–65.

12. G. Cyril Claridge, *Wild Bush Tribes of Tropical Africa*, 1922 (reprint. New York: Negro Universities Press, 1969), 73.

13. Ibid., 219–20.

14. Frederick Starr, Congo Diaries, November 19, 1906. American Museum of Natural History, Anthropology Division Collections Database. Starr fieldnotes courtesy of the Regenstern Library, University of Chicago. Available at: *http://www.anthro.amnh.org*.

15. Theodore Rosengarten, *Tombee: Portrait of a Cotton Planter, with the Journal of Thomas B. Chaplin, 1822–1890* (New York: William Morrow & Co., 1986), 530.

16. Lathan A. Windley, comp., *Runaway Slave Advertisements: A Documentary History from the 1730s to 1790*, vol. 3: *South Carolina* (Westport, Conn.: Greenwood Press, 1983), 68, 89.

17. David P. Gamble, *The Wolof of Senegambia, Together with Notes on the Lebu and the Serer*, Part 14, Ethnographic Survey of Africa, ed. Daryll Forde (London: International African Institute, 1967), 35, 38, 45.

18. Margaret W. Sullivan, "Fine Hands People: A Portrait of Sierra Leonean Craftsmen and their Skills" (draft), 1977, 123. In 1996, Sullivan gave the Smithsonian Institution's National Museum of Natural History a copy of this manuscript, her field notes, a large collection of objects from Sierra Leone, and photographs taken by Lisa M. Turnbull-Laramee documenting a wide range of crafts. Letter from Margaret Sullivan, Alexandria, Va., to Dale Rosengarten, January 4, 1996.

19. T. J. H. Chappel, "Decorated Gourds in Northeastern Nigeria," *Ethnographica*, The Nigerian Museum, 1977, 24.

20. Joseph A. Opala, *The Gullah: Rice, Slavery, and the Sierra Leone–American Connection*, pamphlet commissioned by the United States Information Service, Freetown, Sierra Leone, 1987, 11–14.

21. The connection intensified after 1756, when the firm's principal partner, Richard Oswald, entered a close personal and business relationship with Henry Laurens, one of South Carolina's most successful rice planters and slave dealers. At the end of the Revolutionary War, the relationship again had historic consequences, as Laurens, one of four American peace commissioners, faced Oswald, head of the British team, across the negotiating table. Ibid., 4–6. Located twenty miles upriver from Sierra Leone's capital city of Freetown, Bunce Island has also been spelled "Bance," "Bense," or "Bence" at different times in its history.

22. Introduction to Ibid., n.p.

23. Ibid., 27.

24. "Aleathia Manigault: Sweetgrass Basket Maker," n.d. [1993], collection of Dale Rosengarten. Sierra Leone is also claimed as the sole source of sweetgrass baskets in "Expressions in Sweetgrass," the brochure for an exhibit of paintings and baskets by Jery Bennett-Taylor, Penn Center, St. Helena Island, S.C., July 2007.

25. See Sullivan, "Fine Hands People," 120–23, for a description of the processes involved in sewing *suku blai*, dyeing raffia, and creating geometric designs.

26. Ibid., 119–20.

27. *Muhlenbergia sericea* (syn. *M. filipes*, *M. capillaris* var. *filipes*).

28. Sullivan, "Fine Hands People," 117.

29. Ibid., 114–16.

30. The Fouta Jallon region is the watershed where the Niger River starts and flows through the inland Niger Delta, site of the Mali empire. G. E. Brooks, *Landlords and Strangers: Ecology, Society, and Trade in Western Africa, 1000–1630*

(Boulder, Co.: Westview Press, 1993), 69; A. E. Nyerges, "Ethnography in the Reconstruction of African Land Use Histories: A Sierra Leone Example," *Africa: Journal of the International African Institute* 66:1 (1996), 122–44.

31. See Judith A. Carney, *Black Rice: The African Origins of Rice Cultivation in the Americas* (Cambridge: Harvard University Press, 2001), 39, 65.

32. Frederick Lamp, *Art of the Baga: A Drama of Cultural Reinvention* (New York: The Museum for African Art and Prestel, 1996), 156.

33. Ibid., 163, 158–59.

34. Ibid., 124.

35. Dominique Zahan and Allen F. Roberts, "The Two Worlds of Ciwara," *African Arts* 33:2 (2000), 39. See also Lamp, *Art of the Baga*, 39, 101–3. Zahan's argument is tantalizing but complicated. While the Baga object has to do with rice, a plant that lives in the water but flowers above, the horizontal form of the *ci-wara*, according to Zahan, has to do with the peanut, *Voandzeia*, a plant that flowers below ground. Zahan examines the varied forms of Baga and Bamana bird and antelope sculptures to show how each relates to a particular understanding of the relevant plant which the sculpture celebrates. Lamp correctly puts the origin of the Baga in Fouta Jallon, not the inland Niger Delta of Mali.

36. Anita J. Glaze, "Dialectics of Gender in Senufo Masquerades," *African Arts* 19:3 (May 1986), 30–39, 82. While there is no evidence of a direct link with Senufo staffs, stout walking canes carved with figures of snakes, birds, lizards, alligators, and other creatures were and still are made on the Sea Islands and indeed across the African diaspora.

37. Eberhard Fischer and Hans Himmelheber, *The Arts of the Dan in West Africa* (Zurich: Museum Rietberg, 1984), 122–33.

38. Daniel C. Littlefield, *Rice and Slaves: Ethnicity and the Slave Trade* (Baton Rouge: Louisiana State University Press, 1981), 113; Philip D. Curtin, *The Atlantic Slave Trade: A Census* (Madison: The University of Wisconsin Press, 1969), 222, 229; Curtin, *Africa Remembered*, 29–30, n.15; Joseph C. Miller, "The Slave Trade in Congo and Angola," in *The African Diaspora: Interpretive Essays*, eds. Martin L. Kilson and Robert I. Rotberg (Cambridge: Harvard University Press, 1976), 75. Approximately forty percent of the ten million or so Africans who landed in the New World between 1500 and 1870 boarded ships on the Congo and Angola coast.

39. Wilfrid D. Hambly, *The Ovimbundu of Angola*, Field Museum of Natural History Publication 329, Anthropological Series 20:2 (1934), 319. The Ovimbundu, whose name, "people of the fog," may derive from the heavy morning mists of the highlands, are related culturally to people of the southwest Congo and to western Bantu-speakers in general. Hambly described them as the Portugueses' "native henchmen," a reference to their historic role as purveyors of captives for the slave trade and their subsequent collaboration with European interests in the region.

40. McCulloch, *The Ovimbundu of Angola*, 18.

41. Joachim John Monteiro, *Angola and the River Congo*, 1875 (reprint. London: Frank Cass & Co. Ltd., 1968), vol. 1, 274–77; vol. 2, 276–77. For a comparison with the Serer of Senegal, among whom "the grave of a man is marked by his bow and arrow, that of a woman by her mortar and pestle," see Gamble, *The Wolof of Senegambia*, 103.

42. The Mbundu had followed the Kongo and preceded the Ovimbundu as the dominant power in west central Africa.

43. Maggie Manigault, Mt. Pleasant, S.C., March 23, 1985, interview by Dale Rosengarten. McKissick Museum, Folklife Resource Center, University of South Carolina.

44. Hambly, *The Ovimbundu of Angola*, 171.

45. See Elizabeth Hyde Botume, *First Days Amongst the Contrabands*, 1893 (reprint. New York: Arno Press, 1968), 135; Dale Rosengarten, *Row Upon Row: Sea Grass Baskets of the South Carolina Lowcountry*, 1986 (reprint. Columbia: McKissick Museum, 1994), 20–21.

46. Robert Brain, *Art and Society in Africa* (London: Longman Group Ltd., 1980), 213.

47. L. Tucker, "The Divining Basket of the Ovimbundu," *Journal of the Royal Anthropological Institute*, 1940, 201, quoted in McCulloch, *The Ovimbundu of Angola*, 39.

48. McCulloch, *The Ovimbundu of Angola*, 37–38. For a discussion of a nearly identical ritual among the Chokwe, see Brain, *Art and Society in Africa*, 216.

49. McCulloch, *The Ovimbundu of Angola*, 38.

50. See Leland Ferguson, *Uncommon Ground: Archaeology and Early African America, 1650–1800* (Washington, D.C.: Smithsonian Institution Press, 1992), 109–16. For a report on colonial African-American ritual objects discovered in Maryland, see John Noble Wilford, "Slave Artifacts under the Hearth," *The New York Times*, August 27, 1996.

51. "William Ladd, Esq., Minot, Maine. President of the American Peace Society, formerly a slave-holder in Florida," quoted in *American Slavery as It Is: Testimony of a Thousand Witnesses* [ed. Theodore Dwight Weld], 1839 (reprint. New York: Arno Press, 1968), 43.

52. Ferguson, *Uncommon Ground*, 116.

53. Claridge, *Wild Bush Tribes of Tropical Africa*, 215.

54. See A. Werner, "The Bushongo" in *Journal of the Royal African Society* 11:42 (January 1912), 206–12.

55. Sir Harry Johnston, *George Grenfell and the Congo*, vol. 2, 1918 (reprint. New York: Negro Universities Press, 1969), 807–8. Johnston based his account on the diaries and researches of the British Baptist missionary George Grenfell.

56. For a detailed analysis of the genocidal plundering of the Congo, see Adam Hochschild, *King Leopold's Ghost: A Story of Greed, Terror, and Heroism in Colonial Africa* (Boston: Houghton Mifflin/Mariner Books, 1999).

57. E. D. Morel, "The 'Commercial' Aspect of the Congo Question," *Journal of the Royal African Society* 3:12 (July 1904), 430–48.

58. Enid Schildkrout, "Personal Styles and Disciplinary Paradigms: Frederick Starr and Herbert Lang," in *The Scramble for Art in Central Africa*, eds. Enid Schildkrout and Curtis Keim (Cambridge: Cambridge University Press, 1998), 183. See also E. Schildkrout and C. Keim, *African Reflections: Art from Northeastern Zaire* (New York: American Museum of Natural History and Seattle: University of Washington Press, 1990).

59. *Publication of the Commission pour la Protection des Arts et Métiers Indigenes*, Belgian Colonial Office, 1936, 15.

60. John H. Weeks, *Among the Primitive Bakongo*, 1914 (reprint. New York: Negro Universities Press, 1969), 228, 127.

61. Ibid., 103–5.

62. Karl Laman, *The Kongo I*, Studia Ethnographica Upsaliensia, vol. 4 (Uppsala: Almqvist & Wiksells, 1953), 142.

63. Claridge, *Wild Bush Tribes of Tropical Africa*, 216.

64. Sónia Silva, *A Vez dos Cestos [Time for Baskets]* (Lisbon: Museu Nacional de Etnologia, 2003), 46 fig. 15.

65. Laman, *The Kongo*, 81–82.

66. Gordon D. Gibson and Cecilia R. McGurk, "High-Status Caps of the Kongo and Mbundu Peoples," *Textile Museum Journal* 4:4 (1977), 81.

67. Personal communication from Huguette Van Geluwe, former Head of the Section of Ethnography at the Royal Museum for Central Africa, Turveren, Belgium, to Dale Rosengarten, July 26, 1990.

68. Frederick Starr, *Congo Natives: An Ethnographic Album* (Chicago: Lakeside Press, 1912), Plate 63. "Occasionally," Joachim John Monteiro wrote, "in the case of a big 'soba,' there are several tiers of earth raised one above the other, and ornamented with broken glass and crockery and various figures representing 'fetishes,' and I have also seen a shade of sticks and grass erected over the whole, to keep it from the rain." *Angola and the River Congo*, vol. 2, 1875 (reprint. London: Frank Cass & Co. Ltd., 1968), 276–77. Additionally, there is a 1930s photograph of anthropologist G. I. Jones seated at a tiered grave in Nigeria, see *http://mccoy.lib.siu.edu/jmccall/jones* (accessed November 5, 2007).

69. Thompson, the leading exponent of "Kongoisms" in New World cultures, construes crosses chalked on the floor of shrines and altars in Cuba, Trinidad, St. Vincent, and especially Brazil, as Kongo symbols. He admits that simple cruciforms may be "complex signs" fusing diverse elements—"a mixture of Kongo, Yoruba, Dahomean, Roman Catholic, Native American, and Spiritualist allusions"—but claims that in these New World examples, Kongo influence predominates. Robert Farris Thompson, *Flash of the Spirit: African and Afro-American Art and Philosophy* (New York: Random House, 1983), 113. For further discussion of Kongoisms, see Rosengarten, "Social Origins," 26, 88–91, 172–89.

70. A Kongo basket with a three-tiered lid, says religious scholar Fu-Kiau Bunseki-Lumanisa, would be used only in the upper world, not on a grave. Personal communication with Dale Rosengarten, December 2, 1991. J. Lorand

Matory cautions against a too-literal explanation of the Kongo cosmogram, noting that the term has no KiKongo counterpart. Personal communication with Rosengarten, May 8, 1997.

71. Wyatt MacGaffey, *Religion and Society in Central Africa: The BaKongo of Lower Zaire* (Chicago: University of Chicago Press, 1986), 46. For a full exploration of "the reciprocating universe," see Ibid., 42–62.

72. Ibid., 75.

73. David Doar, *Rice and Rice Planting in the South Carolina Lowcountry* (Charleston, S.C.: The Charleston Museum, 1936), 33–34.

74. Gregory Day, "Afro-Carolinian Art: Towards the History of a Southern Expressive Tradition," *Contemporary Art/Southeast* 1:5 (January/February 1978), 13, 19. Day also attributes the Charleston triple chest and the Charleston single house to African influences—claims that are hotly contested.

75. Kay Young Day [Kate Porter Young], "My Family Is Me: Women's Kin Networks and Social Power in a Black Sea Island Community," Ph.D. diss., Rutgers University, 1983.

76. Kate Porter Young, personal communication with Dale Rosengarten, March 14, 1994.

77. "On any given morning in a Georgia [or South Carolina] rice field," writes Charles Joyner, "an enslaved African would meet more Africans from more ethnic groups than he or she would encounter in a lifetime in Africa." Charles Joyner, *Remember Me: Slave Life in Coastal Georgia* (Atlanta: Georgia Humanities Council, 1989), 2.

78. Ibid., 2.

CHAPTER 2
THEY UNDERSTAND THEIR BUSINESS WELL: WEST AFRICANS IN EARLY SOUTH CAROLINA

1. An earlier version of this essay appeared as "'It Was a Negro Taught Them': A New Look at African Labor in Early South Carolina," *Journal of Asian and African Studies* 9:3/4 (July/October 1974), 164. Some material appearing here is presented in a fuller context in Peter H. Wood, *Black Majority. Negroes in Colonial South Carolina from 1670 through the Stono Rebellion* (New York: Alfred A. Knopf, 1974).

2. From Reconstruction onward, generations of historians reinforced this interpretation. No

one did more to enhance its scholarly acceptance than Ulrich B. Phillips (1877–1934), who was awarded his doctorate at Columbia in 1902 under a like-minded mentor, William Dunning. Using rich documentary evidence, Phillips drew attention to the importance of southern plantations and earned an eminent teaching position at Yale. But like many white Georgians of his generation, he viewed the South as "a white man's country," and he rationalized the region's former slavery system as a method to exert social control over a "stupid" and inferior race. In an early article on black labor, Phillips acknowledged the primacy of "the low-lying coast region of South Carolina and Georgia" in the African-American experience. Ulrich B. Phillips, "The Slave Labor Problem in the Charleston District," *Political Science Quarterly* 22 (1907), 416–39.

3. Richard Hofstadter, *America at 1750: A Social Portrait* (New York: Alfred A. Knopf, 1971), 90. Drawing on early Holocaust scholarship and the influential work of slavery historian Stanley Elkins, Hofstadter emphasized, "as one tries to imagine the mental state of the newly arrived Africans, one must think of people still sick, depleted, and depressed, by the ordeal of the voyage, the terror of the unknown, the sight of deaths and suicides, and the experience of total helplessness in the hands of others."

4. Wood, *Black Majority*, chapter 2; Daniel C. Littlefield, *Rice and Slaves* (Baton Rouge: Louisiana State University Press, 1981); Margaret Washington Creel, *"A Peculiar People": Slave Religion and Community-Culture Among the Gullahs* (New York: New York University Press, 1988); Philip D. Morgan, *Slave Counterpoint: Black Culture in the Eighteenth-Century Chesapeake and Lowcountry* (Chapel Hill: University of North Carolina Press, 1998); Judith A. Carney, *Black Rice: The African Origins of Rice Cultivation in the Americas* (Cambridge: Harvard University Press, 2001) and related essays; see also Julia Floyd Smith, *Slavery and Rice Culture in Low Country Georgia, 1750–1860* (Knoxville: University of Tennessee Press, 1985), and Amelia Wallace Vernon, *African Americans at Mars Bluff, South Carolina* (Baton Rouge: Louisiana State University Press, 1993). Perhaps predictably, the validity of the African rice connection is still questioned in some quarters.

5. Converse D. Clowse, *Economic Beginnings in Colonial South Carolina, 1670–1730* (Columbia: University of South Carolina Press, 1971); Peter A. Coclanis, *The Shadow of a Dream: Economic Life and Death in the South Carolina Low Country, 1670–1920* (New York: Oxford University Press, 1989), chapters 2 and 3.

6. John Lawson, *A New Voyage to Carolina*, 1709, ed. Hugh Talmage Lefler (Chapel Hill: University of North Carolina Press, 1967), 80, 81; David Bertelson, *The Lazy South* (New York: Oxford University Press, 1967).

7. Claude Lévi-Strauss, *The Savage Mind* (London: Weidenfeld & Nicolson, 1966), 5. Even prior to the 1600s, black slaves had established a reputation for being able to subsist off the land more readily than Europeans in the Southeast. On June 4, 1580, nearly a century before the founding of Carolina, when enslaved Africans were sent to work on the fortifications at St. Augustine, a Spanish official wrote approvingly, "With regard to their food, they will display diligence as they seek it in the country, without any cost to the royal treasure." Jeanette Thurber Conner, trans. and ed., *Colonial Records of Spanish Florida*, vol. 3 (Deland: Florida State Historical Society, 1930), 315.

8. *American Husbandry*, 1775, ed. Harry J. Carman (reprint. New York: Columbia University Press, 1939), 303. Authorship remains uncertain; the writer may have been either John Mitchell or Arthur Young.

9. Landgrave Thomas Smith, Dr. Henry Woodward, an anonymous sea captain, and a treasurer of the East Indian Company all took or received the credit at some point. A letter of November 4, 1726, from Swiss correspondent Jean Watt in Neufchatel makes the claim "that it was by a woman that Rice was transplanted into Carolina." Records of the British Public Record Office Relating to South Carolina, 12, 156–57.

10. At the end of the eighteenth century, the Abbé Raynal wrote: "Opinions differ about the manner in which rice hath been naturalized in Carolina. But whether the province may have acquired it by a shipwreck, or whether it may have been carried there with slaves, or whether it be sent from England, it is certain that the soil is favourable for it." Abbé Raynal, *Philosophical and Political History of the Possessions and Trade of Europeans in the Two Indies*, 2nd ed., vol. 6 (London, 1798), 59. The first edition of this work, in 1772, offered only the shipwreck theory. The tradition of a Madagascar origin was popularized in Duncan Clinch Heyward, *Seed from Madagascar* (Chapel Hill: University of North Carolina Press, 1937). On slaves from that region, see Virginia Bever Platt, "The East India Company and the Madagascar Slave Trade," *William and Mary Quarterly*, 3rd ser., 26 (October 1969), 548–77. For a dissenting view on African rice linkages, see David Eltis, Philip Morgan, and David Richardson, "Agency and Diaspora in Atlantic History: Reassessing the African Contribution to Rice Cultivation in the Americas," *American Historical Review* 112:5 (December 2007), 1329–58.

11. South Carolina Historical Society, *Collections*, vol. 5 (Charleston: S. G. Courtenay & Co., 1897), 333.

12. Lawson, *New Voyage*, 81.

13. Mark Catesby, *The Natural History of Carolina, Florida and the Bahama Islands* (London, 1743), appendix, xviii.

14. Lawson, *New Voyage*, 81–83; Sir William A. Craigie and James R. Hulbert, with George Watson, Mitford M. Mathews, and Allen Walker Read, eds., *A Dictionary of American English on Historical Principles*, vol. 2 (Chicago: University of Chicago Press, 1938–1944), 1193.

15. Jan Vansina, "Once Upon a Time: Oral Traditions as History in Africa," *Daedalus* 100 (Spring 1971), 443; Philip D. Curtin, "Epidemiology and the Slave Trade," *Political Science Quarterly* 83 (June 1968), 215. Cf. W. E. Grimé, *Ethno-botany of the Black Americans* (Algonac, Mich.: Reference Publications, 1979).

16. *South-Carolina Gazette*, May 9, 1750; Mabel L. Webber, comp., "South Carolina Almanacs, to 1800," *South Carolina Historical and Genealogical Magazine* 15 (April 1914), 78. On Caesar, cf. John D. Duncan, "Slave Emancipation in Colonial South Carolina," *American Chronicle, A Magazine of History* 1 (January 1972), 64–66.

17. John Brickell, *The Natural History of North-Carolina*, 1737 (reprint. Raleigh: Trustees of the Public Libraries of North Carolina, 1911), 275. In the early eighteenth century, European colonists still made occasional use of religion, rather than race, to distinguish themselves from Africans.

18. A copy of this letter (January 10, 1726) is in vol. 2 (labeled vol. 3) of the typescript marked, "Charleston Museum, Miscellaneous Papers, 1726–1730," South Caroliniana Library, Columbia, S.C.

19. Douglas Grant, *The Fortunate Slave: An Illustration of African Slavery in the Early Eighteenth Century* (London: Oxford University Press, 1968), 24. In *Gourds of the Southeastern Indians* (Boston: The New England Gourd Society, 1941), 25, anthropologist Frank G. Speck observed: "As a container for water the large, or giant, gourd served a major purpose wherever the fruit can be induced to grow to the size of a vessel or carrier capable of holding a gallon."

20. Speck, *Gourds*, 40, 51, 52, 64, 65, 71.

21. Marla C. Burns and Barbara Rubin Hudson, *The Essential Gourd: Art and History in Northeast Nigeria* (Los Angeles: UCLA Museum of Cultural History, 1986), 123–25. When Africans, familiar with bottle gourds that grew on vines (*Lagenaria siceraria*), reached Suriname in South America, they found a similar fruit (on the botanically unrelated calabash tree) that local Indians often painted. "Faced with memories of carved gourds from Africa and exposure to painted calabashes in Suriname, the early Afro-Surinamers developed their own distinctive art—utilizing the American calabash, processing it according to the Indian method, and embellishing it with external African-style carvings." Sally Price, *Co-Wives and Calabashes* (Ann Arbor: University of Michigan Press, 1984), 93–94.

22. During the antebellum era, "Follow the Drinking Gourd" became a song that assisted slaves escaping northward toward the Ohio River and freedom, especially from the Tombigbee River region of western Alabama. Given this symbolic association between gourds and black freedom, it is not surprising that northern artists sometimes depicted enslaved southerners with gourds, as in Thomas Waterman Wood, *A Southern Cornfield, Nashville, Tenn.* (1861), and Winslow Homer, *Near Andersonville* (1865–1866).

23. Lawson, *New Voyage*, 149.

24. Thomas Jefferson, *Notes on the State of Virginia*, ed. William Peden (Chapel Hill: University of North Carolina Press, 1954), 288 n.

25. Lawson, *New Voyage*, 14; Joseph Corry, *Observations upon the Windward Coast of Africa*, 1807 (reprint. London: Frank Cass & Co. Ltd., 1968), 66.

26. E. Milby Burton, *Charleston Furniture, 1700–1825* (Charleston: The Charleston Museum, 1955), 36–37.

27. Wills, Inventories, and Miscellaneous Records, 1729–1731, 27, in the South Carolina Department of Archives and History, Columbia, S.C. [hereafter SCDAH].

28. Dale Rosengarten, *Row Upon Row: Sea Grass Baskets of the South Carolina Lowcountry*, 1986 (reprint. Columbia, S.C.: McKissick Museum, 1994), 33–47.

29. Lawson, *New Voyage*, 195–96.

30. Dale Rosengarten, "Social Origins of the African-American Lowcountry Basket," Ph.D. diss., Harvard University, 1997.

31. Charles Joyner, *Down by the Riverside: A South Carolina Slave Community* (Urbana: University of Illinois Press, 1984), 75–76.

32. Rosengarten, *Row Upon Row*, 9.

33. On pottery, see Leland Ferguson, *Uncommon Ground: Archaeology and Early African America, 1650–1800* (Washington D.C.: Smithsonian Institution Press, 1992). Ferguson showed that what had once been called "Colono-Indian ware" by his fellow archaeologists actually owed far more to African traditions. See also Joyner, *Down by the Riverside*, 75, and the articles by Ferguson, Dale Rosengarten, and others in the proceedings from an important 1996 conference, sponsored by The Museum of Early Southern Decorative Arts: Sally Gant, *African Impact on the Material Culture of the Americas* (Winston-Salem, N.C., 1998).

34. Alan Dundes, "African Tales among the North American Indians," *Southern Folklore Quarterly* 29 (September 1965), 207–19; Charles M. Hudson, ed., "Red, White, and Black, Symposium on Indians in the Old South," in Southern Anthropological Society, *Proceedings*, no. 5 (Athens, Ga., 1971); Alan Gallay, *The Indian Slave Trade: The Rise of the English Empire in the American South, 1670–1717* (New Haven: Yale University Press, 2002).

35. Letter from William Orr, Rector of St. Paul's Parish, March 30, 1743, in Gertrude Foster, "Documentary History of Education in South Carolina as Revealed in the Manuscripts of the Society for the Propagation of the Gospel and Other Learned Societies," 13 vols., Ph.D. diss., University of South Carolina, 1932, vol. 5, 703.

36. Gene Waddell, *Indians of the South Carolina Lowcountry, 1526–1751* (Spartanburg, S.C.: The Reprint Company, 1980); Peter H. Wood, "The Changing Population of the Colonial South: An Overview by Race and Region, 1685–1790," in *Powhatan's Mantle: Indians in the Colonial Southeast*, eds. Peter H. Wood, Gregory Waselkov, and M. Thomas Hatley (Lincoln: University of Nebraska Press, 1989), 35–103.

37. Thomas Cooper and David J. McCord, eds., *The Statutes at Large of South Carolina*, 10 vols. (Columbia, S.C.: A. S. Johnston, 1836–1841), vol. 2, 188–89 [hereafter cited as *Statutes of South Carolina*]; *South-Carolina Gazette*, September 17, 1737; May 3, 1739; November 20, 1740.

38. Lawson, *New Voyage*, 20–21.

39. Journal of the Commons House of Assembly, 1726–1727, 119, SCDAH.

40. James Pemberton, "Diary of a trip to South Carolina, 1745," entry for October 17, original in Library of Congress, microfilm in South Caroliniana Library, Columbia, S.C.

41. Charles Boschi to S.P.G. Secretary, October 20, 1745, *South Carolina Historical and Genealogical Magazine* 50 (October 1949), 185.

42. P. C. J. Weston, ed., *Documents Connected with the History of South Carolina* (London: Printed for private distribution only, 1856), 179.

43. Joseph Lyons, *The Diary of Joseph Lyons, 1833–1835*, eds. Marie Ferrara, Harlan Greene, Dale Rosengarten, and Susan Wyssen (reprint. Charleston: College of Charleston Library, 2005), 580–81. This work first appeared in *American Jewish History* 91:3/4 (September/December 2003), 493–606. The Old Testament psalm 119, verse 105, describes God's word as "a lamp to our feet, a light for our path."

44. Cf. William Elliott, *Carolina Sports by Land and Water*, 1859 (reprint. Columbia: University of South Carolina Press, 1994); Mason Crum, *Gullah: Negro Life in the Carolina Sea Islands* (Durham, N.C.: Duke University Press, 1940), chapter 4.

45. For the history of English bathing, see, for example, A. S. Turberville, *English Men and Manners in the Eighteenth Century*, 2nd ed. (London: Oxford University Press, 1929), 126.

46. Lawson, *New Voyage*, 158. For the complex relation of African Americans to sharks in art, literature, and Atlantic history, see Peter H. Wood, *Weathering the Storm: Inside Winslow Homer's Gulf Stream* (Athens: University of Georgia Press, 2004), 72–81.

47. Grant, *Fortunate Slave*, 13, 23. See also Janet Schaw, *Journal of a Lady of Quality*, eds. Evangeline W. Andrews and Charles M. Andrews (New Haven: Yale University Press, 1922), 149–51.

48. Robert Smith, "The Canoe in West African History," *Journal of African History* 11:4 (1970), 515–33. Quotations are from pages 521, 532, 533.

49. J. Barbot, "A Description of the Coasts of North and South Guinea," in *A New General Collection of Voyages and Travels*, eds. Thomas Astley and John Churchill, vol. 5 (London, 1732), 152, 261, 266, 268. Barbot was among thousands of Huguenots who fled France after Louis XIV revoked the Edict of Nantes in 1685, ending religious toleration. He settled in England, where an account of his African travels was translated into English.

50. William Bosman, *A New and Accurate Description of the Coast of Guinea, Divided into the Gold, the Slave, and the Ivory Coasts*, 1705 (reprint. New York: Barnes & Noble, 1967), 129. A 1937 expedition to Sierra Leone found that the Sherbro fished extensively from dugout canoes, hollowed using fire and a large adze and then shaped with an axe and adze. Native carpenters had also become expert in building planked boats of European introduction, propelled by oars and a kite-shaped sail. H. U. Hall, *The Sherbro of Sierra Leone: A Preliminary Report on the Work of the University Museum's Expedition to West Africa, 1937* (Philadelphia: University of Pennsylvania Press, 1938), 15.

51. Captain John Adams, *Remarks on the Country Extending from Cape Palmas to the River Congo*, 1823 (reprint. London: Frank Cass & Co. Ltd., 1966), 37–38.

52. Joshua A. Carnes, *Journal of a Voyage from Boston to the West Coast of Africa: With a Full Description of the Manner of Trading with the Natives of the Coast*, 1852 (reprint. New York: Johnson Reprint Corporation, 1970), 357–58.

53. Ibid., 54–55, 87–90, 141. See also Frederick Starr, *Congo Natives: An Ethnographic Album* (Chicago: Lakeside Press, 1912), 34–37. Along the Congo River and its tributaries, Starr observed diverse canoes in constant use, paddles with carved decorations, and large fishing nets that used wooden floats at the top and cylindrical weights along the bottom, made from baked clay.

54. In 1682, Thomas Newe found that horses brought from New England were still scarce and expensive, "so there is but little use of them, all Plantations being seated on the Rivers, they can go to and fro by Canoo or Boat as well and as soon as they can ride." Alexander S. Salley, Jr., ed., *Narratives of Early Carolina, 1650–1708*, 1911 (reprint. New York: Barnes & Noble, 1967), 184.

55. The English experience in Carolina must have been comparable to that of the French among the Island Caribs of the Antilles at the same time. "The French learned from the

Savages to hollow out trees to make canoes; but they did not learn from them to row them, steer them, or jump overboard to right them when they overturned: the Savages are not afraid of overturning, wetting their clothes, losing anything, or drowning, but most French fear all of these. . . . Every day one sees disastrous accidents." R. P. Raymond Breton, *Dictionnaire Caraibe-Français*, 1665 (reprint. Leipzig: B. G. Teubner, 1892), 331.

56. Lawson, *New Voyage*, 103, 104, 107; F. W. Clontes, "Travel and Transportation in Colonial North Carolina," *North Carolina Historical Review* 3 (January 1926), 16–35; cf. Marshall B. McKusick, "Aboriginal Canoes in the West Indies," in Sidney W. Mintz, comp., *Papers in Caribbean Anthropology*, Yale University Publications in Anthropology, no. 57 (New Haven, 1960).

57. Joyner, *Down by the Riverside*, 77.

58. Ibn Batutah (Muhammed ibn abd Allah), *Travels in Asia and Africa, 1325–1354*, translated and selected by H. A. R. Gibb (London: G. Routledge, 1929), 333; Richard Hakluyt, *The Principal Navigations, Voyages, Traffiques & Discoveries of the English Nation*, vol. 10 (Glasgow: J. MacLehose & Sons, 1904), 18. See also Darold D. Wax, "A Philadelphia Surgeon on a Slaving Voyage to Africa, 1749–1751," *Pennsylvania Magazine of History and Biography* 92 (October 1968), 474, 478.

59. Edward McCrady, *The History of South Carolina Under the Royal Government, 1719–1776* (New York: The Macmillan Company, 1899), 516; Miles Mark Fisher, *Negro Slave Songs in the United States* (New York: The Citadel Press, 1953), 8. According to Joyner, *Down by the Riverside*, 76: "Each plantation had certain slaves designated and trained to serve its transportation needs. Boatmen, for example, took charge of the fleet of flats, rowboats, and dugout canoes. Boats were valuable property, and the crews were charged with their use and care. All the boats were kept sheltered from the sun, except when being used, and were locked up at night."

60. *Virginia Gazette*, December 24, 1772.

61. *South-Carolina Gazette*, April 6, 1734; April 11, 1739; January 31, 1743; February 18, 1741.

62. Wax, "A Philadelphia Surgeon," 475–76.

63. *South-Carolina Gazette*, November 5, 1737. For an excellent discussion of fishing slaves as a privileged subgroup, see Richard Price, "Caribbean Fishing and Fishermen: A Historical Sketch," *American Anthropologist* 68:6 (December 1966), 1363–83.

64. Undated letter in the Coe Papers (Documents of the Lords Commissioners, 1719–1742), South Carolina Historical Society, Charleston, S.C.

65. Baron de Montlezun, "A Frenchman Visits Charleston, 1817," *South Carolina Historical and Genealogical Magazine* 49 (July 1948), 136; see also Price, "Caribbean Fishing and Fishermen," 1372.

66. Christopher Fyfe, *Sierra Leone Inheritance* (London: Oxford University Press, 1964), 96.

67. Price, "Caribbean Fishing and Fishermen," 1366, 1372; Carroll Quigley, "Aboriginal Fish Poisons and the Diffusion Problem," *American Anthropologist* 58:3 (June 1956), 508–25.

68. *Statutes of South Carolina*, vol. 3, 270. The misdemeanor seems to have continued; cf. *South-Carolina Gazette*, April 6, 1734.

69. Wax, "A Philadelphia Surgeon," 474; see also Norman E. Whitten, Jr. and John F. Szwed, *Afro-American Anthropology: Contemporary Perspectives* (New York: Free Press, 1970), pictorials, n.p. [p.11].

70. Price, "Caribbean Fishing and Fishermen," 1374.

71. *South-Carolina Gazette*, November 5, 1737.

72. The Doulla-Bakweri language of Africa's Cameroon River area provided the Jamaican creole word for the crayfish or river prawn. "This part of Africa, indeed, took its name from the plentiful shrimp or prawns in the river: *Cameroon* is from Portuguese *camarao* 'shrimp.'" Frederic G. Cassidy, "Some New Light on Old Jamaicanisms," *American Speech* 42:3 (October 1967), 191–92.

73. Barbadians interested in Carolina in the 1660s hoped they could soon produce "wine, oil, currants, raisins, silks, etc., the planting of which will not injure other Plantations, which may very well happen if there were a very great increase of sugar works or more tobacco, ginger, cotton, and indigo made" than Atlantic markets could absorb. *Calendar of State Papers, Colonial, 1661–1668*, 157.

74. "A Briefe Description of the Province of Carolina, by Robert Horne (?), 1666," Salley, *Narratives of Early Carolina*, 69.

75. Louis Thibou, letter in French dated September 20, 1683; typescript translation in the South Caroliniana Library, Columbia, S.C.

76. South Carolina Historical Society, *Collections*, vol. 5, 437–38.

77. Melville J. Herskovits, "The Culture Areas of Africa," *Africa: Journal of the International African Institute* 3:1 (January 1930), 67, 72, 73.

78. Elizabeth Donnan, ed., *Documents Illustrative of the Slave Trade to America*, 4 vols. (Washington, D.C.: Carnegie Institution of Washington, 1930–1935), vol. 1, 129.

79. Grant, *Fortunate Slave*, 24–25. Crocodiles posed a threat to Fula herds along the Gambia River, just as alligators represented a problem for stock grazing in the swamps of the Carolina Lowcountry.

80. In 1673, Edmund Lister of Virginia bought one hundred acres on the Ashley River and sent several men ahead of him to prepare the land. Lister died before he could take up residence, and a white servant completed his indenture and departed. But the other men Lister had sent to South Carolina were apparently slaves experienced with livestock, for in 1676 Lister's widow stated in a bill of sale that her "Decd Housband, did formerly Transport Severall Negros, out of this Colony of Virginia, into Carolina and did there Settle them upon a Plantacon, together wth Some Cattle." Records of the Secretary of the Province, 1675–1695, 39–41, SCDAH; Alexander S. Salley, Jr., ed., *Records of the Secretary of the Province and the Register of the Province of South Carolina, 1671–1675* (Columbia: Historical Commission of South Carolina, 1944), 59, 66–69.

81. Miscellaneous Records A, 1682–1690, 318–19, SCDAH.

82. Archdale Papers, item 26, January 25, 1690, SCDAH; cf. Gary S. Dunbar, "Colonial Carolina Cowpens," *Agricultural History* 35 (1961), 125–30.

83. Records of the Secretary of the Province, 1692–1700, 38, SCDAH.

84. *South-Carolina Gazette*, March 19, 1741.

85. As late as 1865, young African Americans with livestock responsibilities were still being designated as "cow boys" (two words) in southern plantation records. U. B. Phillips and J. D. Glunt, eds., *Florida Plantation Records from the Papers of George Noble Jones* (St. Louis: Missouri

Historical Society, 1927), 566, 568, 570. Wood, *Black Majority*, 28–32.

86. Such a drum, collected in Virginia in the eighteenth century (and initially assumed to be of Native American origin), is now in the British Museum, exhibit 1368 of the extensive bequest from Sir Hans Sloane, made in 1753. The drum is pictured and discussed in Dena J. Epstein, *Sinful Tunes and Spirituals: Black Folk Music to the Civil War* (Urbana: University of Illinois Press, 1977), 48–49.

87. Well into the twentieth century, black southerners continued to shape these sturdy mortars, with their related wooden maul, or pestle. See Vernon, *African Americans at Mars Bluff*, esp. 177–86, and Katherine Clark, *Motherwit: An Alabama Midwife's Story* (New York: Dutton, 1989), 9.

88. Mark Miles Fisher, *Negro Slave Songs in the United States*, 1953 (reprint. New York: Citadel Press, 1969), 29. Fisher explains (p. 3) that in West Africa "drums were by far the oldest rhythmic instruments. They were usually made of hollowed logs, with heads of animal skins tightened by pegs driven into the wood. . . . They might call a chief by name, or they might give notice of danger, of the approach of an enemy or stranger, or of fire, death, or summons to arms."

89. Quoted in Epstein, *Sinful Tunes*, 47.

90. In September 1739, "an insurrection openly broke out in the heart of the settlement which alarmed the whole province. A number of negroes having assembled together at Stono, first surprised and killed two young men in a warehouse, and then plundered it of guns and ammunition. Being thus provided with arms, they elected one of their number captain, and agreed to follow him, marching toward the south west with colours flying and drums beating, like a disciplined company." Account of Alexander Hewatt, published in 1779 and reprinted in Mark M. Smith, ed., *Stono: Documenting and Interpreting a Southern Slave Revolt* (Columbia: University of South Carolina Press, 2005), 33. See additional references to drumming throughout Smith's publication.

91. Quoted in Wood, *Black Majority*, 316.

92. Epstein, *Sinful Tunes*, 52. Epstein goes on to quote Wash Wilson, a former slave who was interviewed in the 1930s, at age 94, by the Federal Writers' Project (pp. 53–54). He recalled that growing up in rural Louisiana before the Civil War, "Dere wasn't no music instruments. Us take pieces of sheep's rib or cow's jaw or a piece iron, with a old kettle, or a hollow

gourd and some horse-hairs to make de drum. Sometimes dey'd get a piece of tree trunk and hollow it out and stretch a goat's skin over it for de drum. Dey's be one to four foot high and a foot up to six foot 'cross. In gen'ral two niggers play with de fingers or sticks on dis drum."

93. Salley, *Narratives of Early Carolina*, 172; Thomas Nairne, *A Letter from South Carolina* (London, 1710), 13. The latter work is reprinted in Jack P. Greene, ed., *Selling a New World: Two Colonial South Carolina Promotional Pamphlets* (Columbia: University of South Carolina Press, 1989), 33–73; see esp. 41.

94. *Statutes of South Carolina*, vol. 2, 106; vol. 7, 382.

95. *Statutes of South Carolina*, vol. 3, 604; cf. vol. 4, 285 (Act of 1768).

96. *Statutes of South Carolina*, vol. 3, 626; vol. 9, 72 (Act of 1731).

97. *Statutes of South Carolina*, vol. 2, 105.

98. *Statutes of South Carolina*, vol. 7, 368 (Act of 1714), 382 (1722), 409–10 (1740).

99. *Journal of the Commons House of Assembly*, 1741–1742, 272, SCDAH.

100. Henry C. Wilkinson, *Bermuda in the Old Empire* (London: Oxford University Press, 1950), 112; cf. Wood, *Black Majority*, 205 n. 32.

101. *Statutes of South Carolina*, vol. 7, 419–20.

102. Orlando Patterson, *The Sociology of Slavery, An Analysis of the Origins, Development and Structure of Negro Society in Jamaica*, 1967 (American ed., Rutherford, N.J.: Fairleigh Dickinson University Press, 1969), 265–66; Philip J. Schwarz, *Twice Condemned: Slaves and the Criminal Laws of Virginia, 1705–1865* (Baton Rouge: Louisiana State University Press, 1988), passim; Sylvia R. Frey and Betty Wood, *Come Shouting to Zion: African American Protestantism in the American South and British Caribbean to 1830* (Chapel Hill: University of North Carolina Press, 1998), 37, 60–62.

103. *Statutes of South Carolina*, vol. 7, 402.

104. Ibid., 422–23.

105. *South-Carolina Gazette*, January 17, 1761; Herbert Aptheker, *American Negro Slave Revolts*, 1943 (2nd ed. New York: International Publishers, 1969), 143–44; H. Marburg and W. H. Crawford, *Digest of the Laws of Georgia* (Savannah, 1802), 430.

106. Joseph I. Waring, *A History of Medicine in South Carolina, 1670–1825* (Charleston: South Carolina Medical Association, 1964), 225–26.

107. On "basket names" and attitudes toward naming, see Mary A. Twining and Keith E. Baird, eds., *Sea Island Roots: African Presence in the Carolinas and Georgia* (Trenton, N.J.: Africa World Press, 1991), 37–55.

108. Peter H. Wood, "Slave Labor Camps in Early America: Overcoming Denial and Discovering the Gulag," in *Time Longer Than Rope: A Century of African American Activism, 1850–1950*, eds. Charles M. Payne and Adam Green (New York: New York University Press, 2003), chapter 1. For a Soviet Gulag escape comparable to any American slave narrative, see Slavomir Rawicz, *The Long Walk*, 1956 (reprint. New York: Lyons & Burford, 1984).

109. On this general subject, see the forthcoming work of historian Frederick Knight, "The Forests Gave Way Before Them," concerning the impact of African workers on the Anglo-American colonies.

110. Corry, *Observations upon the Windward Coast of Africa*, 65–66.

CHAPTER 3
RICE IN THE NEW WORLD

1. A. S. Salley, Jr., *The Introduction of Rice Culture into South Carolina*, Bulletins of the Historical Commission of South Carolina, 6 (Columbia, S.C.: State Company, 1919).

2. Duncan Clinch Heyward, *Seed from Madagascar* (Chapel Hill: University of North Carolina Press, 1937).

3. Salley, *The Introduction of Rice Culture*, 14–16, quotes P. Collinson, "Of the Introduction of Rice and Tar in Our Colonies," *Gentleman's Magazine* 36 (June 1766), 278–80.

4. David Eltis, S. Behrendt, D. Richardson, and H. Klein, eds. *The Trans-Atlantic Slave Trade: A Database on CD-ROM* (Cambridge: Cambridge University Press, 1999); Arturo Warman, *Corn and Capitalism* (Chapel Hill: University of North Carolina Press, 2003), 63.

5. Judith A. Carney, *Black Rice: The African Origins of Rice Cultivation in the Americas* (Cambridge: Harvard University Press, 2001), 70–73.

6. Salley, *The Introduction of Rice Culture*, 11.

7. By the second half of the twentieth century the scientific community generally accepted the French botanical finding that African rice is a separate species. A. Chevalier and O. Roehrich, "Sur l'origine botanique des riz cultivés," *Comptes Rendus de l'Academie de Sciences* 159 (1914), 560–62.

8. The correspondence on red rice between Jefferson and slave traders in Sierra Leone and Guinea Conakry dates to 1789 and is summarized in Paul Richards, "Culture and Community Values in the Selection and Maintenance of African Rice," in *Valuing Local Knowledge: Indigenous People and Intellectual Property Rights*, eds. Stephen Brush and Doreen Stabinsky (Washington, D.C.: Island Press, 1996), 209–29. On his 1793–94 voyage to Sierra Leone, slave captain Samuel Gamble specifically mentioned the purchase of rough rice that was red. Bruce L. Mouser, "Who and Where Were the Baga? European Perceptions from 1793 to 1821," *History in Africa* 29 (2002), 337–64, esp. 356 n. 42; Bruce L. Mouser, ed., *A Slaving Voyage to Africa and Jamaica: The Log of the Sundown, 1793–1794* (Bloomington: Indiana University Press, 2002), 86–99. See also, Malcolm Cowley, ed., *Adventures of an African Slaver. Being a True Account of the Life of Captain Theodore Canot* (New York: Albert and Charles Boni, 1928), 139.

9. The same statement applies to slaves accustomed to other African food staples, such as yams, millet, sorghum, and plantains. Judith Carney, *Seeds of Memory: Africa's Botanical Legacy in the Black Atlantic* (Cambridge: Harvard University Press, forthcoming in 2009).

10. Judith Carney, "Out of Africa: Colonial Rice History in the Black Atlantic," in *Colonial Botany: Science, Commerce, and Politics in the Early Modern World*, eds. L. Schiebinger and C. Swan (Philadelphia: University of Pennsylvania Press, 2004), 204–20. On women captives used to clean and cook on slave ships, see Robert Harms, *The Diligent: A Voyage through the Worlds of the Slave Trade* (New Haven: Yale University Press, 2002), 312–13.

11. Judith A. Carney, "Rice and Memory in the Age of Enslavement: Atlantic Passages to Suriname," *Slavery and Abolition* 26:3 (2005), 325–47.

12. Carney, *Black Rice*, 77–78, 115–16, 137–38.

13. See, for instance, the arguments advanced by David Eltis, Philip Morgan, and David Richardson in "The African Contribution to Rice Cultivation in the Americas," an unpublished paper presented at the Georgia Workshop in Early American History and Culture, December 2, 2005, University of Georgia. The paper is based on revised data from an updated and as yet unpublished version of the authors' *Trans-Atlantic Slave Trade Database*, CD-ROM (Eltis et al. 1999). See *http://www.metascholar. org/TASTD-Voyages/index.html* for a description of the expanded project (accessed October 18, 2007).

14. George Warren, who spent three years in Suriname in the 1660s, left a revealing portrayal of how enslaved Africans in this formative plantation era struggled to grow the food upon which their very survival depended. George Warren, *An impartial description of Surinam upon the continent of Guiana in America with a history of several strange beasts, birds, fishes, serpents, insects and customs of that colony, etc.* (London: William Godbid for Nathaniel Brooke, 1667), 19.

15. The significance of subsistence and the role of slaves and African food crops in securing it in the early plantation period are discussed in detail in Carney, *Seeds of Memory*.

16. Researching the Gullah language in the 1930s, Lorenzo Dow Turner attributed the word for rice, *malo*, to Bambara, in the Mende language group spoken in the region where West African rice was domesticated. The Senegambian Wolof also sometimes refer to rice as *malo*. Turner, *Africanisms in the Gullah Dialect*, 1949 (reprint. Columbia: University of South Carolina Press, 2002), 128; Roland Portères, "Primary Cradles of Agriculture in the African Continent," in *Papers in African Prehistory*, eds. J. D. Fage and R. A. Oliver (Cambridge: Cambridge University Press, 1970), 43–58.

17. Paul Richards, *Indigenous Agricultural Revolution* (London: Hutchinson, 1985), passim.

18. Jessica B. Harris, *Iron Pots and Wooden Spoons: Africa's Gift to New World Cooking* (New York: Simon & Schuster, 1989), 10, 28, 38, 45, 70, 103, 106; Jessica B. Harris, *Beyond Gumbo: Creole Fusion Food from the Atlantic Rim* (New York: Simon & Schuster, 2003), 245, 265.

19. A possible predecessor to "Carolina Gold," a variety known as "Carolina White" is grown today by poor peasant farmers in parts of Latin America where moisture-holding soils or high rates of precipitation keep the crop moist. It is not found in the deep-water tidal river systems that favored "Carolina Gold."

20. Carney, "Rice and Memory."

21. John Drayton, *A View of South Carolina* (Charleston: W. P. Young, 1802), 115.

22. Malaria and water-borne dysentery were rampant in tidewater rice regions. William Dusinberre, *Them Dark Days: Slavery in the American Rice Swamps* (Oxford: Oxford University Press, 1996), 53–55, 74–75, 240–42, 325–26.

23. M. Vaillant, "Milieu cultural et classification des variétés de Riz des Guyanes française et hollandaise," *Revue internationale de botanique appliquée et d'agriculture tropicale* 28 (1948): 522.

24. R. Portères, "Présence ancienne d'une varieté cultivée d'*Oryza glaberrima* en Guyane française," *Journal d'agriculture tropicale et de botanique appliquée* 11/12 (1955), 680.

25. The Asian rice varieties "Carolina White" and "Carolina Gold" were imported for plantation rice development in the eastern Amazonian states of Brazil (Pará, Maranhão, and Amapá) in 1772. See Manoel Barata, *Formação Histórico do Pará* (Belém, Brazil: Universidade Federal do Pará, 1973); C. R. Boxer, *The Dutch Seaborne Empire, 1600–1800* (London: Penguin, 1965), 193. Derk HilleRisLamber, a rice agronomist in Suriname, found mention in Dutch accounts written before 1801 of a dryland white variety imported from Carolina (HilleRisLamber, personal communication, September 15, 1998). South Carolina rice planter R. F. W. Allston, in his "Essay on Sea Coast Crops," reported that the white seed was grown in Guiana, as well as China, "to this day." *De Bow's Review* 16 (1854), 607.

26. In public lectures to the Carolina Gold Foundation, rice researcher Tom Hargrove has drawn attention to the survival of the Carolina varieties in the Amazonic region and reported on its eighteenth-century diffusion. Charleston, S.C., August 19–20, 2005. See also, L. Coradin and J. R. Fonseca, *Coleta de Germoplasma de Arroz no Estado do Maranhão* (Brasilia: Empresa Maranhense de Pesquisa Agropecuária, 1982); J. R. Fonseca, P. H. Rangel, I. P. Bendendo, P. M. da Silveira, Ê. P. Guimarães, and L. Coradin, *Características Botânicas e Agronômicas de Cultivares e Raças Regionais de Arroz (Oryza sativa L.) Coletadas no Estado do Maranhão* (Goiânia: Empresa Brasileira de Pesquisa Agropecuária, 1982).

27. For the account of a twenty-first-century grower, see Richard Schulze, *Carolina Gold Rice: The Ebb and Flow History of a Lowcountry Cash Crop* (Charleston, S.C.: History Press, 2005).

28. For a discussion of the content and source of these legends, see Carney, *Black Rice*, 153–54.

CHAPTER 4
BY THE RIVERS OF BABYLON: THE LOWCOUNTRY BASKET IN SLAVERY AND FREEDOM

1. Richard D. Porcher, *Wildflowers of the Carolina Lowcountry and Lower Pee Dee* (Columbia: University of South Carolina Press, 1995), 73–74, 12–13.

2. D. W. Meinig, *The Shaping of America: A Geographical Perspective on 500 Years of History*, vol. 1: *Atlantic America, 1492–1800* (New Haven: Yale University Press, 1986), 176.

3. Unfortunately, very little is known about the baskets produced by coastal Indians in South Carolina. Adept at making coiled earthenware pots, native people may well have made coiled grass baskets, but no specimen survives.

4. Rice was introduced into North Carolina in the 1720s with the settlement of the Lower Cape Fear River by a group of wealthy South Carolina planters. James M. Clifton, "Golden Grains of White: Rice Planting on the Lower Cape Fear," *The North Carolina Historical Review* 50:4 (October 1973), 365. By the mid-1700s the "golden grain" was also grown on a small scale in the Savannah River basin and on St. Simons Island, Georgia. Albert V. House, ed., *Planter Management and Capitalism in Ante-Bellum Georgia* (New York: Columbia University Press, 1954), 20–21.

5. For a discussion of the spread of Lowcountry basketry across the American Southeast and its encounters with Native American and European traditions, see Dale Rosengarten, "Social Origins of the African-American Lowcountry Basket," Ph.D. diss., Harvard University, 1997, chapter 6, "The Lowcountry Basket in a Global Setting," esp. 181–83, 188–91.

6. Ray Crook, Department of Anthropology, University of West Georgia, "Sweet Grass and Fanner Grass: Baskets and Connections between the Georgia/Carolina Coast and the Bahamas Islands," public lecture delivered at the College of Charleston, Charleston, S.C., February 2, 2006.

7. Cited in Gregory Day, "Afro-Carolinian Art, Towards the History of a Southern Expressive Tradition," *Contemporary Art/Southeast* 1:5 (January/February 1978), 21. In an earlier will the abbreviation "fann." probably meant "fanners." Day, personal communication, June 3, 1985.

8. Elaine Herold, personal communication, May 10, 1985. Herold conducted this excavation for The Charleston Museum in the early 1970s.

9. William Gibbons's Account Book, 1765–1782, Georgia Historical Society, Savannah, Ga.

10. South Caroliniana Library, University of South Carolina, Columbia, S.C.

11. Robert Manson Myers, ed., *The Children of Pride: A True Story of Georgia and the Civil War* (New Haven: Yale University Press, 1972), 243–44. For additional references to basket makers on Lowcountry plantations, see Philip D. Morgan, *Slave Counterpoint: Black Culture in the Eighteenth-Century Chesapeake and Lowcountry* (Chapel Hill: University of North Carolina Press, 1998), 232–34, esp. n. 47.

12. James Potter's Journal for Argyle Plantation, September 18, 1828, August 18–21, 1830, August 15–27, 1831, Georgia Historical Society.

13. Quoted in David Doar, *Rice and Rice Planting in the South Carolina Low Country* (Charleston, S.C., 1936), 8.

14. Quoted in Ibid., 18.

15. Alexander S. Salley, Jr., ed., *Narratives of Early Carolina, 1650–1708*, 1911 (reprint. New York: Barnes & Noble, 1967), 69 n. 2.

16. David Doar, *A Sketch of the Agricultural Society of St. James, Santee, South Carolina and an Address on the Traditions and Reminiscences of the Parish Delivered before the Society on 4th of July 1907* (Charleston, S.C., 1908), 11.

17. Quoted in Peter H. Wood, *Black Majority: Negroes in Colonial South Carolina from 1670 through the Stono Rebellion* (New York: Alfred A. Knopf, 1974), 79.

18. James M. Clifton, ed., *Life and Labor on Argyle Island: Letters and Documents of a Savannah River Rice Plantation, 1833–1867* (Savannah: Beehive Press, 1978), xxv.

19. Ulrich B. Phillips, *American Negro Slavery: A Survey of the Supply, Employment, and Control of Negro Labor as Determined by the Plantation Regime*, 1918 (reprint. Baton Rouge: Louisiana State University Press, 1966), 249.

20. Doar, *Rice and Rice Planting*, 33–34.

21. House, *Planter Management and Capitalism*, 53. See also Daniel C. Littlefield, *Rice and Slaves: Ethnicity and the Slave Trade* (Baton Rouge: Louisiana State University Press, 1981); Judith A. Carney, *Black Rice: The African Origins of Rice Cultivation in the Americas* (Cambridge: Harvard University Press, 2001); and J. Leitch Wright, Jr., *The Only Land They Knew* (New York: The Free Press, 1981), 263.

22. For a technical description of splitting oak, see Eliot Wigginton, ed., *The Foxfire Book* (Garden City, N.Y.: Doubleday & Co., 1972), 115–18. White oak basket making as a cross-cultural phenomenon is discussed in Rosengarten, "Social Origins," 296–97.

23. To prepare saw palmetto binders, the outer layer or skin of the stalk was peeled off with a knife and laid across the knees, the smooth, green side resting on a burlap sack or other heavy fabric. Then the pithy core of the stem was scraped away and the skin split lengthwise into narrow weavers. These were dried in the sun and stored in pails of fresh water to keep them supple. To add a binder, whether of oak or palmetto "butt," the new strip was tied onto the preceding stitch and passed through a stitch in the underlying row. These interlaced stitches curve out from the center of the basket back toward the rim.

24. Journal of Thomas Walter Peyre, 1834–1851[?], South Carolina Historical Society, Charleston, S.C.

25. Theodore Rosengarten, *Tombee: Portrait of a Cotton Planter, with the Journal of Thomas B. Chaplin, 1822–1890* (New York: William Morrow & Co., 1986), 403.

26. D. E. Huger Smith, "A Plantation Boyhood," in Alice Ravenel Huger Smith and Herbert Ravenel Sass, *A Carolina Rice Plantation of the Fifties* (New York: William Morrow & Co., 1936), 71.

27. For more on plantation underground markets, see Rosengarten, *Tombee*, 162.

28. Lathan A. Windley, comp., *Runaway Slave Advertisements: A Documentary History from the 1730s to 1790*, vol. 3: *South Carolina* (Westport, Conn.: Greenwood Press, 1983), 499, 364. For ads referring to straw hats, see Ibid., 68, 89.

29. Cited in Michael P. Johnson, "Runaway Slaves and the Slave Communities in South Carolina, 1799 to 1830," *William and Mary Quarterly*, 3rd Ser., 38 (1981), 436.

30. *Anti-Slavery Reporter*, ser. 3, vol. 12, September 1, 1864, 202–3, reprinted in *Slave Testimony: Two Centuries of Letters, Speeches, Interviews, and Autobiographies*, ed. John Blassingame (Baton Rouge: Louisiana State University Press, 1977), 449–54.

31. Elizabeth Hyde Botume, *First Days Amongst the Contrabands*, 1893 (reprint. New York: Arno Press, 1968), 178–80. Botume tells how Frowers, whom she calls "Flowers," came to her for news about President Lincoln's assassination.

32. Ibid., 124, 135, 178–80. For an excellent guide to published and unpublished materials generated by Yankee missionaries in South Carolina during and after the Civil War, see Willie Lee Rose's "Notes on Sources," *Rehearsal for Reconstruction: The Port Royal Experiment* (London: Oxford University Press, 1964), 409–33.

33. Quoted by D. E. Huger Smith, "A Plantation Boyhood," in Smith and Sass, *A Carolina Rice Plantation*, 76.

34. Mary Jane Bennett, Mt. Pleasant, S.C., video-taped interview in "Row Upon Row: Sea Grass Baskets of the South Carolina Lowcountry," educators' kit, McKissick Museum, University of South Carolina, Columbia, S.C., 1987.

35. Leola Wright, Mt. Pleasant, S.C., February 11, 1992, interview by Dale Rosengarten. Folklife Resource Center, McKissick Museum.

36. Rose, *Rehearsal for Reconstruction*, 182–83.

37. Circular by the Order of Brig. Gen'l R. Saxton, Commanding, Beaufort, S.C., August 2, 1862. Collection of John Martin Davis, Jr., Beaufort, S.C.

38. House, *Planter Management*, 78; *Rice Planter and Sportsman: The Recollections of J. Motte Alston, 1821–1909*, ed. Arney R. Childs (Columbia: University of South Carolina Press, 1999), 41–42. In the second half of the nineteenth century, Burma became "a major supplier [of rice] for London, Liverpool, and continental milling centers like Hamburg and Bremen." Michael Adas, *The Burma Delta: Economic Development and Social Change on an Asian Rice Frontier, 1852–1941* (Madison: University of Wisconsin Press, 1974), 31, 58–60.

39. Kay Young Day [Kate Porter Young], "My Family Is Me: Women's Kin Networks and Social Power in a Black Sea Island Community," Ph.D. diss., Rutgers University, 1983, 14–15. For a history of "providence rice" production in the pine belt community of Mars Bluff, see Amelia Wallace Vernon, *African Americans at Mars Bluff, South Carolina* (Baton Rouge: Louisiana State University Press, 1993).

40. Elizabeth W. Allston Pringle, *Chronicles of Chicora Wood*, 1922 (reprint. Boston: Christopher Publishing House, 1940), 53–54. Information about Pringle's mother, Adele Petigru, from historian Jane Pease, personal communication, May 24, 1995.

41. See John Michael Vlach, *The Planter's Prospect: Privilege and Slavery in Plantation Paintings* (Chapel Hill: University of North Carolina Press, 2002), 151–78.

42. D. E. Huger Smith, "A Plantation Boyhood," in Smith and Sass, *A Carolina Rice Plantation*, 62.

43. Ibid., 63.

44. "Women Vegetable Venders, An Every Morning Scene on the Streets of Charleston, S.C.," postcard, South Carolina Historical Society.

45. On the relation between local crafts and expanding regional tourism at the turn of the century, see Marta Weigle and Barbara A. Babcock, *The Great Southwest of the Fred Harvey Company and the Santa Fe Railroad* (Phoenix, Az.: The Heard Museum, 1996).

46. Bradford Lee Gilbert, letter to Edward McCrady, Esq., Charleston, S.C., May 18, 1901, Edward McCrady Papers, file #28-307-4, South Carolina Historical Society.

47. *The Exposition*, Charleston, S.C., 1901, 470, South Caroliniana Library.

48. William D. Smyth, "Blacks and the South Carolina Interstate and West Indian Exposition," *South Carolina Historical Magazine* 88:4 (October 1987), 218.

49. A haberdasher and umbrella manufacturer turned professional photographer, George Washington Johnson (1858–1934) documented the 1886 earthquake and the 1901–02 South Carolina Interstate and West Indian Exposition. His extensive photo archives of Charleston buildings and street scenes, plantation gardens, and Lowcountry landscapes are in the collection of the Gibbes Museum of Art, Charleston, S.C. See also Douglas W. Bostick and Daniel J. Crooks, Jr., *On the Eve of the Charleston Renaissance: The George W. Johnson Photographs* (Charleston, S.C.: Joggling Board Press, 2005).

50. Susan V. Donaldson, "Edwin A. Harleston and Charleston's Racial Politics of Preservation," 32, and M. Akua McDanniel, "Edwin Augustus Harleston: Envisioning the Talented Tenth," 24–25, in *Edwin Augustus Harleston: Artist and Activist in a Changing Era*, ed. Leila Potts-Campbell (Charleston, S.C.: Avery Research Center for African American History and Culture, 2006).

51. Martha R. Severens, *The Charleston Renaissance* (Spartanburg, S.C.: Saraland Press, 1998), 6–7, 11–13.

52. For a chronology of events of the Charleston Renaissance and visits of artists from elsewhere, see Ibid., 185–92.

CHAPTER 5
CAROLINA'S GOLD: THREE HUNDRED YEARS OF RICE AND RECIPES IN LOWCOUNTRY KITCHENS

1. Ben Horry, in *Before Freedom, When I Can Just Remember*, ed. Betty Hurmence (Winston-Salem, N.C.: John F. Blair, 1989), 21. Horry was interviewed at length by Genevieve Wilcox Chandler in 1938 for the WPA Writers' Project.

2. Sarah Rutledge, *The Carolina Housewife: A Facsimile of the 1847 Edition, with an Introduction and a Preliminary Checklist of South Carolina Cookbooks Published before 1935 by Anna Wells Rutledge* (Columbia: University of South Carolina Press, 1997), 63.

3. Judith A. Carney, *Black Rice: The African Origins of Rice Cultivation in the Americas* (Cambridge: Harvard University Press, 2001), 145.

4. Peter A. Coclanis, "Introduction" to Duncan Clinch Heyward, *Seed from Madagascar*, 1937 (reprint. Columbia: University of South Carolina Press, 1993), x. The "race season" that commenced in February at Charleston's Washington Course was a major social event for affluent residents and visiting planters. See Christopher C. Boyle, "Rice Planter Lifestyle," 1996, *http://www.ego.net/us/sc/myr/history/riceles.htm* (accessed August 4, 2007).

5. Both the Middleton and Drayton families came from England to South Carolina via Barbados in the late seventeenth century.

6. Rutledge, *The Carolina Housewife*, 63.

7. Ibid., 80.

8. Ibid., Index.

9. Quoted in Peter H. Wood, *Black Majority: Negroes in Colonial South Carolina from 1670 through the Stono Rebellion* (New York: W.W. Norton, 1975), 132.

10. Richard J. Hooker, ed., *A Colonial Plantation Cookbook: The Receipt Book of Harriott Pinckney Horry, 1770* (Columbia: University of South Carolina Press, 1984), 62.

11. Born in Timbo, Guinea, around 1770, Bilali Mohammed was enslaved as a teenager and lived for ten years in the Bahamas before arriving in Georgia in 1802. He became the head driver on Thomas Spalding's Sapelo Island plantation. After his death in 1857, a thirteen-page document written in Arabic and thought to be his diary was discovered. Close analysis revealed the text to be a brief statement of Islamic beliefs and the rules for ablution, morning prayer, and the calls to prayer. Allan D. Austin, "Bilali Mohammed and Salih Bilali: Almaamys on Georgia's Sapelo and St. Simon's Islands," in *African Muslims in Antebellum America: Transatlantic Stories and Spiritual Struggles* (London: Routledge, 1997), chapter 5, 85–114.

12. Sylviane A. Diouf, *Servants of Allah: African Muslims Enslaved in the Americas* (New York: New York University Press, 1998), 65.

13. Eugene Genovese, *Roll, Jordan, Roll: The World the Slaves Made* (New York: Vintage Books, 1976), 543.

14. Gwendolyn Midlo Hall, *Slavery and African Ethnicities in the Americas* (Chapel Hill: University of North Carolina Press, 2005), 91, 93.

15. Harriet Ross Colquitt, *Savannah Cook Book: A Collection of Old Fashioned Receipts from Colonial Kitchens, 1933* (reprint. Charleston, S.C.: The Charleston Printing Company, 1997), 76.

16. Leland Ferguson, *Uncommon Ground: Archeology and Early African America, 1650–1800* (Washington D.C.: Smithsonian Institution Press, 1992), 93–107.

17. Ibid., 93–96; and Charles Joyner, *Down by the Riverside: A South Carolina Slave Community* (Urbana: University of Illinois Press, 1984), 90–106.

18. Michael A. Gomez, *Exchanging Our Country Marks: The Transformation of African Identities in the Colonial and Antebellum South* (Chapel Hill: University of North Carolina Press, 1998), 59–60.

19. Diouf, *Servants of Allah*, 65.

20. Karen Hess, *The Carolina Rice Kitchen: The African Connection, Featuring in Facsimile: Carolina Rice Cook Book* (Columbia: University of South Carolina Press, 1992), 71.

21. *Charleston Receipts Collected by the Junior League of Charleston*, eds. Mary Vereen Huguenin and Anne Montague Stoney (Charleston, S.C.: Walker Evans & Cogswell Co., 1950), 8.

22. Sallie Ann Robinson, *Gullah Home Cooking the Daufuskie Way* (Chapel Hill: University of North Carolina Press, 2003), 122.

CHAPTER 6
MISSIONS AND MARKETS: SEA ISLAND BASKETRY AND THE SWEETGRASS REVOLUTION

1. Letter from E. Murray to Mrs. Christensen, January 3, 1894, Christensen Family Papers, South Caroliniana Library, University of South Carolina, Columbia, S.C. See Monica Maria Tetzlaff, *Cultivating a New South: Abbie Holmes Christensen and the Politics of Race and Gender, 1852–1938* (Columbia: University of South Carolina Press, 2002), esp. 168–71 on the role of basket making in the curricula of Penn and Shanklin schools.

2. On the relationship between the Arts and Crafts and Manual Training movements, see Carlton Edward Bauer, "A Study of the Arts and Crafts Movement and of Art Nouveau in Relation to Industrial Arts Design," Ph.D. diss., New York University, 1955. See also Oscar Lovell Triggs, *Chapters in the History of the Arts and Crafts Movement*, 1902 (reprint. New York: Benjamin Blom, Inc., 1971), 1; and Robert Judson Clark, ed., *The Arts and Crafts Movement in America, 1876–1916* (Princeton: Princeton University Press, 1972), 9.

3. Penn School Papers, Reel 1, Southern Historical Collection, University of North Carolina, Chapel Hill, N.C.

4. Quoted in McDavid Horton, "Negro Island Farmers Are Unique Community," reprinted from *The State* (Columbia, S.C.), January 17–20, 1924, 14.

5. Elizabeth Jacoway, *Yankee Missionaries in the South: The Penn School Experiment* (Baton Rouge: Louisiana State University Press, 1980), 10.

6. *Annual Reports of the Penn Normal, Industrial, and Agricultural School*, 1910, 1928, South Caroliniana Library.

7. *Annual Report*, 1910, 15.

8. Leroy E. Browne, Sr., St. Helena Island, S.C., November 21, 1985, interview by Dale Rosengarten. McKissick Museum, Folklife Resource Center, University of South Carolina, Columbia, S.C.

9. Leroy E. Browne, Sr., St. Helena Island, S.C., July 7, 2006, video interview by Dale Rosengarten, Dana Sardet, and Nakia Wigfall. Avery Research Center, College of Charleston, Charleston, S.C.

10. "BASKET-MAKERS—Recognized as best on St. Helena," Edith M. Dabbs papers, South Caroliniana Library.

11. "The Basket-Maker of St. Helena Island," typescript, n.d. [1915], 6; Grace Bigelow House, "How Freedom Came to Big Pa," *Southern Workman* (April 1916), Edith M. Dabbs papers.

12. David E. Whisnant, *All That Is Native & Fine: The Politics of Culture in an American Region* (Chapel Hill: University of North Carolina Press, 1983), 81–85, 139–41. For a discussion of the relationship between Appalachian settlement schools and "industrial education" on the Sea Islands, see 8–10, 14–15, 71–72.

13. T. J. Woofter, Jr., *Black Yeomanry: Life on St. Helena Island* (New York: Henry Holt & Co., 1930), 12.

14. "What Some of Them Said of It," pamphlet produced by Penn Normal, Industrial, and Agricultural School, St. Helena Island, S.C., n.d. [ca. 1927], Edith M. Dabbs papers.

15. "Palmam Qui Meruit Ferat," promotional material accompanied by a letter dated October 29, 1920, from Dr. Charles T. Loram to George Foster Peabody, chairman of Penn's Board of Trustees, Edith M. Dabbs papers.

16. Dr. Charles T. Loram, "Adaptation of the Penn School Methods to Education in South Africa" (New York: Phelps-Stokes Fund, April 1927), Edith M. Dabbs papers.

17. Leroy E. Browne, Sr., interviews recorded on November 21, 1985 and July 7, 2006.

18. *Annual Report*, 1914, 14.

19. A selection of Miner's St. Helena photographs was published in 1970, following the discovery of his glass negatives in an attic at the school. See Edith M. Dabbs's *Face of an Island: Leigh Richmond Miner's Photographs of St. Helena*

Island (Columbia, S.C.: The R.L. Bryan Co., 1970), n.p.

20. Cooley had initiated the project through Paul Kellogg, the editor of *Survey Graphic*. Jeffrey C. Stewart, *To Color America: Portraits by Winold Reiss* (Washington D.C.: Smithsonian Institution Press for National Portrait Gallery, 1989), 81.

21. Ibid., 17.

22. *Harlem Renaissance: Art of Black America*, 1987 (reprint. New York: The Studio Museum in Harlem and Harry N. Abrams, Inc., 1994), 38, 106.

23. See Dale Rosengarten, *Row Upon Row: Sea Grass Baskets of the South Carolina Lowcountry*, 1986 (reprint. Columbia, S.C.: McKissick Museum, 1994), 28–29.

24. With the death of Jannie Cohen of Hilton Head Island in 2002, the bulrush work basket went out of production. The Sapelo Island (Georgia) basket, however, has recently gained a new lease on life. Several basket makers on Sapelo and in coastal towns on the mainland are working in the tradition of the island's renowned practitioner, Allen Green (1907–1999). Green made coiled baskets in a variety of styles from a marsh grass (most likely *Spartina patens*) sewn with strips from the stem of saw palmetto (*Serenoa repens*). In what might be regarded as a borrowing from the Mt. Pleasant tradition, at least two of Green's disciples, Yvonne Grovner and Herbert James Dixon, sometimes use "purple muhly," or sweetgrass (*Muhlenbergia sericea*), to start their baskets. Personal communication with Yvonne Grovner, Sapelo Island, Ga., November 13, 2007. For information about current Sapelo Island basket makers, see tapes and summary of interview with Yvonne Grovner and Herbert J. Dixon, recorded by former state folklorist, Adrienn Mendonca, April 2, 2007, Sapelo Island Cultural Aid and Revitalization Society, Sapelo Island, Ga. A typescript of the interview summary is available from the Southern Arts Federation, Atlanta, Ga. For more on Allen Green, see Rosengarten, *Row Upon Row*, 32, and *Home Across the Water*, a video documentary directed and produced by Benjamin Shapiro, 1993.

25. Henry Yaschik, Charleston, S.C., personal communication with the author, May 21, 1992. See also Henry Yaschik, *From Kaluszyn to Charleston: The Yaschik Family in Poland, Argentina, and South Carolina* (Charleston, S.C., 1990), 42–43.

26. "The Hammock Shop, Gifts & Novelties from the Carolina Lowcountry," n.d. [ca. 1939], Collection of A. H. and Martha Lachicotte.

27. "The Hammock Shop." For more on the history of merchandising bulrush baskets, see Rosengarten, *Row Upon Row*, 25–26, 32–33, and Dale Rosengarten, "The Lowcountry Basket in 'Changeful Times,'" in *Revivals! Diverse Traditions: 1920–1945*, ed. Janet Kardon (New York: Harry N. Abrams, Inc., in association with the American Craft Museum, 1994), 108–11.

28. Leola Wright, Mt. Pleasant, S.C., February 11, 1992, interview by Dale Rosengarten. McKissick Museum, Folklife Resource Center.

29. Joyce V. Coakley, "Basketweavers," in *Folklife Annual 88–89*, eds. James Hardin and Alan Jabbour (Washington D.C.: Library of Congress, 1989), 164.

30. Dr. Clarence W. Legerton, Jr., Charleston, S.C., July 2, 1985, interview by Dale Rosengarten. McKissick Museum, Folklife Resource Center.

31. For a description of transactions between Legerton and the Mt. Pleasant basket makers, see Rosengarten, *Row Upon Row*, 31–34.

32. Mary Jackson, Charleston, S.C., August 24, 1985, interview by Dale Rosengarten. McKissick Museum, Folklife Resource Center.

33. M. Jeanette Lee, Mt. Pleasant, S.C., January 20, 1992, and Harriett Bailem Brown, Mt. Pleasant, S.C., February 11, 1992, interviews by Dale Rosengarten. McKissick Museum, Folklife Resource Center.

34. Jeannette Gaillard-Lee, "Pioneering Trailblazers," remarks prepared for community workshop on sweetgrass basketry, December 10, 2005. Avery Research Center, College of Charleston.

35. Expenditures for stationery soared from $2.15 to $184.33, reflecting the cost perhaps of printing a mail order brochure. Seagrassco's sales dropped by two thirds in 1922–23, but its profit margin nearly doubled—baskets purchased for $1,347.38 sold for $2,592.27. If the average list price of a basket was fifty cents, Seagrassco would have sold a total of about five thousand baskets in 1924–25. Although the volume of sales tapered off, the basket business continued to be profitable at least through 1928, the last year for which records were available. "Business Record" of Legerton & Co., collection of John E. Huguley, Charleston, S.C.

36. M. Jeanette Lee, "Sweetgrass Baskets: A Blessing from God, A Proud Tradition and a Valuable Investment," in *Low Country Gullah Culture: Special Resources Study and Final Environmental Impact Statement*, National Park Service, July 2005, 68; Gaillard-Lee, "Pioneering Trailblazers."

37. Joyce V. Coakley, *Sweetgrass Baskets and the Gullah Tradition* (Charleston, S.C.: Arcadia Publishing, 2005), 14; J. V. Coakley, "History," *http://www.sweetgrassfestival.com/history.html* (accessed August 30, 2007).

38. Gaillard-Lee, "Pioneering Trailblazers."

39. Joseph Mazyck, Mt. Pleasant, S.C., June 3, 2006, interview by Deborah A. Wright. Avery Research Center, College of Charleston.

40. Eva Wright, Mt. Pleasant, S.C., June 3, 2006, interview by Deborah A. Wright. Avery Research Center, College of Charleston.

41. Annie Scott, Mt. Pleasant, S.C., June 3, 2006, interview by Deborah A. Wright. Avery Research Center, College of Charleston.

42. Quoted in Kate Porter Young, unpublished fieldnotes, 1978. Settlements along Highway 17 North are commonly named for their distance from the Cooper River.

43. Evelyina Foreman, Mt. Pleasant, S.C., October 23, 1985, interview by Dale Rosengarten. McKissick Museum, Folklife Resource Center.

44. Jack Leland, "Basket Weaving African Art Survival?" *News and Courier* (Charleston, S.C.), March 27, 1949.

45. Joyce Coakley, "The Flower Ladies: Mothers of Invention," *Charleston Magazine* (July–August 2006), 158–67.

46. "Jannie Gordine," *Post and Courier* (Charleston, S.C.), October 26, 1980.

47. Mary Catherine Stanley, Mt. Pleasant, S.C., June 3, 2006, interview by Dale Rosengarten. Avery Research Center, College of Charleston.

48. Annie Scott, June 3, 2006.

49. Susan Sully, "Dream Weaver," in *Southern Accents* (September/October 2002), 102–6.

50. Mary Jackson, August 24, 1985.

51. Mary Jackson, quoted by Nkiru Nzegwu in *Uncommon Beauty in Common Objects: The Legacy of African American Craft Art*, ed. Barbara Glass (Wilberforce, Ohio: National Afro-American Museum and Cultural Center, 1993), 62.

52. John Michael Vlach, *The Afro-American Tradition in Decorative Arts*, 1978 (reprint. Athens: University of Georgia Press, 1990), 19.

53. Joseph Mazyck, June 3, 2006.

54. Barbara McCormick, McClellanville, S.C., June 30, 2006, video interview by Dale Rosengarten and Dana Sardet. Avery Research Center, College of Charleston.

55. Mary Catherine Stanley, June 3, 2006.

56. Raymond Manigault, McClellanville, S.C., December 28, 2006, video interview by Dale Rosengarten and Dana Sardet. Avery Research Center, College of Charleston.

57. Elizabeth Mazyck, Mt. Pleasant, S.C., June 3, 2006, interview by Deborah A. Wright. Avery Research Center, College of Charleston.

58. Mary Jackson, quoted in *Uncommon Beauty in Common Objects*, 62.

59. Henrietta Snype, Mt. Pleasant, S.C., June 3, 2006, interview by Deborah A. Wright. Avery Research Center, College of Charleston.

60. Joseph Mazyck, June 3, 2006.

61. Mary Catherine Stanley, June 3, 2006.

62. Annie Scott, June 3, 2006.

CHAPTER 7
NECESSITY AND INVENTION: THE ART OF COILED BASKETRY IN SOUTHERN AFRICA

1. The Cape Colony of the future South Africa was established by the Dutch East India Company in 1652, with the founding of Cape Town.

2. Julian Cobbing, "The Mfecane as Alibi: Thoughts on Dithakong and Mbolompo," *Journal of African History* 29 (1988), 487–519. For responses to Cobbing's hypothesis, see Elizabeth Eldredge and others, in *Slavery in South Africa: Captive Labor on the Dutch Frontier*, eds. Elizabeth A. Eldredge and Fred Morton (Boulder, Colo.: Westview Press, 1994).

3. H. P. N. Muller and J. F. Snelleman, *Industrie des Cafres du Sud-Est de l'Afrique* (Leyden: E. J. Brill, 1892).

4. The Lozi, who live in the floodplains of the Upper Zambezi River in what is now western Zambia, migrated from the Luba-Lunda Empire in the late seventeenth or early eighteenth century.

5. George F. Angas, *The Kafirs Illustrated* (London: Hogarth, 1849).

6. Alfred T. Bryant, *The Zulu People as They Were Before the White Man Came* (Pietermaritzburg: Shuter and Shooter, 1949), 199.

7. Marjorie Locke, *The Dove's Footprint: Basketry Patterns in Matabeleland* (Harare: Baobab Books, 1994), 18.

8. Anthony B. Cunningham and M. Elizabeth Terry, *African Basketry: Grassroots Art from Southern Africa* (Cape Town: Fernwood Press, 2006), 11.

9. Barbara Z. Cohen, *A Survey of Basketmaking in Botswana* (Gaberone: The National Museum and Art Gallery, n.d. [ca. 1980]), 17.

10. Cunningham and Terry, *African Basketry*, 48.

11. Cohen, *A Survey of Basketmaking*, 15.

12. Locke, *The Dove's Footprint*, 16.

13. E. M. Shaw, "The Basketwork of Southern Africa, Part 1. Technology," *Annals of the South African Museum* 100:2 (May 1992), 208.

14. E. M. Shaw, "Basketwork of the Southern Nguni," in "Basketwork of Southern Africa, Part 3," *Annals of the South African Museum* 111:1 (2004), 61, 67.

15. Locke, *The Dove's Footprint*, 14.

16. E. M. Shaw, "The Craft of Basketry in Southern Africa," *Sagittarius* 3:4, 4.

17. Shaw, "Basketwork of the Southern Nguni," 14.

18. Cohen, *A Survey of Basketmaking*, 22.

19. Cunningham and Terry, *African Basketry*, 90.

20. Ibid., 175.

21. Locke, *The Dove's Footprint*, 12.

22. Sónia Silva, *A Vez dos Cestos* (Lisbon: Museu National de Etnologia, 2003), cited in Peter Mark, "A vez dos centos/Time for Baskets," *African Arts* 38:1 (Spring 2005), 91. Belgian-born historian and anthropologist, Jan Vansina is widely regarded as an authority on the peoples of Central Africa.

23. The London Missionary Society opened its first schools for Africans in the Eastern Cape in 1799. Because of the emphasis on vocational training, craft teaching figured prominently in the curricula of these mission schools.

24. D. F. van Dyk, "The Contact Between the Early Tribal African Education and the Westernized System of Missionary Education," *Educare* 3:1 (1975), 10.

25. Shaw, "Basketwork of the Southern Nguni," 68.

26. The 1820 settlers were white colonists recruited by the British government to act as a buffer between the Cape Colony and neighboring Xhosa-speaking communities.

27. Shaw, "Basketwork of the Southern Nguni," 23.

28. Ibid., 1.

29. E. M. Shaw, "Basketwork of the Khoisan and the Dama," in "The Basketwork of Southern Africa, Part 2," *Annals of the South African Museum* 102:8 (February 1993), 281.

30. Shaw, "Basketwork of the Southern Nguni," 61.

31. Ibid., 64.

32. Colin de B. Webb and John B. Wright, eds., *The James Stuart Archive of Recorded Oral Evidence Relating to the History of the Zulu and Neighbouring Peoples*, vol. 1 (Pietermaritzburg: University of Natal Press, 1996), 63–64, 68.

33. Melinda E. Ebert, "Patterns of Manufacture and Use of Baskets among Basarwa of the Nata River Region," *Botswana Notes and Records* 9 (1977), 79.

34. Ibid., 71.

35. Ibid., 75.

36. Ibid., 77.

37. Zwoitwa Makhado, "Crafting a Livelihood: Local-Level Trade in Mats and Baskets in

Pondoland, South Africa," M.Ph. thesis, University of the Western Cape, 2005, 51.

38. Ibid., 75.

39. Ibid., 68.

40. Manuel L. Rodriques de Areia, "Le Panier Divinatoire des Tshokwe," *Arts d'Afrique noire* (1974), 30–44, and Manuel Jordán, "Art and Divination among Chokwe, Lunda, Luvale, and Other Related Peoples of Northwestern Zambia," in *Insight and Artistry in African Divination*, ed. John Pemberton III (Washington: Smithsonian Institution Press, 2000), 134–43.

41. Jordán, "Art and Divination," 142.

42. It is remarkable that the literature on this method of divination focuses on the content of the baskets, but fails to consider the production of the baskets themselves.

43. For a detailed consideration of the gendered history of basket coiling among Zulu-speaking communities, see Nessa Liebermann, "Technologies and Transformations: Baskets, Women and Change in Twentieth-century KwaZulu-Natal," in *Between Union and Liberation: Women Artists in South Africa, 1910 –1994*, eds. Marion Arnold and Brenda Schmahmann (Aldershot, Hants: Ashgate, n.d. [ca. 2005]).

44. For a discussion of the impact of influx control regulations on the lives of rural black communities in the course of the twentieth century, see David Hindson, *Pass Controls and the Urban African Proletariat in South Africa* (Johannesburg: Ravan Press, 1987).

45. Prior to this exhibition, the work of artists associated with this HIV/AIDS project was celebrated in an article by Allen F. Roberts, "'Break the Silence': Art and HIV/AIDS in KwaZulu-Natal," *African Arts* 34:1 (Spring 2001), 36–49, 93–95.

46. The BAT Centre was founded by the Bartel Arts Trust in 1992 to fund development projects, workshops, and residential facilities for craft specialists in Durban's harbor area.

47. Marisa Fick-Jordaan, interview with the author, May 2000. In 2005, Fick-Jordaan collaborated with collector, David Arment, to publish a coffee-table book on the work of the wirework artists who sell their baskets through the BAT Centre. See D. Arment and M. Fick-Jordaan,

Wired: Contemporary Zulu Telephone Wire Basket (Santa Fe: S/C Editions and Johannesburg: David Krut Publishing, 2005).

48. Elliot Mkhize, interview with the author, African Art Centre, Durban, May 2000.

49. See Hervé Di Rosa's catalogue of the work generated by this collaboration, *DiroZulu* (Durban: Institut Français d'Afrique du Sud, Les Editions des Alpes and Orange Juice Design, 2000), n.p.

50. See Celia Britton, *Edouard Glissant and Postcolonial Theory: Strategies of Language and Resistance* (Virginia: University of Virginia Press, 1999). Born in Martinique and trained at the Sorbonne in Paris, Glissant is a poet, novelist, and cultural theorist best known for his critique of colonialism and support of the Negritude movement whose purpose was to restore an African cultural identity throughout the diaspora.

51. The widespread conviction that designs like these nevertheless are underpinned by clear mathematical principles is reflected in, for example, Getz's analysis of several beer pot lids. See Chonat G. L. Getz, "Computer generation of geometric designs woven into the *izimbenge* using algorithmic processes developed in the field of fractal geometry," *South African Journal of Science* 95 (October 1999), 434–39.

52. T. Nhlapo, "Rural Art Rewired," *Weekly Mail and Guardian* (Johannesburg), April 12, 2001, 13; P. Hlahla, "Telkom Battles Crime by Empowering Weavers," *Pretoria News*, May 12, 2000, 2.

53. *In Short: The South African Cultural Industries, www.dac.gov.za/reports/music_pu_film_craft/summary.doc*, 3 (accessed ca. 1998).

54. Joseph Gaylard, "The Craft Industry in South Africa: A Review of Ten Years of Democracy," *African Arts* 37:4 (2004), 27.

55. Ibid., 26–29.

56. Susan Sellshop, *Craft South Africa: Traditional, Transitional, Contemporary* (Johannesburg: Pan Macmillan, 2002), 92.

57. S. Packree, "Berg Baskets Change Lives," *Daily News* (Durban), July 26, 2005, 13.

58. *http://www.kuboboyi.co.za; http://www.rooms-forafrica.com/establishment.do?id+114; http://www.ultimateafrica.com/southafrica_accommodation.htm* (all accessed August 20, 2007).

59. Rhoda Levinsohn reported on the impact of these initiatives in *Basketry: A Renaissance in Southern Africa* (Cleveland Heights, Ohio: Protea Press, 1979).

60. Jannie van Heerden, *Ukusimama KwaMasiko – Cultural Survival* (Durban: Durban Art Gallery, 1993), 2.

61. The most comprehensive account of the history of the Löfroths and the Vukani Association is provided by M. A. Jones, "A Discussion of the Historical Influences on the Production, Presentation and Promotion of Zulu Basketry and Related Grasswork," M.A. thesis, University of Natal, Pietermaritzburg, 2001.

62. For a study of the history of the Centre, see Phillipa Hobbs and Elizabeth Rankin, *Rorke's Drift: Empowering Prints* (Cape Town: Double Storey Books, 2003).

63. The Löfroths' collection has been housed in the Old Post Office building in Eshowe in northern KwaZulu-Natal.

64. For a history of the policies implemented to manage and control African communities in South Africa, see Ivan Evans, *Bureaucracy and Race: Native Administration in South Africa* (Berkeley: University of California Press, 1997).

65. Hendrik W. van der Merwe, "Changing Attitudes of Whites towards African Development," in *The Role of the Church in Socio-economic Development in Southern Africa* (Durban: Lutheran Publishing House, 1972), 115.

66. Swedish missionaries first went to South Africa in 1876. For a history of early mission activity in present-day KwaZulu-Natal, see N. Etherington, "Christianity and African society in nineteenth-century Natal," in *Natal and Zululand from Earliest Times to 1910: A New History*, eds. Andrew Duminy and Bill Guest (Pietermaritzburg: University of Natal Press and Shuter & Shooter, 1989), 275–301.

67. Bertha and Kjell Löfroth, "How We Got Involved in Community Development Projects," Vukani Association, July 1972–December 1976, 5. Typed manuscript obtained from the Vukani Association.

68. Ibid., 8.

69. Ibid., 9.

70. Ibid., 12.

71. Ibid., Appendix D1-3.

72. van Heerden, *Ukusimama KwaMasiko – Cultural Survival*, 5.

73. B. and K. Löfroth, "How We Got Involved in Community Development Projects," Appendix K1-2.

74. Jannie van Heerden, "Zulu Basketry: A Proud and Living Tradition," *Vuka SA* (April 1996), 52. For an interesting consideration of the tendency to overlook the material nature of crafts in favor of a consideration of their function as communicative media, see N. C. M. Brown, "Theorising the Crafts: New Tricks of the Trade," in *Craft and Contemporary Theory*, ed. Sue Rowley (St. Leonards, Australia: Allen and Unwin, 1997), 3–17, 14.

75. van Heerden, *Ukusimama KwaMasiko – Cultural Survival*, 2.

76. Rev. Joseph Shooter, *The Kafirs of Natal and the Zulu Country*, 1857 (reprint. New York: Negro Universities Press, 1969), 356.

77. Walter F. Morris, Jr., *Handmade Money: Latin American Artisans in the Marketplace* (Washington, D.C.: Organization of American States, 1996).

78. Katarina Pierre, "Korgama fràn KwaZulu – Ett kvinnligt konsthantverk I Sydafrika" [The Baskets from KwaZulu – A Women's Art and Craft in South Africa], diss., Umeå University, Sweden, 1990, 48. The quotation has been slightly modified to conform to common English speech patterns.

79. Ibid., 40. The quotation has been slightly modified to conform to English speech patterns.

80. Anthony B. Cunningham and Sue J. Milton, "Effects of Basket-weaving Industry on Mokola Palm and Dye Plants in Northwestern Botswana," *Economic Botany* 41:3 (1987), 386; and Cohen, *A Survey of Basketmaking in Botswana*, 6.

81. Cunningham and Terry, *African Basketry*, 19.

82. Shaw, "The Basketwork of Southern Africa, Part 1. Technology," 208.

83. Eleanore Preston-Whyte, *Black Women in the Craft and Curiotrade in KwaZulu and Natal* (Pretoria: Human Sciences Research Council Report, 1983); Anthony B. Cunningham, "Commercial Craftwork: Balancing Out Human Needs and Resources," *South African Journal of Botany* 53:4 (1987), 250–66.

84. Cunningham and Milton, "Effects of Basket-weaving Industry," 388.

85. D. L. Kgathi, G. Mmopelwa, and K. Mosepele, "Natural Resources Assessment in the Okavango Delta, Botswana: Case Studies of Some Key Resources," *Natural Resources Forum* 29:1 (2005), 77.

86. This was one of the areas from which the Zulu kingdom acquired baskets as part of the tribute it extracted from neighboring Tsonga-speaking communities before the mid-nineteenth century.

87. Cunningham, "Commercial Craftwork," 261.

88. Ibid., 265.

89. Dieter Heinsohn, "Wetland Plants as a Craftwork Resource," *Veld and Flora* (September 1990), 74–77.

90. Cunningham and Milton, "Effects of Basket-weaving Industry," 386.

91. Kgathi, Mmopelwa, and Mosepele, "Natural Resources Assessment in the Okavango Delta, Botswana," 77.

92. Ben Cousins, "Invisible Capital: The Contribution of Communal Rangelands to Rural Livelihoods in South Africa," *Development South Africa* 16:2 (1999), 299–318.

93. Notably the National Forestry Act No. 84 (1998), the National Environmental Management Act No. 107 (1998), and the National Environmental Management Biodiversity Bill (2003).

94. Thembela Kepe, "Grassland Vegetation and Rural Livelihood: A Case Study of Resource Value and Social Dynamics on the Wild Coast, South Africa," Ph.D. diss., University of the Western Cape, 2002.

95. Technical and manual training first became compulsory in what is now KwaZulu-Natal in 1884.

96. Lamin Sanneh, *Encountering the West: Christianity and the Global Cultural Process: The African Dimension* (New York: Orbis Books, 1993), 152.

97. Ibid., 179.

98. *In Short: The South African Cultural Industries*, www.dac.gov.za/reports/music_pu_film_craft/summary.doc (accessed ca. 1998).

CHAPTER 8
DOCUMENTARY IMAGES AND DEVOTIONAL ACTS: PLANTATION PAINTING AS PROPAGANDA

1. Edward King, *The Great South*, 1875, eds. W. Magruder Drake and Robert R. Jones (reprint. Baton Rouge: Louisiana State University Press, 1972), xxxiii–xxxiv.

2. Ibid., 429–37. Champney's "Negro Cabins on a Rice Plantation" (p. 431) was based on half of a stereographic image of a mealtime at a plantation close to Charleston, South Carolina, made by S. T. Sander in the period between 1860 and 1861. See "The History of South Carolina Slide Collection," ed. Constance B Schulz, at: *www.knowitall.org/schistory* (accessed October 7, 2007).

3. Antonio Pace, trans. and ed., *Luigi Castiglioni's "Viaggio": Travels in the United States of North America, 1785–87* (Syracuse, N.Y.: Syracuse University Press, 1983), 167–70.

4. Roberta Kefalos, "Landscapes of Thomas Coram and Charles Fraser," *American Art Review* 10:3 (1998), 127.

5. See John Michael Vlach, *The Planter's Prospect: Privilege and Slavery in Plantation Paintings* (Chapel Hill: University of North Carolina Press, 2002), for *View of Mulberry, House and Street*, 8; for *Rose Hill*, 10.

6. T. Addison Richards, "The Landscape of the South," *Harper's New Monthly Magazine* 6 (1853), 721.

7. T. Addison Richards, "The Rice Lands of the South," *Harper's New Monthly Magazine* 19 (1859), 724, 726, and 729.

8. Basil Hall, *Travels in North America, in the Years 1827 and 1828*, 3 vols. (Edinburgh: Cadell and Co., 1829).

9. James E. Taylor, "Rice Culture in North Carolina," *Frank Leslie's Illustrated Newspaper*, October 20, 1866, 5.

10. A first-hand assessment of the impact of the 1893 hurricane is offered by Joel Chandler Harris, "The Sea Island Hurricanes," *Scribner's Magazine* 15:2 (February 1894), 229–47. The series of storms that finally ended rice cultivation in South Carolina in 1913 is described in

Christopher C. Boyle, "Collapse of Georgetown Rice Culture" at: *www.ego.net/us/sc/myr/history/decline.html* (accessed October 8, 2007).

11. Martha R. Severens, *Alice Ravenel Huger Smith: An Artist, a Place and a Time* (Charleston, S.C.: Carolina Art Association and the Gibbes Museum of Art, 1993), 45.

12. Vlach, *The Planter's Prospect*, 151.

13. Alice Ravenel Huger Smith, "Reminiscences," quoted in Severens, *Alice Ravenel Huger Smith*, 71.

14. Patience Pennington (Elizabeth W. Allston Pringle), *A Woman Rice Planter*, 1913, ed. Cornelius O. Cathey (reprint. Cambridge: Harvard University Press, 1961).

15. For a history of Smithfield Plantation, see Suzanne Cameron Linder, *Historical Atlas of the Rice Plantations of the ACE River Basin—1860* (Columbia: South Carolina Department of Archives and History, 1995), 563–72.

16. Smith, "Reminiscences," quoted in Severens, *Alice Ravenel Huger Smith*, 97.

17. Sass in Alice Huger Ravenel Smith and Herbert Ravenel Sass, *A Carolina Rice Plantation of the Fifties* (New York: William Morrow & Co., 1936), 39–40.

18. Ulrich B. Phillips, *American Negro Slavery: A Survey of the Supply, Employment, and Control of Negro Labor as Determined by the Plantation Regime* (New York: A. Appleton & Co., 1918), 342–43. See also John David Smith, *An Old Creed for the New South: Proslavery Ideology and Historiography, 1865–1918*, 1985 (Athens: University of Georgia Press, 1991), chapter 8, 239–83.

19. Sass in Smith and Sass, *A Carolina Rice Plantation*, 39.

20. Mary Boykin Chesnut, *A Diary of Dixie* (New York: Appleton and Co., 1907), 253.

21. Martha Severens, "Lady of the Lowcountry," *South Carolina Wildlife* (March/April 1979), 19.

22. D. E. Huger Smith, *A Charlestonian's Recollections: 1846–1913* (Charleston, S.C.: Carolina Art Association, 1950), 129, 134.

23. *The Parish Church* was modeled on Strawberry Church, a chapel of ease standing on the banks of the western branch of the Cooper River. *The Mill and Barn* was based on a photograph made ca. 1900 at Fairfield Plantation by George

W. Johnson. For the apparent source for *The Plantation Church*, see "The church in Peaceville" in *A Woman Rice Planter*, 331.

24. Harlan Greene and James M. Hutchisson, "The Charleston Renaissance Considered," in *Renaissance in Charleston: Art and Life in the Low Country*, eds. James M. Hutchisson and Harlan Greene (Athens: University of Georgia Press, 2003), 9.

25. Kelly A. Linton, "Alice Ravenel Huger Smith: A Commitment to Conservation—Gibbes Exhibition Celebrates Debut of Conserved Watercolors Series," press release, Gibbes Museum of Art, Charleston, S.C., July 2004.

26. Wal-Mart's selection of framed prints by Alice R. Huger Smith can be found at: *http://framedart.walmart.com*. For the same prints, unframed, offered by Iraq Museum International and the Baghdad Museum Project, see: *http://www.baghdadmuseum.org/posters/c34606.html* (accessed October 8, 2007).

27. See William Dusinberre, *Them Dark Days: Slavery in the American Rice Swamps* (New York: Oxford University Press, 1996), 237, 241

CHAPTER 9
THE PARADOX OF PRESERVATION:
GULLAH LANGUAGE, CULTURE, AND
IMAGERY

1. For more on New Hampshire–born photographer Henry P. Moore (1842–1900), see the exhibition catalog by W. Jeffrey Bolster and Hilary Anderson, *Soldiers, Sailors, Slaves, and Ships: The Civil War Photographs of Henry P. Moore* (Concord: New Hampshire Historical Society, 1999). For a biography of Timothy O'Sullivan (1840–1882), who worked for the studio of Matthew Brady during the Civil War, see James D. Horan, *Timothy O'Sullivan, America's Forgotten Photographer* (New York: Bonanza, 1966).

2. Higginson's collection of *Negro Spirituals* is available online through the University of Virginia's Alderman Library, Electronic Text Center, Charlottesville, Va., at: *http://etext.lib.virginia.edu/modeng/modengH.browse.html* (accessed November 10, 2007). Best known today as critic, champion, and publisher of the poems of Emily Dickinson, Thomas Wentworth Higginson (1823–1911) is also noted for his account of his experiences as colonel of the First South Carolina Volunteers, originally published in 1870. See Thomas W. Higginson, *Army Life in a Black Regiment*, 1962 (reprint. New York: W.W. Norton, 1984).

3. William Francis Allen, Charles Pickard Ware, and Lucy McKim Garrison, eds., *Slave Songs of the United States* (New York: A. Simpson and Co., 1867). Available online in its entirety at: www.docsouth.unc.edu/church/allen/menu.html (accessed November 10, 2007).

4. Douglas W. Bostick and Daniel J. Crooks, Jr., *On the Eve of the Charleston Renaissance: The George W. Johnson Photographs* (Charleston, S.C.: Joggling Board Press, 2005).

5. Stephanie E. Yuhl, *A Golden Haze of Memory: The Making of Historic Charleston* (Chapel Hill: University of North Carolina Press, 2005).

6. Ambrose E. Gonzales, *The Black Border: Gullah Stories of the Carolina Coast* (1922), *The Captain: Stories of the Black Border* (1924), *With Aesop Along the Black Border* (1924), and *Laguerre: A Gascon of the Black Border* (1924), all issued by The State Company, Columbia, S.C. In 1888, Charles Colcock Jones, Jr., had published a collection of Gullah tales under the title *Negro Myths on the Georgia Coast*, reprinted as *Gullah Tales of the Georgia Coast* (Athens: University of Georgia Press, 2000).

7. John Bennett, "Gullah: A Negro Patois," *South Atlantic Quarterly*, Part I (October 1908) and Part II (January 1909). For a literary biography of Bennett and a portrait of his milieu, see Harlan Greene, *Mr. Skylark: John Bennett and the Charleston Renaissance* (Athens: University of Georgia Press, 2001).

8. For example, audio recording of Samuel G. Stoney's Gullah rendition of "how Adam and Eve lost their tails," available online at: *www.archive.org/details/Authentic_White_Gullah* (accessed November 10, 2007).

9. Yuhl, *A Golden Haze of Memory*, 116–17.

10. See Susan Millar Williams, *A Devil and a Good Woman, Too: The Lives of Julia Peterkin* (Athens: University of Georgia Press, 1997).

11. See James M. Hutchisson, *DuBose Heyward: A Charleston Gentleman and the World of Porgy and Bess* (Jackson: University Press of Mississippi, 2000), and *A DuBose Heyward Reader*, ed. James M. Hutchisson (Athens: University of Georgia Press, 2003).

12. Personal communications from Judith Wragg Chase and her sister Louise Graves to the author, 1983.

13. A complete run of "Street Strolls" can be found at the South Carolina Historical Society, Charleston, S.C.

14. For a detailed history of the Old Slave Mart Museum, see Theodore C. Landsmark, "'Haunting Echoes': Histories and Exhibition Strategies for Collecting Nineteenth-Century African-American Crafts," 3 vols., Ph.D. diss., Boston University, 1999, vol. 1, 191–256.

15. Melville J. Herskovits, *The Myth of the Negro Past*, 1941 (reprint. Boston: Beacon Press, 1958).

16. Lorenzo Dow Turner, *Africanisms in the Gullah Dialect*, 1949 (reprint. Ann Arbor: University of Michigan Press, 1973).

17. On pictorialism, see Naomi Rosenblum and Susan Fillin-Ych, *Documenting a Myth: The South as Seen by Three Women Photographers, Chansonetta Stanley Emmons, Doris Ulmann, Bayard Wootten, 1910–1940*, exhibition catalogue (Portland, Ore.: Douglas F. Cooley Memorial Art Gallery, Reed College, 1998).

18. For biographies of the two women, see Jerry W. Cotton, *Light and Air: The Photography of Bayard Wootten* (Chapel Hill: University of North Carolina Press, 1998); and Philip Walker Jacobs, *The Life and Photography of Doris Ulmann* (Lexington: University Press of Kentucky, 2001).

19. See Carl Fleischhauer and Beverly W. Brannan, eds., *Documenting America, 1935–1943* (Berkeley: University of California Press, in association with the Library of Congress, 1988); Constance B. Schulz, *A South Carolina Album, 1936–1948: Documentary Photography in the Palmetto State from the Farm Security Administration, Office of War Information, and Standard Oil of New Jersey* (Columbia: University of South Carolina Press, 1991); Paul Hendrickson, *Looking for the Light: The Hidden Life and Art of Marion Post Wolcott* (New York: Alfred A. Knopf, 1992).

20. Founded in 1932 by Myles Horton and Don West, Highlander was the first place that many people in the Movement experienced an interracial environment. For a history of this incubator of political activism, see John M. Glen, *Highlander: No Ordinary School* (Knoxville: University of Tennessee Press, 1996).

21. See *www.seaptnes.com/around_the_resort/resort_history.cfm* (accessed October 19, 2007).

22. Dale Rosengarten, "'Bulrush Is Silver, Sweetgrass Is Gold': The Enduring Art of Sea Grass Basketry," *Folklife Annual 88–89*, eds. James Hardin and Alan Jabbour (Washington D.C.: American Folklife Center, Library of Congress, 1989); Dale Rosengarten and Gary Stanton, eds., *The Proceedings of the Sweetgrass Conference* (Columbia: McKissick Museum, University of South Carolina, 1989); Dale Rosengarten, "'Sweetgrass Is Gold': Natural Resources, Conservation Policy, and African-American Basketry," in *Conserving Culture: A New Discourse on Heritage*, ed. Mary Hufford (Urbana: University of Illinois Press, 1994).

23. The holdings of the Old Slave Mart eventually were sold to the Acacia Collection, a private foundation in Savannah, Georgia, founded by African-American curator Carroll Greene. The building, now owned by the City of Charleston, was extensively renovated and on October 31, 2007, reopened under the same name, the Old Slave Mart Museum.

CHAPTER 10
ISLANDS ARE NOT ISOLATED:
RECONSIDERING THE ROOTS OF GULLAH
DISTINCTIVENESS

1. See *Low Country Gullah Culture Special Resource Study and Final Environmental Impact Statement* (Atlanta, Ga.: National Park Service Southeast Regional Office, 2005), 13, 21, 39, 51–52, 70, 74, 79, 84 [hereafter NPS 2005]; William S. Pollitzer, "The Gullah People and Their African Heritage," Appendix D (author's synopsis), included on CD insert, NPS 2005, D2, 9, 10, 49; Melissa D. Hargrove, "Overview and Synthesis of Scholarly Literature," Appendix F, included on CD insert, in NPS 2005, F5, 8–9, 22–23; William R. Bascom, "Acculturation among the Gullah Negroes," *American Anthropologist* 43:1 (January–March 1941), 43, 47; Lorenzo Dow Turner, *Africanisms in the Gullah Dialect*, 1949 (reprint. Ann Arbor: University of Michigan Press, 1973), iix, 5, 42, 200; Charles Joyner, *Down by the Riverside: A South Carolina Slave Community* (Urbana: University of Illinois Press, 1984), 6, 9; Margaret Washington Creel, *"A Peculiar People": Slave Religion and Community-Culture among the Gullahs* (New York: New York University Press, 1988), 3, 15, 97, 99, 100, 197, 240; Roger Pinckney, *Blue Roots: African-American Folk Magic of the Gullah People*, 1998 (reprint. Orangeburg, S.C.: Sandlapper Publishing, 2003), 2, 3, 7; Andrew Curry, "The Gullahs' last stand?" *U.S. News and World Report* 130:24 (June 18, 2001), 40–41; Brian D. Joyner, *African Reflections on the America Landscape: Identifying and Interpreting Africanisms*, Washington, D.C.: Office of Diversity and Special Projects, National Center for Cultural Resources, National Park Service, 2003, 40, cited in Joko Sengova, "'My Mother Dem Nyus to Plan' Reis': Reflections on Gullah/Geechee Creole Communication, Connections, and the Construction of Cultural Identity," in *Afro-Atlantic Dialogues: Anthropology in the Diaspora*, ed. Kevin A. Yelvington (Santa Fe, N.M.: School of American Research, 2006), 241, 247–48.

2. Turner, *Africanisms in the Gullah Dialect*, 5—emphasis added.

3. Guy B. Johnson, *Folk Culture on St. Helena Island, South Carolina* (Chapel Hill: University of North Carolina Press, 1930); Guion Griffis Johnson, *A Social History of the Sea Islands* (Chapel Hill: University of North Carolina Press, 1930); T. J. Woofter, Jr., *Black Yeomanry: Life on St. Helena Island* (New York: Henry Holt & Co., 1930); "Wal-Mart black history program gives glimpse of Gullah/Geechee Nation," *Target Market News: The Black Consumer Market Authority*, January 26, 2006, at: *http://www.targetmarketnews.com/storyid01270602.htm* (accessed August 18, 2007).

4. NPS 2005, 13—emphasis added.

5. Daniel C. Littlefield, *Rice and Slaves: Ethnicity and the Slave Trade in Colonial South Carolina* (Urbana: University of Illinois Press, 1981), 2.

6. Peter H. Wood, *Black Majority: Negroes in Colonial South Carolina from 1670 through the Stono Rebellion* (New York: Alfred A. Knopf, 1974), 6; NPS 2005, 21; Carolyn Morrow Long, *Spiritual Merchants: Religion, Magic, and Commerce* (Knoxville: University of Tennessee Press, 2001), 89; Joyner, *Down by the Riverside*, 205, 207.

7. David Moltke-Hansen, Foreword to William S. Pollitzer, *The Gullah People and Their African Heritage* (Athens: University of Georgia Press, 1999), xiii.

8. See Samuel Wilson, "An Account of the Province of Carolina, 1682," in *Narratives of Early Carolina, 1650–1708* (1911), ed. Alexander S. Salley, Jr., 167, quoted in Guion Griffis Johnson, *A Social History of the Sea Islands*, 14.

9. William Bascom, "Gullah Folk Beliefs Concerning Childbirth," in *Sea Island Roots: African Presence in the Carolinas and Georgia*, eds. Mary A. Twining and Keith E. Baird (Trenton, N.J.: Africa World Press, Inc., 1991), 27.

10. Bascom, "Acculturation among the Gullah Negroes," 48–49, cited in Dale Rosengarten, "Social Origins of the African-American Lowcountry Basket," Ph.D. diss., Harvard University, 1997, 50.

11. Granger was director of the Savannah Unit of the WPA's Federal Writers' Project that produced *Drums and Shadows: Survival Studies Among the Georgia Coastal Negroes* (Athens: University of Georgia Press, 1940).

12. Bascom, "Acculturation among the Gullah Negroes," 48–49, cited in Rosengarten, "Social Origins," 50.

13. Tom Hamrick, "Old Craft Is Dying Out," *The State* (Columbia, S.C.), May 16, 1971, quoted in Dale Rosengarten, *Row Upon Row: Sea Grass Baskets of the South Carolina Lowcountry*, 1986 (reprint. Columbia: McKissick Museum, 1994), 44.

14. Charles Joyner, "Gullah/Geechee Region Becomes a Cultural Heritage Corridor," *Heritage Matters: News of the Nation's Diverse Cultural Heritage*, National Park Service newsletter, January 2007, 1.

15. "National Park Service and State Accepting Nominations for the Gullah/Geechee Cultural Heritage Corridor Commission," National Park Service News Release, March 26, 2007.

16. Joyner, *Down by the Riverside*, 207; D. W. Meinig, *The Shaping of America: A Geographical Perspective on 500 Years of History*, vol. 1: *Atlantic America, 1492–1800* (New Haven: Yale University Press, 1986), 176–90; Pollitzer, *The Gullah People and Their African Heritage*, 7.

17. NPS 2005, 23–26.

18. Littlefield, *Rice and Slaves*, 132–34.

19. Advertisement in the *South-Carolina Gazette* (June 25 to July 2, 1763) by John Dutarque, jun., in *Runaway Slave Advertisements: A Documentary History from the 1730s to 1790*, vol. 3: *South Carolina*, comp. Lathan A. Windley (Westport, Conn.: Greenwood Press, 1983), 231.

20. Wood, *Black Majority*, 253.

21. Littlefield, *Rice and Slaves*, 133.

22. W. Jeffrey Bolster, *Black Jacks: African American Seamen in the Age of Sail* (Cambridge: Harvard University Press, 1997), 21–23, 155–56.

23. David Barry Gaspar and David P. Geggus, eds., *A Turbulent Time: The French Revolution and the Greater Caribbean* (Bloomington: Indiana University Press, 1997).

24. NPS 2005, 26.

25. Richard A. Long, "Gullah Culture Special Resource Statement of National Historical and Cultural Significance," in NPS 2005, 103.

26. For example, NPS 2005, 82; Hargrove in NPS 2005, F5, 36–40; Pollitzer in NPS 2005, D49.

27. Pinckney, *Blue Roots*, 94, also 93, 104; Carolyn Morrow Long, *Spiritual Merchants*, 94.

28. Pinckney, *Blue Roots*, 50, 92.

29. Ibid., 7.

30. Long, *Spiritual Merchants*, 14–16, 121–22.

31. Pinckney, *Blue Roots*, 93, 99.

32. Ibid., 58.

33. NPS 2005, 52, 84, 95–96.

34. See Rosengarten, *Row Upon Row*, 26–31; NPS 2005, 118; Elizabeth Jacoway, *Yankee Missionaries in the South: The Penn School Experiment* (Baton Rouge: Louisiana State University Press, 1980), 140–44, 262–64.

35. Rosengarten, *Row Upon Row*, 43.

36. Roger Bastide, *Estudos Afro-Brasileiros* (São Paulo: Perspectiva, 1983), 242–43.

37. Melville J. Herskovits, *The Myth of the Negro Past*, 1941 (reprint. Boston: Beacon Press, 1958), 115–16, 120, 124; Newbell Niles Puckett, *Folk Beliefs of the Southern Negro*, 1926 (reprint. New York: Dover Publications, 1969), 10–11; J. Lorand Matory, "Surpassing 'Survival': On the Urbanity of 'Traditional Religion' in the Afro-Atlantic World," *Black Scholar* 30:3/4 (2000), 36, 41 n. 5.

38. Wood, *Black Majority*; John Michael Vlach, *The Afro-American Tradition in Decorative Arts*, 1978 (reprint. Athens: University of Georgia Press, 1990); Littlefield, *Rice and Slaves*; Judith A. Carney, *Black Rice: The African Origins of Rice Cultivation in the Americas* (Cambridge: Harvard University Press, 2001).

39. See Abner Cohen, *Custom and Politics in Africa* (Berkeley: University of California Press, 1969); Fredrik Barth, Introduction to *Ethnic Groups and Boundaries: The Social Organization of Cultural Difference* (Boston: Little, Brown and Co., 1969), 9–38; Enid Schildkrout, *People of the Zongo: The Transformation of Ethnic Identities in Ghana* (Cambridge: Cambridge University Press, 1978); Virginia R. Dominguez, *People as Subject, People as Object* (Madison: University of Wisconsin Press, 1989); Richard Handler, *Nationalism and the Politics of Culture in Quebec* (Madison: University of Wisconsin Press, 1988).

40. Bascom, "Acculturation among the Gullah Negroes," 43.

41. For example, Yvonne P. Chireau, *Black Magic: Religion and the African American Conjuring Tradition* (Berkeley: University of California Press, 1997), 53–54; Pinckney, *Blue Roots*, 73, 111.

42. For example, Joyner, *Down by the Riverside*, 148; Pinckney, *Blue Roots*, 40.

43. For example, Pinckney, *Blue Roots*, 17, 97–109, 111; Jennifer Ritterhouse, "Reading, Intimacy, and the Role of Uncle Remus in White Southern Social Memory," *Journal of Southern History* 69:3 (August 2001), 585–622; Long, *Spiritual Merchants*, 150–51 and passim; John Edward Philips, "The African Heritage of White America," in *Africanisms in American Culture*, ed. Joseph E. Holloway (Bloomington: Indiana University Press, 1990), 225–39.

44. Carney, *Black Rice*, 116.

45. Turner, *Africanisms in the Gullah Dialect*, 40.

46. Salikoko S. Mufwene and Charles Gilman, "How African is Gullah, and Why?" *American Speech* 62:2 (Summer 1987), 130.

47. For example, Pollitzer in NPS 2005, D29; Sengova, "'My Mother Dem Nyus to Plan' Reis,'" 226; Turner, *Africanisms in the Gullah Dialect*, 11–13.

48. Unlike many linguists, Mufwene and Gilman (1987) argue that the Gullah language is not dying or decreolizing, and that it is likely to survive as long as some predominantly Gullah-speaking residential communities remain intact. They report that the Gullah language is changing and varies across generations, but no more so than most non-creole languages, and the trajectory of its changes is not toward English.

49. See J. Lorand Matory, "The English Professors of Brazil: On the Diasporic Roots of the Yoruba Nation," *Comparative Studies in Society and History* 41:1 (January 1999), 72–103.

50. By the term "socially white," I mean that many such elites in Northeastern Brazil are considered "white" (*branco*) on account of their wealth, education, and/or social networks, despite physical evidence of African ancestry.

Here I refer to Charles Wagley's concept of "social race." Charles Wagley, Introduction to *Race and Class in Rural Brazil*, 1952 (New York: UNESCO/International Documents Service, Columbia University Press, 1963), 7–15. In Brazil, the "one-drop rule"—whereby "one drop" of African "blood" makes one "black"—does not usually apply. São Paulo's elite tended to have fewer African ancestors than did the elites of the Northeast. The manner in which they are considered "white" would be more familiar to most people in the United States.

51. J. Lorand Matory, *Black Atlantic Religion: Tradition, Transnationalism, and Matriarchy in the Afro-Brazilian Candomblé* (Princeton: Princeton University Press, 2005), 157.

52. Ibid., 149–87.

53. Ibid., 296–97; see Pinckney, *Blue Roots*, 55–56.

54. For example, Turner, *Africanisms in the Gullah Dialect*, 247, 292.

55. Littlefield, *Rice and Slaves*, 118–23, 129–31.

56. See Carney, *Black Rice*, 19.

57. NPS 2005, 56.

58. Alphonso Brown, personal communication, December 9, 2005.

59. For example, Rosengarten, *Row Upon Row*, 25–30; Turner, *Africanisms in the Gullah Dialect*, xv; NPS 2005, 118.

60. Sengova, "'My Mother Dem Nyus to Plan' Reis,'" 219–32; Matory, *Black Atlantic Religion*, 295–96, 341 n. 1.

61. See also NPS 2005, 93–98.

62. Ibid., 96.

63. Ibid., 95–96; Hargrove in NPS 2005, F31–32; Sengova, "'My Mother Dem Nyus to Plan' Reis,'" 235–42.

64. Sengova, "'My Mother Dem Nyus to Plan' Reis,'" 242–43; NPS 2005, 59–71.

65. *De Nyew Testament: The New Testament in Gullah Sea Island Creole with marginal text of the King James Version*, translated by the Sea Island Translation Team in cooperation with Wycliffe Bible translators (New York: American Bible Society, 2005).

66. Matory, *Black Atlantic Religion*, 54, 56–57; Matory, "The English Professors of Brazil," 85.

67. See NPS 2005, 65.

MUSEUM FOR AFRICAN ART

DONORS

CORPORATE, FOUNDATION, AND GOVERNMENT DONORS

PRESIDENT'S CIRCLE

Altria Group, Inc.
Carnegie Corporation of New York
Checker Motors
Gaylord and Dorothy Donnelley Foundation
The Getty Foundation
Merrill Lynch & Co. Foundation, Inc.
MetLife Foundation's Museums and Community
 Connections Program
JPMorgan Chase Foundation
National Endowment for the Arts
National Endowment for the Humanities
New York City Department of Cultural Affairs
Tishman Realty and Construction
The Andy Warhol Foundation for the
 Visual Arts, Inc.

SPONSORS

American Express Foundation
Benenson Capital Partners, LLC
Brickman
Prince Claus Fund for Culture and Development
The Community Preservation Corporation
Con Edison
DaimlerChrysler Corporation Fund
HIP Health Plan of New York
Merrill Lynch & Co., Inc.
Mitsui & Co. (U.S.A.), Inc.
Rockefeller Group Development Corp.

BENEFACTORS

Aetna Foundation
Colgate-Palmolive Company
Debevoise & Plimpton LLP
Deloitte & Touche USA LLP
Entrust Capital, Inc.
Mitsui USA Foundation
The New York Times Company Foundation
May and Samuel Rudin Family Foundation, Inc.
Weil, Gotshal & Manges LLP

PATRONS

American Express Company
Bloomberg L.P.
GNYHA Ventures
Goldman Sachs
LEF Foundation
Macy's East, Inc.
Marsh USA Inc. Japan Client Services
Mitsubishi International Corporation
Mitsui Lifestyle (U.S.A.), Inc.
Mitsui Steel, Inc.
New York Council for the Humanities
New York State Council on the Arts
News Corporation

NTT America Group, Inc.
Oppenheimer & Co. Inc.
Pfizer Inc
Shearman & Sterling LLP
Silverman Charitable Group
Robert A.M. Stern Architects, LLP
Wachtell, Lipton, Rosen & Katz

SUPPORTERS

Brookfield Properties
The Ford Foundation
The Gramercy Park Foundation, Inc.
The Leon Levy Foundation
Mitsui Sumitomo Marine Management
 (USA), Inc.
Nihon Unisys, Ltd.
Pace Primitive
Pitney Bowes Employee Involvement Fund
Road Machinery, LLC
Silver Spring Group
Simpson Thacher and Bartlett LLP
Sotheby's Inc.
Transfreight, LLC
Wachovia
Wachovia Foundation
WellPoint, Inc.

INDIVIDUAL DONORS

PRESIDENT'S CIRCLE

Henry Buhl
Betty and Louis Capozzi
Paul W. Critchlow
Irwin Ginsburg
Sally and Jonathan Green
Agnes Gund and Daniel Shapiro
Frances N. Janis and Mitchell Harwood
Jane and Gerald Katcher
Helen and Martin Kimmel
Linda and Benjamin Lambert
Kathy MacArdle and Jay Kriegel
Jeanne Moutoussamy-Ashe
Louise and Leonard Riggio
Laura and James Ross
Elease E. Wright
Jason H. Wright

BENEFACTORS

Peg Alston
Patricia Blanchet
Gordon Davis
Perkins Foss
Steve and Myrna D. Greenberg
Lesley and Evan Heller
Lloyd Kaplan
Suri Kasirer
Lucille and Ted Kaufman
Jerome and Carol B. Kenney
Charles and Jane D. Klein
Guy and Roxanne Lanquetot
Ann Walker Marchant

Celeste Mazzone
Patricia and Ronald Nicholson
Tarrus and Kimberly Richardson
Kerri Scharlin and Peter Klosowicz
Ralph Schlosstein
Peter J. Sposato
Rebecca and Christopher Steiner
Sonia Toledo
Helen S. Tucker
Claudia Wagner

FRIENDS

Shahara A. Ahmad-Llewellyn
Alan and Arlene Alda
Ernest A. Bates, M.D.
Joseph Blatt
Mary Ann and Owen Blicksilver
Estrellita and Daniel Brodsky
Larry Carty
Bernice and Sidney Clyman
Heather and Jeffrey Collins
Christy Ferer
David Goldring
Liz and Steven Goldstone
Gail Gregg and Arthur Sulzberger, Jr.
Douglas A. P. Hamilton
Lesley Heller
Gail Koff
Alice and Arthur Kramer
Caral and Joe Lebworth
Harvey S. Shipley Miller
Margaret Morton
John Pantazis
Veronica Pollard
Rita and Fred M. Richman
Margaret Rinkevich and Robert T. Wall
Janice Roberts
David Rockefeller, Sr.
Doris Rubin
Ellen and Jerome Stern
Jonathan M. Tisch
Mark L. Wagar
Lola C. West

CONTRIBUTORS

Susan Allen
Joan and Jeffrey Barist
Sarreta and Howard Barnet
Emily Bauman
Lynn and Samuel Berkowitz
Suzanne and Rudolph L. Blier
David Bogaisky
David Bowen
Frank and Elizabeth Breuer
Marie H. Buncombe
Sandra Bynum
Pamela F. and Oliver E. Cobb
Kathleen Comfrey
Annette M. Cravens
Lila Dannenberg
Theo Davis, Esq.

Claudia DeMonte and Ed McGowin
Ronald A. DeSouza
William and Barbara Dewey
David N. Dinkins
Richard W. Eaddy
Laura Ensler and David Rivel
Jeremy G. and Amy K. Epstein
Aaron and Rosa Esman
Michael and Nancy Feller
Linda Florio
Sam and Judy Florman
Diane B. and Charles Frankel
Charles Flowers and David Freenkel
Mortimer B. Fuller III
Phillip T. George
Maxine Griffith
Geoffrey and Sarah Gund
Robert Hackne, Jr.
Frank Hall
William A. Harper
Marain L. and Winlow M. Heard
John and Anne Herrmann
Paul E. Hertz and James Rauchman
Fred Hochberg and Tom Healy
Susan Horsey and Art Sherin
Nancy and Douglas Ingram
Robert Jacobs
Fern and Bernard Jaffe
Judith and Harmer F. Johnson
Dennis and Shirley B. Kluesener
Sarah Kovner
Judith A. Langer and Arthur N. Applebee
Loida Nicolas Lewis
Diane and Brian Leyden
Mary C. Lutz
Delia B. and Eugene Mahon
Joanne and Lester Mantell
Daisy W. Martin
Michele Coleman Mayes
Amy and Charles Merrill
Colette Michaan
Caroline and Marshall Mount
Thomas Murray
Patricia M. Papper
Maria Patterson
Martin Puryear
Andre Rice
Holly and David Ross
William and Josephine M. Roth
Barbara Rubin
Lucy and Richard M. Sallick
Arthur Sarnoff
Natalie and Robert Schaffer
Darrel Schoeling and Jeff Corbin
Tim Seibold
Sydney L. Shaper
Ruth Lande Shuman
Edwin and Cherie Silver
Daniel Simmons
Lowery Stokes Sims
Maurice H. Solomon
Betty and Robert Soppelsa

Deirdre Stanley
Doris Sullivan
Alan Sussman and Martha Cotter
Gerard Tate
Antony Van Couvering
William Watson
Carl Weisbrod
Stanley and Mikki Weithorn
Varick Wettlaufer-Traore and Bamba
 Zoumana Traore
Jo and Ralph Wickstrom
Michelle and Claude Winfield

SUPPORTERS
Lea and Rowland Abiodun
Edward Albee
Robert A. Annibale
Phyllis and Arthur Bargonetti
Dr. Phyllis Beren and Dr. Sheldon Bach
Michael Berger, M.D.
Rena M. and Charles A. Berger
Laura P. Bernard and Marson Pratt
Barbara Blackmun
Elizabeth T. Bolden
Shirley and Martin Bresler
Sarah C. Brett-Smith and Stephen L. Adler
Chaday Brown
Leanna Brown
Valerie S. Brown
Jean Bunce
John D. Cahill
Anne E. Canty and Victor M. Quintana
Tony and Robert Ceisler
Bernadine Chapelle and Marcus A. Styles
Nancy L. Clipper
Sandra D. Colony
Joan Cregg
Margaret and James Cunningham
Susan Davis
Ann E. Day
Marjolijn de Jager and David Vita
Ella Dixon and John J. Spata
Charliese Drakeford
Steven Dubin
Kevin D. Dumouchelle
Elizabeth Eames
Joy Elliott
David Eskin
Debra and Harris Feinn
Emily H. Fine
Ann Fitzgerald and Paul Lauter
Barbara Frank
Ben F. Freedman
Cori H. and R. Harold Garrett-Goodyear
Paula L. and John Gavin
Aliza Gebiner
Alan Gettis
Jewelle T. and James L. Gibbs
Brenda Gill
Denyse and Marc Ginzberg
Arthur Goldberg

Larry Mark Goldblatt
Jean R. Goldman
Betsy Gould and Alan Bomser
Denise L. Greene
Mary Haberle
Benjamin Hanani
Hannah and Yehuda Hanani
Chris Hansen
Mable Hedger
Patricia and Bern Heller
Myra Tate Herlihy
Ghislaine Hermanuz
Sam Hilu
Rita and John Hirsch
George O. Hobson
Edwin C. Horne, D.D.S.
Richard W. Hull
Nicole Ifill
James Ilako
Henrietta and Albert Imesch
Catti James
Jose Jimenez
Susie Johnson
Ben Jones
Edwina K. Jordan
Arthur Kamell
Paul Katcher
Matthew Kaufman
Christopher Kelley
Lee Krueckeberg
La Toya Ladson
Stanley Lederman
Jenifer Lee
Valerie Leiman
Lydia and John O. Lenaghan
Roberta and Martin Lerner
Susan and Peter LeVangia
Kenita Lloyd
Eileen Lynch
Christine Mahoney
Myra Malkin
Suzan Marks and Vincent Campo
Jane Martin
Molly and Harry Martin
Shirley Mason
Carmen and Herbert B. Matthew
Lorraine Matys
Susan Maurer
Tamara McCaw
Julie McGee
Stephen McGill
Frances V. McKinnely
R. Anthony Mills
Sally and Alan G. Morton
Lee and Robert Naiman
Sharon G. Nathan and Stephen A. Udem
The Norborn Family
Naututu Okhoya
Shea Owens
Lenore Parker and Robert Fagan
Philip M. Peek
Gail Pellett

Philip W. Pillsbury, Jr.
Yvonne G. Pisacane
Marquita J. Pool-Eckert
Atkins Preston
Alice H. Proskauer
Shirley Rodriguez Remeneski
Marcia and Philip Rothblum
Mark M. Rubenstein, M.D.
Joanne Saccio
William and Susan Schlansky
Ellen Seidensticker and Louis Wells
Karen R. and Douglass J. Seidman
Jack Shainman
Gale D. and William Simmons
Gwendolyn A. Simmons
Marsha E. Simms
Elizabeth and Ron Singer
Janet L. Stanley
Anne H. Stark
Diane and Abraham Sunshine
Antoine Tempe
Heidi Terralavoro
Susan S. and Richard Ulevitch
Elaine and Jay Unkeless
Hippoliet Verbeemen
Judith and Pheroze Wadia
Paul Weidner
Rudy Whitehead
Nancy Wolfson
Linda and Carl Yearwood

And all of those who wish to remain
anonymous

Current as of January 2008

LENDERS TO THE EXHIBITION

American Museum of Natural History, New York, New York
Timothy and Pearl V. Ascue
Avery Research Center, College of Charleston, Charleston, South Carolina
Brooklyn Museum, Brooklyn, New York
Estate of Leroy E. Browne, Sr.
Charleston County Aviation Authority/Charleston International Airport, Charleston, South Carolina
The Charleston Museum, Charleston, South Carolina
Culture and Heritage Museums, Rock Hill, South Carolina
Greg Day
Durban Art Gallery, KwaZulu-Natal, Durban, South Africa
The Field Museum of Natural History, Chicago, Illinois
Joseph Foreman, Jr.
Gibbes Museum of Art/Carolina Art Association, Charleston, South Carolina
Jessica B. Harris
Edith Howle and Rick Throckmorton
William R. Judd
Frederick John Lamp
McKissick Museum, University of South Carolina, Columbia, South Carolina
Medical University of South Carolina Foundation, Charleston, South Carolina
Amy Lofton Moore
Jackie Morrison
Carl and Allison Muller
Amyas Naegele and Eve Glasberg
Alberta Lachicotte Quattlebaum
Dale Rosengarten
Rafael D. Rosengarten
Royal Museum for Central Africa, Tervuren, Belgium
Mrs. Jervey D. Royall
Kim Sacks
Dana Sardet
William Siegmann
Bill and Gale Simmons
Henrietta Snype
South Carolina Arts Commission, Columbia, South Carolina
South Carolina Historical Society, Charleston, South Carolina
South Carolina State Museum, Columbia, South Carolina
Mary Catherine Stanley
Irving Stokes
The Tiller Family
Virginia Museum of Fine Arts, Richmond, Virginia

And all of those who wish to remain anonymous

PHOTO CREDITS

Jack Alterman: figs. 6.18, 6.23

American Museum of Natural History, Division of Anthropology, New York, New York: cover, cats. 4, 5, 8, 14–18, 20, 21, 29, 31, 32, 39, 40, 43, 75, 97–99, 104

Avery Research Center, College of Charleston, Charleston, South Carolina: fig. 9.2

Brookgreen Gardens, Murrells Inlet, South Carolina: figs. 2.2, 9.8

Brooklyn Museum, Brooklyn, New York: cat. 30

Rosalyn Browne: fig. 6.4

Judith A. Carney: figs. 1.1, 3.1, 3.4

Charleston Library Society, Charleston, South Carolina: fig. 4.5

The Charleston Museum, Charleston, South Carolina: figs. 4.9, 8.5

Charleston News and Courier, Charleston, South Carolina: fig. 6.21

Culture and Heritage Museums, Rock Hill, South Carolina: cat. 41

The Danish Maritime Museum, Helsingør, Denmark: fig. 3.2 (#SR 2006:0205)

Greg Day collection: cats. 47, 50, 53, 71, 85, 86; figs. 2.6–2.8, 3.8, 5.3, 6.22, 10.2, 10.3, 10.5, 10.6

Duke University, Rare Book, Manuscript, and Special Collections Library, Durham, North Carolina: fig. 1.7

Durban Art Gallery, KwaZulu-Natal, South Africa: cats. 107–113

Early American Newspapers, an Archive of Americana Collection, published by Readex, a division of NewsBank, and in cooperation with the American Antiquarian Society: figs. 1.8, 2.3, 2.4, 3.9, 3.10

The Field Museum of Natural History, Chicago, Illinois: cats. 33, 34; fig. 1.13 (negative #69098)

Fisk University Museum of Art, Nashville, Tennessee: fig. 6.6

Foreign Press Center: fig. 10.9

Francis Marion National Forest, U.S. Department of Agriculture, Columbia, South Carolina: figs. 4.11, 6.13

David P. Gamble: figs. 3.5, 3.6

Gibbes Museum of Art/Carolina Art Association, Charleston, South Carolina: cats. 54, 58, 59, 115–119; figs. 4.8, 4.10, 8.4, 9.6, 9.7

Jessica B. Harris: 5.2, 5.4

Iziko Museums of Cape Town, Cape Town, South Africa: fig. 7.4 (photo: Cecil Kortjie)

Sandra Klopper: figs. 7.1, 7.2, 7.6, 7.7

Library of Congress, Washington, D.C.: figs. 1.9, 2.5, 5.1, 8.8, 8.9, 9.1, 9.4, 9.5, 9.10

McGregor Museum, Kimberley, South Africa: fig. 7.5

McKissick Museum, University of South Carolina, Columbia, South Carolina: figs. 4.7, 6.8–6.12

Lisa M. Turnbull Laramee collection: fig. 1.12

Sally McLendon: figs. 6.14, 6.15

Musée du Quai Branly, Paris, France: fig. 1.16

Museu Nacional de Etnologia, Divisão de Documentação Fotográfica-Instituto dos Museus e da Conservação, I.P., Lisbon, Portugal: cats. 9, 35, 36, 38 (photo: José Pessoa)

Museum for African Art, New York, New York: cats. 1–3, 6, 7, 10–13, 19, 22–24, 26, 44–46, 48, 49, 51, 52, 55–57, 60–66, 68–70, 72–74, 77–84, 87–96, 100–103, 106, 114, 120–123; figs. 1.14, 2.1, 4.3, 4.4, 6.19, 10.10 (photo: Karin Willis); cats. 28, 37 (photo: Jerry Thompson)

National Maritime Museum, London, England: fig. 3.3 (©National Maritime Museum)

The New-York Historical Society, New York, New York: fig. 4.6

Penn School Collection. Permission granted by Penn Center, Inc., St. Helena Island, South Carolina. Images courtesy of Penn School

Papers #3615, Southern Historical Collection, Wilson Library, University of North Carolina at Chapel Hill, Chapel Hill, North Carolina: figs. 4.1, 6.1–6.3, 6.5, 6.7, 9.11, 10.4, 10.7, 10.8

Private collection: cat. 25 (photo: Michael Cichon)

Lynn Robertson: cat. 67

Dale Rosengarten: figs. 1.2, 1.3, 1.5, 1.6, 1.17, 4.12, 6.16, 6.17

Royal Museum for Central Africa, Tervuren, Belgium: cat. 42 (photo J.-M. Vandyck, © RMCA Tervuren); fig. 1.15 (negative no. 24266)

Christian Sardet: fig. 6.25

Enid Schildkrout: fig. 1.4

Bill and Gale Simmons collection: cat. 105 (photo: © Bruce M. White, 2007)

Smithsonian American Art Museum, Washington, D.C.: cat. 76 (photo: Gene Young)

Snite Museum of Art, Notre Dame, Indiana: fig. 9.9

Henrietta Snype: fig. 6.24

University of North Carolina at Chapel Hill, Chapel Hill, North Carolina: figs. 8.1, 8.2, 8.10 (used with Permission of Documenting the American South, The University of North Carolina at Chapel Hill Libraries)

University of Virginia Library, Charlottesville, Virginia: 8.6

Virginia Museum of Fine Arts, Richmond, Virginia: cat. 27 (photo: Katherine Wetzel © Virginia Museum of Fine Arts)

Gene Waddell: figs. 3.7, 9.3, 10.1

Yale University, Beinecke Rare Book and Manuscript Library, New Haven, Connecticut: figs. 8.3, 8.7